THE GREAT
MASTERS

Giorgio Vasari

THE GREAT MASTERS

GIOTTO · BOTTICELLI · LEONARDO

RAPHAEL · MICHELANGELO · TITIAN

Translation by Gaston Du C. de Vere

Edited by Michael Sonino

Galley Press

Published in this edition in 1989 by Hugh Lauter
Levin Associates, Inc. for Galley Press, an imprint of
W H Smith Ltd, Registered number 237811 England,
trading as W H Smith Distributors, St Johns House,
East Street, Leicester LE1 6NE.

ISBN 0-86136-106-7

Produced by Mandarin Offset/Printed and bound in Hong Kong

© 1986 Hugh Lauter Levin Associates, Inc., New York

CONTENTS

EDITOR'S INTRODUCTION

Giorgio Vasari and his Lives

In the mid-1540s a Tuscan painter and architect named Giorgio Vasari embarked on a writing project, and in 1550 the first edition of his *Lives of the Most Eminent Painters, Sculptors, and Architects* was published, containing the biographies of some 120 masters from the thirteenth-century painter Giovanni Cimabue to the then-thriving Michelangelo. In 1568 the second edition appeared, greatly expanded and revised to include scores of living artists. In addition to new biographies, this edition contained woodcut portraits of the artists, special introductions to various sections, and a comprehensive index.

Today, Vasari's *Lives* is considered the fundamental source for our knowledge of the origins, growth, and flowering of the Italian Renaissance. It presents a unique picture of the times written *by* a painter and architect *about* his fellow-artists and craftsmen. Vasari *knew* Michelangelo and Titian and dozens of other celebrated painters, architects, and sculptors, as well as popes, princes, and illustrious men of letters, and thus, his work offers an unparalleled eyewitness account of an age whose glory has never been surpassed.

The unabridged edition of the *Lives* is monumental and runs into thousands of pages; fully annotated, it runs into even more thousands. Its sheer bulk is intimidating to the general reader, who would in any case need to know Italian, since the only two complete annotated editions are nine stout volumes edited under the supervision of Gaetano Milanesi in 1878–85, and nearly twice as many volumes produced under the editorship of Paola Barocchi a few years ago. Of the three complete English-language translations of the text alone, it is the De Vere version of 1912 that has long been considered the most elegant, and it is this translation that forms the basis of the present edition.

Included in this volume are six undisputed masters. Their biographies are illustrated with many of the works seen and discussed by Vasari. Editorial annotations, which are kept to a minimum, have been included as an aid to the general reader, who is also provided with a chronology, listing events and protagonists of the extraordinarily turbulent and stimulating centuries in which the artists lived.

Here then, are the lives and times of Giotto, Botticelli, Leonardo da Vinci, Raphael, Michelangelo, and Titian. But what of the man who wrote of them, who spoke and corresponded with Michelangelo and Titian—what was his role in the history of art? Florence abounds with Giorgio Vasari's paintings. They inescapably seem to cover acres and catch the eye in scores of churches, the Cathedral (Santa Maria del Fiore, or Duomo), and in dozens of vast halls and suites of apartments in the Palazzo Vecchio.

In Rome, too, Vasari's frescoes are almost as unavoidable. In the Vatican there is the Sala Regia, and in the great hall of the Palazzo della Cancelleria are enormous frescoes that the artist and his assistants completed in a hundred days. (Michelangelo, whom Vasari idolized, commented on this speed when Vasari proudly stated how rapidly he had completed the work: "You can see it," Michelangelo said.)

Why, with so many greater masters active at the time, did Vasari receive so many commissions, becoming at the height of his career the art dictator of Florence? The simple answer is that artists of genius were usually temperamental and, when finally convinced to accept a commission, took their time. For instance, when an impatient Pope Julius II asked Michelangelo when he would finally complete the Sistine Ceiling, the artist replied that the work would be completed when it was finished, which it might never be if he were not left alone. Or, as in the case of Leonardo, an artist might be too involved in technical theories to bring a project to its successful conclusion. Vasari, however, was cooperative, enthusiastic, diplomatic, witty, and inventive—and he met deadlines effortlessly. Even though his work lacked genius, it was nonetheless colorful, the narrative or allegory was rendered effectively, and the end product was, if nothing else, quite decorative. Perhaps the only genius of the High Renaissance able to produce the masterpieces in vast fresco cycles with ease and dispatch was Raphael, who died when Vasari was only a boy.

In contrast to his overinflated frescoes and altarpieces, Vasari's drawings are often spontaneous and stylish and certain of his less ambitious easel paintings reflect charm and a delightful sense of fantasy. And for the house he built himself in Arezzo, Vasari contrived several elegant fresco decorations.

As a designer of theatrical entertainments and ceremonial festivities Vasari was possibly without rival. His most ambitious work in this field was a series of elaborate floats, lavish outdoor decorations constructed of lathe and painted canvas (false façades and triumphal arches that lined and intersected entire streets and public squares), and hundreds of fanciful costumes designed under his supervision for the celebrations held in Florence to honor the nuptials of Francesco de' Medici and Joanna of Austria. This event lasted for months, and Vasari's creations must count among the most sumptuous scenic marvels of that age, and possibly of all time.

Vasari's architectural achievements are also impressive. For Cosimo I de' Medici, his patron and ruler of Florence, he designed the Uffizi, a vast building housing the civic records and municipal offices (*uffizi* is Italian for offices) of the dukedom of Florence. Although sometimes criticized as stiff and cold, the Uffizi embodies an unerring sense of proportion and brilliantly harmonizes a Classically influenced Mannerist building with a thirteenth-century structure—the ponderous though impressive Palazzo Vecchio. Vasari's plan is all the more outstanding in the way it successfully integrates the Piazza della Signoria with the river Arno; the public space is both functional and inventive, while the narrow corridor-like court leading from the river to the square offers a dramatic series of vistas. Equally fine (many think it his masterpiece) is the Palazzo dei Cavalieri in Pisa, another commission for Cosimo, who was the patron of the Cavalieri di San Stephano. The palace itself (there is also a monastery and a church) is faultlessly proportioned and has a beautifully decorated façade.

Vasari was born in the Tuscan town of Arezzo on July 20, 1511. The city of Florence, some fifty miles to the northwest in the valley of the Arno, was ruled by the Medici, a powerful family who had made their fortune in banking, and whose members were enlightened patrons of the arts. The Medici, it could be said, also ruled Europe, for there were Medici seated in

Rome as popes and Medici women married to kings of France. But Florence, then in its greatest glory, *was* the Medici, and the Medici were Florence.

Giorgio Vasari's forebears came from the town of Cortona. In the *Lives* Messer Giorgio includes a biography of a great-grandfather, Lazzaro, a successful craftsman who decorated saddles and furniture with little painted scenes. (Lazzaro reportedly created more ambitious works, such as frescoes in certain of Arezzo's churches; this is a moot point, for none have survived.) Vasari's father, Antonio, was a ceramicist (*vasari* means "makers of vases"). His great-aunt married the celebrated painter Luca Signorelli, who became young Giorgio's first teacher. He later received more extensive training from Guillaume de Marcillat, a Frenchman who had come to Arezzo to create the stained-glass windows for the cathedral. (These windows are still in place, and are masterpieces.)

In 1524, young Giorgio came under the patronage of Silvio Passerini, Cardinal of Cortona. This prelate was the first of the many cardinals who loom so large in Vasari's life, as well as in the *Lives* themselves. Renaissance cardinals were unlike present-day princes of the church; the ideal Renaissance cardinal exhibited ruthless power, diplomatic suavity, political cunning, and artistic judgment. Piety and theological perception were unnecessary, but if the cardinal possessed the strategic genius of a great general. . . . Such men became the popes of that day.

For Cardinal Passerini's delectation, young Giorgio recited lengthy passages from Virgil's *Aeneid*, which he knew by heart. Impressed with such erudition, the cardinal commanded that Antonio take his son to Florence to study.

Florence in 1524 was the artistic center of the world, and passages in the *Lives* of Raphael and Michelangelo give the reader a first-hand account of its wonders. Young Giorgio was lodged with Niccolo Vespucci and began his studies with Michelangelo. Today it is believed that, in so doing, Vasari did little more than run errands for the master, who was then at the zenith of his career. Whatever the relationship, it brought the fledgling artist into contact with the greatest master of the day, one whom Vasari came to venerate above all other human beings. He became Michelangelo's close friend in the artist's old age, corresponded with him, and eventually designed some of the elaborate decorations for his funeral.

In addition to Vasari's artistic education, the Cardinal of Cortona directed his academic studies. Young Giorgio spent two hours every day studying in company with Ippolito (who eventually became a cardinal) and Alessandro de' Medici. His associations with the illustrious and high-born thus began; and owing to his investigatory mind, ingratiating demeanor, industry, and eloquence, Vasari soon became an intimate with influential patrons—popes, cardinals, princes, and dukes—as well as with some of the finest intellects of the day—writers, poets, and philosophers.

After Michelangelo left for Rome to confer with Pope Clement on plans for the Laurentian Library, Vasari went to study with Andrea del Sarto (the "perfect painter," as Browning termed him), and subsequently Ippolito de' Medici placed him in the studio of the sculptor, Baccio Bandinelli.

In 1527, Florence was thrown into a turmoil which culminated in the temporary expulsion of the Medici. During the attendant riots, a bench thrown from one of the windows of the Palazzo Vecchio struck the statue of Michelangelo's *David*, breaking one of its arms. The fragments lay in the piazza for three days, until Vasari and a fellow-student, the painter Francesco Salviati, gathered up the fragments and brought them to Salviati's father. This rescue mission was accomplished in the face of considerable danger, for the Piazza della Signoria was overrun by soldiers who, sta-

tioned there to preserve the peace, looked on intruders with suspicion. The damaged statue was later restored by orders of Cosimo I.

With Florence in the throes of civil strife, and all of Italy reeling from the Sack of Rome, Antonio Vasari decided that he and his son should return to Arezzo. Yet fate was unkind, for in 1528 Antonio died of the plague, and Giorgio was left with his mother and six siblings to support.

Vasari was not fated to languish in Arezzo for long, however. His former fellow-student Ippolito de' Medici, now a cardinal, passed through the town on his way to Rome and offered his patronage and wrote letters of influence. It was Vasari's usual luck; he was in the right place at the right time—and so, he was summoned to Rome.

Rome at that time was recovering from the terrifying Sack, when the Spanish and German mercenaries of the army of the Holy Roman Emperor had engaged in an orgy of carnage, rapine, and mindless destruction. In Rome, Vasari re-encountered Salviati, and the two young artists spent their free time exploring, sightseeing, and drawing masterpieces in the Vatican, often forgetting to eat in their zeal and excitement. In Rome, too, Vasari embarked on his first commissions.

He traveled the path of success easily. He painted tirelessly. He married well, although his wife was to complain he was never home, so occupied was he with his work. He also began systematically to collect drawings of other artists past and present, and in so doing became the first major collector who was not a monarch, nobleman, or prelate. Although he had always collected drawings in a modest way, his growing fame and his travels now gave him access to many sources. For a few coins he was able to purchase drawings (inexpensive in those days), or he acquired them gratis from his colleagues or their heirs.

Vasari carefully assembled these works in a large folio volume, "our book," as he called it, placing each example within an exquisitely rendered architectural frame of his own devising and sometimes grouping a number of drawings on a single page.

Although he believed he had attained his goal of acquiring works by every important artist from Cimabue to those of his own day, Vasari ingenuously misattributed his past masters often; his "Giottos" and "Leonardos" are no longer attributed to these artists. Examples by contemporaries are, of course, authentic, since the majority were presented to him by the artists themselves. Connoisseurship is a recent phenomenon, brought to its present-day standards by Bernard Berenson at the turn of the century; thus, it would be erroneous to hold Vasari to present-day criteria and to accuse him of being an ignorant collector. Unable to attribute his works by modern methods, he was yet the first to trace the course of Italian art from the thirteenth century to his time and to arrange the works in roughly chronological order. Equally important is that he believed that the foundation of all art was good drawing, good design—buon disegno, to use his phrase. Today this is a given, but in Vasari's age it was a novelty.

Vasari's book of drawings was broken up and the works dispersed after his death. But it has been possible to trace most of its contents, and they can be found in numerous collections, public and private, throughout the world. A few examples are reproduced in the present volume.

In 1546, Vasari attended a dinner party hosted by Pope Paul III, the former Alessandro Farnese, scion of an illustrious family, who had commissioned Vasari's hastily executed frescoes in the Palazzo della Cancelleria. The pontiff was a worldly man and an intellectual, and that particular evening the guests included the noted diplomat and Humanist poet Annibale Caro, the collector and scholar Paolo Giovio, and (in Vasari's words) "many other men of learning and distinction, of whom the Court of that Lord is ever

full." In their conversation, Giovio mentioned he "had a great desire to add to his museum . . . a treatise with an account of the men who had been illustrious in the art of design from Cimabue down to our own times." He continued to discuss his ideas in detail, and after he had finished his discourse—according to Vasari it was rather haphazard and liberally sprinkled with factual errors—the Pope turned to the artist and asked his opinion of the idea. Messer Giorgio replied that it would be perhaps advisable if Giovio were to take on a collaborator to help him in assembling the facts, and the Pope immediately nominated him for the task.

Within a few days, Vasari gathered notes he had been amassing on the subject and brought them to Giovio. The collector, deeply impressed, suggested that Vasari himself write the treatise, since he seemed so well qualified. At first the artist demurred, but after consultation with Caro and others he decided to take on the task.

Libraries in the mid-sixteenth century did not possess voluminous archives systematically catalogued as in the present day, so Vasari's sources were chiefly oral, being the recollections of artists and their families, friends, and colleagues. Vasari probably consulted archives and records in churches and monasteries, however. The project must have been enormous, and if he had collaborators to aid him in the task in assembling the material he makes no mention of them. He does state that the manuscript was transcribed into a fair copy by a monk in the Monastery of Santa Maria di Scolca in Rimini, and that the abbot of that monastery offered to correct it for him.

Despite the paucity of material at Vasari's disposal (which would unnerve a contemporary art historian), and despite his ongoing painting in Ravenna, Rimini, Arezzo (he was at this time also decorating his house), Rome, Monte Cassino, and Florence, the book was ready four years after it had first been discussed at the pontiff's supper party. In 1550, the first edition of *The Lives of the Most Eminent Painters, Sculptors, and Architects* appeared in Florence, dedicated to Vasari's patron Cosimo I de' Medici.

The second edition of the *Lives* appeared in 1568 in a greatly expanded form. In addition to over 150 biographies, which had other artists' lives tucked within them, it included a section on the Academy of Design, an institution founded by Vasari (and still active), and a lengthy (though ghost-written) description of the elaborate festivities conceived by the academicians under Vasari's supervision.

Since Vasari never stopped painting, designing buildings, and producing theatrical spectacles while he was writing the *Lives*, the speed in which the first edition was completed is amazing. He seemed to have transcended the limitations of his resources.

Vasari was always on the move, journeying from place to place in central and northern Italy to fulfill commissions. Travel in the sixteenth century was difficult and slow. Even under the most favorable circumstances, it took over two weeks to travel the 200 miles between Florence and Rome, even on horseback. Carriages did not exist because springs had not been invented; travel in a cart was horrendously uncomfortable. The roads, unpaved, were either seas of mud or clouds of choking dust. A traveler could be ambushed. Inns were filthy. Yet Vasari made dozens of trips between Rome and Florence and visited Venice several times.

And how it registered on him! His powers of observation and skill in describing what he saw were extraordinary. His discussion of Michelangelo's Sistine Chapel ceiling or of the model of the dome of St. Peter's are wonderfully detailed. (Extraordinary, too, is that much of what Vasari saw still exists. Art is fragile, yet despite centuries of war, natural disasters, conflagrations, and human folly, much of what Vasari marveled at over three centuries ago, we can marvel at today.)

Between 1546, when he began the *Lives*, and 1568, when it appeared in its second edition, Vasari never ceased working and writing. From 1545 to 1572, he was master supervisor for one of the most ambitious projects in Florentine history, the redesigning and redecoration of the Palazzo Vecchio. In 1560, he embarked on the building of the Uffizi, and he was engaged in the frescoes for Brunelleschi's dome of the Florence Cathedral when he died in 1574. It is doubtful whether anyone today could match such accomplishments. In truth, Giorgio Vasari epitomized what we now refer to figuratively as a Renaissance man.

A note on the present edition

Vasari's literary style is typical of his era, and its tone and often archaic flavor has been expertly retained in De Vere's translation. The writing is elegant, elevated, or sprightly as the narrative demands, with numerous anecdotes and insights that enliven the biographies and bring the protagonists to life. Of considerable interest to present-day readers is *how* Vasari saw and how he expressed his observations. As mentioned above, his powers of observation were acute, and in his eyes realism in a work of art was of the utmost importance. Thus, when he states that a work was lifelike ("as if from life" is a phrase he often employs), that was high praise.

Because Vasari often included additional biographies within a single Life, certain cuts have been made in this edition where such instances occur. Other cuts have also been made—chiefly, the very lengthy description of Michelangelo's funeral ceremonies, of which Vasari was in charge, is deleted. Such deletions are indicated by ellipses. The substitution of a name or a date within the text is indicated by the use of square brackets to avoid an overabundance of notes. Because Vasari was often vague or inexact about dates (especially when writing about an artist who had died before Vasari's time), the currently accepted dates for works of art are not given separate notes, but are included in the captions.

The portraits preceding each Life are taken from the 1568 edition. These wood engravings were executed by Cristofano Coriolano after drawings by Vasari or his pupils.

MICHAEL SONINO
March 1986

TRANSLATOR'S PREFACE TO THE 1912 EDITION OF VASARI'S *LIVES OF THE MOST EMINENT PAINTERS, SCULPTORS, AND ARCHITECTS*

Vasari introduces himself sufficiently in his [text]; a translator need concern himself only with the system by which the Italian text can best be rendered in English. The style of that text is sometimes laboured and pompous; it is often ungrammatical. But the narrative is generally lively, full of neat phrases, and abounding in quaint expressions—many of them still recognizable in the modern Florentine vernacular—while, in such Lives as those of Giotto, Leonardo da Vinci, and Michelangelo, Vasari shows how well he can rise to a fine subject. His criticism is generally sound, solid, and direct; and he employs few technical terms, except in connection with architecture, where we find passages full of technicalities, often so loosely used that it is difficult to be sure of their exact meaning. In such cases I have invariably adopted the rendering which seemed most in accordance with Vasari's actual words, so far as these could be explained by professional advice and local knowledge; and I have included brief notes where they appeared to be indispensable.

In Mrs. Foster's familiar English paraphrase—for a paraphrase it is rather than a translation—all Vasari's liveliness evaporates, even where his meaning is not blurred or misunderstood. Perhaps I have gone too far towards the other extreme in relying upon the Anglo-Saxon side of the English language rather than upon the Latin, and in taking no liberties whatever with the text of 1568. My intention, indeed, has been to render my original word for word, and to err, if at all, in favour of literalness. The very structure of Vasari's sentences has usually been retained, though some freedom was necessary in the matter of the punctuation, which is generally bewildering. As Mr. Horne's only too rare translation of the Life of Leonardo da Vinci has proved, it is by some such method that we can best keep Vasari's sense and Vasari's spirit—the one as important to the student of Italian art as is the other to the general reader. Such an attempt, however, places an English translator of the first volume at a conspicuous disadvantage. Through-

out the earlier Lives Vasari seems to be feeling his way. He is not sure of himself, and his style is often awkward. The more faithful the attempted rendering, the more plainly must that awkwardness be reproduced.

* * *

With this much explanation, I may pass to personal matters, and record my thanks to many Florentine friends for help in technical and grammatical questions; to Professor Baldwin Brown for the notes on technical matters printed with Miss Maclehose's translation of *Vasari on Technique*; and to Mr. C. J. Holmes, of the National Portrait Gallery, for encouragement in a task which has proved no less pleasant than difficult.

G. DU C. DE V.
London,
March 1912

THE GREAT MASTERS

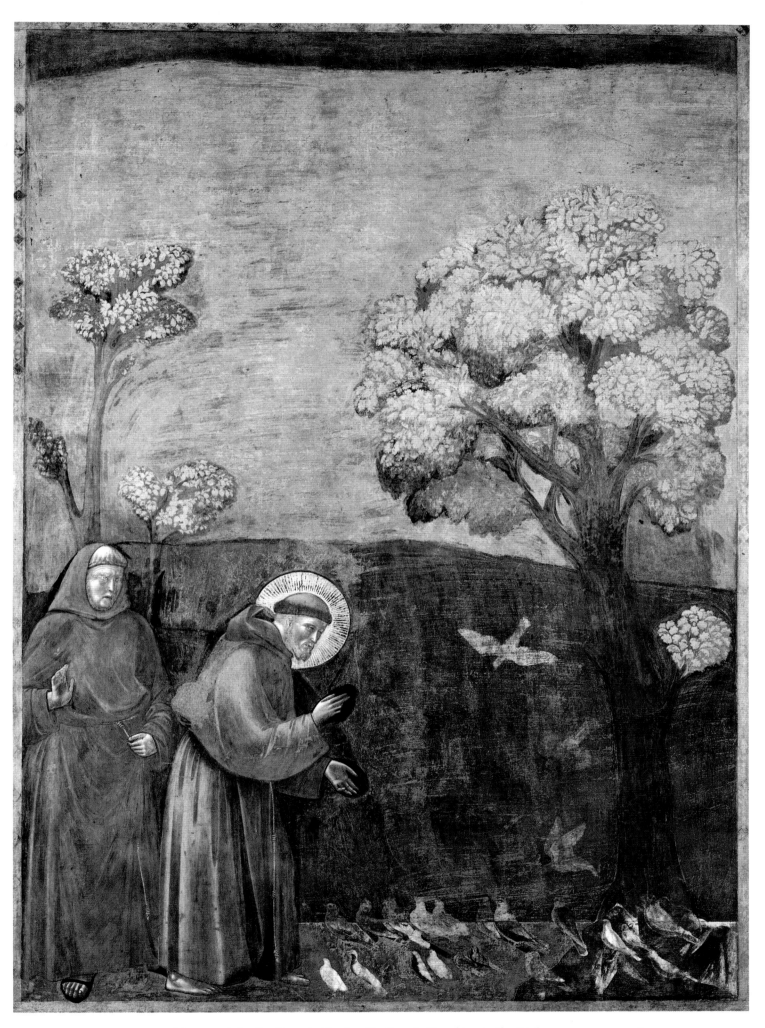

COLORPLATE 1. Master of the St. Francis Cycle. *St. Francis Preaching to the Birds*. c. 1297–1300. Fresco.
Upper Church of San Francesco, Assisi.

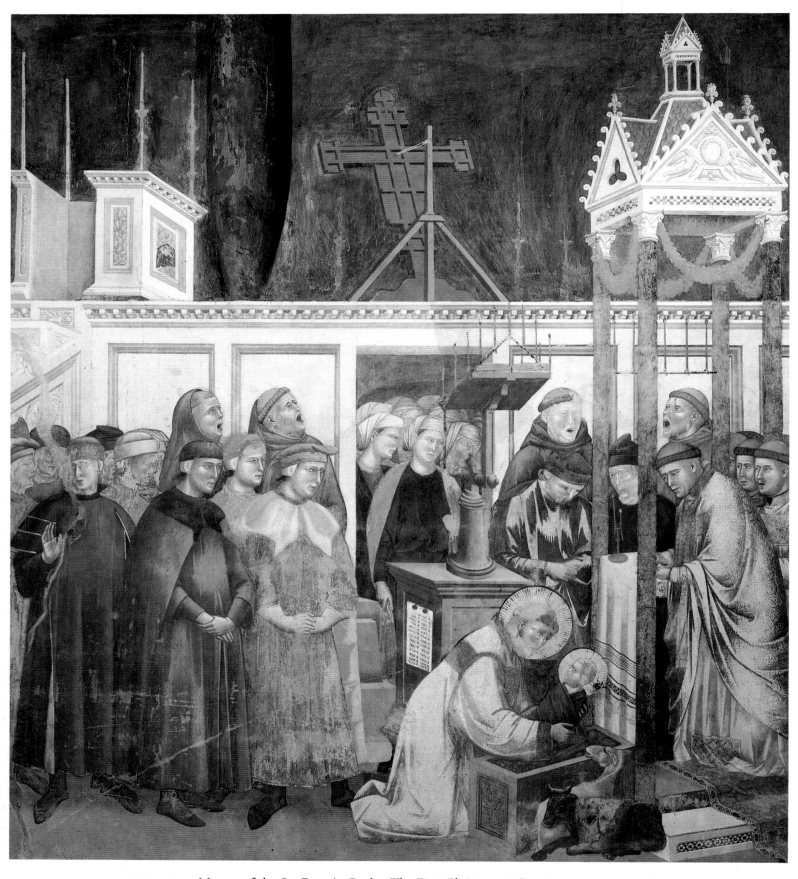

COLORPLATE 2. Master of the St. Francis Cycle. *The First Christmas at Greccio*. c. 1297–1300. Fresco.
Upper Church of San Francesco, Assisi.

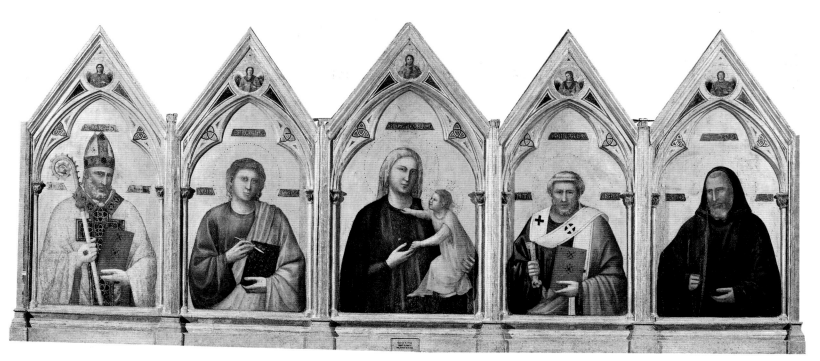

COLORPLATE 3. Giotto. *Badia Altarpiece*. c. 1301–02. Panel. 35¾ × 123″ (91 × 340 cm).
Uffizi Gallery, Florence.

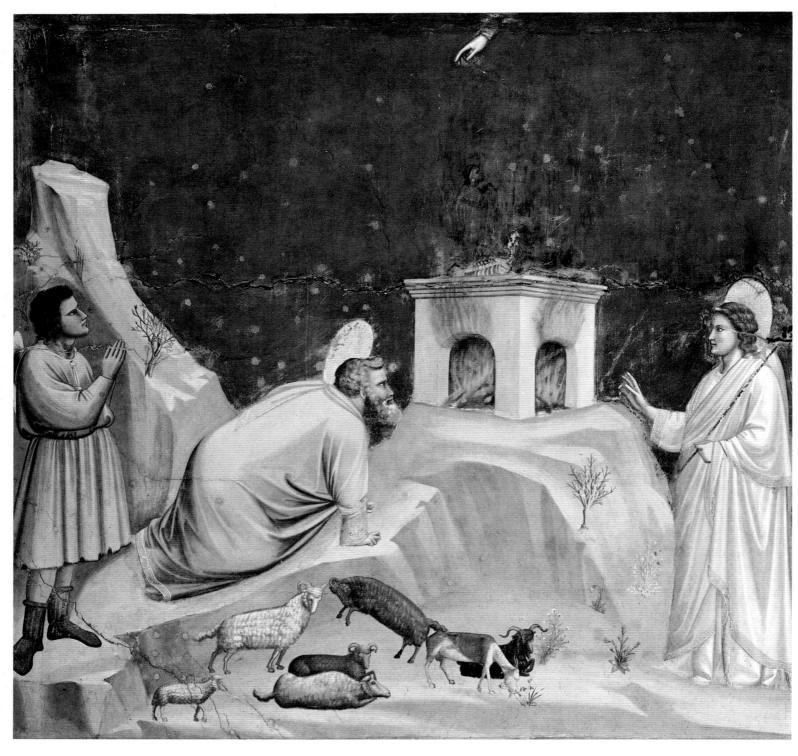

COLORPLATE 4. Giotto. *The Sacrifice of Joachim*. c. 1304–06. Fresco.
Arena (Scrovegni) Chapel, Padua.

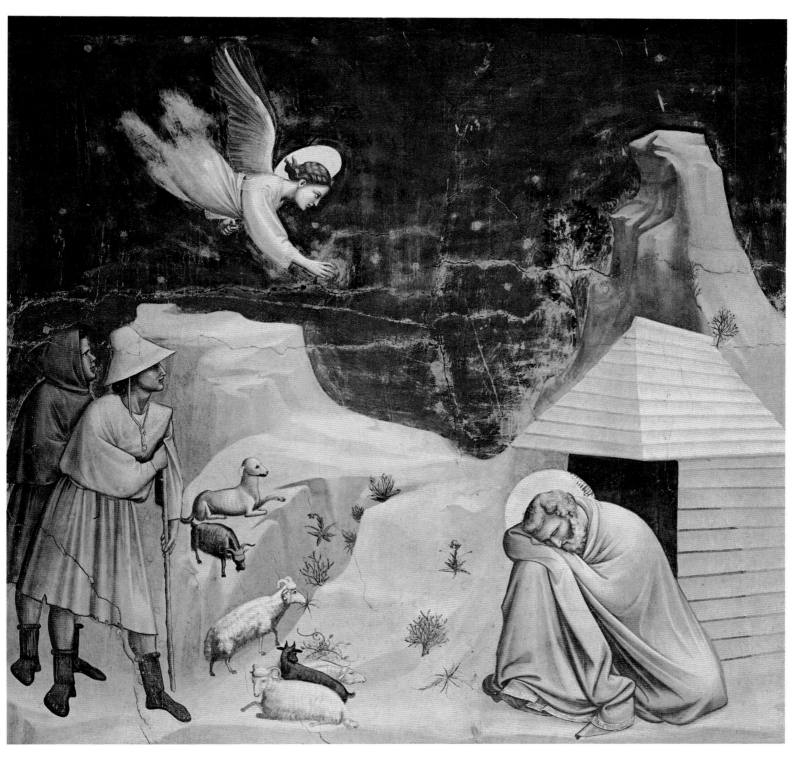

COLORPLATE 5. Giotto. *The Vision of Joachim*. c. 1304–06. Fresco.
Arena (Scrovegni) Chapel, Padua.

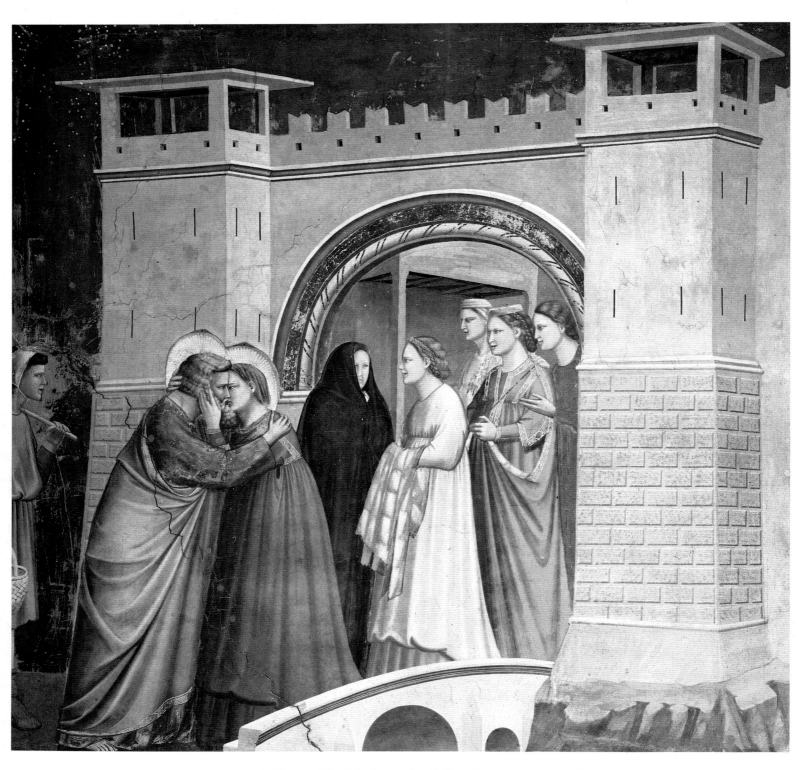

COLORPLATE 6. Giotto. *The Meeting at the Golden Gate.* c. 1304–06. Fresco.
Arena (Scrovegni) Chapel, Padua.

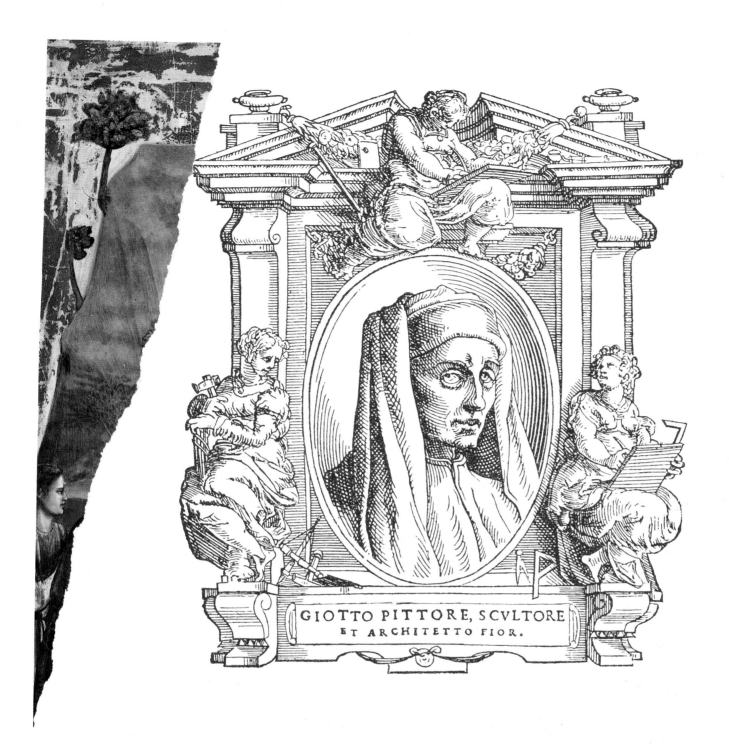

GIOTTO PITTORE, SCVLTORE
ET ARCHITETTO FIOR.

THE LIFE OF
GIOTTO

[1267–1337]

THE FLORENTINE PAINTER,
SCULPTOR, AND ARCHITECT

THAT VERY OBLIGATION which the craftsmen of painting owe to nature, who serves continually as model to those who are ever wresting the good from her best and most beautiful features and striving to counterfeit and to imitate her, should be owed, in my belief, to Giotto, painter of Florence, for the reason that, after the methods of good paintings and their outlines had lain buried for so many years under the ruins of the wars, he alone, although born among inept craftsmen, by the gift of God revived that art, which had come to a grievous pass, and brought it to such a form as could be called good. And truly it was a very great miracle that that age, gross and inept, should have had strength to work in Giotto in a fashion so masterly, that design, whereof the men of those times had little or no knowledge, was restored completely to life by means of him. And yet this great man was born at the village of Vespignano, in the district of Florence, fourteen miles distant from that city, in the year [1267], from a father named Bondone, a tiller of the soil and a simple fellow. He, having had this son, to whom he gave the name Giotto, reared him conformably to his condition; and when he had come to the age of ten, he showed in all his actions, although childish still, a vivacity and readiness of intelligence much out of the ordinary, which rendered him dear not only to his father but to all those also who knew him, both in the village and beyond. Now Bondone gave some sheep into his charge, and he, going about the holding, now in one part and now in another, to graze them, and impelled by a natural inclination to the art of design, was for ever drawing, on stones, on the ground, or on sand, something from nature, or in truth anything that came into his fancy. Wherefore Cimabue, going one day on some business of his own from Florence to Vespignano, found Giotto, while his sheep were browsing, portraying a sheep from nature on a flat and polished slab, with a stone slightly pointed, without having learnt any method of doing this from others, but only from nature; whence Cimabue, standing fast all in a marvel, asked him if he wished to go to live with him. The child answered that, his father consenting, he would go willingly. Cimabue then asking this from Bondone, the latter lovingly granted it to him, and was content that he should take the boy with him to Florence; whither having come, in a short time, assisted by nature and taught by Cimabue, the child not only equalled the manner of his master, but became so good an imitator of nature that he banished completely that rude Greek manner and revived the modern and good art of painting, introducing the portraying well from nature of living people, which had not been used for more than two hundred years. If, indeed, anyone had tried it, as has been said above, he had not succeeded very happily, nor as well by a great measure as Giotto, who portrayed among others, as is still seen to-day in the Chapel of the Palace of the Podestà at Florence, Dante Alighieri, a contemporary and his very great friend, and no less famous as poet than was in the same times Giotto as painter, so much praised by Messer Giovanni Boccaccio in the preface to the story of Messer Forese da Rabatta and of Giotto the painter himself. In the same chapel are the portraits, likewise

Giovanni Cimabue (c. 1240–1302), Florentine painter. One of the first Italian artists to break away from the stiff Byzantine style (which Vasari, below, terms "that rude Greek manner").

Dante Alighieri (1265–1321), Italian poet. The first major author to write in Italian, his most famous work is the Divine Comedy *(three parts:* Inferno, Purgatorio, Paradiso*).*

Giovanni Boccaccio (1313–1375), Italian poet and prose writer. His best-known work is the Decameron, *a collection of one hundred stories of Classical, folk, and original inspiration.*

by the same man's hand, of Ser Brunetto Latini, master of Dante, and of Messer Corso Donati, a great citizen of those times.

The first pictures of Giotto were in the chapel of the high-altar in the Badia of Florence, wherein he made many works held beautiful, but in particular a Madonna receiving the Annunciation, for the reason that in her he expressed vividly the fear and the terror that the salutation of Gabriel inspired in Mary the Virgin, who appears, all full of the greatest alarm, to be wishing almost to turn to flight. By the hand of Giotto, likewise, is the panel on the high-altar of the said chapel, which has been preserved there to our own day, and is still preserved there, more because of a certain reverence that is felt for the work of so great a man than for any other reason. And in S. Croce there are four chapels by the same man's hand: three between the sacristy and the great chapel, and one on the other side. In the first of the three, which is that of Messer Ridolfo de' Bardi, and is that wherein are the bell-ropes, is the life of S. Francis, in the death of whom a good number of friars show very naturally the expression of weeping. In the next, which is that of the family of Peruzzi, are two stories of the life of S. John the Baptist, to whom the chapel is dedicated; wherein great vivacity is seen in the dancing and leaping of [Salome], and in the promptness of some servants bustling at the service of the table. In the same are two marvellous stories of S. John the Evangelist—namely, when he brings Drusiana back to life, and when he is carried off into Heaven. In the third, which is that of the Giugni, dedicated to the Apostles, there are painted by the hand of Giotto the stories of the martyrdom of many of them. In the fourth, which is on the other side of the church, towards the north, and belongs to the Tosinghi and to the Spinelli, and is dedicated to the Assumption of Our Lady, Giotto painted her Birth, her Marriage, her Annunciation, the Adoration of the Magi, and when she presents Christ as a little Child to Simeon, which is something very beautiful, seeing that, besides a great affection that is seen in that old man as he receives Christ, the action of the child, stretching out its arms in fear of him and turning in terror towards its mother, could not be more touching or more beautiful. Next, in the death of the Madonna herself, there are the Apostles, and a good number of angels with torches in their hands, all very beautiful. In the Chapel of the Baroncelli, in the said church, is a panel in distemper by the hand of Giotto, wherein is executed with much diligence the Coronation of Our Lady, with a very great number of little figures and a choir of angels and saints, very diligently wrought. And because in that work there are written his name and the date in letters of gold, craftsmen who will consider at what time Giotto, with no glimmer of the good manner, gave a beginning to the good method of drawing and of colouring, will be forced to hold him in the highest veneration. In the same Church of S. Croce, over the marble tomb of Carlo Marsuppini of Arezzo, there is a Crucifix, with the Madonna, S. John, and Magdalene at the foot of the Cross; and on the other side of the church, exactly opposite this, over the burial-place of Lionardo Aretino, facing the high-altar, there is an Annunciation, which has been recoloured by modern painters, with small judgment on the part of him who has had this done. In the refectory, on a Tree of the Cross, are stories of S. Louis and a Last Supper by the same man's hand; and on the wardrobes in the sacristy are scenes with little figures from the life of Christ and of S. Francis. He wrought, also, in the Church of the Carmine, in the Chapel of S. Giovanni Battista, all the life of that Saint, divided into a number of pictures; and in the Palace of the Guelph party, in Florence, there is a story of the Christian Faith, painted perfectly in fresco by his hand; and therein is the portrait of Pope Clement IV, who created that magisterial body, giving it his arms, which it has always held and holds still.

After these works, departing from Florence in order to go to finish in Assisi the works begun by Cimabue, in passing through Arezzo he painted in the Pieve the Chapel of S. Francesco, which is above the place of baptism; and on

For generations, the Badia Altarpiece *was thought to have been lost; it was rediscovered by chance in 1940 in the Church of Santa Croce. The Badia frescoes were hidden behind a wall for centuries, but in 1958 fragments were found in situ.*

COLORPLATE 3

COLORPLATE 17

COLORPLATE 13

COLORPLATE 18

This "Tree of the Cross" is not by Giotto, but by his pupil and assistant, Taddeo Gaddi (c. 1300–1366). It is illustrated on page 30.

OPPOSITE:

Giotto (attributed). *Dante Alighieri and Brunetto Latini* (detail of *Paradise* segment of *Last Judgment*, before recent restoration). c. 1334–35. Fresco. Chapel, Bargello (Museo Nazionale), Florence.

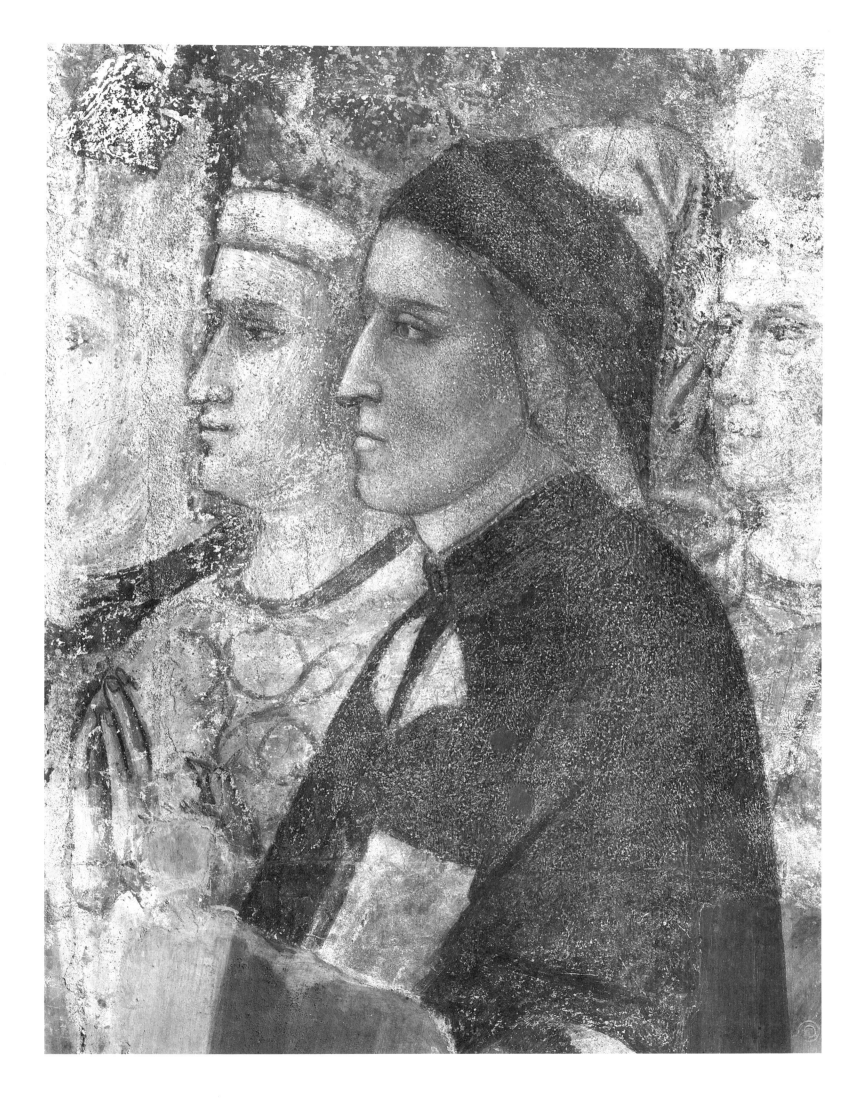

29

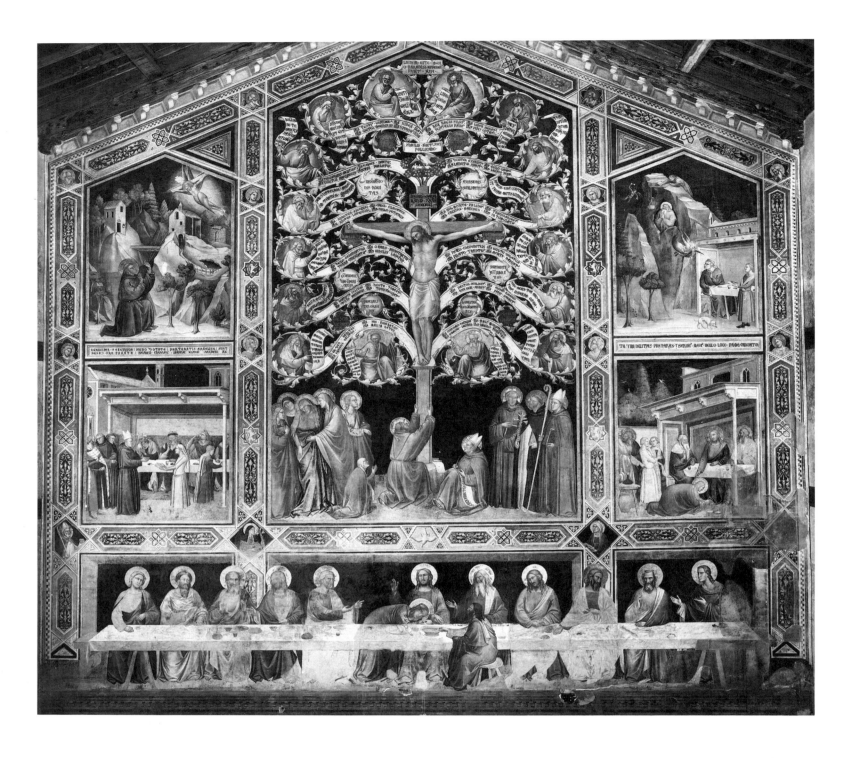

a round column, near a Corinthian capital that is both ancient and very beautiful, he portrayed from nature a S. Francis and a S. Dominic; and in the Duomo without Arezzo he painted the Stoning of S. Stephen in a little chapel, with a beautiful composition of figures. These works finished, he betook himself to Assisi, a city of Umbria, being called thither by Fra Giovanni di Muro della Marca, then General of the Friars of S. Francis; where, in the upper church, he painted in fresco, under the gallery that crosses the windows, on both sides of the church, thirty-two scenes of the life and acts of S. Francis—that is, sixteen on each wall—so perfectly that he acquired thereby very great fame. And in truth there is seen great variety in that work, not only in the gestures and attitudes of each figure but also in the composition of all the scenes; not to mention that it enables us very beautifully to see the diversity of the costumes of those times, and certain imitations and observations of the things of nature. Among others, there is one very beautiful scene, wherein a thirsty man, in whom the desire for water is vividly seen, is drinking, bending down on the ground by a fountain with very great and truly marvellous expression,

The Arezzo works have vanished; the Madonna and Child *reproduced in colorplate 15 formed the central panel of a now dismantled altarpiece (possibly once in Santa Croce).*

COLORPLATE 1
COLORPLATE 2

There is considerable debate over the Assisi frescoes. Documents that might have substantiated Vasari were destroyed by Napoleon's soldiers. Many Italian and European experts give these works to Giotto, while on the basis of style and the pigments employed, others (mainly British and American) reject this attribution.

in a manner that it seems almost a living person that is drinking. There are also many other things there most worthy of consideration, about which, in order not to be tedious, I do not enlarge further. Let it suffice that this whole work acquired for Giotto very great fame, by reason of the excellence of the figures and of the order, proportion, liveliness, and facility which he had from nature, and which he had made much greater by means of study, and was able to demonstrate clearly in all his works. And because, besides that which Giotto had from nature, he was most diligent and went on ever thinking out new ideas and wresting them from nature, he well deserved to be called the disciple of nature and not of others. The aforesaid scenes being finished, he painted in the same place, but in the lower church, the upper part of the walls at the sides of the high-altar, and all the four angles of the vaulting above in the place where lies the body of S. Francis; and all with inventions both fanciful and beautiful. In the first is S. Francis glorified in Heaven, surrounded by those virtues which are essential for him who wishes to be perfectly in the grace of God. On one side Obedience is placing a yoke on the neck of a friar who is before her on his

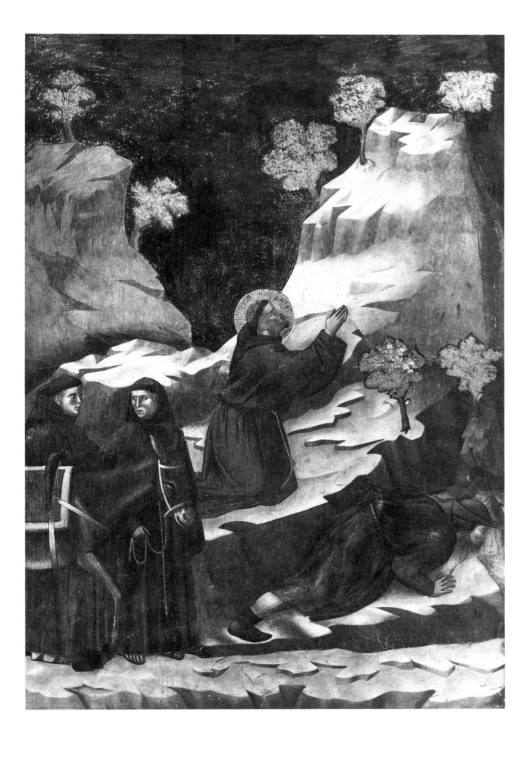

OPPOSITE:

Taddeo Gaddi. *The Tree of Life* and *The Last Supper*. c. 1355–60. Fresco. Refectory, Monastery of Santa Croce, Florence.

Master of the St. Francis Cycle. *The Miracle of the Spring*. c. 1297–1300. Fresco. Upper Church of San Francesco, Assisi.

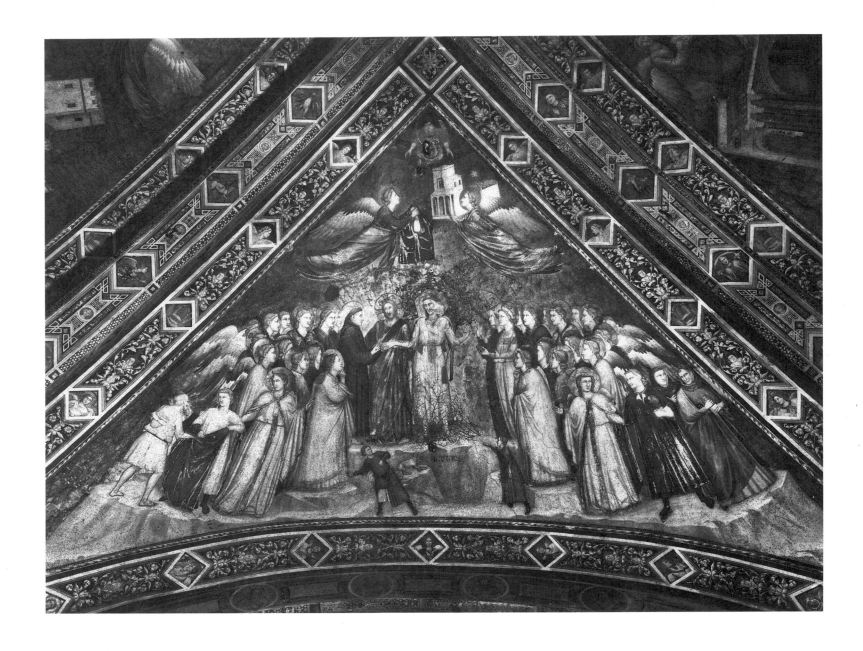

knees, and the bands of the yoke are drawn by certain hands towards Heaven; and, enjoining silence with one finger to her lips, she has her eyes on Jesus Christ, who is shedding blood from His side. And in company with this virtue are Prudence and Humility, in order to show that where there is true obedience there are ever humility and prudence, which enable us to carry out every action well. In the second angle is Chastity, who, standing in a very strong fastness, is refusing to be conquered either by kingdoms or crowns or palms that some are presenting to her. At her feet is Purity, who is washing naked figures; and Force is busy leading people to wash and purify themselves. Near to Chastity, on one side, is Penitence, who is chasing Love away with a Discipline, and putting to flight Impurity. In the third space is Poverty, who is walking with bare feet on thorns, and has a dog that is barking at her from behind, and about her a boy who is throwing stones at her, and another who is busy pushing some thorns with a stick against her legs. And this Poverty is seen here being espoused by S. Francis, while Jesus Christ is holding her hand, there being present, not without mystic meaning, Hope and Compassion. In the fourth and last of the said spaces is a S. Francis, also glorified, in the white tunic of a deacon, and shown triumphant in Heaven in the midst of a multitude of angels who are forming a choir round him, with a standard whereon is a Cross with seven stars; and on high is the Holy Spirit. Within each of these angles are some Latin words that explain the scenes. In like manner, besides the said four

Giottesque Master. *Marriage of St. Francis to Lady Poverty*. c. 1334. Fresco. Section of vault, Lower Church of San Francesco, Assisi.

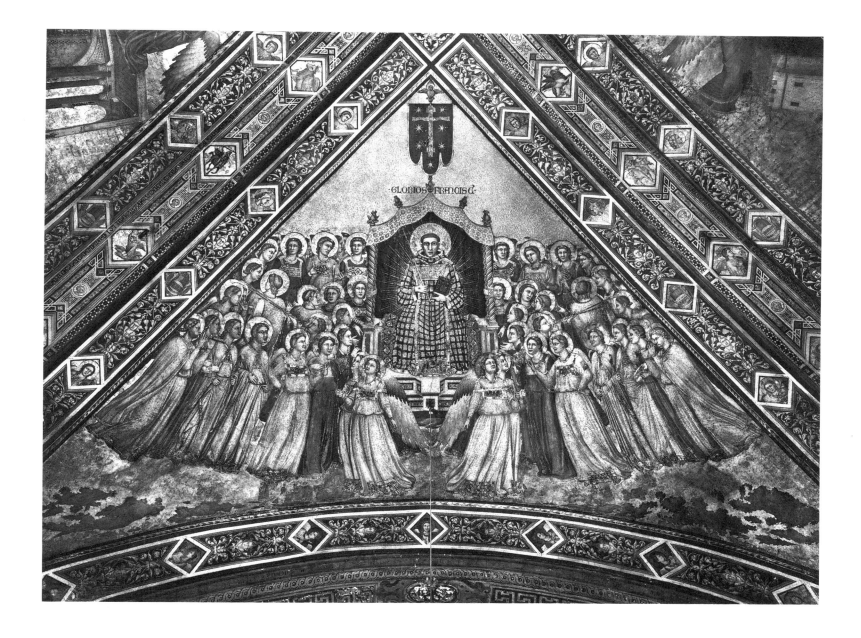

GLORIOS FRANCISC

Giottesque Master. *The Glorification of St. Francis.* c. 1334. Fresco. Section of vault, Lower Church of San Francesco, Assisi.

angles, there are pictures on the side walls which are very beautiful and truly to be held in great price, both by reason of the perfection that is seen in them and because they were wrought with so great diligence that up to our own day they have remained fresh. In these pictures is the portrait of Giotto himself, very well made, and over the door of the sacristy, by the same man's hand and also in fresco, there is a S. Francis who is receiving the Stigmata, so loving and devout that to me it appears the most excellent picture that Giotto made in these works, which are all truly beautiful and worthy of praise.

Having finished, then, for the last, the said S. Francis, he returned to Florence, where, on arriving there, he painted, on a panel that was to be sent to Pisa, a S. Francis on the tremendous rock of La Vernia, with extraordinary diligence, seeing that, besides certain landscapes full of trees and cliffs, which was something new in those times, there are seen in the attitude of a S. Francis, who is kneeling and receiving the Stigmata with much readiness, a most ardent desire to receive them and infinite love towards Jesus Christ, who, being surrounded in the sky by seraphim, is granting them to him with an expression so vivid that anything better cannot be imagined. In the lower part of the same panel there are three very beautiful scenes of the life of the same Saint. This panel, which to-day is seen in S. Francesco in Pisa on a pillar beside the high-altar, and is held in great veneration as a memorial of so great a man, was the reason that the Pisans, having just finished the building of the Campo Santo

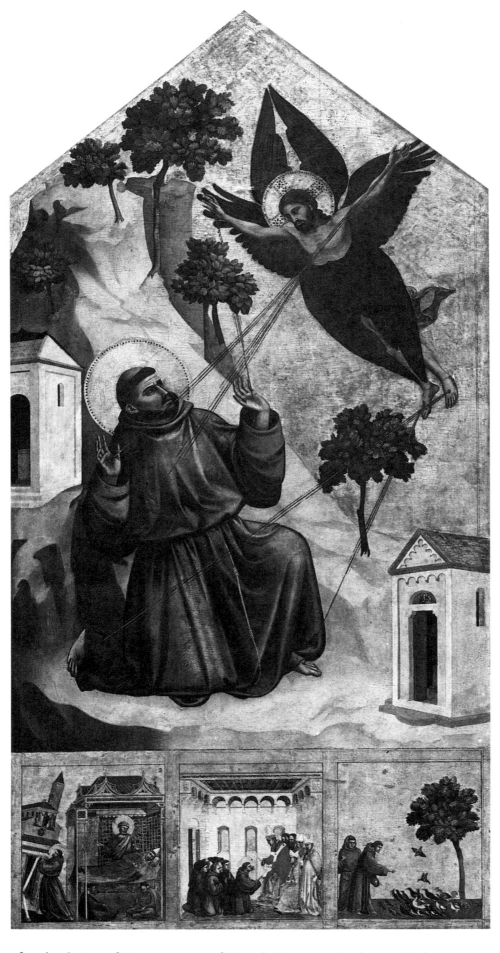

Follower of Giotto. *St. Francis Receiving the Stigmata* (predella: *The Dream of Pope Innocent III; The Pope Approves the Monastic Order; St. Francis Preaching to the Birds*). c. 1300. Panel. 124 × 63¾″ (314 × 162 cm). The Louvre, Paris.

after the design of Giovanni, son of Niccola Pisano, as has been said above, gave to Giotto the painting of part of the inner walls, to the end that, since this so great fabric was all incrusted on the outer side with marbles and with carvings made at very great cost, and roofed over with lead, and also full of sarcophagi and ancient tombs once belonging to the heathens and brought to Pisa

Giovanni Pisano (c. 1250–after 1314), Italian sculptor. His most notable works are the pulpits in Sant'Andrea, Pistoia, and the Pisa Cathedral. There is no evidence that he was an architect.

from various parts of the world, even so it might be adorned within, on the walls, with the noblest painting. Having gone to Pisa, then, for this purpose, Giotto made in fresco, on the first part of a wall in that Campo Santo, six large stories of the most patient Job. And because he judiciously reflected that the marbles of that part of the building where he had to work were turned towards the sea, and that, all being saline marbles, they are ever damp by reason of the south-east winds and throw out a certain salt moisture, even as the bricks of Pisa do for the most part, and that therefore the colours and the paintings fade and corrode, he caused to be made over the whole surface where he wished to work in fresco, to the end that his work might be preserved as long as possible, a coating, or in truth an intonaco or incrustation—that is to say, with lime, gypsum, and powdered brick all mixed together; so suitably that the pictures which he afterwards made thereon have been preserved up to the present day. And they would be still better if the negligence of those who should have taken care of them had not allowed them to be much injured by the damp, because the fact that this was not provided for, as was easily possible, has been the reason that these pictures, having suffered from damp, have been spoilt in certain places, and the flesh-colours have been blackened, and the intonaco has peeled off; not to mention that the nature of gypsum, when it has been mixed with lime, is to corrode in time and to grow rotten, whence it arises that afterwards, perforce, it spoils the colours, although it appears at the beginning to take a good and firm hold. In these scenes, besides the portrait of Messer Farinata degli Uberti, there are many beautiful figures, and above all certain villagers, who, in carrying the grievous news to Job, could not be more full of feeling nor show better than they do the grief that they felt over the lost cattle and over the other misadventures. Likewise there is amazing grace in the figure of a man-servant who is standing with a fan beside Job, who is covered with ulcers and almost abandoned by all; and although he is well done in every part, he is marvellous in the attitude that he strikes in chasing the flies from his leprous and stinking master with one hand, while with the other he is holding his nose in disgust, in order not to notice the stench. In like manner, the other figures in these scenes and the heads both of the males and of the women are very beautiful; and the draperies are wrought to such a degree of softness that it is no marvel if this work acquired for him so great fame, both in that city and abroad, that Pope [Boniface VIII] sent one of his courtiers into Tuscany to see what sort of man was Giotto, and of what kind his works, having designed to have some pictures made in S. Pietro. This courtier, coming in order to see Giotto and to hear what other masters there were in Florence excellent in painting and in mosaic, talked to many masters in Siena. Then, having received drawings from them, he came to Florence, and having gone into the shop of Giotto, who was working, declared to him the mind of the Pope and in what way it was proposed to make use of his labour, and at last asked him for some little drawing, to the end that he might send it to His Holiness. Giotto, who was most courteous, took a paper, and on that, with a brush dipped in red, holding his arm fast against his side in order to make a compass, with a turn of the hand he made a circle, so true in proportion and circumference that to behold it was a marvel. This done, he smiled and said to the courtier: "Here is your drawing." He, thinking he was being derided, said: "Am I to have no other drawing but this?" " 'Tis enough and to spare," answered Giotto. "Send it, together with the others, and you will see if it will be recognized." The envoy, seeing that he could get nothing else, left him, very ill-satisfied and doubting that he had been fooled. All the same, sending to the Pope the other drawings and the names of those who had made them, he also sent that of Giotto, relating the method that he had followed in making his circle without moving his arm and without compasses. Wherefore the Pope and many courtiers that were versed in the arts recognized by this how much Giotto surpassed in excellence all the other

The Camposanto frescoes were seriously bomb-damaged in World War II; in addition, the Job frescoes have long been regarded as the work of Taddeo Gaddi or one of his followers.

painters of his time. This matter having afterwards spread abroad, there was born from it the proverb that is still wont to be said to men of gross wits: "Tu sei più tondo che l' O di Giotto!" ("Thou art rounder than Giotto's circle"). This proverb can be called beautiful not only from the occasion that gave it birth, but also for its significance, which consists in the double meaning; tondo being used, in Tuscany, both for the perfect shape of a circle and for slowness and grossness of understanding.

The aforesaid Pope then made him come to Rome, where, honouring him much and appreciating his talents, he made him paint five scenes from the life of Christ in the apse of S. Pietro, and the chief panel in the sacristy, which were all executed by him with so great diligence that there never issued from his hands any more finished work in distemper. Wherefore he well deserved that the Pope, holding himself to have been well served, should cause to be given to him six hundred ducats of gold, besides granting him so many favours that they were talked of throughout all Italy.

About this time—in order to withhold nothing worthy of remembrance in connection with art—there was in Rome one Oderigi d' Agobbio, who was much the friend of Giotto and an excellent illuminator for those days. This man, being summoned for this purpose by the Pope, illuminated many books for the library of the palace, which are now in great part eaten away by time. And in my book of ancient drawings are some remains from the very hand of this man, who in truth was an able man; although a much better master than Oderigi was Franco Bolognese, who wrought a number of works excellently in that manner for the same Pope and for the same library, about the same time, as can be seen in the said book, wherein I have designs by his hand both in painting and in illumination, and among them an eagle very well done, and a very beautiful lion that is tearing a tree. Of these two excellent illuminators Dante makes mention in the eleventh canto of the *Purgatorio*, where he is talking of the vainglorious, in these verses:

> *"Oh," I said to him,*
> *"Art thou not Oderigi, the pride of Gubbio,*
> *And glorifier of that art*
> *Which they in Paris call 'Illuminating'?"*
> *"Brother," he replied, "more pleasing are*
> *The pages that Franco Bolognese paints;*
> *The glory now belongs to him,*
> *While mine is half obscured."*

The Pope, having seen these works, and the manner of Giotto pleasing him infinitely, ordered him to make scenes from the Old Testament and the New right round S. Pietro; wherefore, for a beginning, Giotto made in fresco the Angel that is over the organ, seven braccia high, and many other paintings, whereof part have been restored by others in our own days, and part, in founding the new walls, have been either destroyed or removed from the old edifice of S. Pietro, up to the space below the organ; such as a Madonna on a wall, which, to the end that it might not be thrown to the ground, was cut right out of the wall and made fast with beams and iron bars thus removed, and afterwards built in, by reason of its beauty, in the place that pleased the pious love that is borne towards everything excellent in art by Messer Niccolò Acciaiuoli, doctor of Florence, who richly adorned this work of Giotto with stucco-work and also with modern paintings. By his hand, also, was the Navicella in mosaic that is over the three doors of the portico in the court of S. Pietro, which is truly marvellous and deservedly praised by all beautiful minds, because in it, besides the design, there is the grouping of the Apostles, who are travailing in diverse manners through the sea-tempest, while the winds are blowing into a

Apart from the work reproduced on page 38 and a few other surviving fragments, Giotto's Roman frescoes no longer exist.

COLORPLATE 14

The Navicella mosaic has been restored so often that it is now a mere shadow of the original. The drawing illustrated once formed part of Vasari's collection; he believed it was by Giotto. At present there seem to be no drawings extant that can be attributed to Giotto.

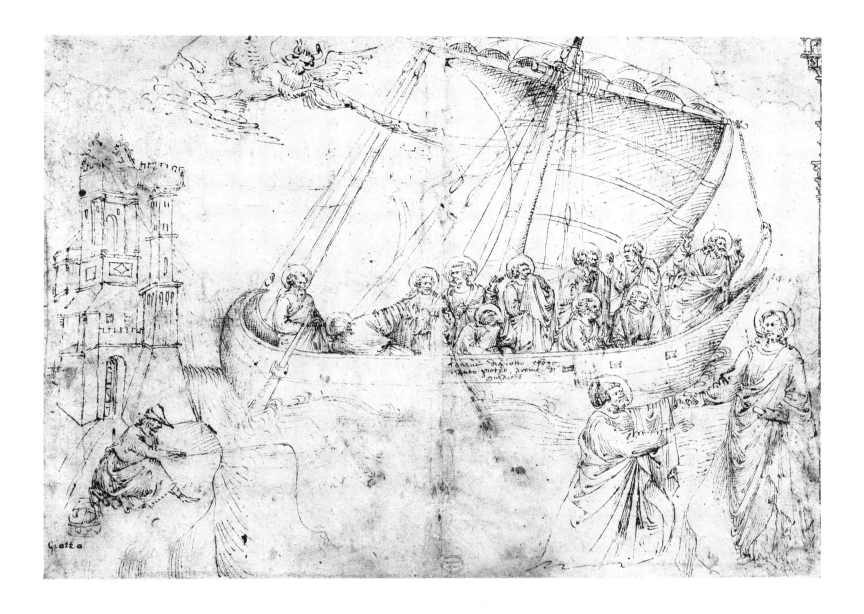

Parri Spinelli (attributed). Copy of Giotto's *Navicella* mosaic of c. 1310. Pen and brown ink. 10¾ × 15¼" (274 × 388 mm). The Metropolitan Museum of Art, New York; Hewitt Fund; 1917.

sail, which has so high a relief that a real one would not have more; and moreover it is difficult to have to make with those pieces of glass a unity such as that which is seen in the lights and shadows of so great a sail, which could only be equalled by the brush and with great difficulty and by making every possible effort; not to mention that in a fisherman, who is fishing from a rock with a line, there is seen an attitude of extreme patience proper to that art, and in his face the hope and the wish to make a catch. Under this work are three little arches in fresco, of which, since they are for the greater part spoilt, I will say no more. The praises universally given by craftsmen to this work are well deserved.

Giotto, having afterwards painted on a panel a large Crucifix coloured in distemper, for the Minerva, a church of the Preaching Friars, returned to his own country, having been abroad six years. But no long time after, by reason of the death of Pope Benedict IX, Clement V was created Pope in Perugia, and Giotto was forced to betake himself with that Pope to the place where he brought his Court, to Avignon, in order to do certain works there; and having gone there, he made, not only in Avignon but in many other places in France, many very beautiful panels and pictures in fresco, which pleased the Pontiff and the whole Court infinitely. Wherefore, the work dispatched, the Pope dismissed him lovingly and with many gifts, and he returned home no less rich than honoured and famous; and among the rest he brought back the portrait of that Pope, which he gave afterwards to Taddeo Gaddi, his disciple. And this return of Giotto to Florence was in the year 1316. But it was not granted to him

Giotto's Avignon works no longer exist; in fact, some scholars doubt he ever went to France. The works Giotto is subsequently supposed to have created in other parts of Italy—including Padua, Verona, Ferrara, and Ravenna—have also vanished. The later Padua works are discussed and illustrated, however.

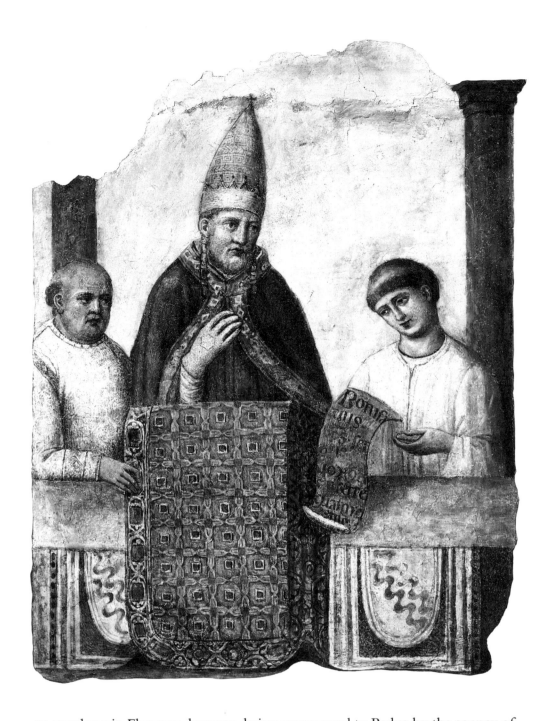

Giotto. *Pope Boniface VIII Declaring the Holy Year.* c. 1300. Detached fresco fragment (prior to restoration). Church of St. John Lateran, Rome.

COLORPLATES 4-10

to stay long in Florence, because, being summoned to Padua by the agency of the Signori della Scala, he painted a very beautiful chapel in the Santo, a church built in those times. From there he went to Verona, where, for Messer Cane, he made certain pictures in his palace, and in particular the portrait of that lord; and a panel for the Friars of S. Francis. These works completed, in returning to Tuscany he was forced to stay in Ferrara, and he painted at the behest of those Signori d' Este, in their palace and in S. Agostino, some works that are still seen there to-day. Meanwhile, it coming to the ears of Dante, poet of Florence, that Giotto was in Ferrara, he so contrived that he brought him to Ravenna, where he was living in exile; and he caused him to make round the Church of S. Francesco, for the Signori da Polenta, some scenes in fresco that are passing good. Next, having gone from Ravenna to Urbino, there too he wrought some works. Then, chancing to pass through Arezzo, he could not but comply with the wish of Piero Saccone, who had been much his friend; wherefore he made for him in fresco, on a pillar in the principal chapel of the Vescovado, a S. Martin who has cut his cloak in half and is giving one part of it to a beggar, who is standing before him almost wholly naked. Then, having made for the Abbey of S. Fiore a large Crucifix painted in distemper on wood, which is to-day in the middle of that church, he returned finally to Florence, where, among many other works, he made some pictures in the Convent of the Nuns of

Faenza, both in fresco and in distemper, that are not in existence to-day, by reason of the destruction of that convent. In the year 1322, likewise—Dante, very much his friend, having died in the year before, to his great sorrow—he went to Lucca, and at the request of Castruccio, then Lord of that city, his birthplace, he made a panel in S. Martino with a Christ in air and four Saints, Protectors of that city—namely, S. Peter, S. Regulus, S. Martin, and S. Paulinus—who appear to be recommending a Pope and an Emperor, who, according to what is believed by many, are Frederick of Bavaria and the Anti-Pope Nicholas V. Some, likewise, believe that Giotto designed the castle and fortress of Giusta, which is impregnable, at San Frediano, in the same city of Lucca.

Afterwards, Giotto having returned to Florence, Robert, King of Naples, wrote to Charles, King of Calabria, his first-born son, who chanced to be in Florence, that he should send him Giotto to Naples at all costs, for the reason that, having finished the building of S. Chiara, a convent of nuns and a royal church, he wished that it should be adorned by him with noble paintings. Giotto, then, hearing himself summoned by a King so greatly renowned and famous, went more than willingly to serve him, and, on arriving, painted many scenes from the Old Testament and the New in some chapels of the said convent. And the scenes from the Apocalypse that he made in one of the said chapels are said to have been inventions of Dante; and this may be also true of those at Assisi, so greatly renowned, whereof there has been enough said above. And although Dante at that time was dead, they may have held discourse on these matters, as often comes to pass between friends.

None of the works described below (including those in Naples and Gaeta) have survived.

But to return to Naples; Giotto made many works in the Castel dell' Uovo, and in particular the chapel, which much pleased that King, by whom he was so greatly beloved that many times, while working, Giotto found himself entertained by the King in person, who took pleasure in seeing him at work and in hearing his discourse. And Giotto, who had ever some jest on his tongue and some witty repartee in readiness, would entertain him with his hand, in painting, and with pleasant discourse, in his jesting. Wherefore, the King saying to him one day that he wished to make him the first man in Naples, Giotto answered, "And for that end am I lodged at the Porta Reale, in order to be the first in Naples." Another time, the King saying to him, "Giotto, an I were you, now that it is hot, I would give over painting for a little;" he answered, "And I, i' faith, an I were you." Being then very dear to the King, he made for him a good number of pictures in a hall (that King Alfonso I pulled down in order to make the Castle), and also in the Incoronata; and among others in the said hall were the portraits of many famous men, and among them that of Giotto himself. Now the King having one day out of caprice besought him to paint his realm for him, Giotto, so it is said, painted for him an ass saddled, that had at its feet a new pack-saddle, and was sniffing at it and making semblance of desiring it; and on both the old pack-saddle and the new one were the royal crown and the sceptre of sovereignty; wherefore Giotto, being asked by the King what such a picture signified, answered that such were his subjects and such the kingdom, wherein every day a new lord was desired.

Departing from Naples in order to go to Rome, Giotto stopped at Gaeta, where he was forced to paint some scenes from the Old Testament in the Nunziata, which are now spoilt by time, but yet not so completely that there may not be seen in them very well the portrait of Giotto himself, near a large and very beautiful Crucifix. This work finished, not being able to refuse this to Signor Malatesta, he first occupied himself in his service for some days in Rome, and afterwards he betook himself to Rimini, of which city the said Malatesta was lord; and there, in the Church of S. Francesco, he made very many pictures, which were afterwards thrown to the ground and destroyed by Gismondo, son of Pandolfo Malatesta, who rebuilt the whole said church

anew. In the cloisters of the said place, also, opposite to the wall of the church, he painted in fresco the story of the Blessed Michelina, which was one of the most beautiful and excellent works that Giotto ever made, by reason of the many and beautiful ideas that he had in working thereon; for besides the beauty of the draperies, and the grace and vivacity of the heads, which are miraculous, there is a young woman therein as beautiful as ever a woman can be, who, in order to clear herself from the false charge of adultery, is taking oath over a book in a most wonderful attitude, holding her eyes fixed on those of her husband, who was making her take the oath by reason of mistrust in a black son born from her, whom he could in no way bring to believe to be his. She, even as the husband is showing disdain and distrust in his face, is making clear with the purity of her brow and of her eyes, to those who are most intently gazing on her, her innocence and simplicity, and the wrong that he is doing to her in making her take oath and in proclaiming her wrongly as a harlot.

In like manner, very great feeling was that which he expressed in a sick man stricken with certain sores, seeing that all the women who are round him, overcome by the stench, are making certain grimaces of disgust, the most gracious in the world. The foreshortenings, next, that are seen in another picture among a quantity of beggars that he portrayed, are very worthy of praise and should be held in great price among craftsmen, because from them there came the first beginning and method of making them, not to mention that it cannot be said that they are not passing good for early work. But above everything else that is in this work, most marvellous is the gesture that the aforesaid Blessed Michelina is making towards certain usurers, who are disbursing to her the money from the sale of her possessions for giving to the poor, seeing that in her there is shown contempt of money and of the other things of this earth, which appear to disgust her, and, in them, the personification of human avarice and greed. Very beautiful, too, is the figure of one who, while counting the money, appears to be making sign to the notary who is writing, considering that, although he has his eyes on the notary, he is yet keeping his hands on the money, thus revealing his love of it, his avarice, and his distrust. In like manner, the three figures that are upholding the garments of S. Francis in the sky, representing Obedience, Patience, and Poverty, are worthy of infinite praise, above all because there is in the manner of the draperies a natural flow of folds that gives us to know that Giotto was born in order to give light to painting. Besides this, he portrayed Signor Malatesta on a ship in this work, so naturally that he appears absolutely alive; and some mariners and other people, in their promptness, their expressions, and their attitudes—and particularly a figure that is speaking with some others and spits into the sea, putting one hand up to his face—give us to know the excellence of Giotto. And certainly, among all the works of painting made by this master, this may be said to be one of the best, for the reason that there is not one figure in so great a number that does not show very great craftsmanship, and that is not placed in some characteristic attitude. And therefore it is no marvel that Signor Malatesta did not fail to reward him magnificently and to praise him.

Having finished his labours for that lord, he complied with the request of a Prior of Florence who was then at S. Cataldo d'Arimini, and made a S. Thomas Aquinas, reading to his friars, without the door of the church. Departing thence, he returned to Ravenna and painted a chapel in fresco in S. Giovanni Evangelista, which is much extolled. Having next returned to Florence with very great honour and ample means, he painted a Crucifix on wood and in distemper for S. Marco, larger than life and on a ground of gold, which was placed on the right hand in the church. And he made another like it in S. Maria Novella, whereupon Puccio Capanna, his pupil, worked in company with him; and this is still to-day over the principal door, on the right as you enter the church, over the tomb of the Gaddi. And in the same church, over the tran-

By the mid-nineteenth century the Rimini frescoes were nearly invisible. Also, because the Blessed Michelina died some nineteen years after Giotto, it is impossible that he could have painted this cycle.

The only Giotto to survive in Rimini is a Crucifix. *It is typical of the some half-dozen similar crucifixes by Giotto still extant—including those in the churches of San Marco, Santa Maria Novella, and Ognissanti in Florence.*

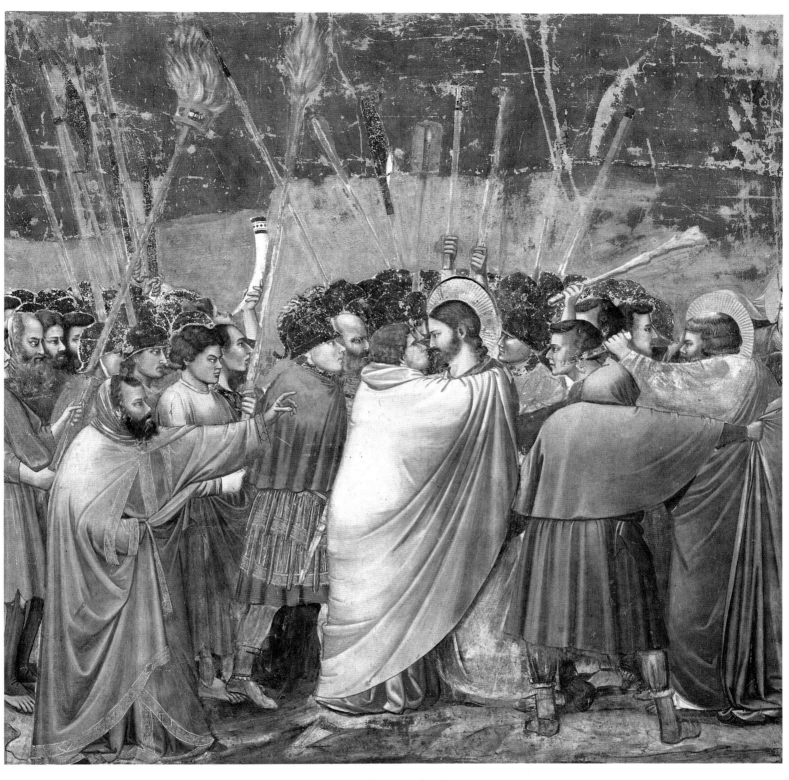

COLORPLATE 9. Giotto. *The Kiss of Judas*. c. 1304–06. Fresco.
Arena (Scrovegni) Chapel, Padua.

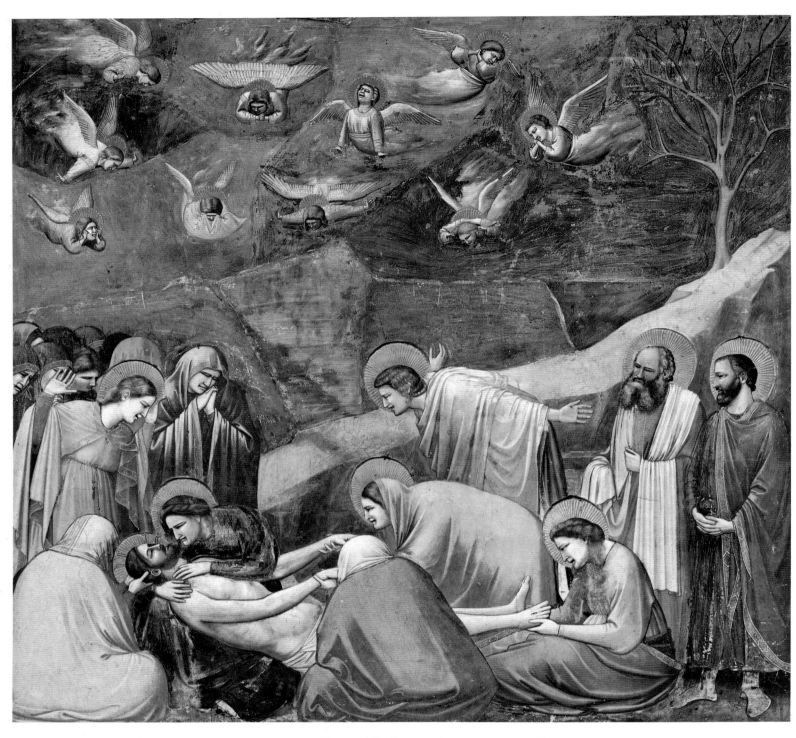

COLORPLATE 10. Giotto. *The Lamentation*. c. 1304–06. Fresco.
Arena (Scrovegni) Chapel, Padua.

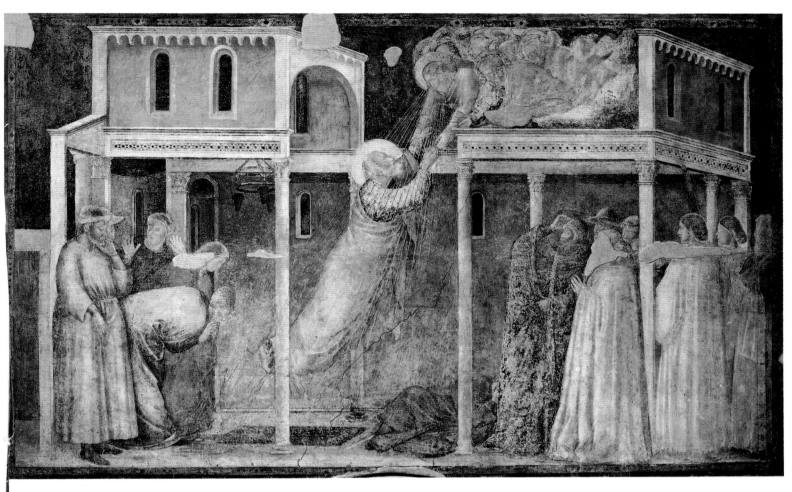

COLORPLATE 13. Giotto. *Ascension of St. John the Evangelist.* c. 1320. Fresco.
Peruzzi Chapel, Church of Santa Croce, Florence.

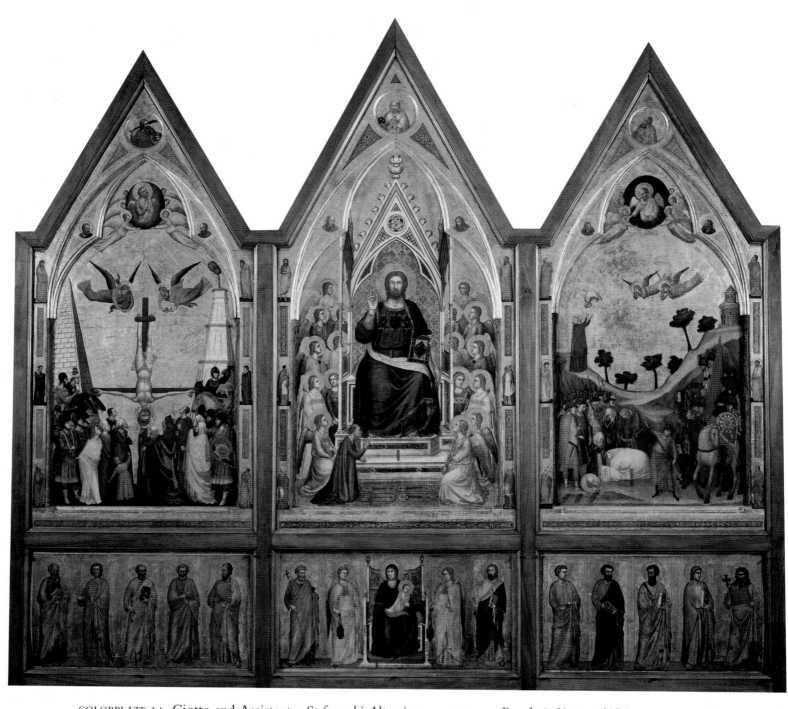

COLORPLATE 14. Giotto and Assistants. *Stefaneschi Altarpiece.* c. 1320–25. Panel. 86¾ × 96¾″ (220 × 245 cm).
Pinacoteca Vaticana, Rome.

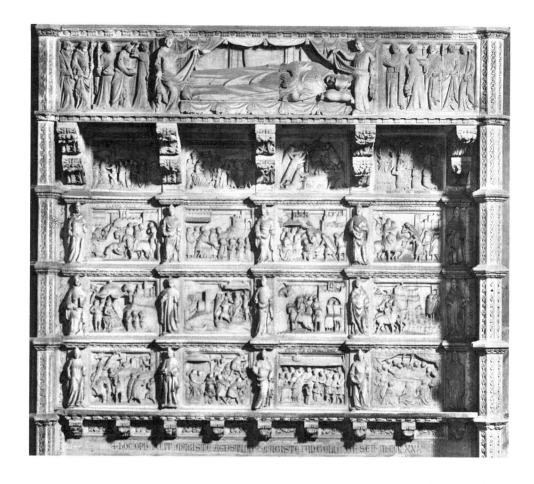

Agostino di Giovanni and Agnolo di Ventura (from designs by Giotto?). *Tomb of Bishop Tarlati* (portion). 1330. Marble. Cathedral, Arezzo.

sept, he made a S. Louis for Paolo di Lotto Ardinghelli, and at the foot thereof the portrait of him and of his wife, from the life.

Afterwards, in the year 1327, Guido Tarlati da Pietramala, Bishop and Lord of Arezzo, died at Massa di Maremma in returning from Lucca, where he had been to visit the Emperor, and after his body had been brought to Arezzo and the most magnificent funeral honours had been paid to it, Piero Saccone and Dolfo da Pietramala, the brother of the Bishop, determined that there should be made for him a tomb in marble worthy of the greatness of so notable a man, who had been a lord both spiritual and temporal, and head of the Ghibelline party in Tuscany. Wherefore, having written to Giotto that he should make the design of a tomb very rich and with all possible adornment, and having sent him the measurements, they prayed him afterwards that he should place at their disposal the sculptor who was the most excellent, according to his opinion, of all that were in Italy, because they were relying wholly on his judgment. Giotto, who was most courteous, made the design and sent it to them; and after this design, as will be told in the proper place, the said tomb was made. And because the said Piero Saccone had infinite love for the talent of this man, having taken Borgo a San Sepolcro no long time after he had received the said design, he brought from there to Arezzo a panel with little figures by the hand of Giotto, which afterwards fell to pieces; and Baccio Gondi, nobleman of Florence, a lover of these noble arts and of every talent, being Commissary of Arezzo, sought out the pieces of this panel with great diligence, and having found some brought them to Florence, where he holds them in great veneration, together with some other works that he has by the hand of the same Giotto, who wrought so many that their number is almost beyond belief. And not many years ago, chancing to be at the Hermitage of Camaldoli, where I have wrought many works for those reverend Fathers, I saw in a cell, whither it had been brought by the Very Reverend Don Antonio da Pisa, then General of the Congregation of Camaldoli, a very beautiful little Crucifix on a ground of gold,

The Ghibellines and the Guelphs were the opposing political factions of the time; their intense and bitter rivalry often erupted in violence and bloodshed.

The statement that Giotto designed the Tarlati monument follows Aretine tradition. Though documentary evidence is lacking, Giotto's participation has been accepted by some authorities.

This small crucifix has vanished.

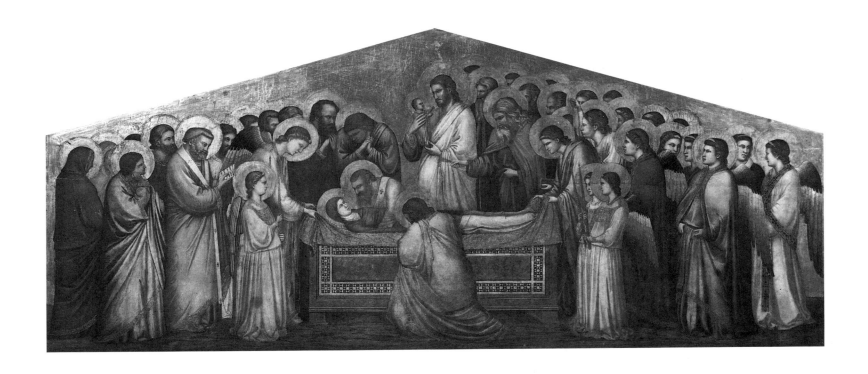

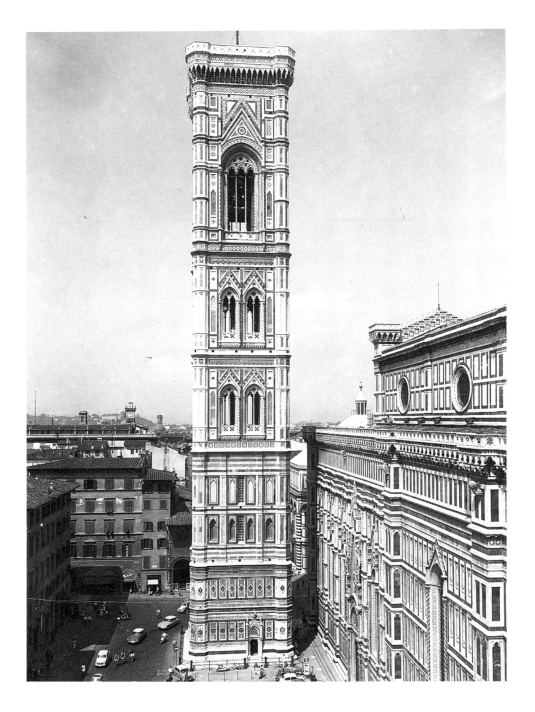

Giotto. *Dormition of the Virgin*. c. 1320.
Panel. 29½ × 70″ (75 × 178 cm).
Gemäldegalerie, Staatliche Museen, Berlin.

Campanile of the Florence Cathedral.
1334–mid 1350s.

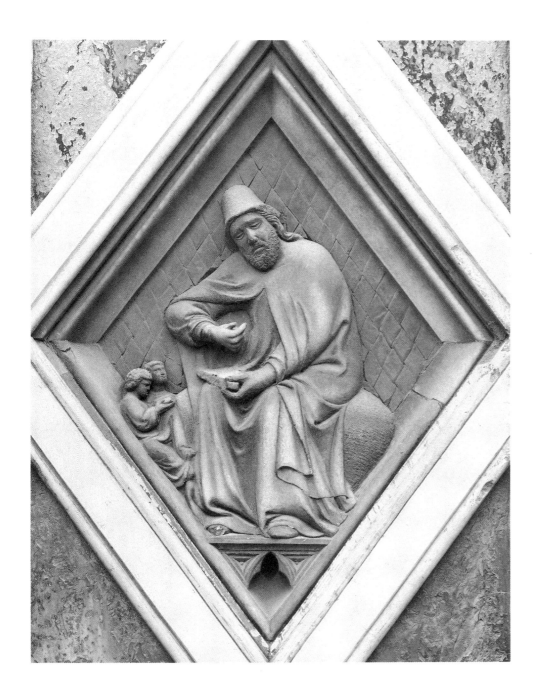

Assistant of Andrea Pisano (from a design by Giotto?). *The Planet Mercury*. c. 1334–47. Marble and blue-glazed tiles. 34¼ × 24¾" (87 × 63 cm). Formerly upper row of reliefs on Campanile, now in Museo dell'Opera del Duomo, Florence.

with the name of Giotto in his own hand; which Crucifix, according to what I hear from the Reverend Don Silvano Razzi, monk of Camaldoli, is kept to-day in the cell of the Superior of the Monastery of the Angeli, as being a very rare work and by the hand of Giotto, in company with a most beautiful little picture by Raffaello da Urbino.

For the Frati Umiliati of Ognissanti in Florence, Giotto painted a chapel and four panels, in one of which there was the Madonna, with many angels round her and the Child in her arms, and a large Crucifix on wood, whereof Puccio Capanna took the design and wrought many of them afterwards throughout all Italy, having much practice in the manner of Giotto. In the transept of the said church, when this book of the Lives of the Painters, Sculptors, and Architects was printed the first time, there was a little panel in distemper painted by Giotto with infinite diligence, wherein was the death of Our Lady, with the Apostles round her and with a Christ who is receiving her soul into His arms. This work was much praised by the craftsmen of painting, and in particular by Michelagnolo Buonarroti, who declared, as was said another time, that the quality of this painted story could not be more like to the truth than it is. This

COLORPLATE 12

Although the panel depicting the "death of Our Lady" (the Berlin Dormition*) is less than half the size of the* Ognissanti Madonna *(colorplate 12), it is hardly "little." It was "carried off" shortly after 1550 and was not seen until 1841, when it was found in a private collection.*

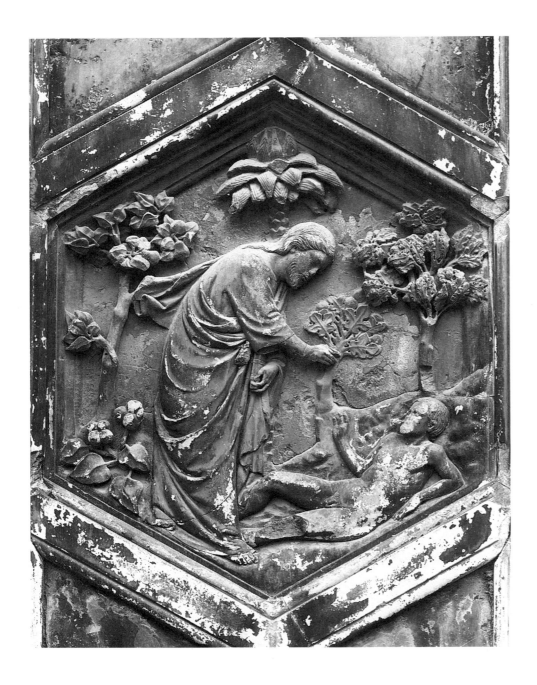

Andrea Pisano (from a design by Giotto?). *The Creation of Man.* c. 1334–47. Marble. 32¾ × 27¼″ (83 × 69 cm). Formerly lower row of reliefs on Campanile, now in Museo dell' Opera del Duomo, Florence.

little panel, I say, having come into notice from the time when the book of these Lives was first published, was afterwards carried off by someone unknown, who, perhaps out of love for art and out of piety, it seeming to him that it was little esteemed, became, as said our poet, impious. And truly it was a miracle in those times that Giotto had so great loveliness in his painting, considering, above all, that he learnt the art in a certain measure without a master.

After these works, in the year 1334, on July 9, he put his hand to the Campanile of S. Maria del Fiore, whereof the foundation was a platform of strong stone, in a pit sunk twenty braccia deep from which water and gravel had been removed; upon this platform he made a good mass of concrete, that reached to the height of twelve braccia above the first foundation, and the rest—namely, the other eight braccia—he caused to be made of masonry. And at this beginning and foundation there officiated the Bishop of the city, who, in the presence of all the clergy and all the magistrates, solemnly laid the first stone. This work, then, being carried on with the said model, which was in the German manner that was in use in those times, Giotto designed all the scenes that were going into the ornamentation, and marked out the model with white, black, and red colours in all those places wherein the marbles and the friezes were to go, with much diligence. The circuit round the base was one hundred brac-

An extant drawing is currently presumed to be a project for a bell tower for the Siena Cathedral; however, it reveals similarities with the Florence Campanile (it also shows the "spire" that Vasari says was planned).

Even though Ghiberti stated (see facing page) he saw Giotto's "models in relief"—Vasari also terms Giotto a "sculptor" in his heading for this Life—none of his sculpture survives. The reliefs illustrated are, in the main, believed to have been based on Giotto's designs.

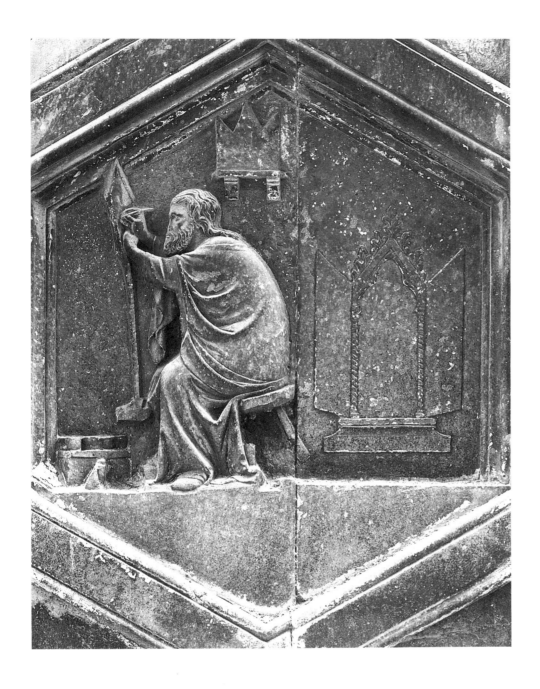

Andrea Pisano (from a design by Giotto?). *The Art of Painting*. c. 1334–47. Marble. 32¾ × 27¼" (83 × 69 cm). Formerly lower row of reliefs on Campanile, now in Museo dell'Opera del Duomo, Florence.

cia—that is, twenty-five braccia for each side—and the height, one hundred and forty-four braccia. And if that is true, and I hold it as of the truest, which Lorenzo di Cione Ghiberti has left in writing, Giotto made not only the model of this campanile, but also part of those scenes in marble wherein are the beginnings of all the arts, in sculpture and in relief. And the said Lorenzo declares that he saw models in relief by the hand of Giotto, and in particular those of these works; which circumstance can be easily believed, design and invention being father and mother of all these arts and not of one alone. This campanile was destined, according to the model of Giotto, to have a spire, or rather a pyramid, four-sided and fifty braccia high, as a completion to what is now seen; but, for the reason that it was a German idea and in an old manner, modern architects have never done aught but advise that it should not be made, the work seeming to be better as it is. For all these works Giotto was not only made citizen of Florence, but was given a pension of one hundred florins yearly by the Commune of Florence, which was something very great in those times; and he was made overseer over this work, which was carried on after him by Taddeo Gaddi, for he did not live so long as to be able to see it finished.

Now, while this work continued to be carried forward, he made a panel for the Nuns of S. Giorgio, and three half-length figures in an arch over the inner

Lorenzo Ghiberti (1378–1455), Florentine sculptor, goldsmith, and writer. His most celebrated work is the so-called Gates of Paradise for the Florence Baptistry. His book Commentaries *was a prime source for Vasari in writing this* Life.

One hundred florins at an average early 1986 gold price would equal about $4,000. The purchasing power of a florin in the fourteenth century was considerably greater, however.

The Campanile was actually completed in the 1350s by the Tuscan architect Francesco Talenti (c. 1300–after 1369).

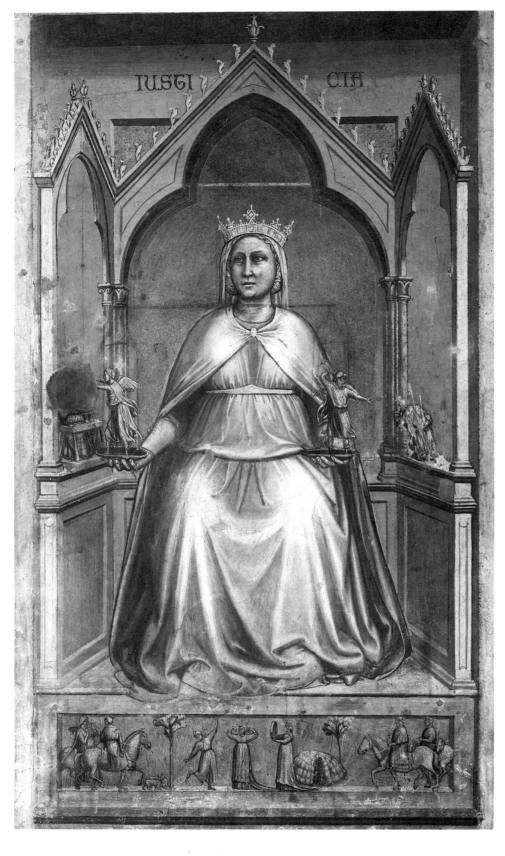

IVSTI CIA

OPPOSITE:

Giotto. *Enthroned Christ in Glory with Saints and Angels*. c. 1306. Fresco. Arena (Scrovegni) Chapel, Padua.

Giotto. *Justice* (one of the *Four Virtues*), portion of lower frieze. c. 1306. Fresco. Arena (Scrovegni) Chapel, Padua.

side of the door of the Badia in Florence, now covered with whitewash in order to give more light to the church. And in the Great Hall of the Podestà of Florence he painted the Commune (an idea stolen by many), representing it as sitting in the form of Judge, sceptre in hand, and over its head he placed the balanced scales as symbol of the just decisions administered by it, accompanying it with four Virtues, that are, Strength with courage, Wisdom with the laws, Justice with arms, and Temperance with words; this work is beautiful as a picture, and characteristic and appropriate in invention.

Afterwards, having gone again to Padua, besides many other works and

The Podestà works have vanished.

COLORPLATE II

54

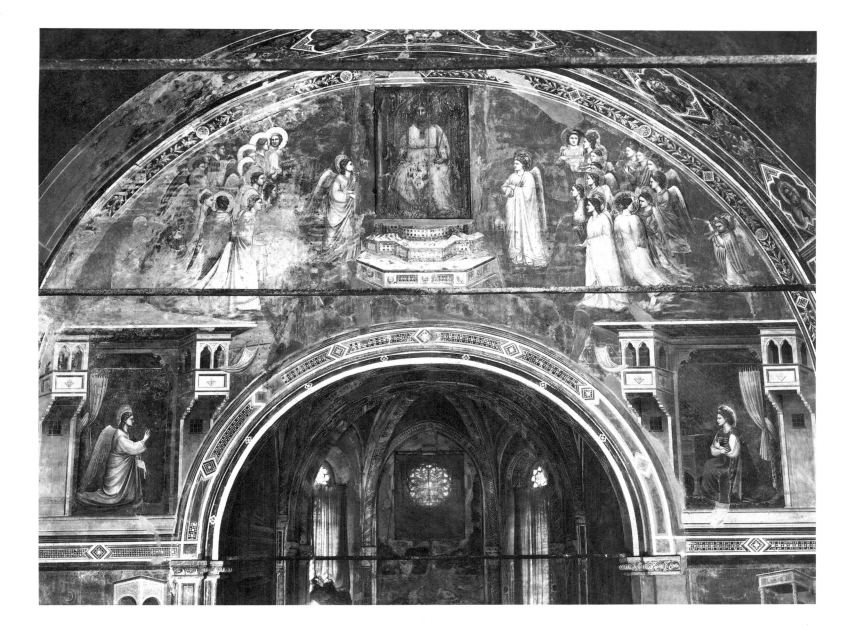

chapels that he painted there, he made a Mundane Glory in the precincts of the Arena, which gained him much honour and profit. In Milan, also, he wrought certain works, that are scattered throughout that city and held most beautiful even to this day. Finally, having returned from Milan, no long time passed before he gave up his soul to God, having wrought so many most beautiful works in his life, and having been no less good as Christian than he was excellent as painter. He died in the year [1337], to the great grief of all his fellow-citizens—nay, of all those who had known him or even only heard his name—and he was buried, even as his virtues deserved, with great honour, having been loved by all while he lived, and in particular by the men excellent in all the professions, seeing that, besides, Dante, of whom we have spoken above, he was much honoured by Petrarch, both he and his works, so greatly that it is read in Petrarch's testament that he left to Signor Francesco da Carrara, Lord of Padua, among other things held by him in the highest veneration, a picture by the hand of Giotto containing a Madonna, as something rare and very dear to him. And the words of that clause in the testament run thus:

I now turn to the disposition of my remaining possessions. To the aforementioned lord of Padua—since by the grace of God he needs nothing for himself—I bequeath the only thing I have that is worthy of him: my panel representing the Blessed Virgin Mary. This picture is the

As Vasari lyrically praises works now thought not to be Giotto's or that have disappeared, it is somewhat ironic that Giotto's greatest achievement and best-preserved fresco cycle—the Arena Chapel—is here accorded the briefest mention.

Petrarch (Francesco Petrarca: 1304–1374), famous Italian poet and scholar, and one of the prime sources of Renaissance culture. The Madonna mentioned in his will has been lost.

work of the distinguished painter Giotto, and was sent to my friend Michele Vanni of Florence. Its beauty is incomprehensible to laymen, yet it astounds professional artists. I bequeath this to my lord with the prayer that the Blessed Virgin herself will intercede for him with her son Jesus Christ.

And the same Petrarch, in a Latin epistle in the fifth book of his *Familiar Letters*, says these words:

> Now—if I may turn from old things to new, and from matters foreign to domestic—I have known two painters whose work is outstanding and not merely attractive: Giotto of Florence, who enjoys a huge reputation at this time, and Simone [Martini] of Siena.

Giotto was buried in S. Maria del Fiore, on the left side as you enter the church, where there is a slab of white marble in memory of so great a man. And [according to an anonymous] commentator of Dante, who lived at the same time as Giotto: "Giotto was and is the most eminent among painters in the same city of Florence, and his works bear testimony for him in Rome, in Naples, in Avignon, in Florence, in Padua, and in many other parts of the world."

* * *

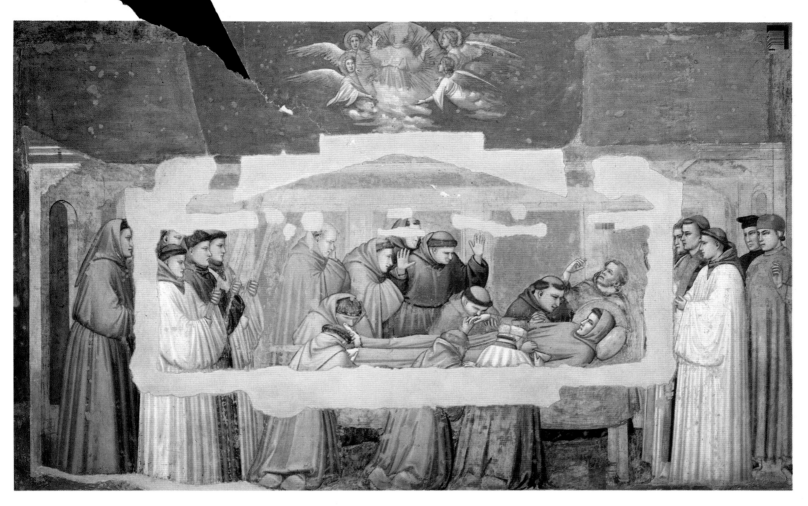

COLORPLATE 17. Giotto. *The Death of St. Francis*. c. 1325. Fresco.
Bardi Chapel, Church of Santa Croce, Florence.

COLORPLATE 18. Giotto and Assistants. *Baroncelli Altarpiece*. c. 1333. Panel.
72¾ × 127″ (185 × 323 cm). Baroncelli Chapel, Church of Santa Croce, Florence.

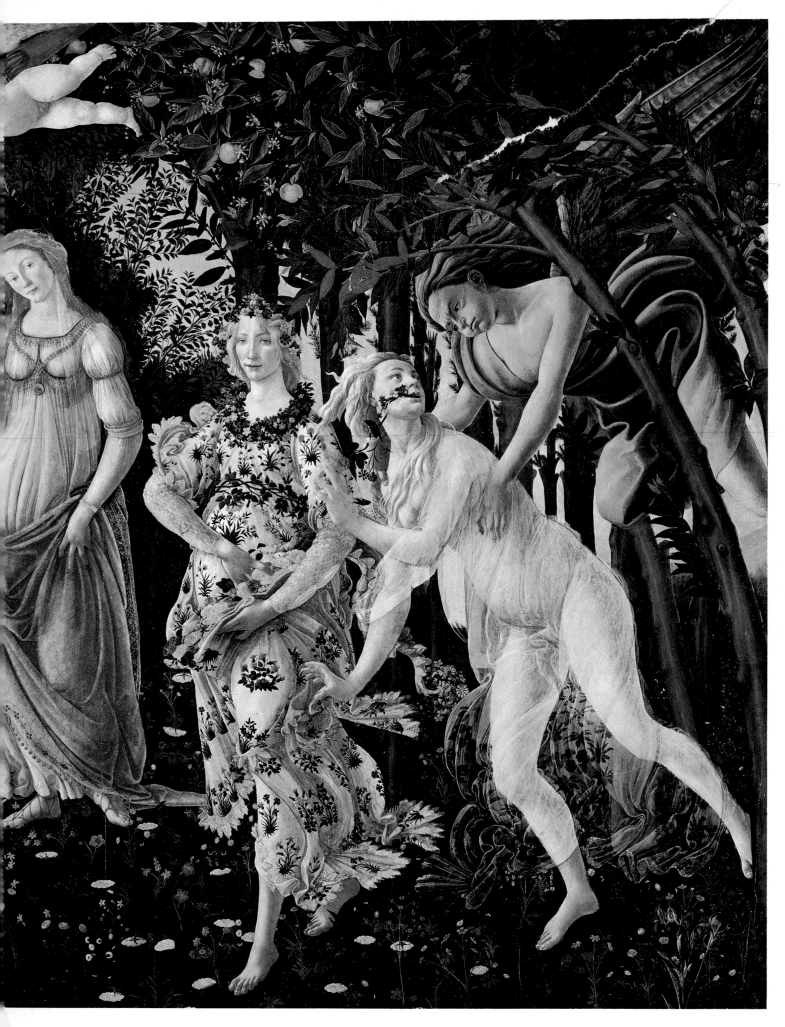

COLORPLATE 19. Sandro Botticelli. *Primavera*. c. 1477–78. Panel. 80¼ × 124″ (203 × 314 cm).
Uffizi Gallery, Florence.

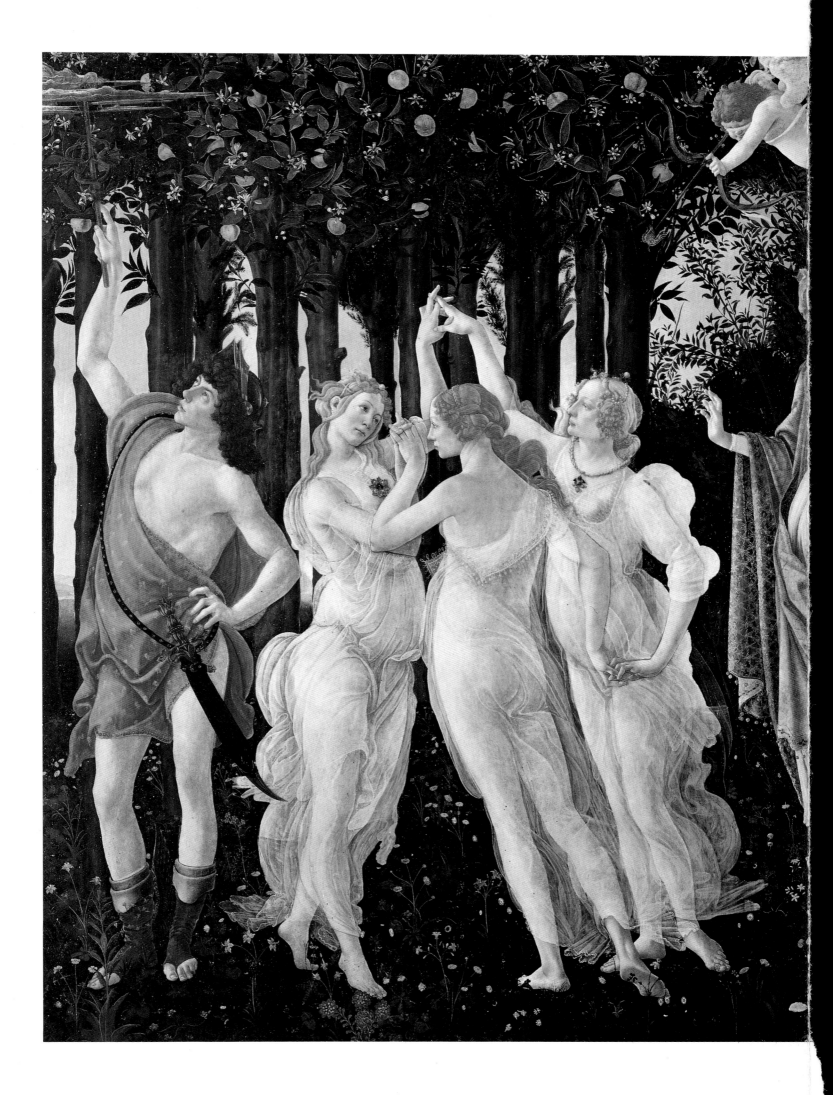

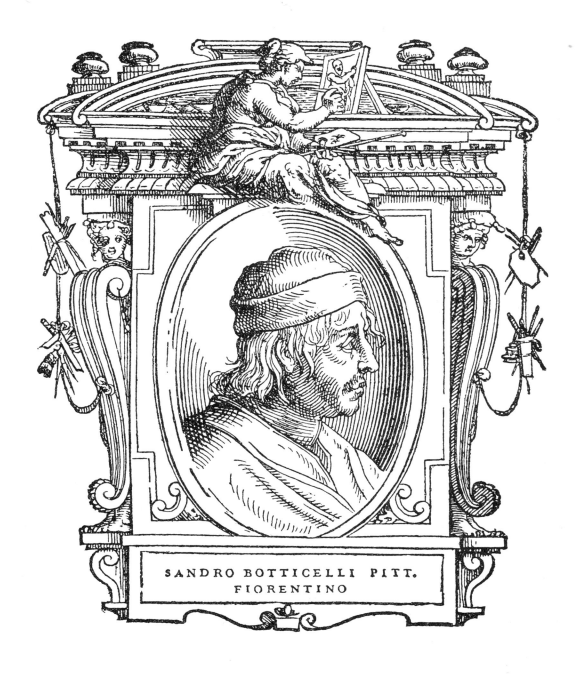

SANDRO BOTTICELLI PITT.
FIORENTINO

THE LIFE OF
SANDRO BOTTICELLI

[c. 1445–1510]

THE FLORENTINE PAINTER

A T THE SAME TIME with the elder Lorenzo de' Medici, the
Magnificent, which was truly a golden age for men of intellect,
there also flourished one Alessandro, called Sandro after our cus-
tom, and surnamed Di Botticello for a reason that we shall see
below. This man was the son of Mariano Filipepi, a citizen of Florence, who
brought him up with care, and had him instructed in all those things that are
usually taught to children before they are old enough to be apprenticed to
some calling. But although he found it easy to learn whatever he wished,
nevertheless he was ever restless, nor was he contented with any form of
learning, whether reading, writing, or arithmetic, insomuch that his father,
weary of the vagaries of his son's brain, in despair apprenticed him as a gold-
smith with a boon-companion of his own, called Botticello, no mean master
of that art in his day.

Now in that age there was a very close connection—nay, almost a con-
stant intercourse—between the goldsmiths and the painters; wherefore San-
dro, who was a ready fellow and had devoted himself wholly to design, be-
came enamoured of painting, and determined to devote himself to that. For
this reason he spoke out his mind freely to his father, who, recognizing the
inclination of his brain, took him to Fra Filippo of the Carmine, a most ex-
cellent painter of that time, with whom he placed him to learn the art, ac-
cording to Sandro's own desire. Thereupon, devoting himself heart and soul
to that art, Sandro followed and imitated his master so well that Fra Filippo,
growing to love him, taught him very thoroughly, so that he soon rose to
such a rank as none would have expected for him.

While still quite young, he painted a figure of Fortitude in the Mercatan-
zia of Florence, among the pictures of Virtues that were wrought by Anto-
nio and Piero del Pollaiuolo. For the Chapel of the Bardi in S. Spirito at
Florence he painted a panel, wrought with diligence and brought to a fine
completion, which contains certain olive-trees and palms executed with con-
summate lovingness. He painted a panel for the Convertite Nuns, and an-
other for those of S. Barnaba. In the transept of the Ognissanti, by the door
that leads into the choir, he painted for the Vespucci a S. Augustine in fresco,
with which he took very great pains, seeking to surpass all the painters of his
time, and particularly Domenico Ghirlandajo, who had made a S. Jerome on
the other side; and this work won very great praise, for in the head of that
Saint he depicted the profound meditation and acute subtlety that are found
in men of wisdom who are ever concentrated on the investigation of the
highest and most difficult matters. This picture [. . .] has this year (1564) been
removed safe and sound from its original position.

Having thus come into credit and reputation, he was commissioned by the
Guild of Porta Santa Maria to paint in S. Marco a panel with the Coronation
of Our Lady and a choir of angels, which he designed and executed very well.
He made many works in the house of the Medici for the elder Lorenzo, par-
ticularly a Pallas on a device of great branches, which spouted forth fire: this

The name Botticelli is derived from
botticello, *Italian for small barrel or tub.*
It was originally the nickname of the
artist's older brother.

"Fra Filippo" is Fra Filippo Lippi
(1406–1469), eminent Florentine painter.
Through papal dispensation, he was
allowed to marry; his son, Filippino Lippi
(1457–1504) was Botticelli's most
distinguished pupil.

COLORPLATE 20

Antonio del Pollaiuolo (c. 1431–1498),
Florentine painter, sculptor, and engraver.

COLORPLATE 22

Domenico del Ghirlandaio (1449–1494),
eminent Florentine painter and
Michelangelo's teacher.

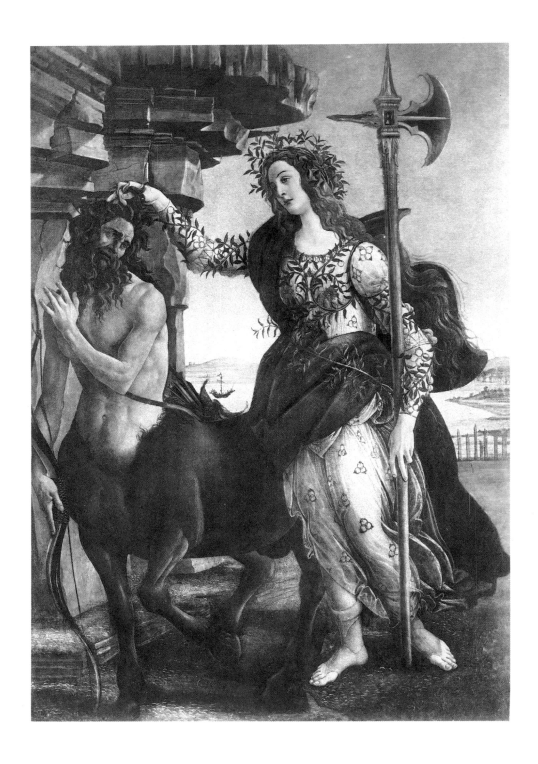

Sandro Botticelli. *Pallas and the Centaur.*
c. 1482. Tempera on canvas. 81¾ × 58½"
(207 × 148 cm). Uffizi Gallery, Florence.

he painted of the size of life, as he did a S. Sebastian. In S. Maria Maggiore in Florence, beside the Chapel of the Panciatichi, there is a very beautiful Pietà with little figures. For various houses throughout the city he painted round pictures, and many female nudes, of which there are still two at Castello, a villa of Duke Cosimo's; one representing the birth of Venus, with those Winds and Zephyrs that bring her to the earth, with the Cupids; and likewise another Venus, whom the Graces are covering with flowers, as a symbol of spring; and all this he is seen to have expressed very gracefully. Round an apartment of the house of Giovanni Vespucci, now belonging to Piero Salviati, in the Via de' Servi, he made many pictures which were enclosed by frames of walnut-wood, by way of ornament and panelling, with many most lively and beautiful figures. In the house of the Pucci, likewise, he painted with little figures Boccaccio's tale of Nastagio degli Onesti in four square pictures of most charming and beautiful workmanship, and the Epiphany in a round picture. For a chapel in the Monastery of Cestello he painted an An-

COLORPLATE 30

COLORPLATE 19

The Florentine Vespucci family was a prominent one; the navigator Amerigo Vespucci (1451–1512) is perhaps its most famous member.

COLORPLATE 29
COLORPLATE 27

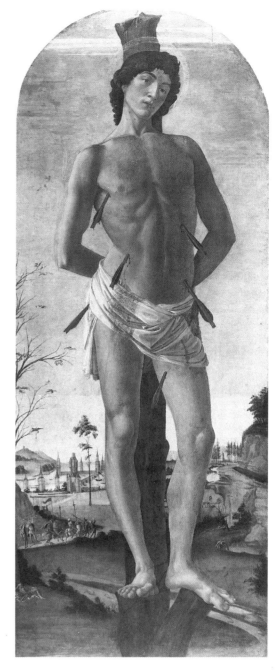

Sandro Botticelli. *St. Sebastian*. c. 1473.
Panel. 76¾ × 29½" (195 × 75 cm).
Gemäldegalerie, Staatliche Museen, Berlin.

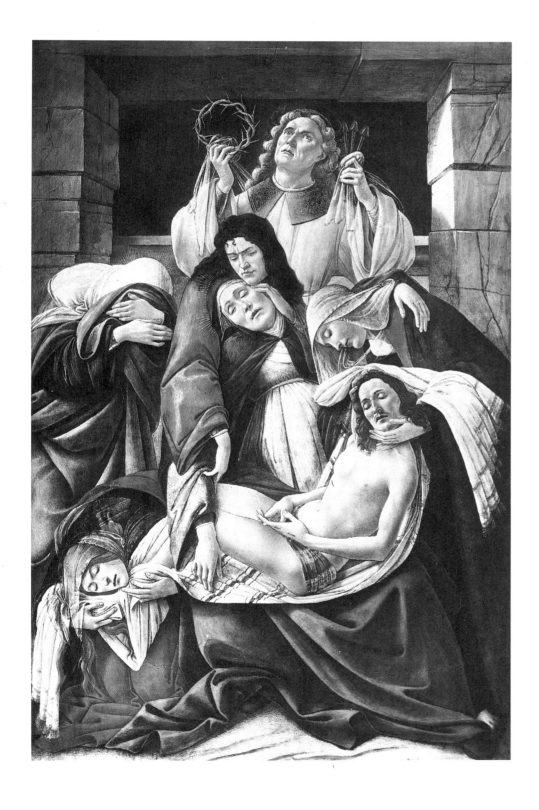

Sandro Botticelli. *The Pietà* (or
Lamentation). c. 1495. Panel. 42¼ × 28"
(107 × 71 cm). Museo Poldi-Pezzoli,
Milan.

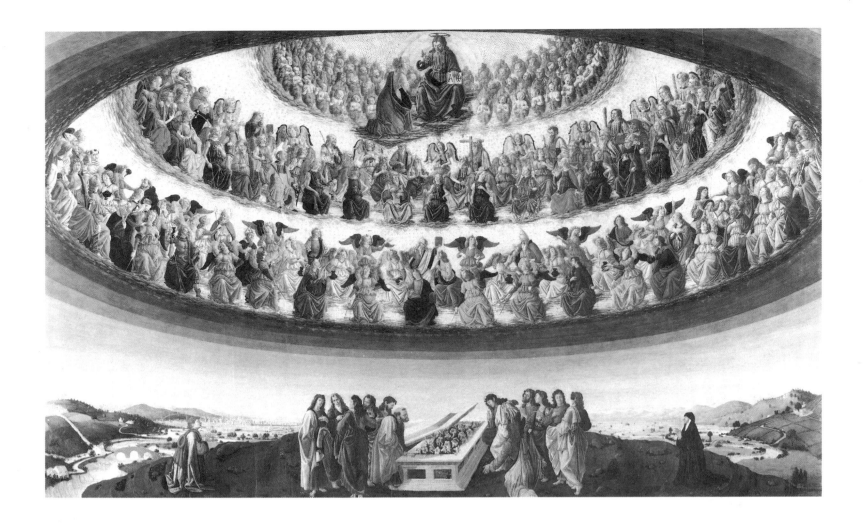

nunciation on a panel. Near the side-door of S. Pietro Maggiore, for Matteo Palmieri, he painted a panel with an infinite number of figures—namely, the Assumption of Our Lady, with the zones of Heaven as they are represented, and the Patriarchs, the Prophets, the Apostles, the Evangelists, the Martyrs, the Confessors, the Doctors, the Virgins, and the Hierarchies; all from the design given to him by Matteo, who was a learned and able man. This work he painted with mastery and consummate diligence; and at the foot is a portrait of Matteo on his knees, with that of his wife. But for all that the work is most beautiful, and should have silenced envy, nevertheless there were certain malignant slanderers who, not being able to do it any other damage, said that both Matteo and Sandro had committed therein the grievous sin of heresy. As to whether this be true or false, I cannot be expected to judge; it is enough that the figures painted therein by Sandro are truly worthy of praise, by reason of the pains that he took in drawing the zones of Heaven and in the distribution of figures, angels, foreshortenings, and views, all varied in diverse ways, the whole being executed with good design.

At this time Sandro was commissioned to paint a little panel with figures three-quarters of a braccio in length, which was placed between two doors in the principal façade of S. Maria Novella, on the left as one enters the church by the door in the centre. It contains the Adoration of the Magi, and wonderful feeling is seen in the first old man, who, kissing the foot of Our Lord, and melting with tenderness, shows very clearly that he has achieved the end of his long journey. The figure of this King is an actual portrait of the elder Cosimo de' Medici, the most lifelike and most natural that is to be found of him in our own day. The second, who is Giuliano de' Medici, father of Pope Clement VII, is seen devoutly doing reverence to the Child with a most in-

Francesco Botticini. *The Assumption.* Before 1478 (?). Canvas, transferred to panel. 88¾ × 180¾" (225 × 458 cm). The National Gallery, London.

This "Assumption" is now known to be by Francesco Botticini (1446–1497). Because Palmieri (d. 1478) was posthumously accused of heresy, the painting was concealed behind a curtain until 1785.

COLORPLATE 21

tent expression, and presenting Him with his offering. The third, also on his knees, appears to be adoring Him and giving Him thanks, while confessing that He is the true Messiah; this is Giovanni, son of Cosimo.

It is not possible to describe the beauty that Sandro depicted in the heads that are therein seen, which are drawn in various attitudes, some in full face, some in profile, some in three-quarter face, others bending down, and others, again, in various manners; with different expressions for the young and the old, and with all the bizarre effects that reveal to us the perfection of his skill; and he distinguished the Courts of the three Kings one from another, insomuch that one can see which are the retainers of each. This is truly a most admirable work, and executed so beautifully, whether in colouring, drawing, or composition, that every craftsman at the present day stands in a marvel thereat. And at that time it brought him such great fame, both in Florence and abroad, that Pope Sixtus IV, having accomplished the building of the chapel of his palace in Rome, and wishing to have it painted, ordained that he should be made head of that work; whereupon he painted therein with his own hand the following scenes—namely, the Temptation of Christ by the Devil, Moses slaying the Egyptian, Moses receiving drink from the daughters of Jethro the Midianite, and likewise fire descending from Heaven on

In addition to the portraits of various members of the Medici, the artist also depicted himself in the Adoration of the Magi, *in the standing figure at far right.*

This "chapel" is the Sistine Chapel, which takes its name from Pope Sixtus IV (r. 1471–84).

COLORPLATE 23
COLORPLATE 24

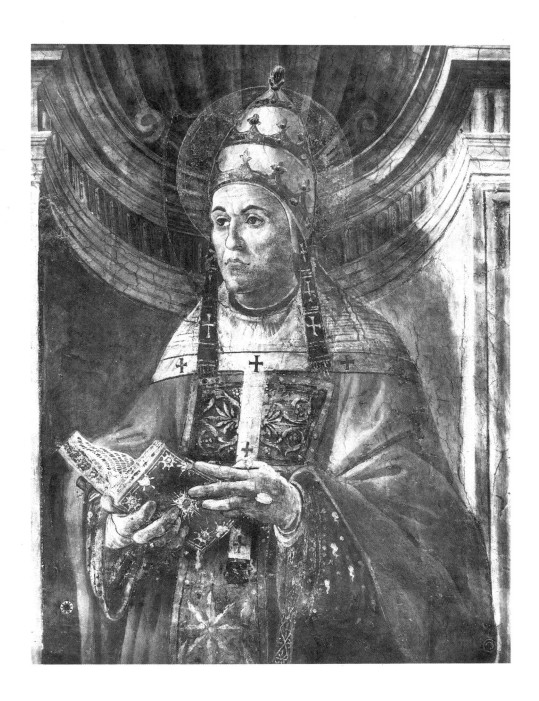

Botticelli and Assistants. *St. Lucius* (?) (portion). 1481–82. Fresco. Sistine Chapel, Vatican, Rome.

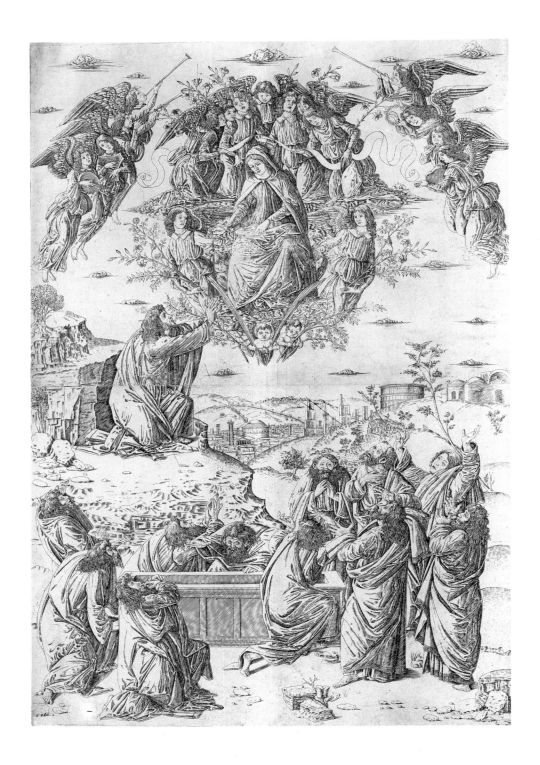

Francesco Rosselli (after Botticelli). *The Assumption*. Copperplate engraving. Fogg Art Museum, Harvard University, Cambridge, Mass. Gift of Belinda L. Randall from the John W. H. Randall Collection.

the sacrifice of the sons of Aaron, with certain Sanctified Popes in the niches above the scenes. Having therefore acquired still greater fame and reputation among the great number of competitors who worked with him, both Florentines and men of other cities, he received from the Pope a good sum of money, the whole of which he consumed and squandered in a moment during his residence in Rome, where he lived in haphazard fashion, as was his wont.

Having at the same time finished and unveiled the part that had been assigned to him, he returned immediately to Florence, where, being a man of inquiring mind, he made a commentary on part of Dante, illustrated the Inferno, and printed it; on which he wasted much of his time, bringing infinite disorder into his life by neglecting his work. He also printed many of the drawings that he had made, but in a bad manner, for the engraving was poorly done. The best of these that is to be seen by his hand is the Triumph of the Faith effected by Fra Girolamo Savonarola of Ferrara, of whose sect he

Actually, Botticelli illustrated almost all of The Divine Comedy, *but the drawings were never engraved. The latter illustrations were probably those of Baccio Baldini (fl. second half sixteenth century), printed in 1481; Botticelli's drawings date from around 1495.*

COLORPLATE 20. Sandro Botticelli. *Fortitude*. 1470. Panel. 65¾ × 34¼″ (167 × 87 cm).
Uffizi Gallery, Florence.

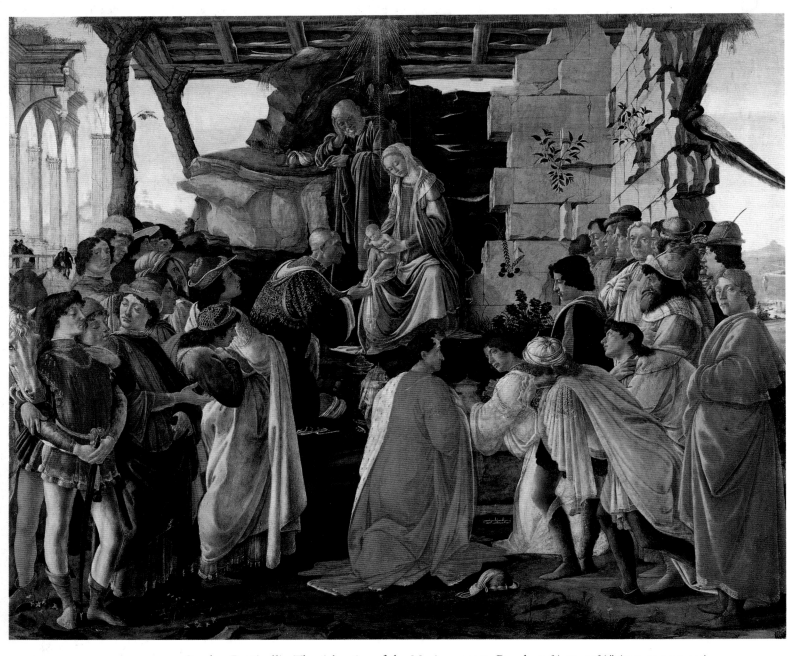

COLORPLATE 21. Sandro Botticelli. *The Adoration of the Magi.* c. 1475. Panel. 43¾ × 52¾″ (111 × 134 cm). Uffizi Gallery, Florence.

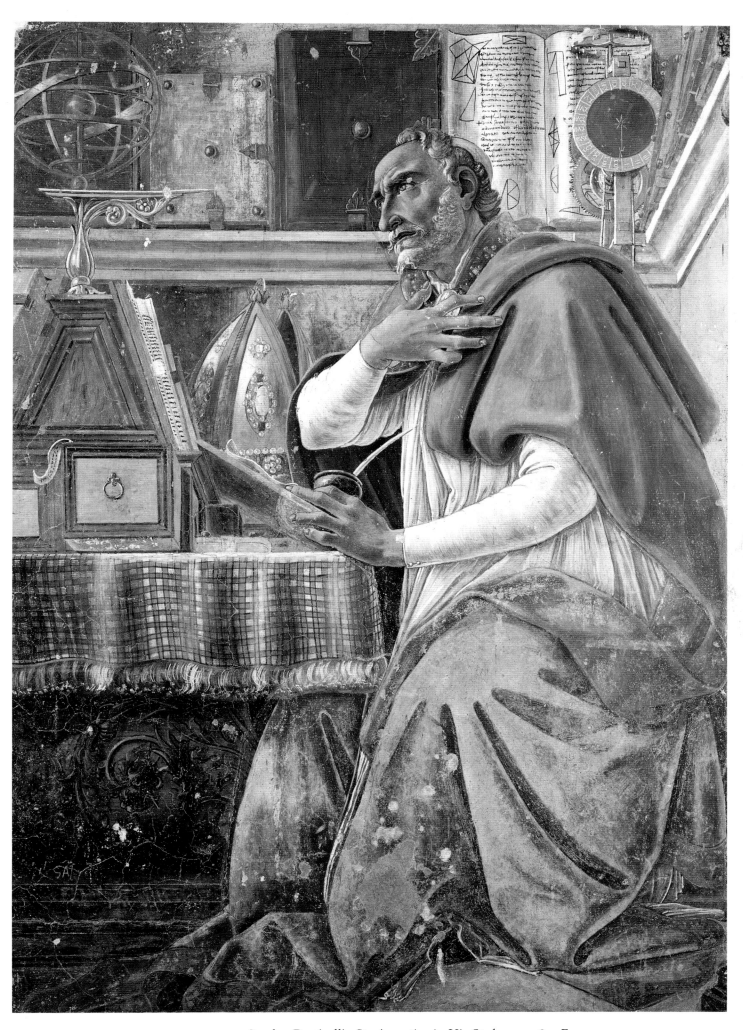

COLORPLATE 22. Sandro Botticelli. *St. Augustine in His Study*. c. 1480. Fresco.
Church of the Ognissanti, Florence.

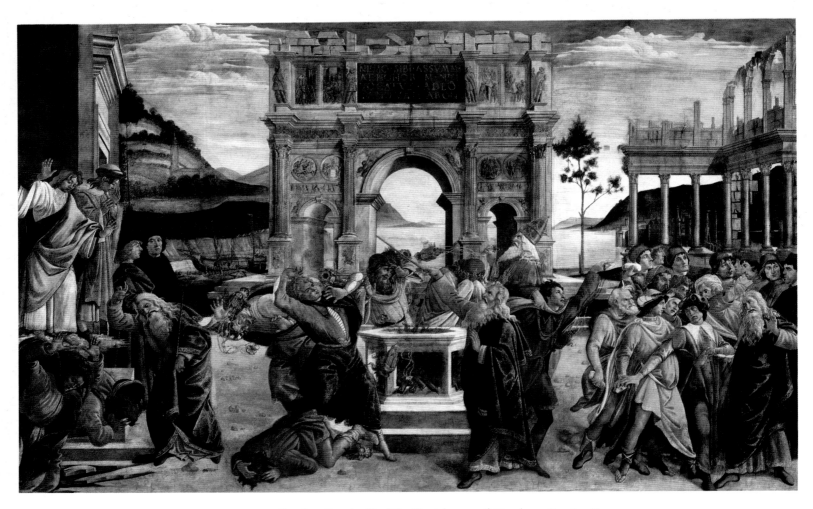

COLORPLATE 23. Sandro Botticelli. *The Punishment of Korah*. 1481–82. Fresco.
Sistine Chapel, Vatican, Rome.

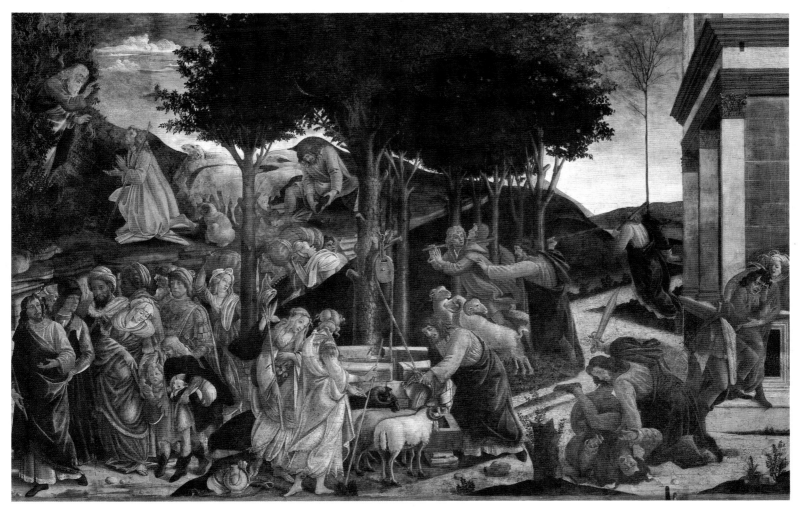

COLORPLATE 24. Sandro Botticelli. *The Youth of Moses*. 1481–82. Fresco.
Sistine Chapel, Vatican, Rome.

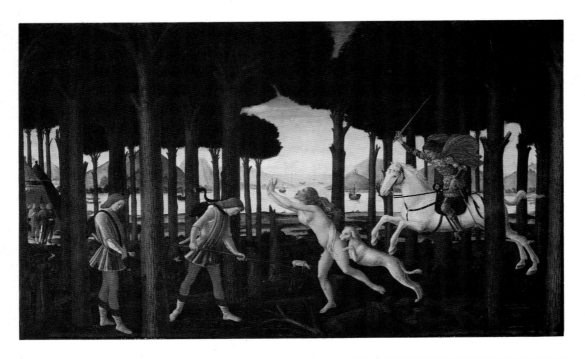

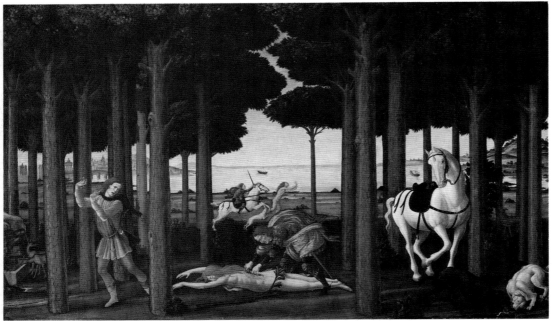

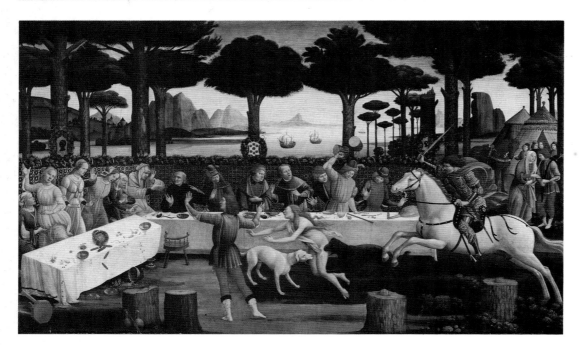

COLORPLATE 25. Sandro Botticelli.
The Story of Nastagio degli Onesti.
1483. Panel.

First panel: *Nastagio Sees a Lady
Pursued by a Knight.*
32¾ × 54¼″ (83 × 138 cm).

Second panel: *Nastagio Witnesses
the Lady Disemboweled.*
32¼ × 54¼″ (82 × 138 cm).

Third panel: *Nastagio Gives a Banquet
in the Forest to Show His Guests the
Lady and the Knight.*
33 × 56″ (84 × 142 cm).
The Prado, Madrid.

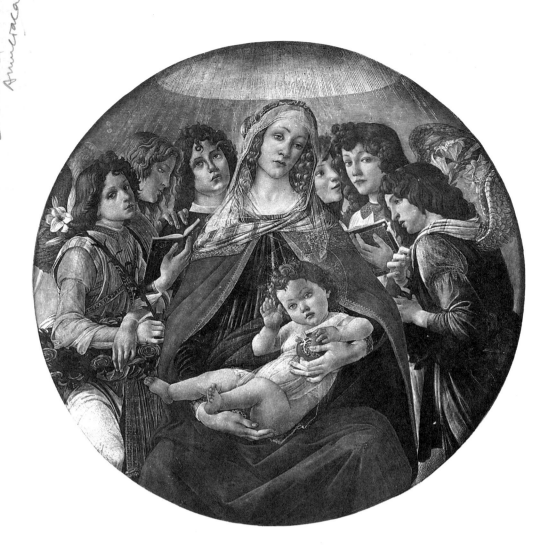

Sandro Botticelli. *Madonna of the Pomegranate*. c. 1487. Panel. 56½″ (143.5 cm) in diam. Uffizi Gallery, Florence.

was so ardent a partisan that he was thereby induced to desert his painting, and, having no income to live on, fell into very great distress. For this reason, persisting in his attachment to that party, and becoming a Piagnone [weeper or mourner] (as the members of the sect were then called), he abandoned his work; wherefore he ended in his old age by finding himself so poor, that, if Lorenzo de' Medici, for whom, besides many other things, he had some work at the little hospital in the district of Volterra, had not succoured him the while that he lived, as did afterwards his friends and many excellent men who loved him for his talent, he would have almost died of hunger.

In S. Francesco, without the Porta a San Miniato, there is a Madonna in a round picture by the hand of Sandro, with some angels of the size of life, which was held a very beautiful work. Sandro was a man of very pleasant humour, often playing tricks on his disciples and his friends; wherefore it is related that once, when a pupil of his who was called Biagio had made a round picture exactly like the one mentioned above, in order to sell it, Sandro sold it for six florins of gold to a citizen; then, finding Biagio, he said to him, "At last I have sold this thy picture; so this evening it must be hung on high, where it will be seen better, and in the morning thou must go to the house of the citizen who has bought it, and bring him here, that he may see it in a good light in its proper place; and then he will pay thee the money." "O, my master," said Biagio, "how well you have done." Then, going into the shop, he hung the picture at a good height, and went off. Meanwhile Sandro and Jacopo, who was another of his disciples, made eight caps of paper, like those worn by citizens, and fixed them with white wax on the heads of the eight angels that surrounded the Madonna in the said picture. Now, in the morning, up comes Biagio with his citizen, who had bought the picture and was in the secret. They entered the shop, and Biagio, looking up, saw his Ma-

Girolamo Savonarola (1452–1498), an eloquent preacher with shrewd political awareness, who became the virtual dictator of Florence for several years. He was ultimately declared a heretic and hanged. His body was burned in the piazza in front of the Palazzo Vecchio.

COLORPLATE 26

donna seated, not among his angels, but among the Signoria of Florence, with all those caps. Thereupon he was just about to begin to make an outcry and to excuse himself to the man who had bought it, when, seeing that the other, instead of complaining, was actually praising the picture, he kept silent himself. Finally, going with the citizen to his house, Biagio received his payment of six florins, the price for which his master had sold the picture; and then, returning to the shop just as Sandro and Jacopo had removed the paper caps, he saw his angels as true angels, and not as citizens in their caps. All in a maze, and not knowing what to say, he turned at last to Sandro and said: "Master, I know not whether I am dreaming, or whether this is true. When I came here before, these angels had red caps on their heads, and now they have not; what does it mean?" "Thou art out of thy wits, Biagio," said Sandro; "this money has turned thy head. If it were so, thinkest thou that the citizen would have bought the picture?" "It is true," replied Biagio, "that he said nothing to me about it, but for all that it seemed to me strange." Finally, all the other lads gathered round him and wrought on him to believe that it had been a fit of giddiness.

Another time a cloth-weaver came to live in a house next to Sandro's and erected no less than eight looms, which, when at work, not only deafened poor Sandro with the noise of the treadles and the movement of the frames, but shook his whole house, the walls of which were no stronger than they should be, so that what with the one thing and the other he could not work or even stay at home. Time after time he besought his neighbour to put an end to this annoyance, but the other said that he both would and could do what he pleased in his own house; whereupon Sandro, in disdain, balanced on the top of his own wall, which was higher than his neighbour's and not very strong, an enormous stone, more than enough to fill a wagon, which threatened to fall at the slightest shaking of the wall and to shatter the roof, ceilings, webs, and looms of his neighbour, who, terrified by this danger, ran to Sandro, but was answered in his very own words—namely, that he both could and would do whatever he pleased in his own house. Nor could he get any other answer out of him, so that he was forced to come to a reasonable agreement and to be a good neighbour to Sandro.

It is also related that Sandro, for a jest, accused a friend of his own of heresy before his vicar, and the friend, on appearing, asked who the accuser was and what the accusation; and having been told that it was Sandro, who had charged him with holding the opinion of the Epicureans, and believing that the soul dies with the body, he insisted on being confronted with the accuser before the judge. Sandro therefore appeared, and the other said: "It is true that I hold this opinion with regard to this man's soul, for he is an animal. Nay, does it not seem to you that he is the heretic, since without a scrap of learning, and scarcely knowing how to read, he plays the commentator to Dante and takes his name in vain?"

It is also said that he had a surpassing love for all whom he saw to be zealous students of art; and that he earned much, but wasted everything through negligence and lack of management. Finally, having grown old and useless, and being forced to walk with crutches, without which he could not stand upright, he died, infirm and decrepit, at the age of [sixty-five], and was buried in Ognissanti at Florence in the year [1510].

In the guardaroba of the Lord Duke Cosimo there are two very beautiful heads of women in profile by his hand, one of which is said to be the mistress of Giuliano de' Medici, brother of Lorenzo, and the other Madonna Lucrezia de' Tornabuoni, wife of the said Lorenzo. In the same place, likewise by the hand of Sandro, is a Bacchus who is raising a cask with both his hands, and putting it to his mouth—a very graceful figure. And in the Duomo of Pisa he began an Assumption, with a choir of angels, in the Chapel of the Impag-

Lucrezia Tornabuoni (d. 1482) was actually Lorenzo's mother; his wife was Clarice Orsini (d. 1488). The portraits mentioned have never been definitively identified.

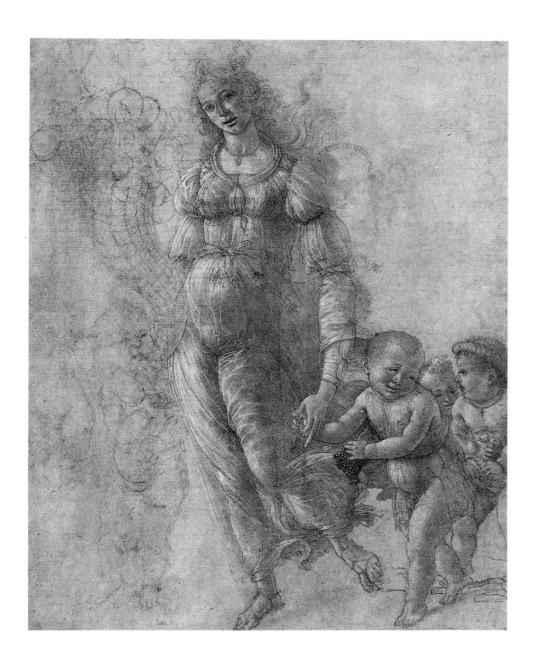

Sandro Botticelli. *Abundance*. c. 1482.
Pencil and wash, highlighted with white.
12½ × 10" (317 × 253 mm). The British
Museum, London.

liata; but afterwards, being displeased with it, he left it unfinished. In S.
Francesco at Montevarchi he painted the panel of the high-altar; and in the
Pieve of Empoli, on the same side as the S. Sebastian of Rossellino, he made
two angels. He was among the first to discover the method of decorating
standards and other sorts of hangings with the so-called inlaid work, to the
end that the colours might not fade and might show the tint of the cloth on
either side. By his hand, and made thus, is the baldacchino of Orsanmichele,
covered with beautiful and varied figures of Our Lady; which proves how
much better such a method preserves the cloth than does the use of mor-
dants, which eat it away and make its life but short, although, being less costly,
mordants are now used more than anything else.

Sandro's drawings were extraordinarily good, and so many, that for some
time after his death all the craftsmen strove to obtain some of them; and we
have some in our book, made with great mastery and judgment. His scenes
abounded with figures, as may be seen from the embroidered border of the
Cross that the Friars of S. Maria Novella carry in processions, all made from
his design. Great was the praise, then, that Sandro deserved for all the pic-
tures that he chose to make with diligence and love, as he did the aforesaid
panel of the Magi in S. Maria Novella, which is marvellous. Very beautiful,
too, is a little round picture by his hand that is seen in the apartment of the

*There is reason to suppose that the drawing
reproduced above once belonged to Vasari.*

Prior of the Angeli in Florence, in which the figures are small but very graceful and wrought with beautiful consideration. Of the same size as the aforesaid panel of the Magi, and by the same man's hand, is a picture in the possession of Messer Fabio Segni, a gentleman of Florence, in which there is painted the Calumny of Apelles, as beautiful as any picture could be. Under this panel, which Sandro himself presented to Antonio Segni, who was much his friend, there may now be read the following verses, written by the said Messer Fabio:

INCRIMINATE NO MAN ON FALSE TESTIMONY
THIS IS THE WARNING MY LITTLE PICTURE GIVES TO THE KINGS OF THE EARTH.
APELLES PRESENTED A SIMILAR PICTURE TO THE KING OF EGYPT;
THE KING WAS WORTHY OF THE GIFT, AND THE GIFT WAS WORTHY OF THE KING.

COLORPLATE 28

Botticelli's "Calumny" is based on a lost picture by the Greek painter Apelles (4th century B.C.), who supposedly painted his version after being acquitted of plotting against his royal patron.

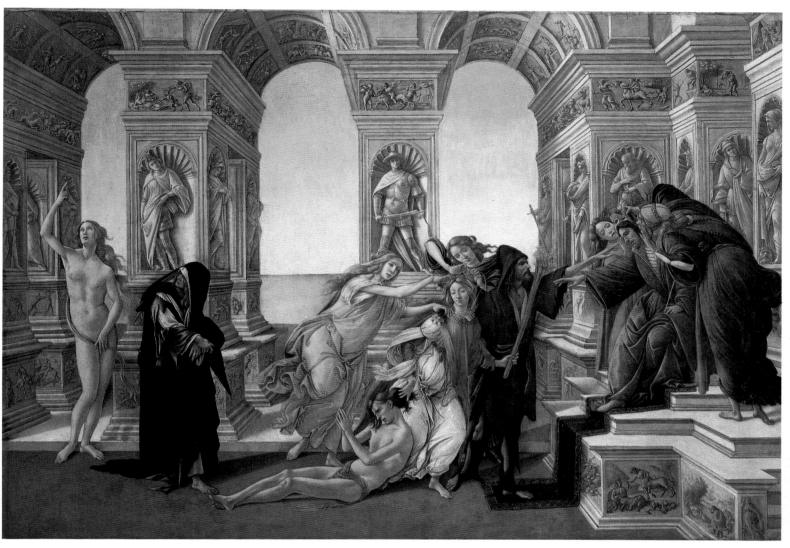

COLORPLATE 28. Sandro Botticelli. *The Calumny of Apelles.* c. 1495. Panel. 24½ × 35¾″ (62 × 91 cm).
Uffizi Gallery, Florence.

83

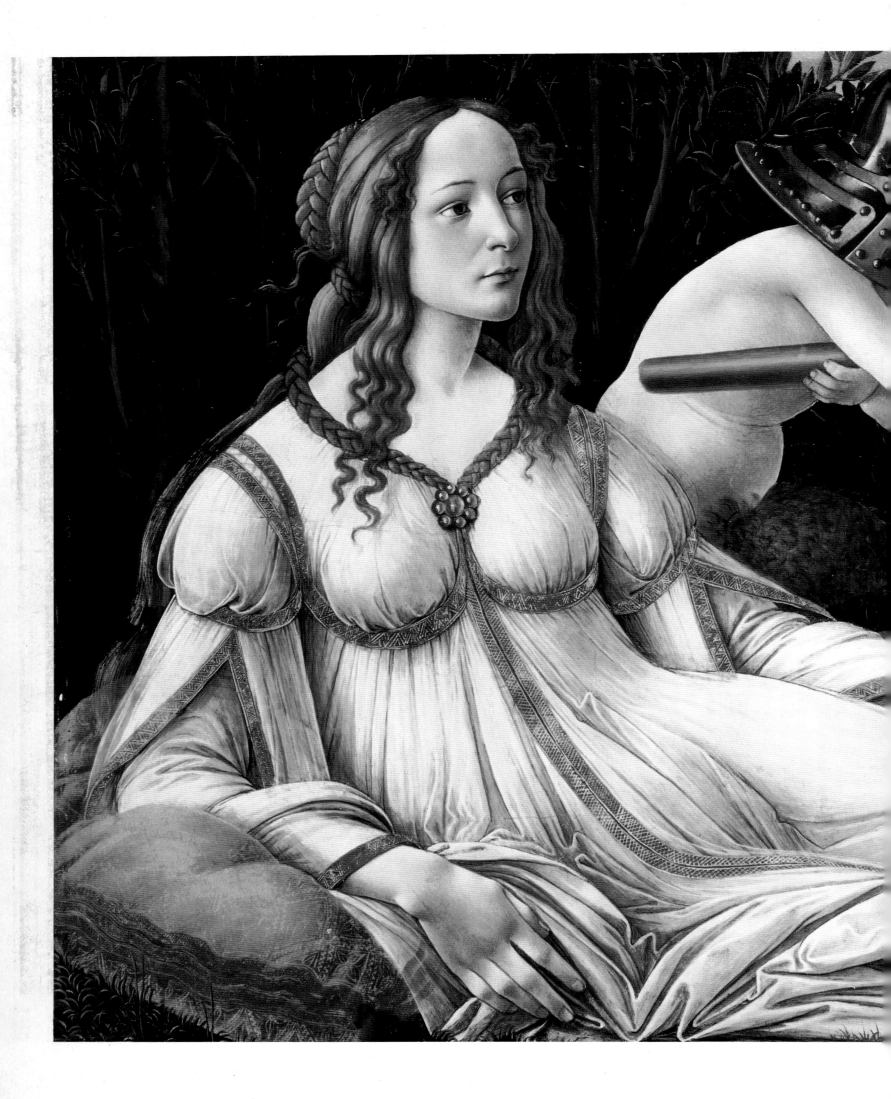

LIONARDO DA VINCI PITT.
E SCVLTOR FIOR.

THE LIFE OF
LEONARDO DA VINCI

[1452–1519]

THE FLORENTINE PAINTER
AND SCULPTOR

THE GREATEST GIFTS are often seen, in the course of nature, rained by celestial influences on human creatures; and sometimes, in supernatural fashion, beauty, grace and talent are united beyond measure in one single person, in a manner that to whatever such an one turns his attention, his every action is so divine, that, surpassing all other men, it makes itself clearly known as a thing bestowed by God (as it is), and not acquired by human art. This was seen by all mankind in Leonardo da Vinci, in whom, besides a beauty of body never sufficiently extolled, there was an infinite grace in all his actions; and so great was his genius, and such its growth, that to whatever difficulties he turned his mind, he solved them with ease. In him was great bodily strength, joined to dexterity, with a spirit and courage ever royal and magnanimous; and the fame of his name so increased, that not only in his lifetime was he held in esteem, but his reputation became even greater among posterity after his death.

Truly marvellous and celestial was Leonardo, the son of Ser Piero da Vinci; and in learning and in the rudiments of letters he would have made great proficience, if he had not been so variable and unstable, for he set himself to learn many things, and then, after having begun them, abandoned them. Thus, in arithmetic, during the few months that he studied it, he made so much progress, that, by continually suggesting doubts and difficulties to the master who was teaching him, he would often bewilder him. He gave some little attention to music, and quickly resolved to learn to play the lyre, as one who had by nature a spirit most lofty and full of refinement: wherefore he sang divinely to that instrument, improvising upon it. Nevertheless, although he occupied himself with such a variety of things, he never ceased drawing and working in relief, pursuits which suited his fancy more than any other. Ser Piero, having observed this, and having considered the loftiness of his intellect, one day took some of his drawings and carried them to Andrea del Verrocchio, who was much his friend, and besought him straitly to tell him whether Leonardo, by devoting himself to drawing, would make any proficience. Andrea was astonished to see the extraordinary beginnings of Leonardo, and urged Ser Piero that he should make him study it; wherefore he arranged with Leonardo that he should enter the workshop of Andrea, which Leonardo did with the greatest willingness in the world. And he practised not one branch of art only, but all those in which drawing played a part; and having an intellect so divine and marvellous that he was also an excellent geometrician, he not only worked in sculpture, making in his youth, in clay, some heads of women that are smiling, of which plaster casts are still taken, and likewise some heads of boys which appeared to have issued from the hand of a master; but in architecture, also, he made many drawings both of ground-plans and of other designs of buildings; and he was the first, although but a youth, who suggested the plan of reducing the river Arno to a navigable canal from Pisa to Florence. He made designs of flour-mills, fulling-mills, and engines, which might be driven by the force of water: and since he wished that his profession should be painting, he studied

Often known as the first true landscape of the Renaissance, the drawing reproduced on page 92 is inscribed, "Day of St. Mary of the Snows, August 5, 1473." It depicts the countryside near Vinci.

Andrea del Verrocchio (1435–1488), Florentine painter, goldsmith, and sculptor.

These sculptured heads have not survived.

much in drawing after nature, and sometimes in making models of figures in clay, over which he would lay soft pieces of cloth dipped in clay, and then set himself patiently to draw them on a certain kind of very fine Rheims cloth, or prepared linen: and he executed them in black and white with the point of his brush, so that it was a marvel, as some of them by his hand, which I have in our book of drawings, still bear witness; besides which, he drew on paper with such diligence and so well, that there is no one who has ever equalled him in perfection of finish; and I have one, a head drawn with the style in chiaroscuro, which is divine.

And there was infused in that brain such grace from God, and a power of expression in such sublime accord with the intellect and memory that served it, and he knew so well how to express his conceptions by draughtsmanship, that he vanquished with his discourse, and confuted with his reasoning, every valiant wit. And he was continually making models and designs to show men how to remove mountains with ease, and how to bore them in order to pass from one level to another; and by means of levers, windlasses, and screws, he showed the way to raise and draw great weights, together with methods for emptying harbours, and pumps for removing water from low places, things which his brain never ceased from devising; and of these ideas and labours many drawings may be seen, scattered abroad among our craftsmen; and I myself have seen not a few. He even went so far as to waste his time in drawing knots of cords, made according to an order, that from one end all the rest might follow till the other, so as to fill a round; and one of these is to be seen in stamp, most difficult and beautiful, and in the middle of it are these words, "Leonardus Vinci Accademia." And among these models and designs, there was one

COLORPLATE 40

"Leonardus Vinci Accademia" implies that Leonardo conducted an academy; however, no record survives to prove such an undertaking.

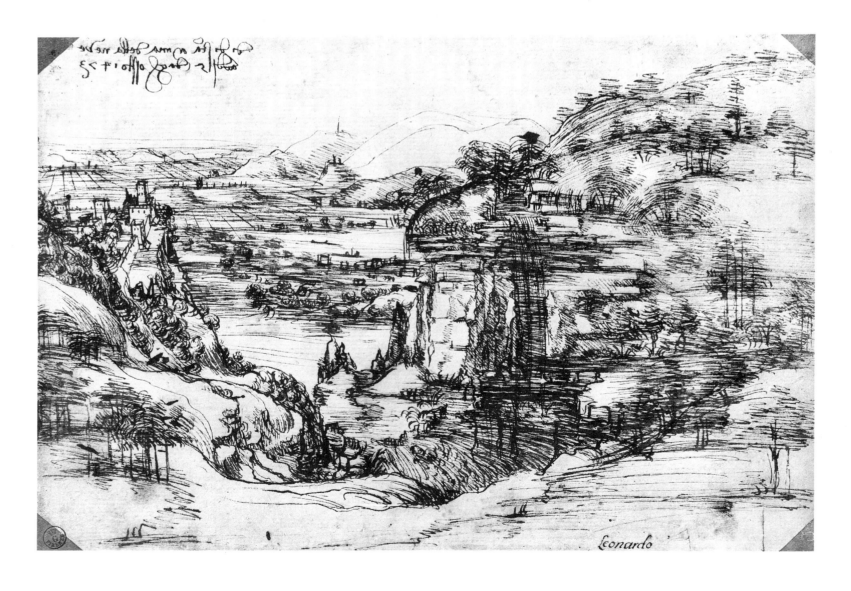

OPPOSITE:

Leonardo da Vinci. *The Arno Valley Near Vinci.* 1473. Pen and brown ink with watercolor wash. 7¾ × 11″ (196 × 280 mm). Gabinetto Disegni e Stampe, Uffizi, Florence.

Leonardo da Vinci. *Study of an Excavation Machine* (detail). Pen and ink on reddish paper. Accademia, Venice.

by which he often demonstrated to many ingenious citizens, who were then governing Florence, how he proposed to raise the Temple of S. Giovanni in Florence, and place steps under it, without damaging the building; and with such strong reasons did he urge this, that it appeared possible, although each man, after he had departed, would recognize for himself the impossibility of so vast an undertaking.

He was so pleasing in conversation, that he attracted to himself the hearts of men. And although he possessed, one might say, nothing, and worked little, he always kept servants and horses, in which latter he took much delight, and particularly in all other animals, which he managed with the greatest love and patience; and this he showed when often passing by the places where birds were sold, for, taking them with his own hand out of their cages, and having paid to those who sold them the price that was asked, he let them fly away into the air, restoring to them their lost liberty. For which reason nature was pleased so to favour him, that, wherever he turned his thought, brain, and mind, he displayed such divine power in his works, that, in giving them their perfec-

The Temple of S. Giovanni is the Florence Baptistry.

tion, no one was ever his peer in readiness, vivacity, excellence, beauty, and grace.

It is clear that Leonardo, through his comprehension of art, began many things and never finished one of them, since it seemed to him that the hand was not able to attain the perfection of art in carrying out the things which he imagined; for the reason that he conceived in idea difficulties so subtle and so marvellous, that they could never be expressed by the hands, be they ever so excellent. And so many were his caprices, that, philosophizing of natural things, he set himself to seek out the properties of herbs, going on even to observe the motions of the heavens, the path of the moon, and the courses of the sun.

He was placed, then, as has been said, in his boyhood, at the instance of Ser Piero, to learn art with Andrea del Verrocchio, who was making a panel-picture of S. John baptizing Christ, when Leonardo painted an angel who was holding some garments; and although he was but a lad, Leonardo executed it in such a manner that his angel was much better than the figures of Andrea; which was the reason that Andrea would never again touch colour, in disdain that a child should know more than he.

He was commissioned to make a cartoon for a door-hanging that was to be executed in Flanders, woven in gold and silk, to be sent to the King of Portugal, of Adam and Eve sinning in the Earthly Paradise; wherein Leonardo drew with the brush in chiaroscuro, with the lights in lead-white, a meadow of infinite kinds of herbage, with some animals, of which, in truth, it may be said that for diligence and truth to nature divine wit could not make it so perfect. In

COLORPLATE 32
Leonardo was actually about twenty at the time.

Leonardo da Vinci. *Study of Drapery* (for Uffizi *Annunciation*). 1470s. Silverpoint, pencil, and wash, highlighted with white, on linen. 10½ × 9¼" (265 × 233 mm). The Louvre, Paris.

Northern Italian (after Leonardo). *Knot.* 1499. Woodcut. The British Museum, London.

It has been suggested that the drawing reproduced on page 96 is somehow connected with a preparatory sketch for the fig tree in the now-lost Adam and Eve cartoon.

it is the fig-tree, together with the foreshortening of the leaves and the varying aspects of the branches, wrought with such lovingness that the brain reels at the mere thought how a man could have such patience. There is also a palm-tree which has the radiating crown of the palm, executed with such great and marvellous art that nothing save the patience and intellect of Leonardo could avail to do it. This work was carried no farther; wherefore the cartoon is now at Florence, in the blessed house of the Magnificent Ottaviano de' Medici, presented to him not long ago by the uncle of Leonardo.

It is said that Ser Piero da Vinci, being at his villa, was besought as a favour, by a peasant of his, who had made a buckler with his own hands out of a fig-tree that he had cut down on the farm, to have it painted for him in Florence, which he did very willingly, since the countryman was very skilful at catching birds and fishing, and Ser Piero made much use of him in these pursuits. Thereupon, having had it taken to Florence, without saying a word to Leonardo as to whose it was, he asked him to paint something upon it. Leonardo, having one day taken this buckler in his hands, and seeing it twisted, badly made, and clumsy, straightened it by the fire, and having given it to a

turner, from the rude and clumsy thing that it was, caused it to be made smooth and even. And afterwards, having given it a coat of gesso, and having prepared it in his own way, he began to think what he could paint upon it, that might be able to terrify all who should come upon it, producing the same effect as once did the head of Medusa. For this purpose, then, Leonardo carried to a room of his own into which no one entered save himself alone, lizards great and small, crickets, serpents, butterflies, grasshoppers, bats, and other strange kinds of suchlike animals, out of the number of which, variously put together, he formed a great ugly creature, most horrible and terrifying, which emitted a poisonous breath and turned the air to flame; and he made it coming out of a dark and jagged rock, belching forth venom from its open throat, fire from its eyes, and smoke from its nostrils, in so strange a fashion that it appeared altogether a monstrous and horrible thing; and so long did he labour over making it, that the stench of the dead animals in that room was past bearing, but Leonardo did not notice it, so great was the love that he bore towards art. The work

The buckler (a small shield) is lost. The drawing of a dragon shown at right, however, offers an idea of Leonardo's conception of imaginary monsters.

Cesare da Sesto (after Leonardo?). *Study of a Tree* (possibly a Fig Tree). c. 1513. Pen and ink over black chalk. 15½ × 10½" (392 × 265 mm). Royal Library, Windsor Castle.

being finished, although it was no longer asked for either by the countryman or by his father, Leonardo told the latter that he might send for the buckler at his convenience, since, for his part, it was finished. Ser Piero, having therefore gone one morning to the room for the buckler, and having knocked at the door, Leonardo opened to him, telling him to wait a little; and, having gone back into the room, he adjusted the buckler in a good light on the easel, and put to the window, in order to make a soft light, and then he bade him come in to see it. Ser Piero, at the first glance, taken by surprise, gave a sudden start, not thinking that that was the buckler, nor merely painted the form that he saw upon it, and, falling back a step, Leonardo checked him, saying, "This work serves the end for which it was made; take it, then, and carry it away, since this is the effect that it was meant to produce." This thing appeared to Ser Piero nothing short of a miracle, and he praised very greatly the ingenious idea of Leonardo; and then, having privately bought from a pedlar another buckler, painted with a heart transfixed by an arrow, he presented it to the country-man, who remained obliged to him for it as long as he lived. Afterwards, Ser Piero sold the buckler of Leonardo secretly to some merchants in Florence, for a hundred ducats; and in a short time it came into the hands of the Duke of Milan, having been sold to him by the said merchants for three hundred ducats.

Leonardo then made a picture of Our Lady, a most excellent work, which was in the possession of Pope Clement VII; and, among other things painted therein, he counterfeited a glass vase full of water, containing some flowers, in which, besides its marvellous naturalness, he had imitated the dewdrops on the flowers, so that it seemed more real than the reality. For Antonio Segni,

Leonardo da Vinci. *Study of Dragons.* c. 1480. Silverpoint. 6¼ × 9½" (159 × 243 mm). Royal Library, Windsor Castle.

At the average early 1986 gold value, a ducat would be worth about $35.00; its purchasing price in Leonardo's time was probably higher, however.

Greatly repainted and restored, and the subject of controversy since its discovery in 1886, this work (The Madonna of the Carnation, colorplate 34) is believed by some to be the one belonging to Pope Clement VII—who was Giulio de' Medici (r. 1523–34), a nephew of Lorenzo the Magnificent.

who was very much his friend, he made, on a sheet of paper, a Neptune executed with such careful draughtsmanship that it seemed absolutely alive. In it one saw the ocean troubled, and Neptune's car drawn by sea-horses, with fantastic creatures, marine monsters and winds, and some very beautiful heads of sea-gods. This drawing was presented by Fabio, the son of Antonio, to Messer Giovanni Gaddi, with this epigram:

> Both Virgil and Homer depicted Neptune
> Spurring his horses through the heaving sea.
> But the poets' depictions are verbal—mental;
> While Da Vinci's is visual, and superior to theirs.

The fancy came to him to paint a picture in oils of the head of a Medusa, with the head attired with a coil of snakes, the most strange and extravagant invention that could ever be imagined; but since it was a work that took time, it remained unfinished, as happened with almost all his things. It is among the rare works of art in the Palace of Duke Cosimo, together with the head of an angel, who is raising one arm in the air, which, coming forward, is foreshortened from the shoulder to the elbow, and with the other he raises the hand to the breast.

It is an extraordinary thing how that genius, in his desire to give the highest relief to the works that he made, went so far with dark shadows, in order to find the darkest possible grounds, that he sought for blacks which might make deeper shadows and be darker than other blacks, that by their means he might make his lights the brighter; and in the end this method turned out so dark, that, no light remaining there, his pictures had rather the character of

The presentation drawing is lost, but it is thought the Neptune *reproduced below is a study for that work.*

The works described in this paragraph are lost.

One of Leonardo's major surviving paintings (the later version of two similar altarpieces executed twenty-five years apart), The Virgin of the Rocks *(colorplate 43) provides us with a stunning example of this description.*

things made to represent an effect of night, than the clear quality of daylight; which all came from seeking to give greater relief, and to achieve the final perfection of art.

He was so delighted when he saw certain bizarre heads of men, with the beard or hair growing naturally, that he would follow one that pleased him a whole day, and so treasured him up in idea, that afterwards, on arriving home, he drew him as if he had him in his presence. Of this sort there are many heads to be seen, both of women and of men, and I have several of them, drawn by his hand with the pen, in our book of drawings, which I have mentioned so many times; such was that of Amerigo Vespucci, which is a very beautiful head of an old man drawn with charcoal, and likewise that of Scaramuccia, Captain of the Gypsies, which afterwards came into the hands of M. Donato Valdambrini of Arezzo, Canon of S. Lorenzo, left to him by Giambullari.

He began a panel-picture of the Adoration of the Magi, containing many beautiful things, particularly the heads, which was in the house of Amerigo Benci, opposite the Loggia de' Peruzzi; and this, also, remained unfinished, like his other works.

It came to pass that Giovan Galeazzo, Duke of Milan, being dead, and Lo-

COLORPLATE 43

The head of Amerigo has not been traced; the drawing reproduced below has been identified with "Scaramaccia, Captain of the Gypsies."

COLORPLATE 36

OPPOSITE:

Leonardo da Vinci. *Neptune Guiding His Seahorses.* 1503. Black chalk. 9¾ × 15½" (251 × 392 mm). Royal Library, Windsor Castle.

Leonardo da Vinci. *Grotesque Head of a Man.* Chalk. 15 × 10¾" (382 × 275 mm). Christ Church, Oxford.

dovico Sforza raised to the same rank, in the year 1494, Leonardo was summoned to Milan in great repute to the Duke, who took much delight in the sound of the lyre, to the end that he might play it; and Leonardo took with him that instrument which he had made with his own hands, in great part of silver, in the form of a horse's skull—a thing bizarre and new—in order that the harmony might be of greater volume and more sonorous in tone; with which he surpassed all the musicians who had come together there to play. Besides this, he was the best improviser in verse of his day. The Duke, hearing the marvellous discourse of Leonardo, became so enamoured of his genius, that it was something incredible; and he prevailed upon him by entreaties to paint an altar-panel containing a Nativity, which was sent by the Duke to the Emperor.

He also painted in Milan, for the Friars of S. Dominic, at S. Maria delle Grazie, a Last Supper, a most beautiful and marvellous thing; and to the heads of the Apostles he gave such majesty and beauty, that he left the head of Christ unfinished, not believing that he was able to give it that divine air which is essential to the image of Christ. This work, remaining thus all but finished, has ever been held by the Milanese in the greatest veneration, and also by strangers as well; for Leonardo imagined and succeeded in expressing that anxiety which had seized the Apostles in wishing to know who should betray their Master. For which reason in all their faces are seen love, fear, and wrath, or rather, sorrow, at not being able to understand the meaning of Christ; which thing excites no less marvel than the sight, in contrast to it, of obstinacy, hatred, and treachery in Judas; not to mention that every least part of the work displays an incredible diligence, seeing that even in the tablecloth the texture of the stuff is counterfeited in such a manner that linen itself could not seem more real.

It is said that the Prior of that place kept pressing Leonardo, in a most importunate manner, to finish the work; for it seemed strange to him to see Leonardo sometimes stand half a day at a time, lost in contemplation, and he would have liked him to go on like the labourers hoeing in his garden, without ever stopping his brush. And not content with this, he complained of it to the Duke, and that so warmly, that he was constrained to send for Leonardo and delicately urged him to work, contriving nevertheless to show him that he was doing all this because of the importunity of the Prior. Leonardo, knowing that the intellect of that Prince was acute and discerning, was pleased to discourse at large with the Duke on the subject, a thing which he had never done with the Prior: and he reasoned much with him about art, and made him understand that men of lofty genius sometimes accomplish the most when they work the least, seeking out inventions with the mind, and forming those perfect ideas which the hands afterwards express and reproduce from the images already conceived in the brain. And he added that two heads were still wanting for him to paint; that of Christ, which he did not wish to seek on earth; and he could not think that it was possible to conceive in the imagination that beauty and heavenly grace which should be the mark of God incarnate. Next, there was wanting that of Judas, which was also troubling him, not thinking himself capable of imagining features that should represent the countenance of him who, after so many benefits received, had a mind so cruel as to resolve to betray his Lord, the Creator of the world. However, he would seek out a model for the latter; but if in the end he could not find a better, he should not want that of the importunate and tactless Prior. This thing moved the Duke so wondrously to laughter, and he said that Leonardo had a thousand reasons on his side. And so the poor Prior, in confusion, confined himself to urging on the work in the garden, and left Leonardo in peace, who finished only the head of Judas, which seems the very embodiment of treachery and inhumanity; but that of Christ, as has been said, remained unfinished. The nobility of this picture, both because of its design, and from its having been wrought with an incomparable diligence, awoke a desire in the King of France [Francis I] to

Leonardo actually went to Milan in 1482. Lodovico Sforza (1451–1508) was by then the ruler of Milan, although the nominal duke was his nephew Gian Galeozzo (who was rumored to have been poisoned by his uncle, who then assumed the dukedom).

This Nativity is lost.

COLORPLATE 42

COLORPLATE 39

COLORPLATE 38

A painstaking restoration of The Last Supper *was commenced in the late 1970s. Employing the latest scientific resources and technical methods, the work advances daily, millimeter by millimeter. It has been projected that the task will be completed sometime after 1990.*

According to discoveries made in 1985 during the restoration, it seems the head of Christ was not left unfinished. However, the work had already deteriorated so badly by Vasari's time, that white patches (either mold or mineral salts) had obscured certain portions.

Francis I (1494–1547), king of France from 1515. He was the finest intellect of any of France's rulers and a great patron of the arts.

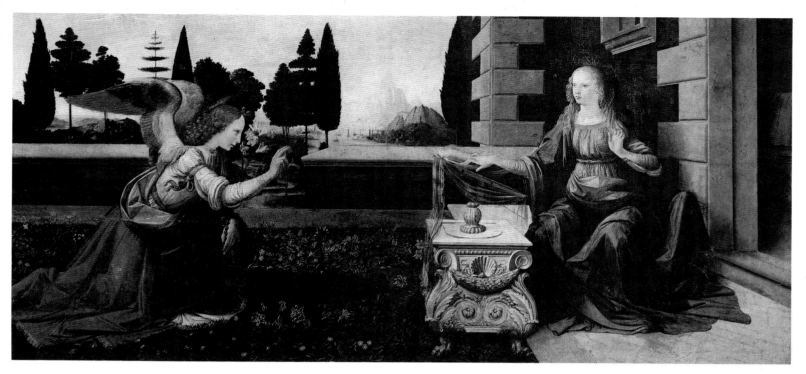

COLORPLATE 31. Leonardo da Vinci. *The Annunciation*. c. 1459. Panel. 5½ × 23½" (14 × 59 cm).
The Louvre, Paris.

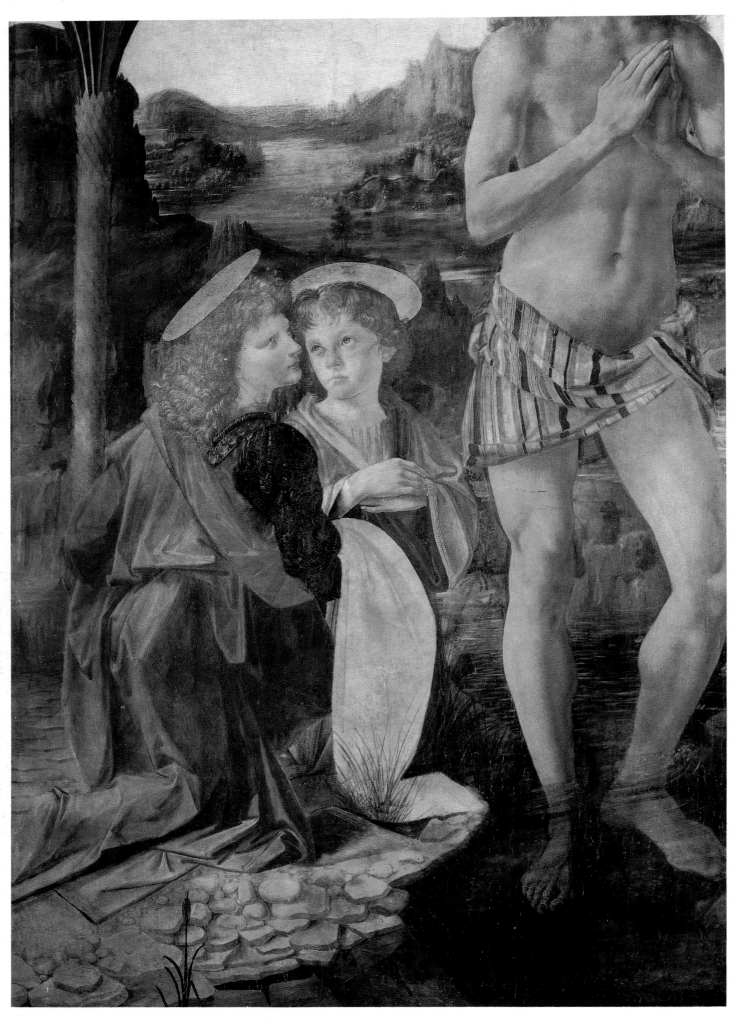

COLORPLATE 32. Leonardo da Vinci. *Head of an Angel* (from Verrocchio's *Baptism of Christ*). c. 1470. Panel.
Uffizi Gallery, Florence.

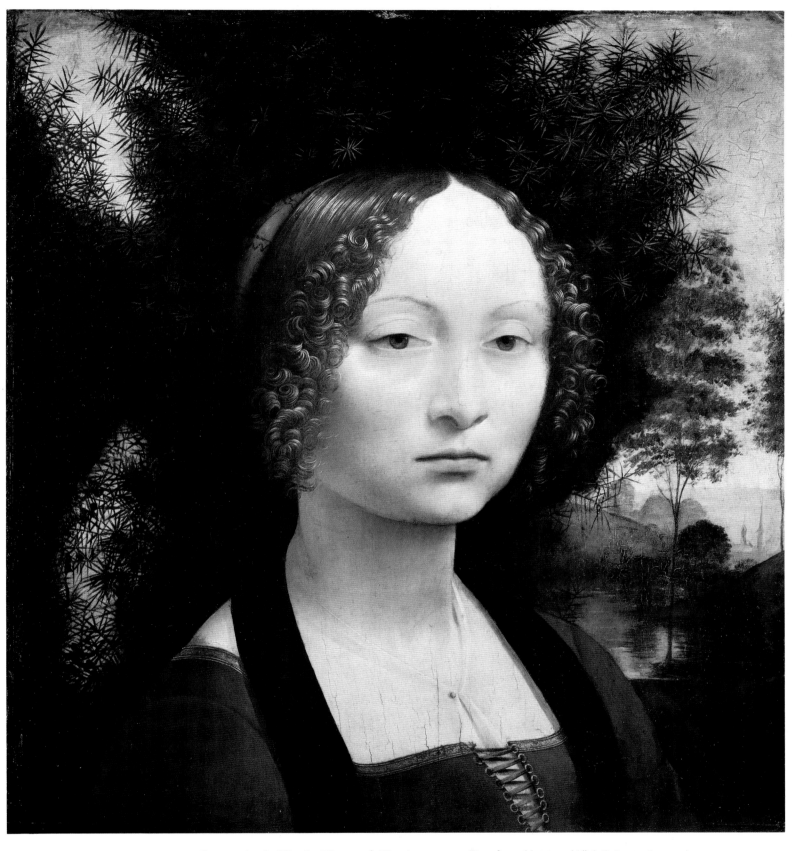

COLORPLATE 33. Leonardo da Vinci. *Ginevra de'Benci*. c. 1474. Panel. 15½ × 14½″ (38.8 × 36.7 cm).
National Gallery of Art, Washington, Ailsa Mellon Bruce Fund.

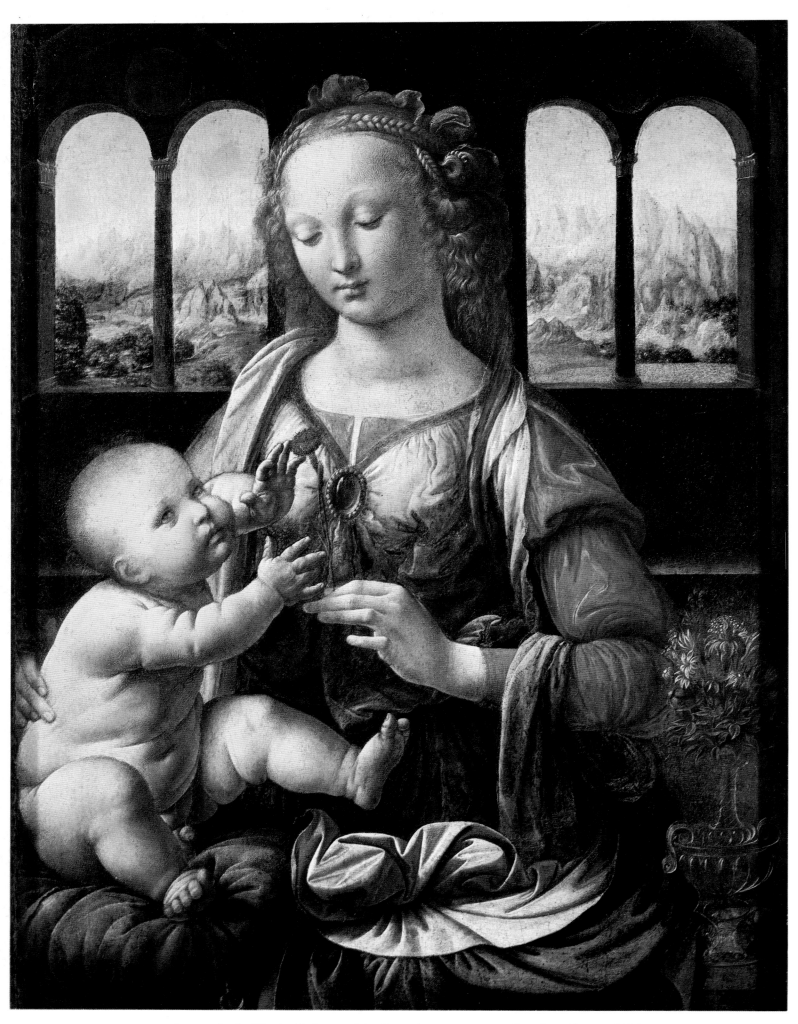

COLORPLATE 34. Leonardo da Vinci. *Madonna of the Carnation*. c. 1478–80. Panel. 24½ × 18½" (62 × 47 cm).
Alte Pinacothek, Munich.

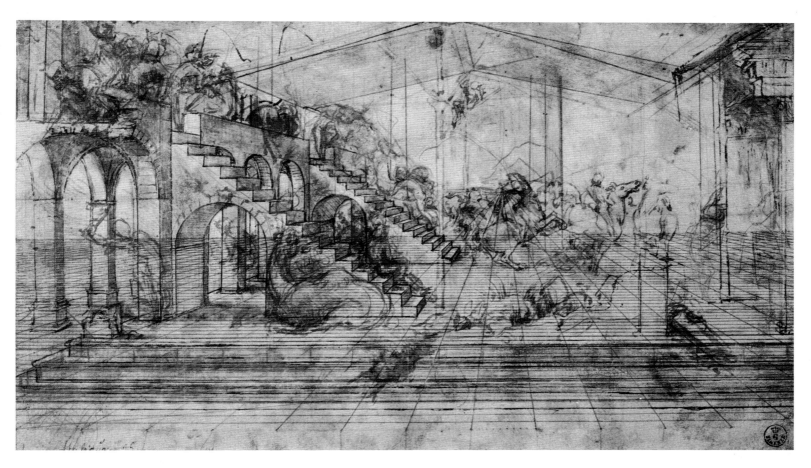

COLORPLATE 35. Leonardo da Vinci. *Architectural Study for the Adoration of the Magi*. c. 1481. Pen and ink wash, heightened with white. 6½ × 11½″ (165 × 292 mm). Gabinetto Disegni e Stampe, Uffizi, Florence.

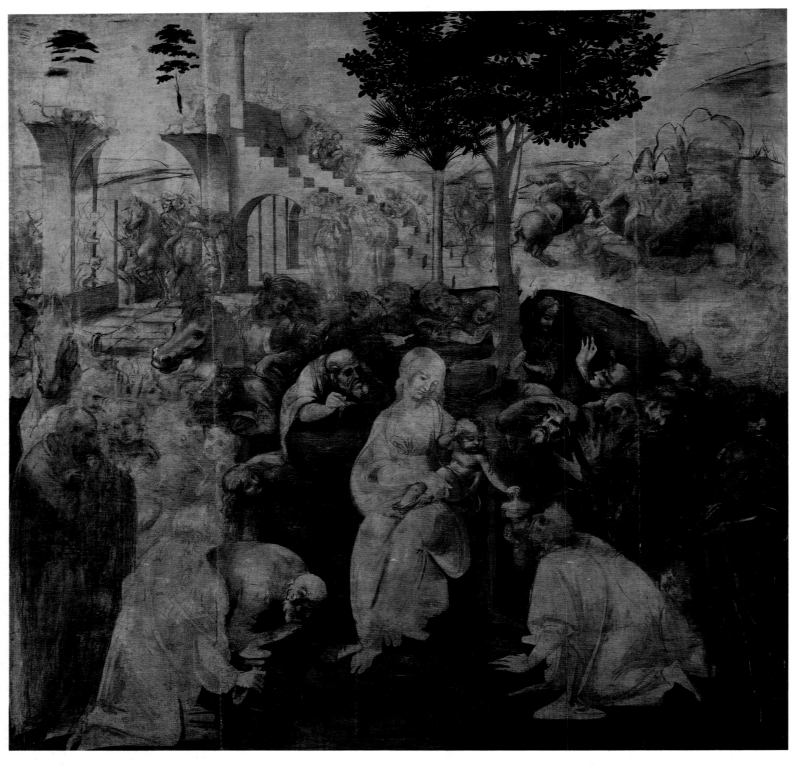

COLORPLATE 36. Leonardo da Vinci. *The Adoration of the Magi*. 1481–82. Panel. 97¼ × 96″ (246 × 243 cm).
Uffizi Gallery, Florence.

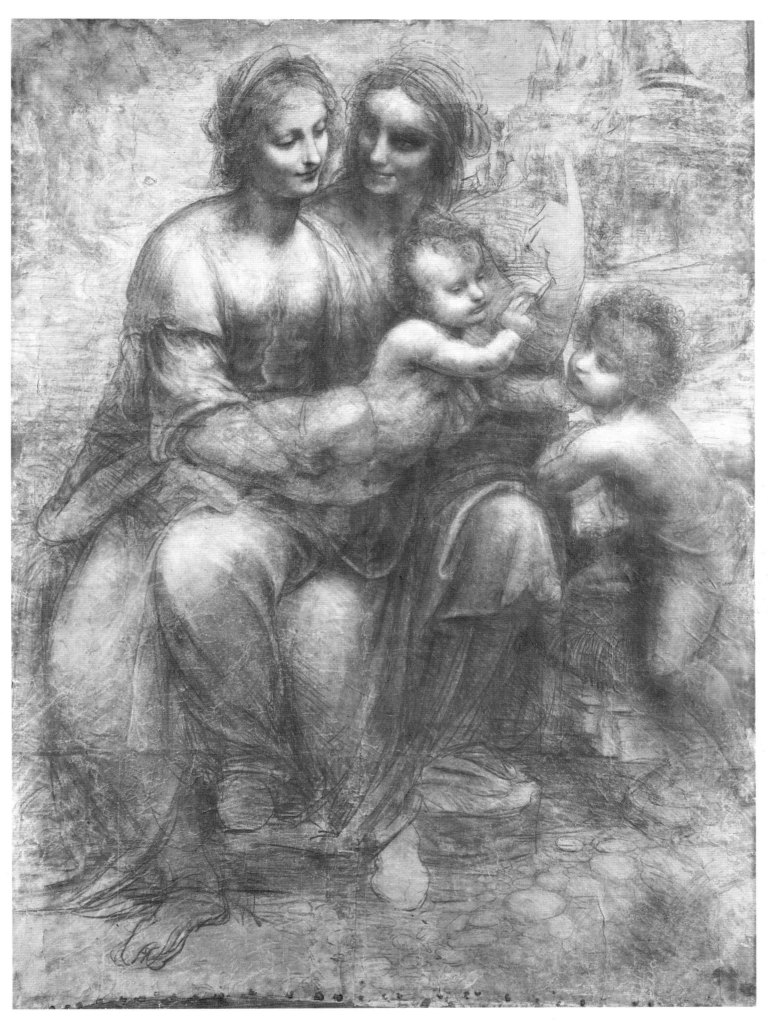

COLORPLATE 37. Leonardo da Vinci. *The Virgin and Child with St. Anne and St. John the Baptist* (Burlington House Cartoon). c. 1495. Black chalk, heightened with white. 55¾ × 41″ (141.5 × 104.6 cm). The National Gallery, London.

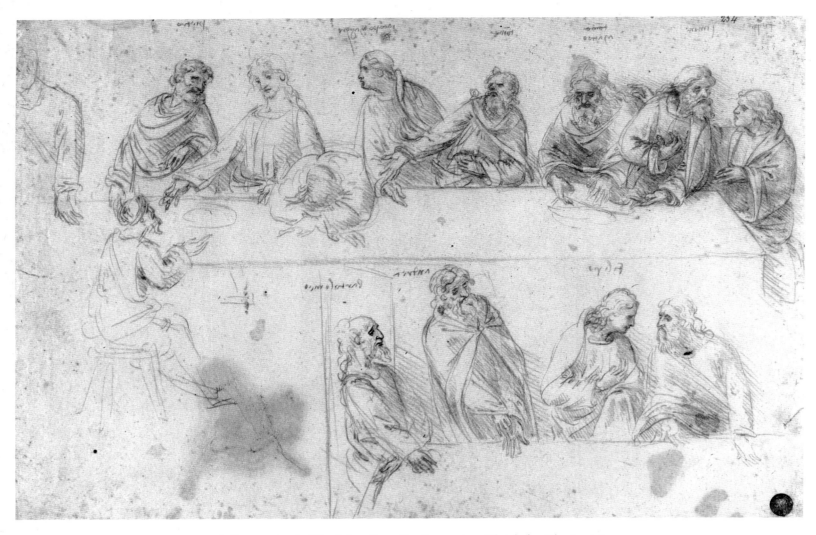

COLORPLATE 38. Leonardo da Vinci (attributed). *Preparatory Sketch for The Last Supper*. c. 1495.
Red Chalk. 10¼ × 15½″ (260 × 394 mm). Accademia, Venice.

transport it into his kingdom; wherefore he tried by all possible means to discover whether there were architects who, with cross-stays of wood and iron, might have been able to make it so secure that it might be transported safely; without considering any expense that might have been involved thereby, so much did he desire it. But the fact of its being painted on the wall robbed his Majesty of his desire; and the picture remained with the Milanese. In the same refectory, while he was working at the Last Supper, on the end wall where is a Passion in the old manner, Leonardo portrayed the said Lodovico, with Massimiliano, his eldest son; and, on the other side, the Duchess Beatrice, with Francesco, their other son, both of whom afterwards became Dukes of Milan; and all are portrayed divinely well.

While he was engaged on this work, he proposed to the Duke to make a horse in bronze, of a marvellous greatness, in order to place upon it, as a memorial, the image of the Duke. And on so vast a scale did he begin it and continue it, that it could never be completed. And there are those who have been of the opinion (so various and so often malign out of envy are the judgments of men) that he began it with no intention of finishing it, because, being of so great a size, an incredible difficulty was encountered in seeking to cast it in one piece; and it might also be believed that, from the result, many may have formed such a judgment, since many of his works have remained unfinished. But, in truth, one can believe that his vast and most excellent mind was hampered through being too full of desire, and that his wish ever to seek out excellence upon excellence, and perfection upon perfection, was the reason of it. "The work was retarded by desire," as our Petrarch has said. And, indeed, those who saw the great model that Leonardo made in clay vow that they have never seen a more beautiful thing, or a more superb; and it was preserved until the French came to Milan with King Louis of France, and broke it all to pieces. Lost, also, is a little model of it in wax, which was held to be perfect, together with a book on the anatomy of the horse made by him by way of study.

He then applied himself, but with greater care, to the anatomy of man, assisted by and in turn assisting, in this research, Messer Marc' Antonio della

The portraits (painted onto the existing fresco by the late fifteenth-century Milanese Giovanni Montorfano) are not generally believed to be Leonardo's work.

Louis XII (1462–1515), king of France from 1498.

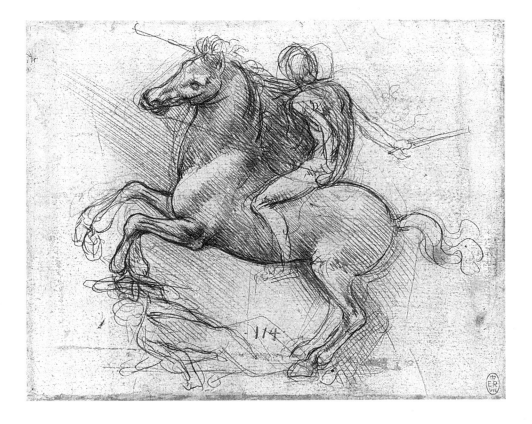

Leonardo da Vinci. *Horseman Trampling a Fallen Foe* (presumed study for *the Sforza Monument*). c. 1485. Silverpoint on paper coated with a bluish ground. 5¾ × 7¼" (148 × 185 mm). Royal Library, Windsor Castle.

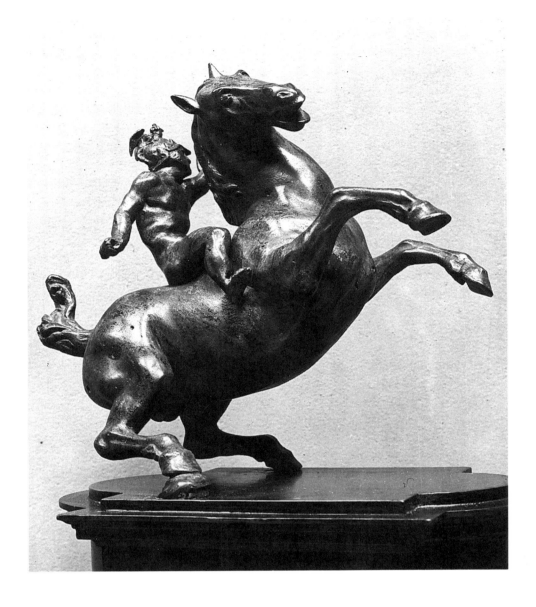

Studio of Leonardo da Vinci. *Mounted Warrior.* c. 1485–90. Bronze. Height: 9½″ (24 cm). Museum of Fine Arts, Budapest.

Torre, an excellent philosopher, who was then lecturing at Pavia, and who wrote of this matter; and he was one of the first (as I have heard tell) that began to illustrate the problems of medicine with the doctrine of Galen, and to throw true light on anatomy, which up to that time had been wrapped in the thick and gross darkness of ignorance. And in this he found marvellous aid in the brain, work, and hand of Leonardo, who made a book drawn in red chalk, and annotated with the pen, of the bodies that he dissected with his own hand, and drew with the greatest diligence; wherein he showed all the frame of the bones; and then added to them, in order, all the nerves, and covered them with muscles; the first attached to the bone, the second that hold the body firm, and the third that move it; and beside them, part by part, he wrote in letters of an ill-shaped character, which he made with the left hand, backwards; and whoever is not practised in reading them cannot understand them, since they are not to be read save with a mirror. Of these papers on the anatomy of man, a great part is in the hands of Messer Francesco da Melzo, a gentleman of Milan, who in the time of Leonardo was a very beautiful boy, and much beloved by him, and now is a no less beautiful and gentle old man; and he holds them dear, and keeps such papers together as if they were relics, in company with the portrait of Leonardo of happy memory; and to all who read these writings, it seems impossible that that divine spirit should have discoursed so well of art, and of the muscles, nerves, and veins, and with such diligence of everything. So, also, there are in the hands of—[*the name is missing*], a painter of Milan, certain writ-

Galen, Greek physician of the second century. For more than a thousand years, his writings were held as the chief medical authority.

Francesco Melzi (1493–c. 1570), Milanese painter and Leonardo's last pupil. After Melzi's death, the collection was dispersed. Many manuscripts are probably lost forever, but major examples have turned up in our own time (in 1967, for example, two volumes were rediscovered in the former Royal Library in Madrid).

The missing name is probably that of Melzi, and the work mentioned is Leonardo's celebrated Treatise on Painting, *which was not printed until 1651.*

ings of Leonardo, likewise in characters written with the left hand, backwards, which treat of painting, and of the methods of drawing and colouring. This man, not long ago, came to Florence to see me, wishing to print this work, and he took it to Rome, in order to put it into effect; but I do not know what may afterwards have become of it.

And to return to the works of Leonardo; there came to Milan, in his time, the King of France, wherefore Leonardo being asked to devise some bizarre thing, made a lion which walked several steps and then opened its breast, and showed it full of lilies.

In Milan he took for his assistant the Milanese Salai, who was most comely in grace and beauty, having fine locks, curling in ringlets, in which Leonardo greatly delighted; and he taught him many things of art; and certain works in Milan, which are said to be by Salai, were retouched by Leonardo.

He returned to Florence, where he found that the Servite Friars had entrusted to Filippino the painting of the panel for the high-altar of the Nunziata;

Salai ("salacious imp") was Leonardo's nickname for Jacopo dei Caprotti (1480–1524), who remained with the master for twenty-five years.

"Filippino" is Filippino Lippi.

Leonardo da Vinci. *Skull in Cross-section.* c. 1489. Pen and ink with traces of black chalk. 7½ × 5¼″ (190 × 134 mm). Royal Library, Windsor Castle.

whereupon Leonardo said that he would willingly have done such a work. Filippino, having heard this, like the amiable fellow that he was, retired from the undertaking; and the friars, to the end that Leonardo might paint it, took him into their house, meeting the expenses both of himself and of all his household; and thus he kept them in expectation for a long time, but never began anything. In the end, he made a cartoon containing a Madonna and a S. Anne, with a Christ, which not only caused all the craftsmen to marvel, but, when it was finished, men and women, young and old, continued for two days to flock for a sight of it to the room where it was, as if to a solemn festival, in order to gaze at the marvels of Leonardo, which caused all those people to be amazed; for in the face of that Madonna was seen whatever of the simple and the beautiful can by simplicity and beauty confer grace on a picture of the Mother of Christ, since he wished to show that modesty and that humility which are looked for in an image of the Virgin, supremely content with gladness at seeing

COLORPLATE 37

Leonardo da Vinci. *Dissection of the Principal Organs and the Arterial System of a Woman.* c. 1500. Pen and ink wash over black chalk on colored ground. 18¾ × 13″ (478 × 333 mm). Royal Library, Windsor Castle.

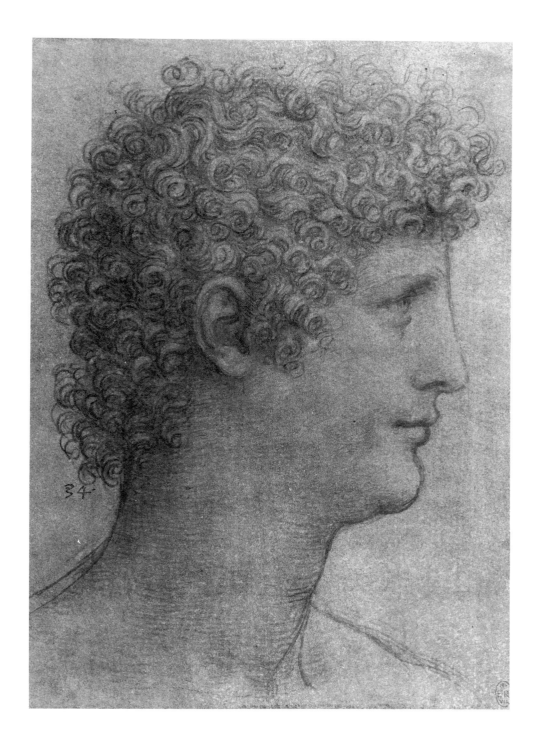

Leonardo da Vinci. *Profile of a Youth
(Salai?).* c. 1510. Red chalk on red prepared
paper. 8¼ × 6″ (217 × 153 mm). Royal
Library, Windsor Castle.

the beauty of her Son, whom she was holding with tenderness in her lap, while
with most chastened gaze she was looking down at S. John, as a little boy, who
was playing with a lamb; not without a smile from S. Anne, who, overflow-
ing with joy, was beholding her earthly progeny become divine—ideas truly
worthy of the brain and genius of Leonardo. This cartoon, as will be told be-
low, afterwards went to France. He made a portrait of Ginevra d'Amerigo
Benci, a very beautiful work; and abandoned the work for the friars, who re-
stored it to Filippino; but he, also, failed to finish it, having been overtaken by
death.

COLORPLATE 33

Leonardo undertook to execute, for Francesco del Giocondo, the portrait
of Monna Lisa, his wife; and after toiling over it for four years, he left it unfin-
ished; and the work is now in the collection of King Francis of France, at Fon-
tainebleau. In this head, whoever wished to see how closely art could imitate
nature, was able to comprehend it with ease; for in it were counterfeited all the
minutenesses that with subtlety are able to be painted, seeing that the eyes had
that lustre and watery sheen which are always seen in life, and around them

COLORPLATE 41

were all those rosy and pearly tints, as well as the lashes, which cannot be represented without the greatest subtlety. The eyebrows, through his having shown the manner in which the hairs spring from the flesh, here more close and here more scanty, and curve according to the pores of the skin, could not be more natural. The nose, with its beautiful nostrils, rosy and tender, appeared to be alive. The mouth, with its opening, and with its ends united by the red of the lips to the flesh-tints of the face, seemed, in truth, to be not colours but flesh. In the pit of the throat, if one gazed upon it intently, could be seen the beating of the pulse. And, indeed, it may be said that it was painted in such a manner as to make every valiant craftsman, be he who he may, tremble and lose heart. He made use, also, of this device: Monna Lisa being very beautiful, he always employed, while he was painting her portrait, persons to play or sing, and jesters, who might make her remain merry, in order to take away that melancholy which painters are often wont to give to the portraits that they paint. And in this work of Leonardo's there was a smile so pleasing, that it was a thing more divine than human to behold; and it was held to be something marvellous, since the reality was not more alive.

By reason, then, of the excellence of the works of this most divine craftsman, his fame had so increased that all persons who took delight in art—nay, the whole city of Florence—desired that he should leave them some memorial, and it was being proposed everywhere that he should be commissioned to execute some great and notable work, whereby the commonwealth might be honoured and adorned by the great genius, grace and judgment that were seen in the works of Leonardo. And it was decided between the Gonfalonier and the chief citizens, the Great Council Chamber having been newly built—the architecture of which had been contrived with the judgment and counsel of Giuliano da San Gallo, Simone Pollaiuoli, called Il Cronaca, Michelagnolo Buonarroti, and Baccio D'Agnolo, as will be related with more detail in the proper places—and having been finished in great haste, it was ordained by public decree that Leonardo should be given some beautiful work to paint; and so the said hall was allotted to him by Piero Soderini, then Gonfalonier of Justice. Whereupon Leonardo, determining to execute this work, began a cartoon in the Sala del Papa, an apartment in S. Maria Novella, representing the story of Niccolò Piccinino, Captain of Duke Filippo of Milan; wherein he designed a group of horsemen who were fighting for a standard, a work that was held to be very excellent and of great mastery, by reason of the marvellous ideas that he had in composing that battle; seeing that in it rage, fury, and revenge are perceived as much in the men as in the horses, among which two with the forelegs interlocked are fighting no less fiercely with their teeth than those who are riding them do in fighting for that standard, which has been grasped by a soldier, who seeks by the strength of his shoulders, as he spurs his horse to flight, having turned his body backwards and seized the staff of the standard, to wrest it by force from the hands of four others, of whom two are defending it, each with one hand, and, raising their swords in the other, are trying to sever the staff; while an old soldier in a red cap, crying out, grips the staff with one hand, and, raising a scimitar with the other, furiously aims a blow in order to cut off both the hands of those who, gnashing their teeth in the struggle, are striving in attitudes of the utmost fierceness to defend their banner; besides which, on the ground, between the legs of the horses, there are two figures in foreshortening that are fighting together, and the one on the ground has over him a soldier who has raised his arm as high as possible, that thus with greater force he may plunge a dagger into his throat, in order to end his life; while the other, struggling with his legs and arms, is doing what he can to escape death.

It is not possible to describe the invention that Leonardo showed in the garments of the soldiers, all varied by him in different ways, and likewise in the helmet-crests and other ornaments; not to mention the incredible mastery that

Giuliano da Sangallo (c. 1445–1516), Il Cronaca (Simone del Pollaiuolo: 1457–1508), and Baccio d'Agnolo (1462–1543) were all Florentine architects.

COLORPLATE 45

he displayed in the forms and lineaments of the horses, which Leonardo, with their fiery spirit, muscles, and shapely beauty, drew better than any other master. It is said that, in order to draw that cartoon, he made a most ingenious stage, which was raised by contracting it and lowered by expanding. And conceiving the wish to colour on the wall in oils, he made a composition of so gross an admixture, to act as a binder on the wall, that, going on to paint in the said hall, it began to peel off in such a manner that in a short time he abandoned it, seeing it spoiling.

Leonardo had very great spirit, and in his every action was most generous. It is said that, going to the bank for the allowance that he used to draw every month from Piero Soderini, the cashier wanted to give him certain paper-packets of pence; but he would not take them, saying in answer, "I am no penny-painter." Having been blamed for cheating Piero Soderini, there began to be murmurings against him; wherefore Leonardo so wrought upon his friends, that he got the money together and took it to Piero to repay him; but he would not accept it.

He went to Rome with Duke Giuliano de' Medici, at the election of Pope Leo, who spent much of his time on philosophical studies, and particularly on alchemy; where, forming a paste of a certain kind of wax, as he walked he shaped animals very thin and full of wind, and, by blowing into them, made them fly through the air, but when the wind ceased they fell to the ground. On the back of a most bizarre lizard, found by the vine-dresser of the Belvedere,

The ruined fresco was eventually concealed by a large mural by Vasari. Leonardo's cartoon was lost, and the Battle *survives only in a few preparatory sketches or through other artists' copies of the central portion (colorplate 45).*

Leo X (r. 1513–21) was born Giovanni de' Medici, the son of Lorenzo the Magnificent. Pope Leo's portrait by Raphael is reproduced in colorplate 76.

Leonardo da Vinci. *Head of a Young Warrior* (study for *The Battle of Anghiari*). c. 1504. Red chalk. 8½ × 7¼" (210 × 183 mm). Museum of Fine Arts, Budapest.

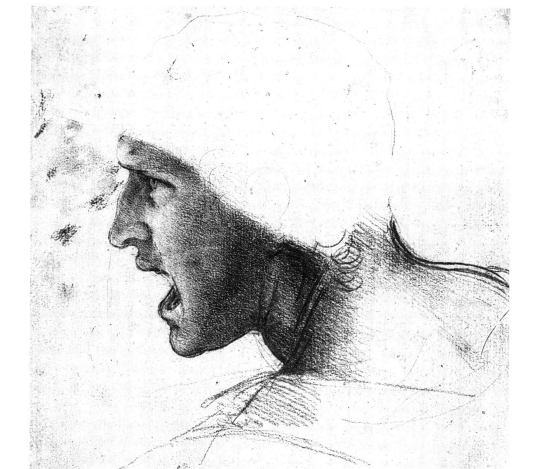

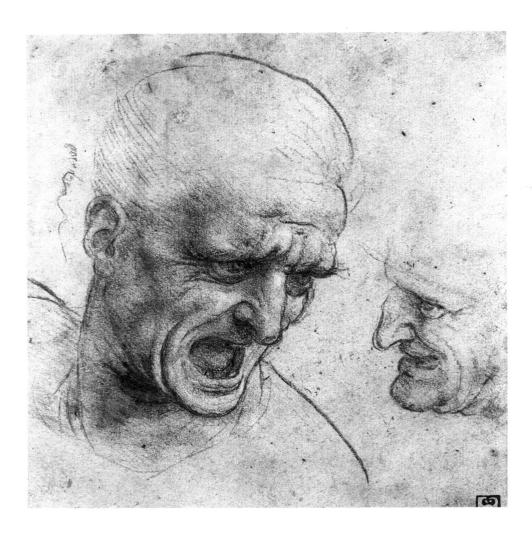

Leonardo da Vinci. *Heads of Warriors*
(study for *The Battle of Anghiari*). c. 1504.
Black chalk. 7½ × 7¼" (191 × 184 mm).
Museum of Fine Arts, Budapest.

he fixed, with a mixture of quicksilver, wings composed of scales stripped from
other lizards, which, as it walked, quivered with the motion; and having
given it eyes, horns, and beard, taming it, and keeping it in a box, he made all
his friends, to whom he showed it, fly for fear. He used often to have the guts
of a wether completely freed of their fat and cleaned, and thus made so fine that
they could have been held in the palm of the hand; and having placed a pair of
blacksmith's bellows in another room, he fixed to them one end of these, and,
blowing into them, filled the room, which was very large, so that whoever was
in it was obliged to retreat into a corner; showing how, transparent and full of
wind, from taking up little space at the beginning they had come to occupy
much, and likening them to virtue. He made an infinite number of such fol-
lies, and gave his attention to mirrors; and he tried the strangest methods in
seeking out oils for painting, and varnish for preserving works when painted.

A "wether" is a ram.

He made at this time, for Messer Baldassarre Turini da Pescia, who was
Datary to Pope Leo, a little picture of the Madonna with the Child in her arms,
with infinite diligence and art; but whether through the fault of whoever
primed the panel with gesso, or because of his innumerable and capricious
mixtures of grounds and colours, it is now much spoilt. And in another small
picture he made a portrait of a little boy, which is beautiful and graceful to a
marvel; and both of them are now at Pescia, in the hands of Messer Giuliano
Turini. It is related that, a work having been allotted to him by the Pope, he
straightway began to distil oils and herbs, in order to make the varnish; at
which Pope Leo said: "Alas! this man will never do anything, for he begins by
thinking of the end of the work, before the beginning."

There was very great disdain between Michelagnolo Buonarroti and him,
on account of which Michelagnolo departed from Florence, with the excuse of
Duke Giuliano having been summoned by the Pope to the competition for the

OPPOSITE:

Giovanni Francesco Rustici (after design
by, or with collaboration of, Leonardo da
Vinci). *St. John the Baptist Preaching*.
c. 1506–11. Bronze. Height: 104" (265 cm).
North facade, Baptistry, Florence.

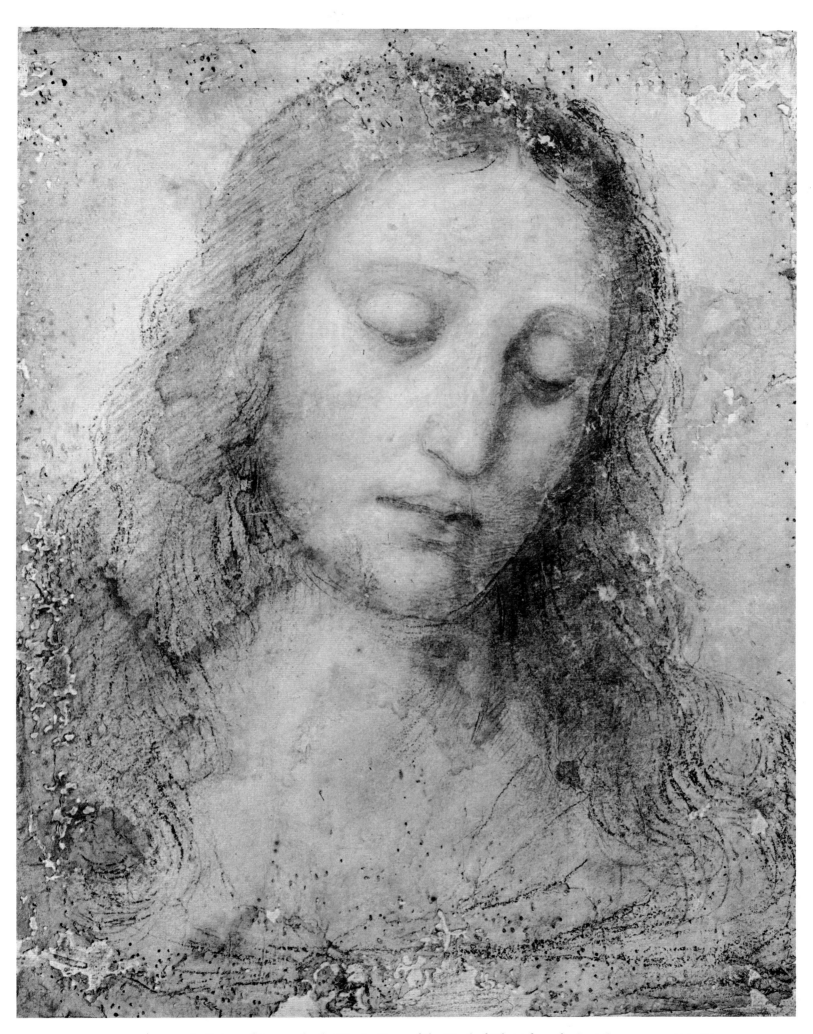

COLORPLATE 39. Imitator of Leonardo da Vinci. *Copy of the Head of Christ from the Last Supper.* c. 1495–97.
Pen and wash. 15¾ × 12½″ (400 × 320 mm). Brera Gallery, Milan.

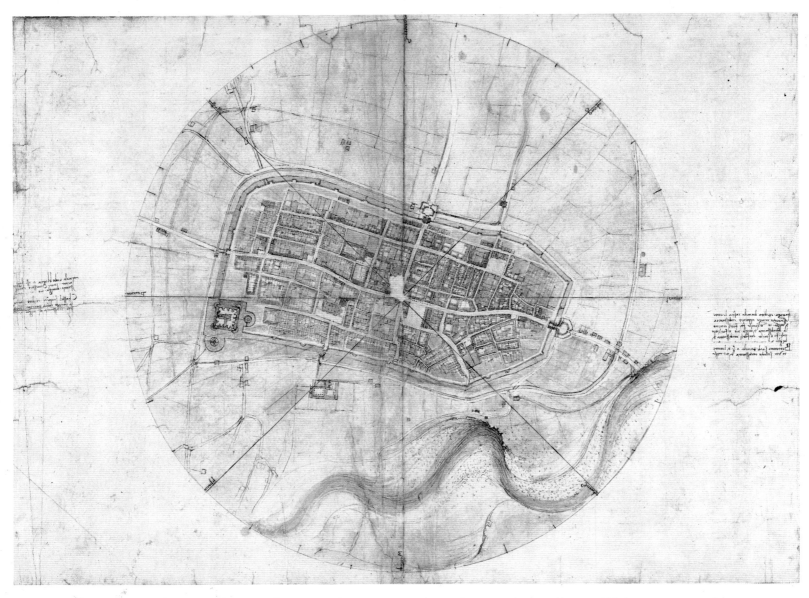

COLORPLATE 40. Leonardo da Vinci. *Plan of Imola*. 1502. Pen and watercolor. 17½ × 23¾″ (440 × 602 mm).
Royal Library, Windsor Castle.

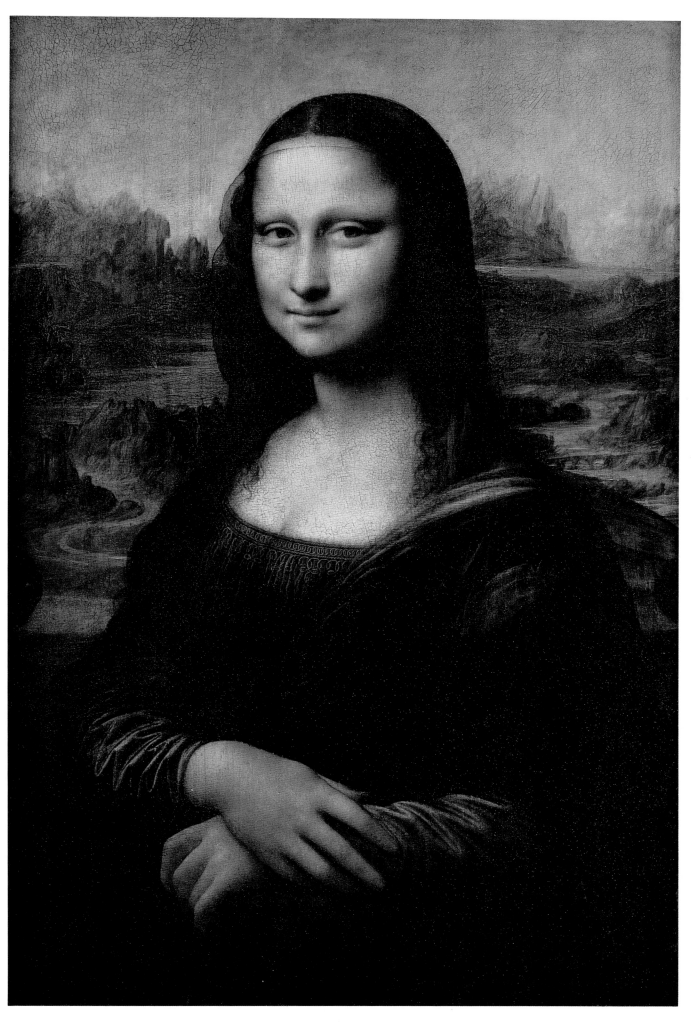

COLORPLATE 41. Leonardo da Vinci. *Mona Lisa*. 1503. Panel. 30⅜ × 20⅞″ (77 × 53 cm).
The Louvre, Paris.

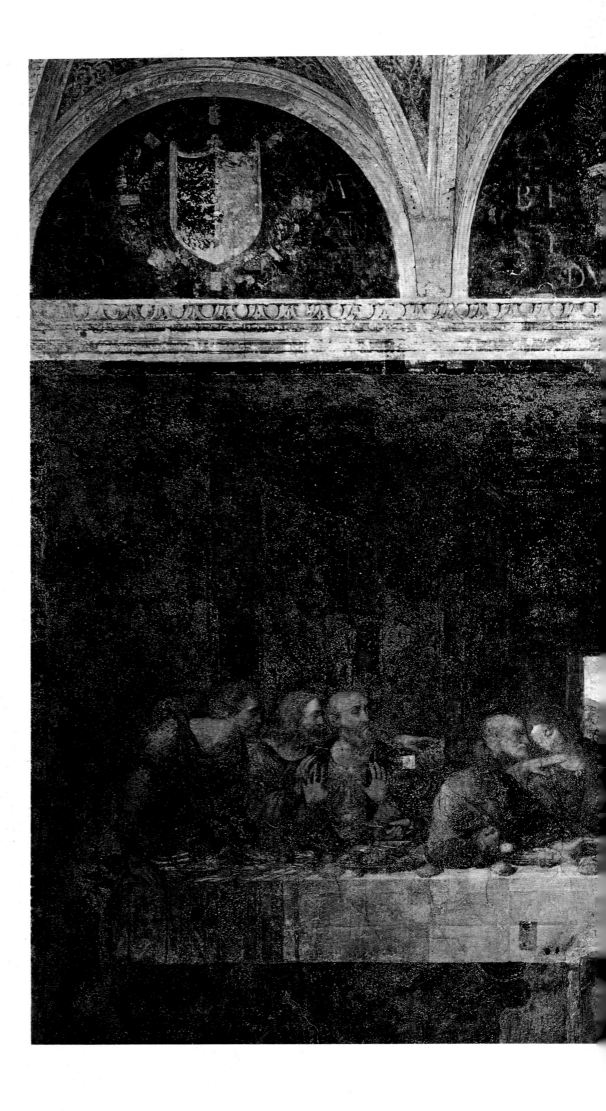

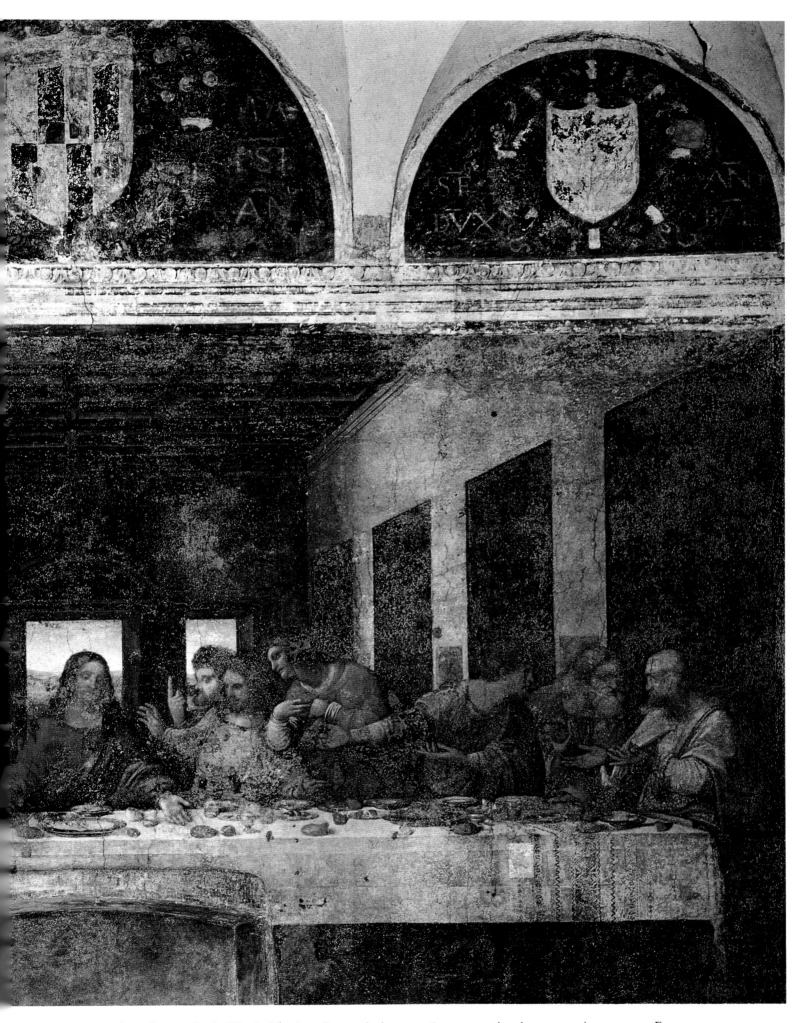

COLORPLATE 42. Leonardo da Vinci. *The Last Supper* (prior to 1980s restoration in progress). 1495–97. Fresco. Refectory, Church of Santa Maria della Grazie, Milan.

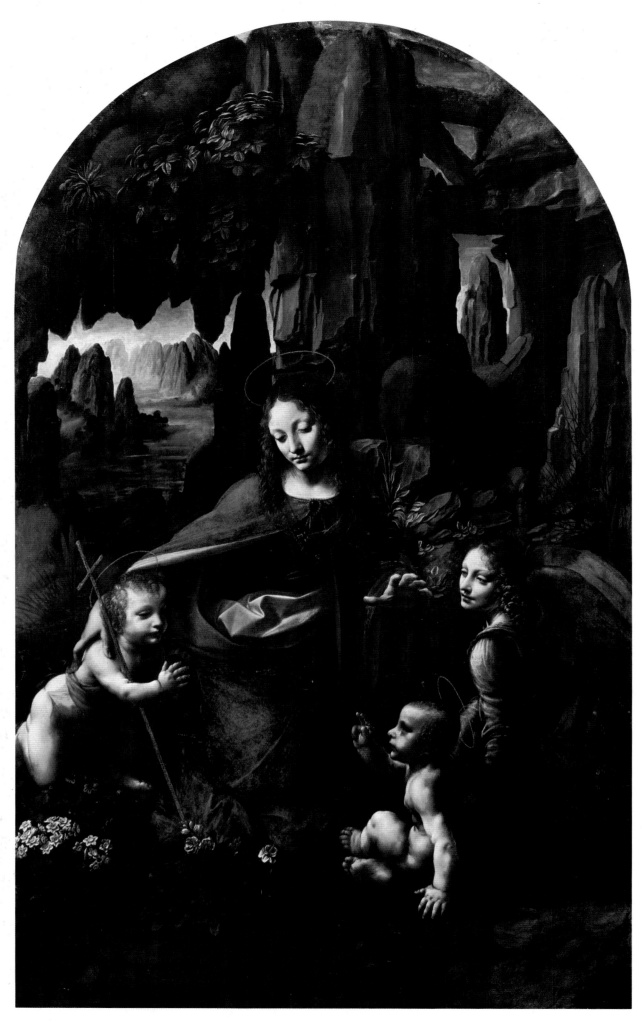

COLORPLATE 43. Leonardo da Vinci. *The Virgin of the Rocks*. 1503–06. Panel. 74⅝ × 47¼″ (189.5 × 120.0 cm). The National Gallery, London.

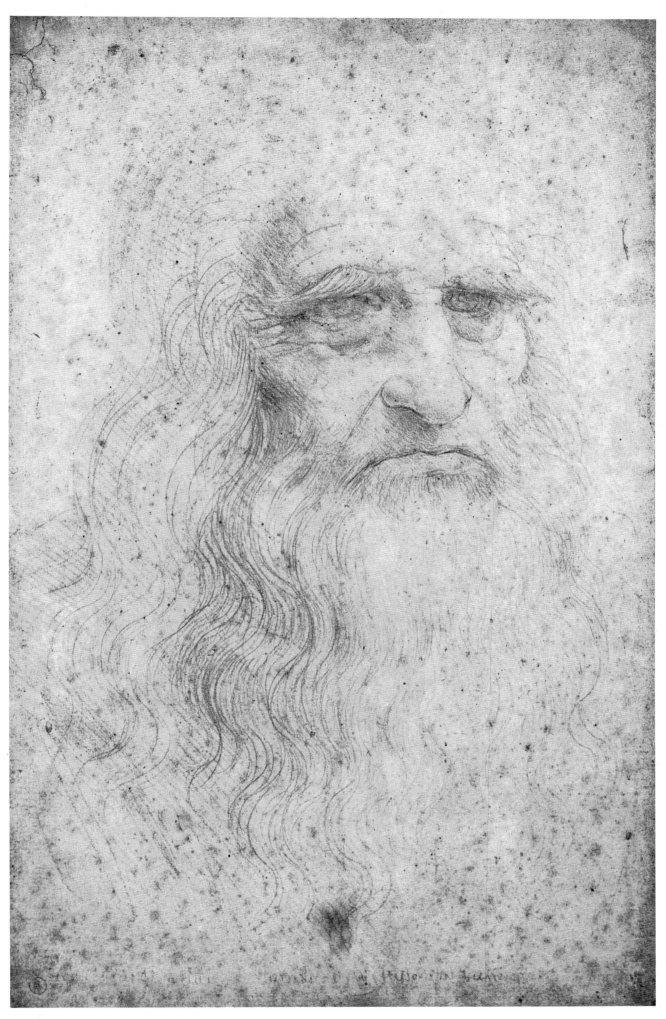

COLORPLATE 44. Leonardo da Vinci. *Self-Portrait in Old Age*. c. 1512. Red Chalk.
13¼ × 8½" (335 × 214 mm). Biblioteca Reale, Turin.

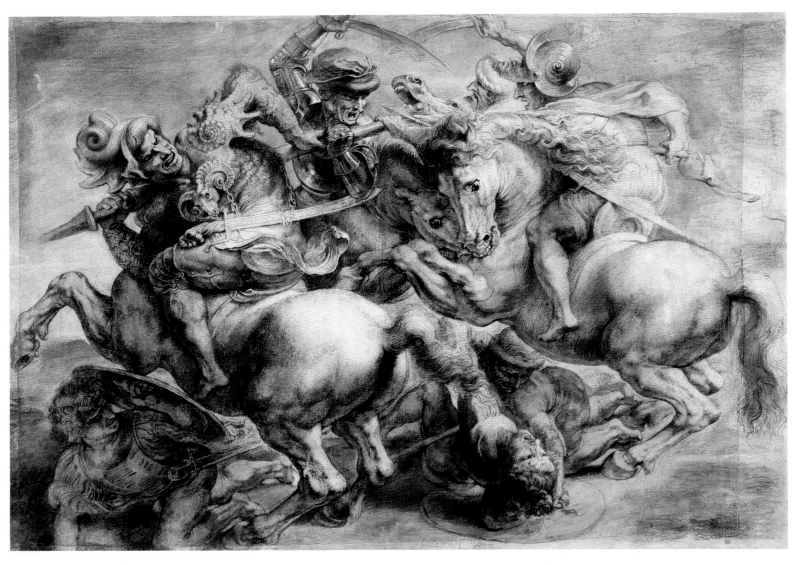

COLORPLATE 45. Peter Paul Rubens. *Copy of the Battle for the Standard for Leonardo's Cartoon for the Battle of Anghiari.*
c. 1515. Pen and ink and colored chalk. 17¾ × 25¼" (451 × 642 mm). The Louvre, Paris.

façade of S. Lorenzo. Leonardo, understanding this, departed and went into France, where the King, having had works by his hand, bore him great affection; and he desired that he should colour the cartoon of S. Anne, but Leonardo, according to his custom, put him off for a long time with words.

Finally, having grown old, he remained ill many months, and, feeling himself near to death, asked to have himself diligently informed of the teaching of the Catholic faith, and of the good way and holy Christian religion; and then, with many moans, he confessed and was penitent; and although he could not raise himself well on his feet, supporting himself on the arms of his friends and servants, he was pleased to take devoutly the most holy Sacrament, out of his bed. The King, who was wont often and lovingly to visit him, then came into the room; wherefore he, out of reverence, having raised himself to sit upon the bed, giving him an account of his sickness and the circumstances of it, showed withal how much he had offended God and mankind in not having worked at his art as he should have done. Thereupon he was seized by a paroxysm, the messenger of death; for which reason the King having risen and having taken his head, in order to assist him and show him favour, to the end that he might alleviate his pain, his spirit, which was divine, knowing that it could not have any greater honour, expired in the arms of the King, in the [sixty-seventh] year of his age.

COLORPLATE 44

This dramatic incident is untrue. On May 2, 1519, the day of Leonardo's death, King Francis was in Saint-Germain-en-Laye celebrating the birth of his second son.

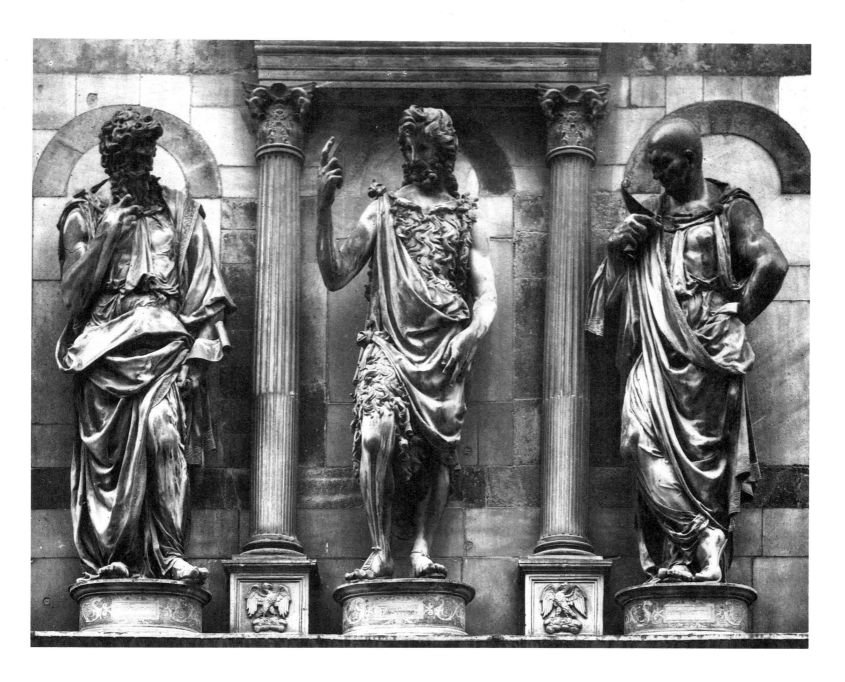

The loss of Leonardo grieved beyond measure all those who had known him, since there was never any one who did so much honour to painting. With the splendour of his aspect, which was very beautiful, he made serene every broken spirit: and with his words he turned to yea, or nay, every obdurate intention. By his physical force he could restrain any outburst of rage: and with his right hand he twisted the iron ring of a door-bell, or a horseshoe, as if it were lead. With his liberality he would assemble together and support his every friend, poor or rich, if only he had intellect and worth. He adorned and honoured, in every action, no matter what mean and bare dwelling; wherefore, in truth, Florence received a very great gift in the birth of Leonardo, and an incalculable loss in his death. In the art of painting, he added to the manner of colouring in oils a certain obscurity, whereby the moderns have given great force and relief to their figures. And in statuary, he proved his worth in the three figures of bronze that are over the door of S. Giovanni, on the side towards the north, executed by Giovan Francesco Rustici, but contrived with the advice of Leonardo; which are the most beautiful pieces of casting, the best designed, and the most perfect that have as yet been seen in modern days. By Leonardo we have the anatomy of the horse, and that of man even more complete. And so, on account of all his qualities, so many and so divine, although he worked much more by words than by deeds, his name and fame can never be extinguished; wherefore it was thus said in his praise by Messer Giovan Battista Strozzi:

Giambattista Strozzi (1488–1538), Florentine statesman.

> He alone vanquished all others;
> Surpassing both Phidias and Apelles
> And their victorious successors.

For Apelles, see page 82. Phidias (fifth century B.C.) was a famous Greek sculptor.

* * *

VITA DI RAFFAELLO DA VRB.
PIT. ARCHITETTO.

THE LIFE OF
RAFFAELLO DA URBINO

Raphael Santi

[1483–1520]

THE PAINTER AND ARCHITECT

HOW BOUNTIFUL and benign Heaven sometimes shows itself in showering upon one single person the infinite riches of its treasures, and all those graces and rarest gifts that it is wont to distribute among many individuals, over a long space of time, could be clearly seen in the no less excellent than gracious Raffaello Sanzio da Urbino, who was endowed by nature with all that modesty and goodness which are seen at times in those who, beyond all other men, have added to their natural sweetness and gentleness the beautiful adornment of courtesy and grace, by reason of which they always show themselves agreeable and pleasant to every sort of person and in all their actions. Him nature presented to the world, when, vanquished by art through the hands of Michelagnolo Buonarroti, she wished to be vanquished, in Raffaello, by art and character together. And in truth, since the greater part of the craftsmen who had lived up to that time had received from nature a certain element of savagery and madness, which, besides making them strange and eccentric, had brought it about that very often there was revealed in them rather the obscure darkness of vice than the brightness and splendour of those virtues that make men immortal, there was right good reason for her to cause to shine out brilliantly in Raffaello, as a contrast to the others, all the rarest qualities of the mind, accompanied by such grace, industry, beauty, modesty, and excellence of character, as would have sufficed to efface any vice, however hideous, and any blot, were it ever so great. Wherefore it may be surely said that those who are the possessors of such rare and numerous gifts as were seen in Raffaello da Urbino, are not merely men, but, if it be not a sin to say it, mortal gods; and that those who, by means of their works, leave an honourable name written in the archives of fame in this earthly world of ours, can also hope to have to enjoy in Heaven a worthy reward for their labours and merits.

Raffaello was born at Urbino, a very famous city in Italy, at three o'clock of the night on Good Friday, in the year 1483, to a father named Giovanni de' Santi, a painter of no great excellence, and yet a man of good intelligence, well able to direct his children on that good path which he himself had not been fortunate enough to have shown to him in his boyhood. And since Giovanni knew how important it is to rear infants, not with the milk of nurses, but with that of their own mothers, no sooner was Raffaello born, to whom with happy augury he gave that name at baptism, than he insisted that this his only child—and he had no more afterwards—should be suckled by his own mother, and that in his tender years he should have his character formed in the house of his parents, rather than learn less gentle or even boorish ways and habits in the houses of peasants or common people. When he was well grown, he began to exercise him in painting, seeing him much inclined to such an art, and possessed of a very beautiful genius: wherefore not many years passed before Raffaello, still a boy, became a great help to Giovanni in many works that he executed in the state of Urbino. In the end, this good and loving father, knowing that his son could learn little from him, made up his mind to place him

Although some authorities believe the painting reproduced on page 131 to be among Raphael's first essays in the medium, others are of the opinion that it is a work of his father's.

with Pietro Perugino, who, as he heard tell, held the first place among painters at that time. He went, therefore, to Perugia: but not finding Pietro there, he set himself, in order to lessen the annoyance of waiting for him, to execute some works in S. Francesco. When Pietro had returned from Rome, Giovanni, who was a gentle and well-bred person, formed a friendship with him, and, when the time appeared to have come, in the most adroit method that he knew, told his desire. And so Pietro, who was very courteous and a lover of beautiful genius, agreed to have Raffaello; whereupon Giovanni, going off rejoicing to Urbino, took the boy, not without many tears on the part of his mother, who loved him dearly, and brought him to Perugia, where Pietro, after seeing Raffaello's method of drawing, and his beautiful manners and character, formed a judgment of him which time, from the result, proved to be very true.

It is a very notable thing that Raffaello, studying the manner of Pietro, imitated it in every respect so closely, that his copies could not be distinguished from his master's originals, and it was not possible to see any clear difference between his works and Pietro's; as is still evident from some figures in a panel in S. Francesco at Perugia, which he executed in oils for Madonna Maddalena degli Oddi. These are a Madonna who has risen into Heaven, with Jesus Christ crowning her, while below, round the sepulchre, are the twelve Apostles, contemplating the Celestial Glory, and at the foot of the panel is a predella divided into three scenes, painted with little figures, of the Madonna receiving the Annunciation from the Angel, of the Magi adoring Christ, and of Christ in the arms of Simeon in the Temple. This work is executed with truly supreme diligence; and one who had not a good knowledge of the two manners, would hold it as certain that it is by the hand of Pietro, whereas it is without a doubt by the hand of Raffaello.

After this work, Pietro returning to Florence on some business of his own, Raffaello departed from Perugia and went off with some friends to Città di Castello, where he painted a panel for S. Agostino in the same manner, and likewise one of a Crucifixion for S. Domenico, which, if his name were not written upon it, no one would believe to be a work by Raffaello, but rather by Pietro. For S. Francesco, also in the same city, he painted a little panel-picture of the Marriage of Our Lady, in which one may recognize the excellence of Raffaello increasing and growing in refinement, and surpassing the manner of Pietro. In this work is a temple drawn in perspective with such loving care, that it is a marvellous thing to see the difficulties that he was for ever seeking out in this branch of his profession.

Meanwhile, when he had acquired very great fame by following his master's manner, Pope Pius II had given the commission for painting the library of the Duomo at Siena to Pinturicchio; and he, being a friend of Raffaello, and knowing him to be an excellent draughtsman, brought him to Siena, where Raffaello made for him some of the drawings and cartoons for that work. The reason that he did not continue at it was that some painters in Siena kept extolling with vast praise the cartoon that Leonardo da Vinci had made in the Sala del Palazzo [della Signoria] of a very beautiful group of horsemen, to be painted afterwards in the Hall of the Palace of the Signoria, and likewise some nudes executed by Michelagnolo Buonarroti in competition with Leonardo, and much better; and Raffaello, on account of the love that he always bore to the excellent in art, was seized by such a desire to see them, that, putting aside that work and all thought of his own advantage and comfort, he went off to Florence.

Having arrived there, and being pleased no less with the city than with those works, which appeared to him to be divine, he determined to take up his abode there for some time; and thus he formed a friendship with some young painters, among whom were Ridolfo Ghirlandajo, Aristotile da San Gallo, and others, and became much honoured in that city, particularly by Taddeo Taddei,

COLORPLATE 48

The panel for the Church of Sant' Agostino was the Altarpiece of the Blessed Nicholas of Tolentino, *of which only fragments survive (see colorplate 46).*

COLORPLATE 47

COLORPLATE 49

Pius II, Aeneas Silvius Piccolomini (1405–1464), a notable Sienese scholar and man of letters who was pope from 1458.

Bernardo Pinturicchio (c. 1454–1513), Umbrian painter. His fresco cycle in the library depicts events in the life of Pius II.

An account of Leonardo's fresco appears on page 114; for Michelangelo's work, see page 229.

Ridolfo Ghirlandaio (1483–1561), Florentine painter; son of Michelangelo's teacher, Domenico Ghirlandaio. Aristotile (or Bastiano) da Sangallo (1477–1549), Florentine painter and sculptor and nephew of the architects Giuliano and Antonio da Sangallo.

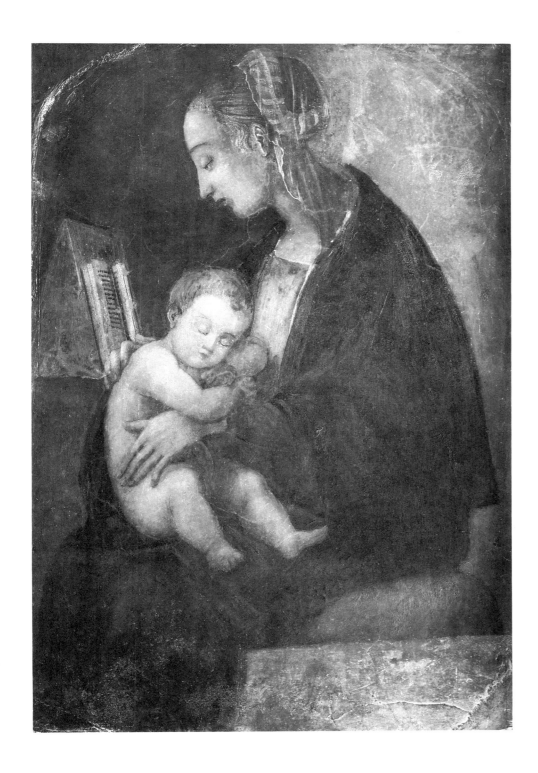

Giovanni Santi (attributed). *Madonna and Child*. 1490s. Detached fresco. 38¼ × 26½″ (97 × 67 cm). Casa Santi, Urbino.

who, being one who always loved any man inclined to excellence, would have him ever in his house and at his table. And Raffaello, who was gentleness itself, in order not to be beaten in courtesy, made him two pictures, which incline to his first manner, derived from Pietro, but also to the other much better manner that he afterwards acquired by study, as will be related; which pictures are still in the house of the heirs of the said Taddeo.

Raffaello also formed a very great friendship with Lorenzo Nasi; and for this Lorenzo, who had taken a wife about that time, he painted a picture in which he made a Madonna, and between her legs her Son, to whom a little S. John, full of joy, is offering a bird, with great delight and pleasure for both of them. In the attitude of each is a certain childlike simplicity which is wholly lovely, besides that they are so well coloured, and executed with such diligence, that they appear to be rather of living flesh than wrought by means of colour and draughtsmanship; the Madonna, likewise, has an air truly full of grace and divinity; and the foreground, the landscapes, and in short all the rest of the work,

COLORPLATE 54

are most beautiful. This picture was held by Lorenzo Nasi, as long as he lived, in very great veneration, both in memory of Raffaello, who had been so much his friend, and on account of the dignity and excellence of the work; but afterwards, on August 9, in the year 1548, it met an evil fate, when, on account of the collapse of the hill of S. Giorgio, the house of Lorenzo fell down, together with the ornate and beautiful houses of the heirs of Marco del Nero, and other neighbouring dwellings. However, the pieces of the picture being found among the fragments of the ruins, the son of Lorenzo, Batista, who was a great lover of art, had them put together again as well as was possible.

After these works, Raffaello was forced to depart from Florence and go to Urbino, where, on account of the death of his mother and of his father Giovanni, all his affairs were in confusion. While he was living in Urbino, therefore, he painted for Guidobaldo da Montefeltro, then Captain of the Florentines, two pictures of Our Lady, small but very beautiful, and in his second manner, which are now in the possession of the most illustrious and excellent Guidobaldo, Duke of Urbino. For the same patron he painted a little picture of Christ praying in the Garden, with the three Apostles sleeping at some dis-

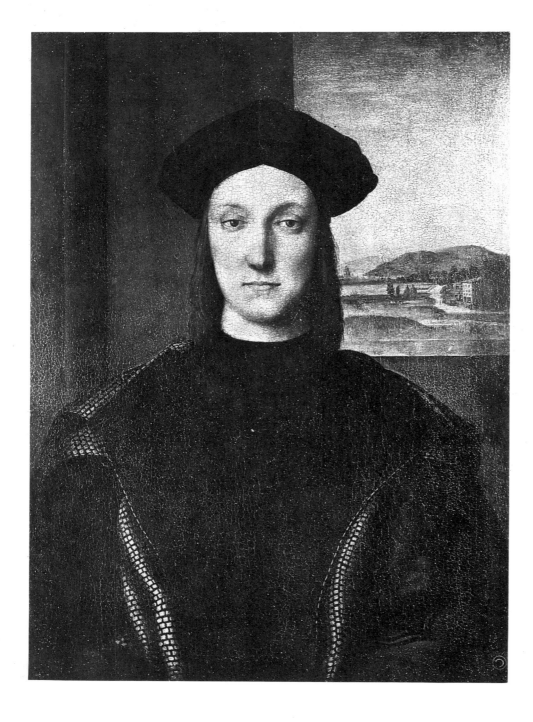

Raphael. *Presumed Portrait of Guidobaldo da Montefeltro, Duke of Urbino.* 1506. Panel. 27¼ × 20½" (69 × 52 cm). Uffizi Gallery, Florence.

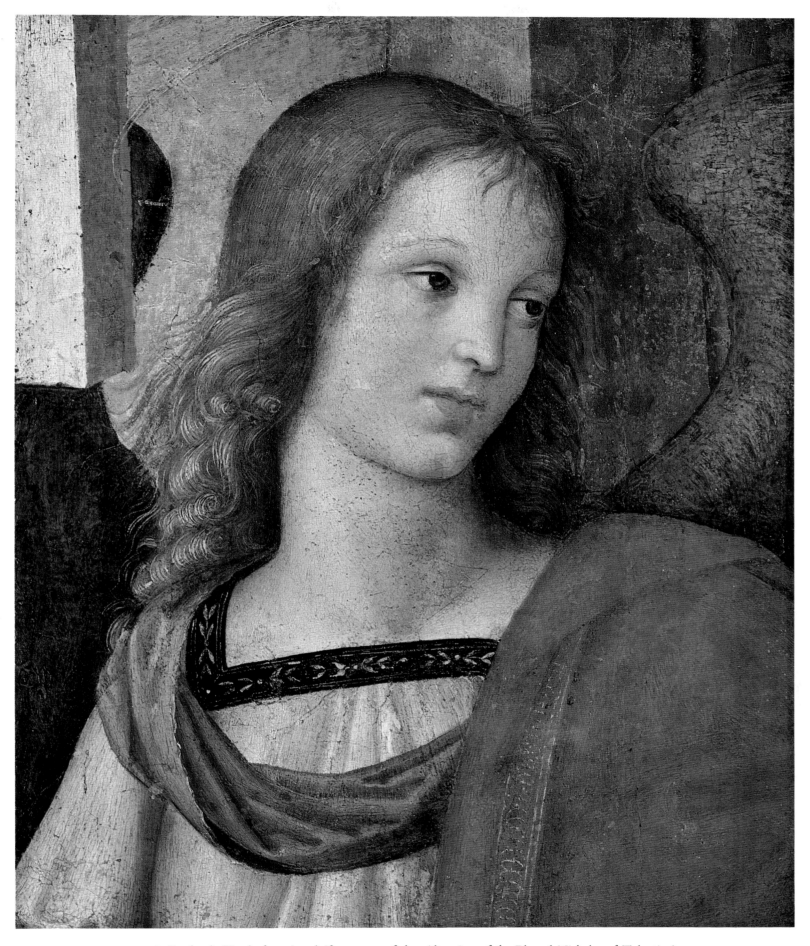

COLORPLATE 46. Raphael. *Head of an Angel* (fragment of the *Altarpiece of the Blessed Nicholas of Tolentino*). 1500–01. Oil on panel. 12¼ × 10¾″ (31 × 27 cm). Pinacoteca Tosio Martinengo, Brescia.

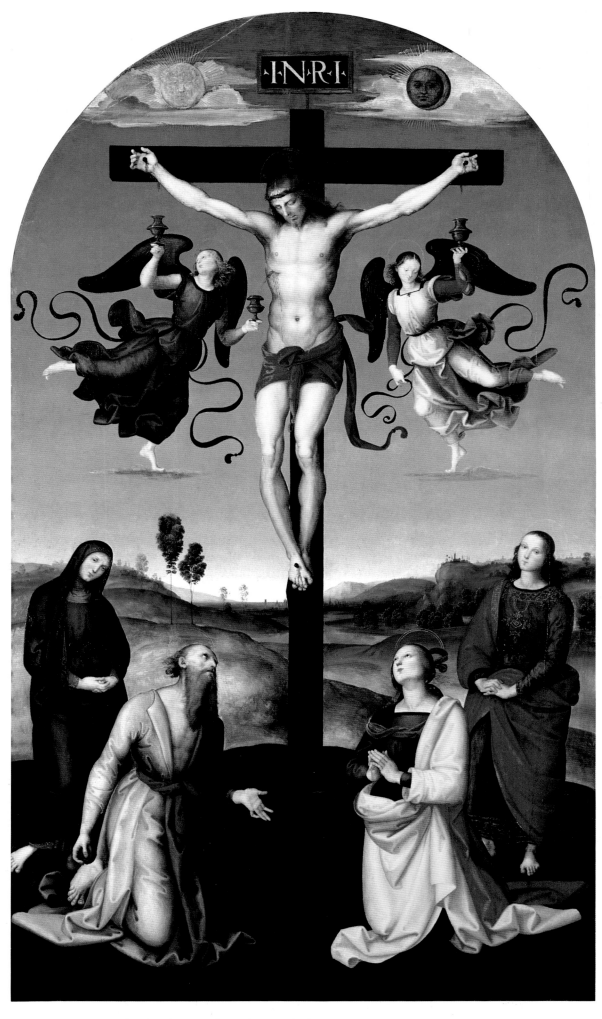

COLORPLATE 47. Raphael. *The Crucified Christ with the Virgin Mary, Saints and Angels (Mond Crucifixion).*
1502–03. Oil on panel. 110½ × 65″ (280.7 × 165.1 cm). The National Gallery, London.

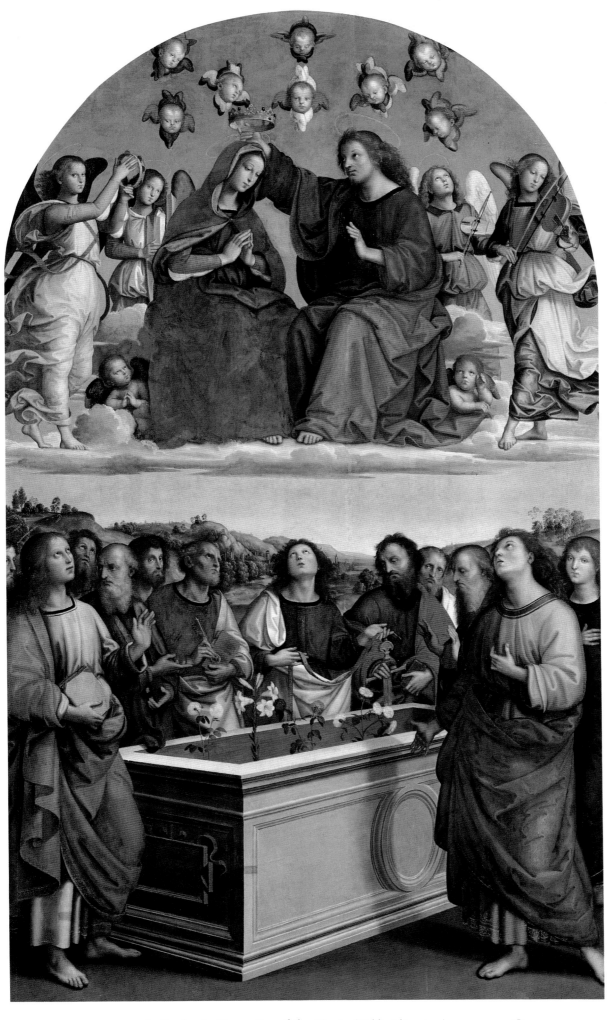

COLORPLATE 48. Raphael. *Coronation of the Virgin (Oddi Altarpiece).* 1502–03. Canvas.
105½ × 64¼" (267 × 163 cm). Pinacoteca Vaticana, Rome.

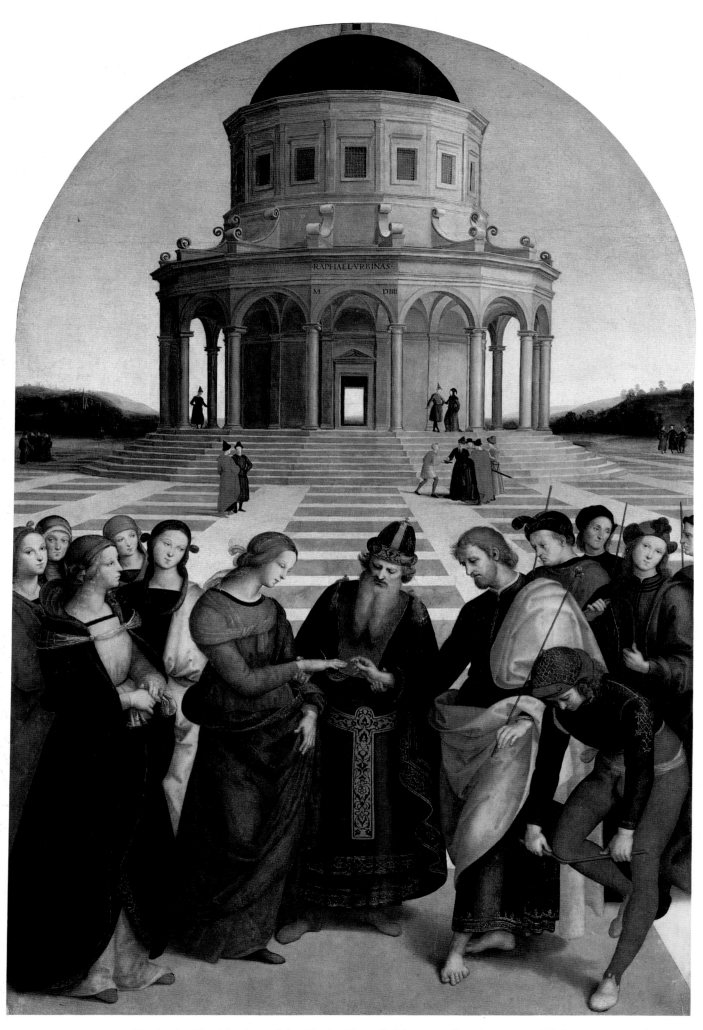

COLORPLATE 49. Raphael. *The Marriage of the Virgin (Sposalizio)*. 1504. Panel. 67 × 46½" (117 × 170 cm).
Brera Gallery, Milan.

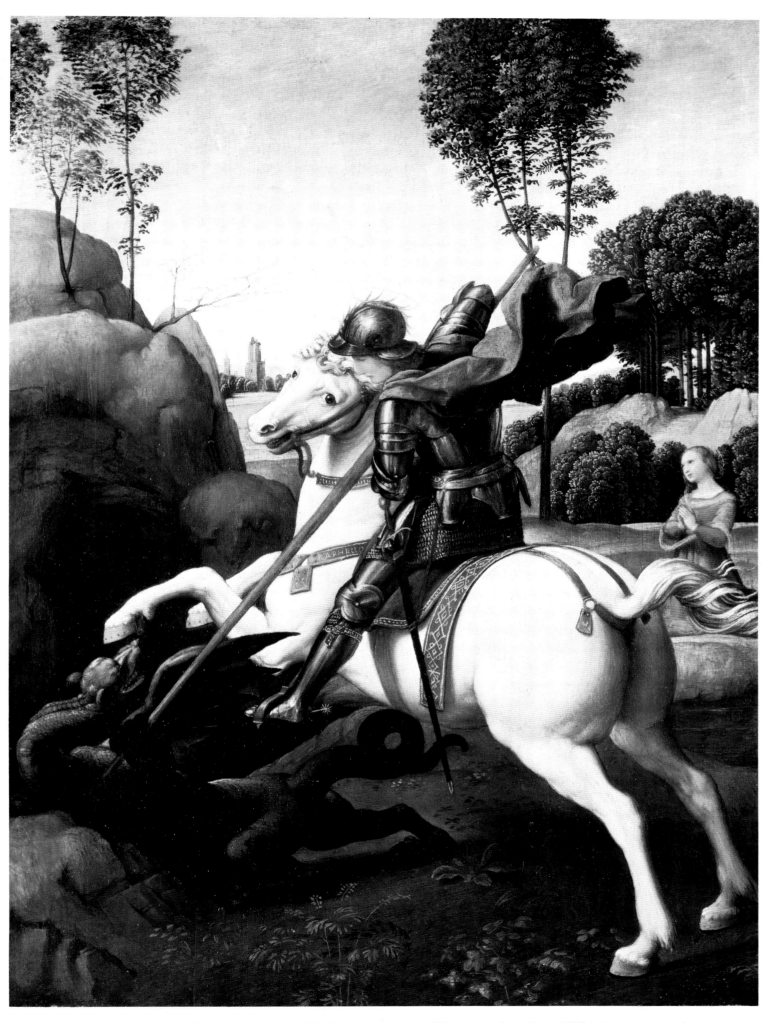

COLORPLATE 52. Raphael. *St. George and the Dragon*. c. 1506. Oil on panel. 11⅛ × 8⅜″ (28.5 × 21.5 cm).
National Gallery of Art, Washington, Andrew W. Mellon Collection.

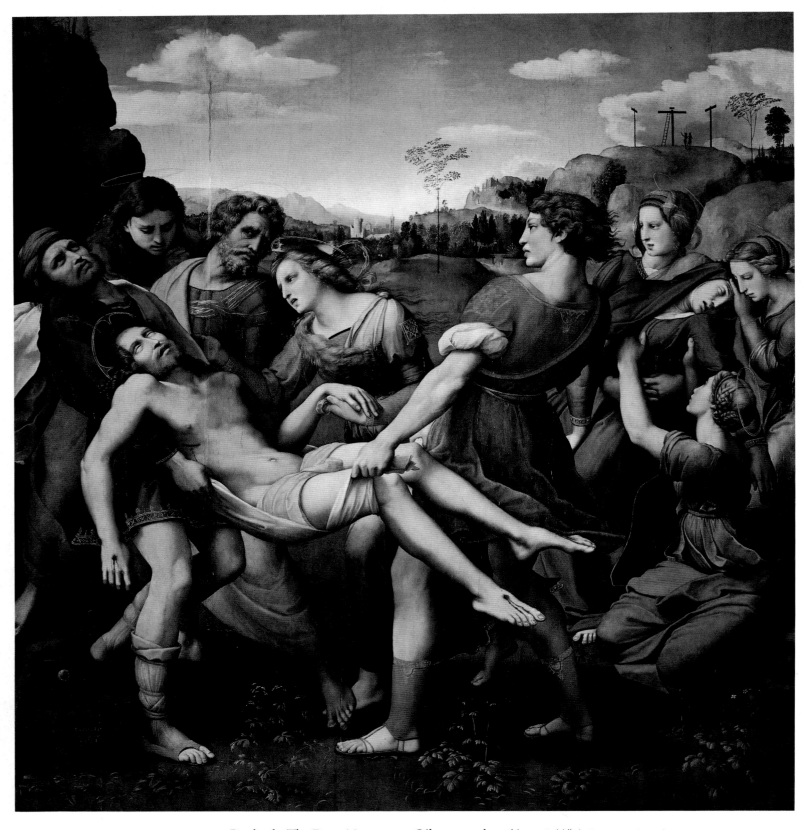

COLORPLATE 53. Raphael. *The Deposition*. 1507. Oil on panel. 72½ × 69¼″ (184 × 176 cm).
Galleria Borghese, Rome.

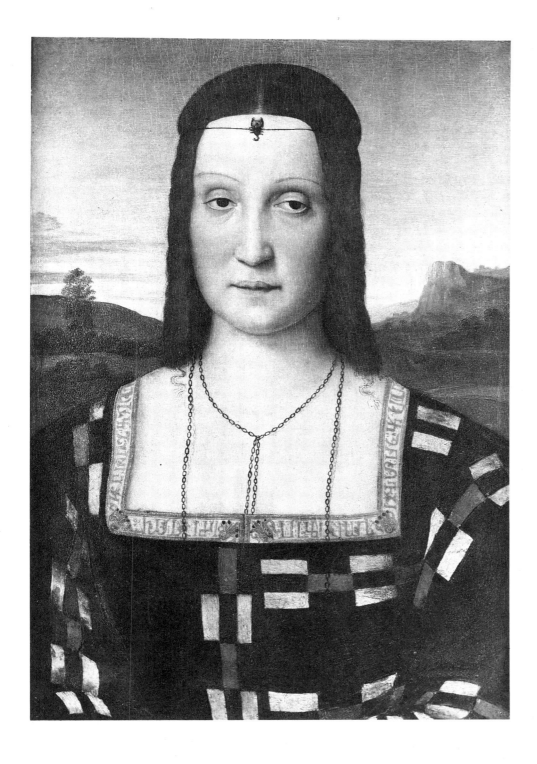

Raphael. *Portrait of Elizabeth Gonzaga, Duchess of Urbino.* 1504–05. Panel. 22¾ × 14¼″ (58 × 36 cm). Uffizi Gallery, Florence.

tance from Him. This painting is so highly finished, that a miniature could not be better, or in any way different; and after having been a long time in the possession of Francesco Maria, Duke of Urbino, it was then presented by the most illustrious Signora Leonara, his consort, to the Venetians Don Paolo Giustiniano and Don Pietro Quirini, hermits of the holy Hermitage of Camaldoli, who afterwards placed it, as a relic and a very rare thing, and, in a word, as a work by the hand of Raffaello da Urbino, and also to honour the memory of that most illustrious lady, in the apartment of the Superior of that hermitage, where it is held in the veneration that it deserves.

Having executed these works and settled his affairs, Raffaello returned to Perugia, where he painted a panel-picture of Our Lady, S. John the Baptist, and S. Nicholas, for the Chapel of the Ansidei in the Church of the Servite Friars. And in the Chapel of the Madonna in S. Severo, a little monastery of the Order of Camaldoli, in the same city, he painted in fresco a Christ in Glory, and a God the Father with angels round Him, and six saints seated, S. Benedict, S.

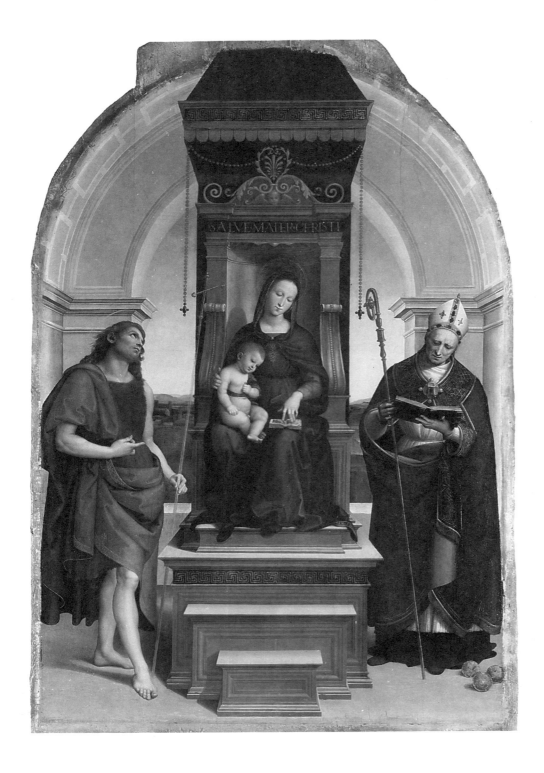

OPPOSITE:

Raphael. *Madonna and Child Enthroned with Sts. Catharine, Peter, Cecilia, Paul, and the Infant St. John the Baptist (The Colonna Altarpiece)*. 1503–06. Panel. Main panel: 66⅝ × 66¾″ (166.7 × 169.6 cm). Lunette: 28¾ × 66¼″ (73.0 × 168.3 cm). The Metropolitan Museum of Art, New York; Gift of J. Pierpont Morgan, 1916.

Raphael. *Madonna and Child with St. John the Baptist and St. Nicholas of Bari (The Ansidei Madonna)*. 1504–06. Panel. 82½ × 58½″ (209.5 × 148.5 cm). The National Gallery, London.

Romualdo, S. Laurence, S. Jerome, S. Mauro, and S. Placido, three on either side; and on his picture, which was held at that time to be most beautiful for a work in fresco, he wrote his name in large and very legible letters. In the same city, also, he was commissioned by the Nuns of S. Anthony of Padua to paint a panel-picture of Our Lady, with Jesus Christ fully dressed, as it pleased those simple and venerable sisters, in her lap, and on either side of the Madonna S. Peter, S. Paul, S. Cecilia, and S. Catherine; to which two holy virgins he gave the sweetest and most lovely expressions of countenance and the most beautifully varied head-dresses that are anywhere to be seen, which was a rare thing in those times. Above this panel, in a lunette, he painted a very beautiful God the Father, and in the predella of the altar three scenes with little figures, of Christ praying in the Garden, bearing the Cross (wherein are some soldiers dragging Him along with most beautiful movements), and lying dead in the lap of His Mother. This work is truly marvellous and devout; and it is held in great veneration by those nuns, and much extolled by all painters.

I will not refrain from saying that it was recognized, after he had been in

The work painted for the Nuns of St. Anthony of Padua is the so-called Colonna Altarpiece, *of which a predella panel is reproduced in colorplate 51.*

COLORPLATE 51

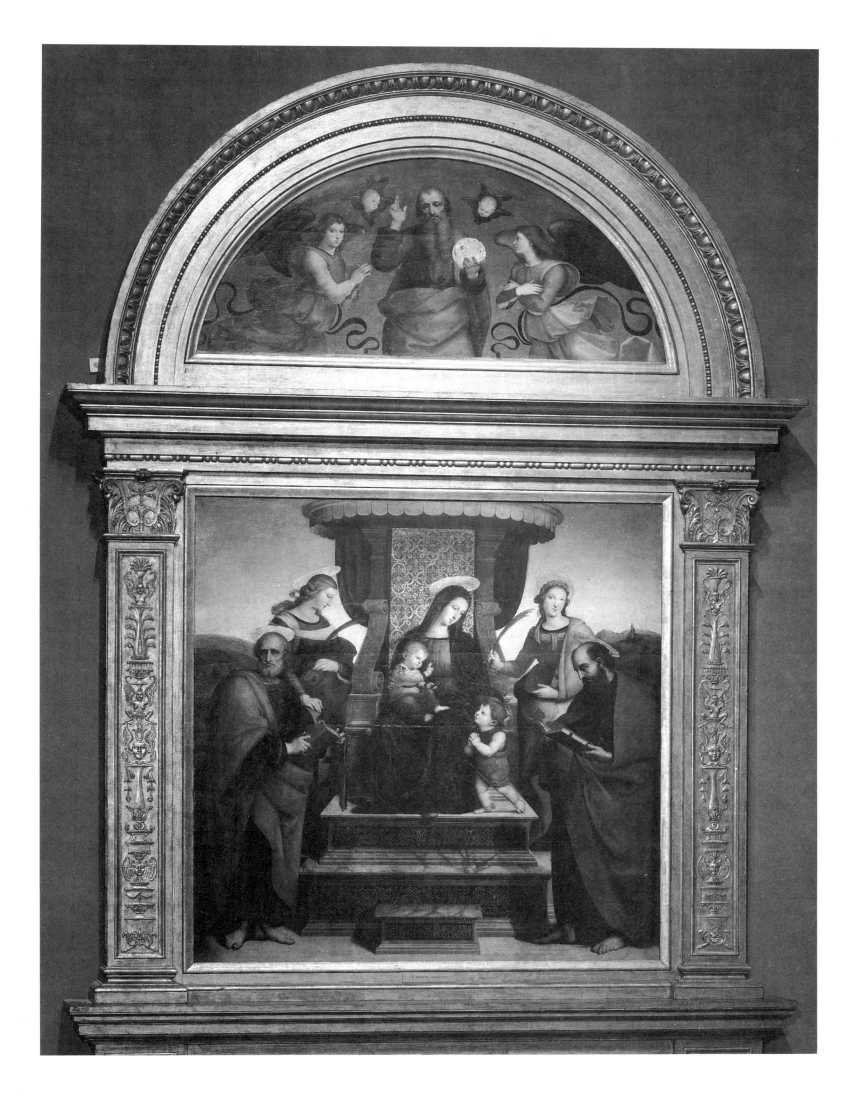

143

Raphael. *The Agony in the Garden* (predella
panel from *The Colonna Altarpiece*).
c. 1505. Tempera and oil on panel. 9½
× 11⅜" (24.1 × 29.8 cm). The
Metropolitan Museum of Art, New York;
Funds from Various Donors, 1932.

COLORPLATE 50

Florence, that he changed and improved his manner so much, from having seen
many works by the hands of excellent masters, that it had nothing to do with
his earlier manner; indeed, the two might have belonged to different masters,
one much more excellent than the other in painting.

Before he departed from Perugia, Madonna Atalanta Baglioni besought him
that he should consent to paint a panel for her chapel in the Church of S. Fran-

Raphael. *The Procession to Calvary* (predella panel from *The Colonna Altarpiece*). c. 1505. Tempera and oil on panel. 9½ × 33½″ (24.1 × 85.1 cm). The National Gallery, London.

cesco; but since he was not able to meet her wishes at that time, he promised her that, after returning from Florence, whither he was obliged to go on some affairs, he would not fail her. And so, having come to Florence, where he applied himself with incredible labour to the studies of his art, he made the cartoon for that chapel, with the intention of going, as he did, as soon as the occasion might present itself, to put it into execution.

While he was thus staying in Florence, Agnolo Doni—who was very careful of his money in other things, but willing to spend it, although still with the greatest possible economy, on works of painting and sculpture, in which he much delighted—caused him to make portraits of himself and of his wife; and these may be seen, painted in his new manner, in the possession of Giovan Battista, his son, in the beautiful and most commodious house that the same Agnolo built on the Corso de' Tintori, near the Canto degli Alberti, in Florence. For Domenico Canigiani, also, he painted a picture of Our Lady, with the Child Jesus welcoming a little S. John brought to Him by S. Elizabeth, who, as she holds him, is gazing with a most animated expression at a S. Joseph, who is standing with both his hands leaning on a staff, and inclines his head towards her, as though praising the greatness of God and marvelling that she, so advanced in years, should have so young a child. And all appear to be amazed to see with how much feeling and reverence the two cousins, for all their tender age, are caressing one another; not to mention that every touch of colour in the heads, hands, and feet seems to be living flesh rather than a tint laid on by a master of that art. This most noble picture is now in the possession of the heirs of the said Domenico Canigiani, who hold it in the estimation that is due to a work by Raffaello da Urbino.

This most excellent of painters studied in the city of Florence the old works of Masaccio; and what he saw in those of Leonardo and Michelagnolo made him give even greater attention to his studies, in consequence of which he effected an extraordinary improvement in his art and manner. While he was living in Florence, Raffaello, besides other friendships, became very intimate with Fra Bartolommeo di San Marco, being much pleased with his colouring, and

Masaccio (1401–28), Florentine painter; sometimes called the true father of Renaissance art. His most famous work is the fresco cycle in the Brancacci Chapel in Santa Maria del Carmine, Florence.

Fra Bartolommeo (1475–1517), the name assumed by the Florentine painter Baccio della Porta upon entering the Dominican order.

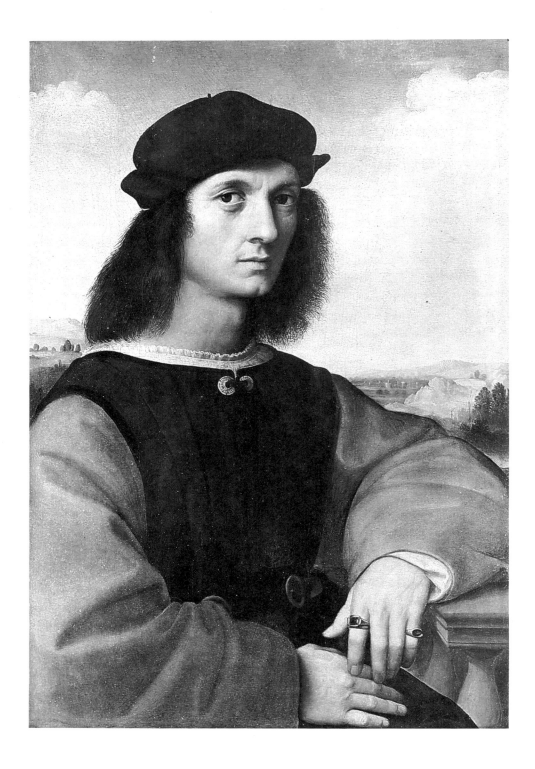

Raphael. *Portrait of Agnolo Doni*. 1506. Oil on panel. 24¾ × 17¾″ (63 × 45 cm). Pitti Gallery, Florence.

COLORPLATE 53

taking no little pains to imitate it: and in return he taught that good father the principles of perspective, to which up to that time the monk had not given any attention.

But at the very height of his friendly intercourse, Raffaello was recalled to Perugia, where he began by finishing the work for the aforesaid Madonna Atalanta Baglioni in S. Francesco, for which, as has been related, he had made the cartoon in Florence. In this most divine picture there is a Dead Christ being borne to the Sepulchre, executed with such freshness and such loving care, that it seems to the eye to have been only just painted. In the composition of this work, Raffaello imagined to himself the sorrow that the nearest and most affectionate relatives of the dead one feel in laying to rest the body of him who has been their best beloved, and on whom, in truth, the happiness, honour, and welfare of a whole family have depended. Our Lady is seen in a swoon; and the heads of all the figures are very gracious in their weeping, particularly that of S. John, who, with his hands clasped, bows his head in such a manner as to

move the hardest heart to pity. And in truth, whoever considers the diligence, love, art, and grace shown by this picture, has great reason to marvel, for it amazes all who behold it, what with the air of the figures, the beauty of the draperies, and, in short, the supreme excellence that it reveals in every part.

This work finished, he returned to Florence, where he received from the Dei, citizens of that city, the commission for an altar-panel that was to be placed in their chapel in S. Spirito; and he began it, and brought the sketch very nearly to completion. At the same time he painted a picture that was afterwards sent to Siena, although, on the departure of Raffaello, it was left with Ridolfo Ghirlandajo, to the end that he might finish a piece of blue drapery that was wanting. This happened because Bramante da Urbino, who was in the service of Julius II, wrote to Raffaello, on account of his being distantly related to him and also his compatriot, that he had so wrought upon the Pope, who had caused some new rooms to be made (in the Vatican), that Raffaello would have a chance of showing his worth in them. This proposal pleased Raffaello: wherefore, abandoning his works in Florence, and leaving the panel for the Dei

Donato Bramante (1444–1514) was the first architect of the new St. Peter's. His work was modified by Michelangelo.

COLORPLATE 55

Julius II (r. 1502–13), the name assumed by Giuliano della Rovere, one of the most dynamic of Renaissance pontiffs. Among his major achievements was instituting the construction of the new St. Peter's. He played an important role in the life of Michelangelo.

Raphael. *Portrait of Maddalana Doni.* 1506. Oil on panel. 23¾ × 17¾″ (63 × 45 cm). Pitti Gallery, Florence.

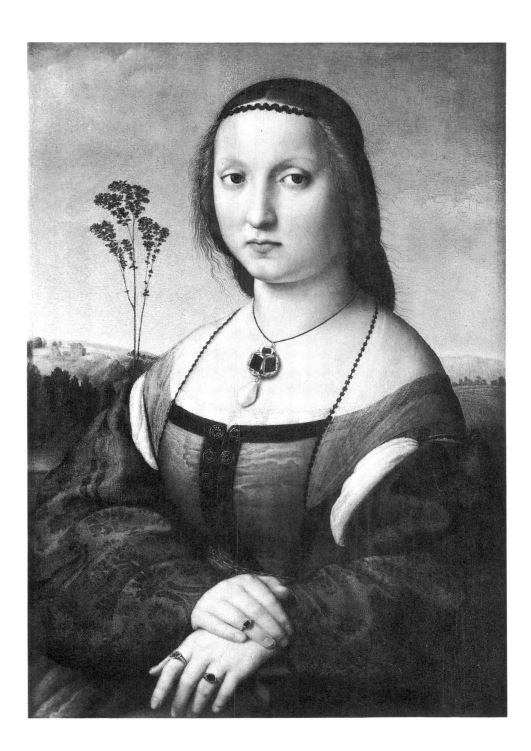

unfinished, in the state in which Messer Baldassarre da Pescia had it placed in the Pieve of his native city after the death of Raffaello, he betook himself to Rome. Having arrived there, he found that most of the rooms in the Palace had been painted, or were still being painted, by a number of masters. To be precise, he saw that there was one room in which a scene had been finished by Piero della Francesca; Luca da Cortona had brought one wall nearly to completion; and Don [Bartolommeo] della Gatta, Abbot of S. Clemente at Arezzo, had begun some works there. Bramantino, the Milanese, had likewise painted many figures, which were mostly portraits from life, and were held to be very beautiful. After his arrival, therefore, having been received very warmly by Pope Julius, Raffaello began in the Camera della Segnatura a scene of the theologians reconciling Philosophy and Astrology with Theology: wherein are portraits of all the sages in the world, disputing in various ways. Standing apart are some astrologers, who have made various kinds of figures and characters of geomancy and astrology on some little tablets, which they send to the Evangelists by certain very beautiful angels; and these Evangelists are expounding them. Among them is Diogenes with his cup, lying on the steps, and lost in thought, a figure very well conceived, which, for its beauty and the characteristic negligence of its dress, is worthy to be extolled. There, also, are Aristotle and Plato, one with the Timæus in his hand, the other with the Ethics; and round them, in a circle, is a great school of philosophers. Nor is it possible to express the beauty of those astrologers and geometricians who are drawing a vast number of figures and characters with compasses on tablets: among whom, in the figure of a young man, shapely and handsome, who is throwing out his arms in admiration, and inclining his head, is the portrait of Federigo II, Duke of Mantua, who was then in Rome. There is also a figure that is stooping to the ground, holding in its hand a pair of compasses, with which it is making a circle on a tablet: this is said to be the architect Bramante, and it is no less the man himself than if he were alive, so well is it drawn. Beside a figure with its back turned and holding a globe of the heavens in its hand, is the portrait of Zoroaster; and next to him is Raffaello, the master of the work, who made his own portrait by means of a mirror, in a youthful head with an air of great modesty, filled with a pleasing and excellent grace, and wearing a black cap.

Nor is one able to describe the beauty and goodness that are to be seen in the heads and figures of the Evangelists, to whose countenances he gave an air of attention and intentness very true to life, and particularly in those who are writing. Thus, behind [Pythagoras], who is copying the characters from the tablet wherein are the figures (which is held before him by an angel), and writing them down in a book, he painted an old man who, having placed a piece of paper on his knee, is copying all that [Pythagoras] writes down; and while intent on his work in that uncomfortable position, he seems to twist his head and his jaws in time with the motion of the pen. And in addition to the details of the conceptions, which are numerous enough, there is the composition of the whole scene, which is truly arranged with so much order and proportion, that he may be said to have given therein such a proof of his powers as made men understand that he was resolved to hold the sovereignty, without question, among all who handled the brush.

He also adorned this work with a view in perspective and with many figures, executed in such a sweet and delicate manner, that Pope Julius was induced thereby to cause all the scenes of the other masters, both the old and the new, to be thrown to the ground, so that Raffaello alone might have the glory of all the labours that had been devoted to these works up to that time. The work of Giovanni Antonio Sodoma of Vercelli, which was above Raffaello's painting, was to be thrown down by order of the Pope; but Raffaello determined to make use of its compartments and grotesques. There were also

Piero della Francesca (1410/20–1492), Tuscan painter. His masterpiece is the fresco cycle The Story of the True Cross *in the Cathedral of Arezzo. His Roman works are lost.*

"Luca da Cortona" is Luca Signorelli (1441–1523), Umbrian painter. His most famous work is the fresco cycle on the Last Judgment in the Cathedral of Orvieto. He was Vasari's great-uncle by marriage.

COLORPLATE 57

The "Evangelists," are in fact pagan mathematicians and philosophers (the "St. Matthew" is actually Pythagoras). Many of the figures are portraits: Plato is Leonardo da Vinci; Zoroaster, probably the Humanist cardinal and celebrated man of letters Piero Bembo (1470–1547); and the somber bearded figure seated in front, left of center, is thought to be Michelangelo. The architecture is inspired by Bramante's design for the then-uncompleted St. Peter's.

Bartolommeo della Gatta (1448–1502), Aretine painter. He was Signorelli's assistant in the Sistene Chapel.

Bramantino (fl. 1490–1530), Milanese painter who took his nickname from his teacher, Bramante.

Sodoma is the nickname by which the Italian painter Giovanni Antonio Bazzi (1477–1549) is known. He, as well as Raphael, painted frescoes in the Farnesina.

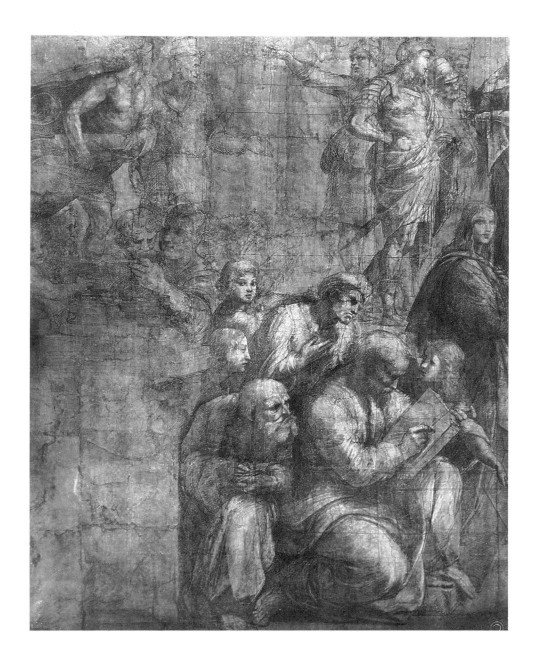

Raphael. *Cartoon for The School of Athens* (first segment). 1509. Charcoal, pencil, and wash, highlighted with white, on joined sheets of paper. Pinacoteca Ambrosiana, Milan.

some medallions, four in number, and in each of these he made a figure as a symbol of the scenes below, each figure being on the same side as the scene that it represented. Over the first scene, wherein he painted Philosophy, Astrology, Geometry, and Poetry making peace with Theology, is a woman representing Knowledge, who is seated on a throne that is supported on either side by a figure of the Goddess Cybele, each with those many breasts which in ancient times were the attributes of Diana Polymastes; and her dress is of four colours, standing for the four elements; from the head downwards there is the colour of fire, below the girdle that of the sky, from the groin to the knees there is the colour of earth, and the rest, down to the feet, is the colour of water. With her, also, are some truly beautiful little boys. In another medallion, on the side towards the window that looks over the Belvedere, is a figure of Poetry, who is in the form of Polyhymnia, crowned with laurel, and holds an antique musical instrument in one hand, and a book in the other, and has her legs crossed. With a more than human beauty of expression in her countenance, she stands with her eyes uplifted towards Heaven, accompanied by two little boys, who are lively and spirited, and who make a group of beautiful variety both with her and with the others. On this side, over the aforesaid window, Raffaello afterwards painted Mount Parnassus. In the third medallion, which is above the scene where the Holy Doctors are ordaining the Mass, is a figure of

COLORPLATE 56

Cybele, ancient Near Eastern mother goddess. Diana Polymastes (Greek for "many breasted") is better known as the Ephesian Diana.

Polyhymnia is the muse of sacred poetry.

149

Theology, no less beautiful than the others, with books and other things round her, and likewise accompanied by little boys. And in the fourth medallion, over the other window, which looks out on the court, he painted Justice with her scales, and her sword uplifted, and with the same little boys that are with the others; of which the effect is supremely beautiful, for in the scene on the wall below he depicted the giving of the Civil and the Canon Law, as we will relate in the proper place.

In like manner, on the same ceiling, in the angles of the pendentives, he executed four scenes which he drew and coloured with great diligence, but with figures of no great size. In one of these, that near the Theology, he painted the Sin of Adam, the eating of the apple, which he executed with a most delicate manner; and in the second, near the Astrology, is a figure of that science setting the fixed stars and planets in their places. In the next, that belonging to Mount Parnassus, is Marsyas, whom Apollo has caused to be bound to a tree and flayed; and on the side of the scene wherein the Decretals are given, there is the Judgment of Solomon, showing him proposing to have the child cut in half. These four scenes are all full of expression and feeling, and executed with excellent draughtsmanship, and with pleasing and gracious colouring.

But now, having finished with the vaulting—that is, the ceiling—of that apartment, it remains for us to describe what he painted below the things mentioned above, wall by wall. On the wall towards the Belvedere, where there are Mount Parnassus and the Fount of Helicon, he made round that mount a laurel wood of darkest shadows, in the verdure of which one almost sees the leaves quivering in the gentle zephyrs; and in the air are vast numbers of naked Loves, most beautiful in feature and expression, who are plucking branches of laurel and with them making garlands, which they throw and scatter about the mount. Over the whole, in truth, there seems to breathe a spirit of divinity, so beautiful are the figures, and such the nobility of the picture, which makes whoever studies it with attention marvel how a human brain, by the imperfect means of mere colours, and by excellence of draughtsmanship, could make painted things appear alive. Most lifelike, also, are those Poets who are seen here and there about the mount, some standing, some seated, some writing, and others discoursing, and others, again, singing or conversing together, in groups of four or six, according as it pleased him to distribute them. There are portraits from nature of all the most famous poets, ancient and modern, and some only just dead, or still living in his day; which were taken from statues or medals, and many from old pictures, and some, who were still alive, portrayed from the life by himself. And to begin with one end, there are Ovid, Virgil, Ennius, Tibullus, Catullus, Propertius, and Homer; the last-named, blind and chanting his verses with uplifted head, having at his feet one who is writing them down. Next, in a group, are all the nine Muses and Apollo, with such beauty in their aspect, and such divinity in the figures, that they breathe out a spirit of grace and life. There, also, are the learned Sappho, the most divine Dante, the gracious Petrarch, and the amorous Boccaccio, who are wholly alive, with Tibaldeo, and an endless number of other moderns; and this scene is composed with much grace, and executed with diligence.

On another wall he made a Heaven, with Christ, Our Lady, S. John the Baptist, the Apostles, the Evangelists, and the Martyrs, enthroned on clouds, with God the Father sending down the Holy Spirit over them all, and particularly over an endless number of saints, who are below, writing the Mass, and engaged in disputation about the Host, which is on the altar. Among these are the four Doctors of the Church, who have about them a vast number of saints, such as Dominic, Francis, Thomas Aquinas, Buonaventura, Scotus, and Nicholas of Lira, with Dante, Fra Girolamo Savonarola of Ferrara, and all the Christian theologians, with an infinite number of portraits from nature; and in

OPPOSITE:

Raphael. *Cartoon for The School of Athens* (fourth segment). 1509. Charcoal, pencil, and wash, highlighted with white, on joined sheets of paper. Pinacoteca Ambrosiana, Milan.

Decretals *are decrees.*

COLORPLATE 59

No "naked Loves" are to be seen in the fresco; Vasari was doubtless making a reference to Marcantonio Raimondi's engraved version, which indeed incorporates cherublike figures.

All are famous poets of the Classical era.

Sappho (b. 612 B.C.), probably the most famous lyric poet of the time. She was often called the tenth muse.

Tibaldeo, or Tebaldeo (1463–1537), Italian poet. It has also been postulated that the figure represents either Michelangelo or the diplomat and writer Baldassare Castiglione.

COLORPLATE 78

The title of the fresco, The Disputation, *derives from a seventeenth-century misinterpretation of Vasari's use of the word (which in this context means "conversation"). Actually, the fresco represents the triumph of faith, or church.*

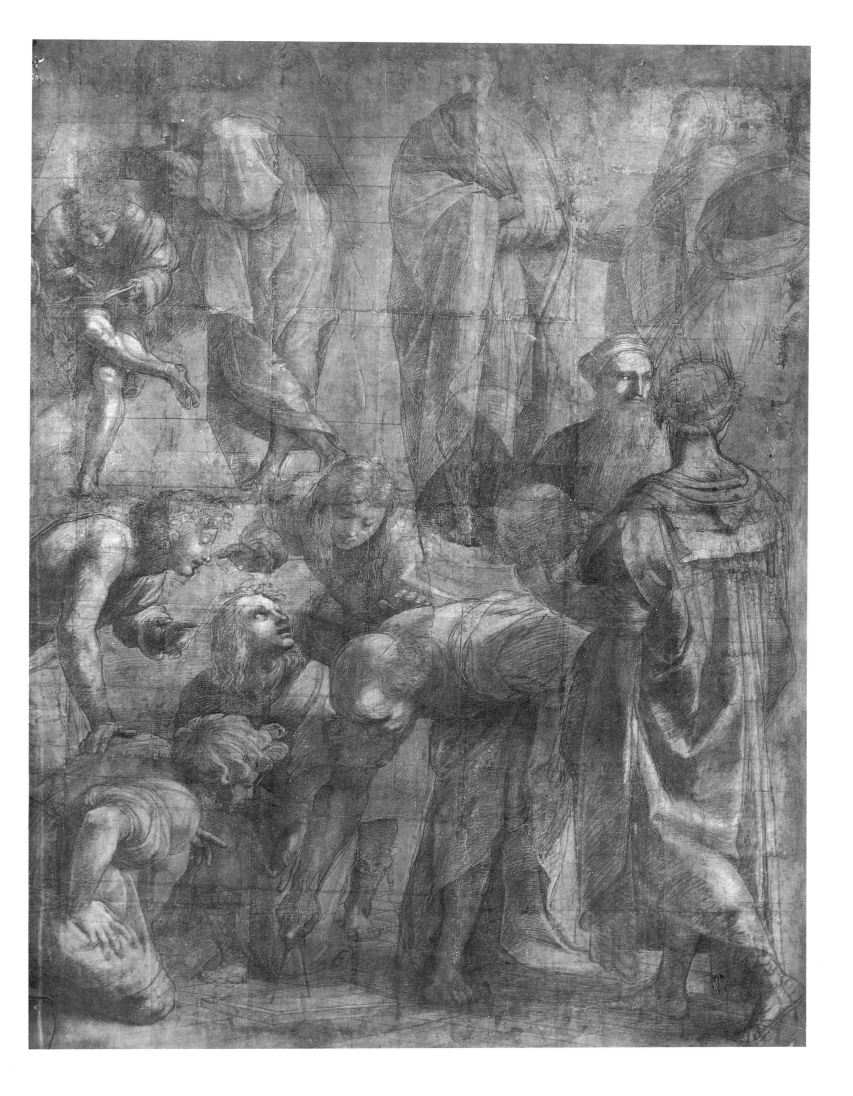

the air are four little children, who are holding open the Gospels. Anything more graceful or more perfect than these figures no painter could create, since those saints are represented as seated in the air, in a circle, and so well, that in truth, besides the appearance of life that the colouring gives them, they are foreshortened and made to recede in such a manner, that they would not be otherwise if they were in relief. Moreover, their vestments show a rich variety, with most beautiful folds in the draperies, and the expressions of the heads are more Divine than human; as may be seen in that of Christ, which reveals all the clemency and devoutness that Divinity can show to mortal men through the medium of painting. For Raffaello received from nature a particular gift of making the expressions of his heads very sweet and gracious; of which we have proof also in the Madonna, who, with her hands pressed to her bosom, gazing in contemplation upon her Son, seems incapable of refusing any favour; not to mention that he showed a truly beautiful sense of fitness, giving a look of age to the expressions of the Holy Patriarchs, simplicity to the Apostles, and faith to the Martyrs. Even more art and genius did he display in the holy Christian Doctors, in whose features, while they make disputation throughout the scene in groups of six or three or two, there may be seen a kind of eagerness and distress in seeking to find the truth of that which is in question, revealing this by gesticulating with their hands, making various movements of their persons, turning their ears to listen, knitting their brows, and expressing astonishment

Marcantonio Raimondi (after Raphael). *Parnassus*. Copperplate engraving. National Gallery of Art, Washington, Ailsa Mellon Bruce Fund.

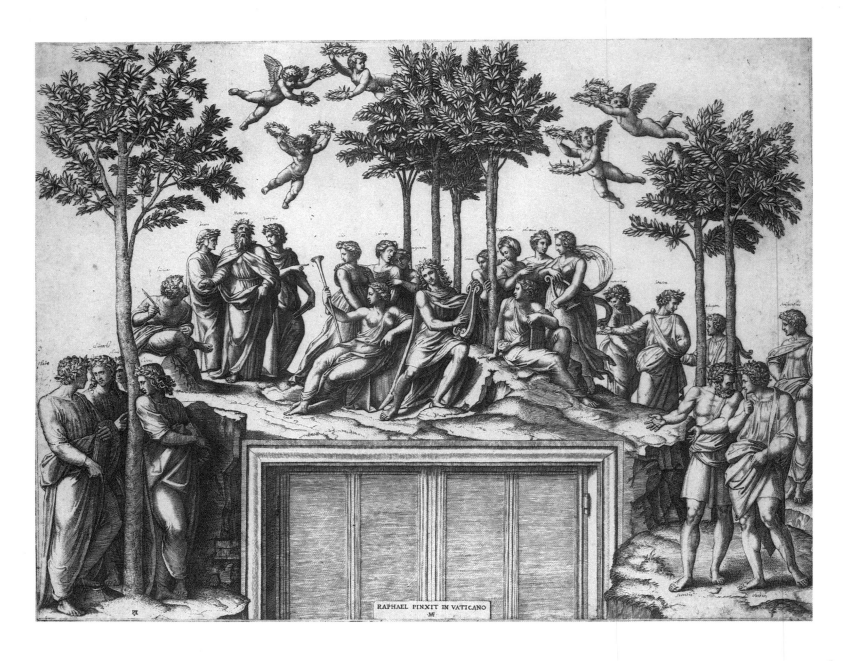

Raphael. *Pope Julius II*. c. 1512. Panel. 42½ × 31¾" (108 × 80.7 cm). The National Gallery, London.

in many different ways, all truly well varied and appropriate; save only the four Doctors of the Church, who, illumined by the Holy Spirit, are unravelling and expounding, by means of the Holy Scriptures, all the problems of the Gospels, which are held up by those little boys who have them in their hands as they hover in the air.

On another wall, where the other window is, on one side, he painted Justinian giving the Laws to the Doctors to be revised; and above this, Temperance, Fortitude, and Prudence. On the other side he the Pope [Gregory IX] giving the Canonical Decretals; for which Pope he made a portrait from life of Pope Julius, and, beside him, Cardinal Giovanni de' Medici, who became Pope Leo, Cardinal Antonio di Monte, and Cardinal Alessandro Farnese, who afterwards became Pope Paul III, with other portraits.

* * *

[Raffaello's] powers grew in such a manner, that he was commissioned by the Pope to go on to paint a second room, that near the Great Hall. And at this time, when he had gained a very great name, he also made a portrait of Pope Julius in a picture in oils, so true and so lifelike, that the portrait caused all who

The accepted title of the Justinian fresco is Tribonian Handing the Pandects to Justinian. *The Pandects were a digest of the fifty books of ancient Roman civic law, made by order of the Byzantine emperor Justinian in the sixth century.*

COLORPLATE 60

COLORPLATE 62

Julius is depicted here as Pope Gregory IX.

saw it to tremble, as if it had been the living man himself. This work is now in S. Maria del Popolo, together with a very beautiful picture of Our Lady, painted at the same time by the same master, and containing the Nativity of Jesus Christ, wherein is the Virgin laying a veil over her Son, whose beauty is such, both in the air of the head and in all the members, as to show that he is the true Son of God. And no less beautiful than the Child is the Madonna, in whom, besides her supreme loveliness, there may be seen piety and gladness. There is also a Joseph, who, leaning with both his hands on a staff, and lost in thoughtful contemplation of the King and Queen of Heaven, gazes with the adoration of a most saintly old man. Both these pictures are exhibited on days of solemn festival.

By this time Raffaello had acquired much fame in Rome; but, although his manner was graceful and held by all to be very beautiful, and despite the fact that he had seen so many antiquities in that city, and was for ever studying, nevertheless he had not yet given thereby to his figures that grandeur and majesty which he gave to them from that time onward. For it happened in those days that Michelagnolo made the terrifying outburst against the Pope in the chapel, of which we will speak in his Life; whence he was forced to fly to Florence. Whereupon Bramante, having the keys of the chapel, allowed Raffaello, who was his friend, to see it, to the end that he might be able to learn the methods of Michelagnolo. And the sight of it was the reason that Raffaello straightway repainted, although he had already finished it, the Prophet Isaiah that is to be seen in S. Agostino at Rome, above the S. Anne by Andrea Sansovino; in which work, by means of what he had seen of Michelagnolo's painting, he made the manner immeasurably better and more grand, and gave it greater majesty. Wherefore Michelagnolo, on seeing afterwards the work of Raffaello, thought, as was the truth, that Bramante had done him that wrong on purpose in order to bring profit and fame to Raffaello.

Andrea Sansovino (1460–1529), Italian sculptor and architect. The work mentioned here is still in the same location.

Not long after this, Agostino Chigi, a very rich merchant of Siena, who was much the friend of every man of excellence, gave Raffaello the commission to paint a chapel; and this he did because a short time before Raffaello had painted for him in his softest manner, in a loggia of his palace, now called the Chigi, in the Trastevere, a Galatea in a car on the sea drawn by two dolphins, and surrounded by Tritons and many sea-gods. Raffaello, then, having made the cartoon for that chapel, which is at the entrance of the Church of S. Maria della Pace, on the right hand as one goes into the church by the principal door, executed it in fresco, in his new manner, which was no little grander and more magnificent than his earlier manner. In this painting Raffaello depicted some Prophets and Sibyls, before Michelagnolo's chapel had been thrown open to view, although he had seen it; and in truth it is held to be the best of his works, and the most beautiful among so many that are beautiful, for in the women and children that are in it, there may be seen a marvellous vivacity and perfect colouring. And this work caused him to be greatly esteemed both in his lifetime and after his death, being the rarest and most excellent that Raffaello executed in all his life.

The palace for Chigi is the Farnesina, built in 1509–11 by the noted architect and painter Baldassare Peruzzi (1481–1536). Chigi was in fact a banker.

COLORPLATE 61

Next, spurred by the entreaties of a Chamberlain of Pope Julius, he painted the panel for the high-altar of the Araceli, wherein he made a Madonna in the sky, with a most beautiful landscape, a S. John, a S. Francis, and a S. Jerome represented as a Cardinal; in which Madonna may be seen a humility and a modesty truly worthy of the Mother of Christ; and besides the beautiful gesture of the Child as He plays with His Mother's hand, there is revealed in S. John that penitential air which fasting generally gives, while his head displays the sincerity of soul and frank assurance appropriate to those who live away from the world and despise it, and, in their dealings with mankind, make war on falsehood and speak out the truth. In like manner, the S. Jerome has his head uplifted with his eyes on the Madonna, deep in contemplation; and in them

It has been postulated that these frescoes were actually by Timoteo Viti (1469/70–1523), who was one of Raphael's many assistants. Vasari even says as much in his own Life of Viti.

COLORPLATE 64

Raphael. *The Prophet Isaiah.* 1511–12.
Detached fresco. 98½ × 61″ (250 × 155
cm). Church of Sant'Agostino, Rome.

seem to be suggested all the learning and knowledge that he showed in his
writings, while with both his hands he is presenting the Chamberlain, in the act
of recommending him to her; which portrait of the Chamberlain is as lifelike
as any ever painted. Nor did Raffaello fail to do as well in the figure of S. Fran-
cis, who, kneeling on the ground, with one arm outstretched, and with his head
upraised, is gazing up at the Madonna, glowing with a love in tone with the
feeling of the picture, which by both the lineaments and by the colouring,
shows him melting with affection, and taking comfort and life from the gra-
cious sight of her beauty and of the vivacity and beauty of her Son. In the mid-
dle of the panel, below the Madonna, Raffaello made a little boy standing, who
raised his head towards her and holding an inscription: than whom none bet-

ter or more graceful could be painted, what with the beauty of his features and the proportionate loveliness of his person. And in addition there is a landscape, which is singularly beautiful in its absolute perfection.

Afterwards, going on with the apartments of the Palace, he painted a scene of the Miracle of the Sacramental Corporal of Orvieto, or of Bolsena, whichever it may be called. In this scene there may be perceived in the face of the priest who is saying Mass, which is glowing with a blush, the shame that he felt on seeing the Host turned into blood on the Corporal on account of his unbelief. With terror in his eyes, dumbfounded and beside himself in the presence of his hearers, he seems like one who knows not what to do; and in the gesture of his hands may almost be seen the fear and trembling that a man would feel in such a case. Round him Raffaello made many figures, all varied and different, some serving the Mass, others kneeling on a flight of steps; and all, bewildered by the strangeness of the event, are making various most beautiful movements and gestures, while in many, both men and women, there is revealed a belief that they are to blame. Among the women is one who is seated on the ground at the foot of the scene, holding a child in her arms; and she, hearing the account that another appears to be giving her of the thing that has happened to the priest, turns in a marvellous manner as she listens to this, with a womanly grace that is very natural and lifelike. On the other side he painted Pope Julius hearing that Mass, a most marvellous work, wherein he made a portrait of Cardinal di San Giorgio, with innumerable others; and the window-opening he turned to advantage by making a flight of steps, in such a way that all the painting seems to be one whole: nay, it appears as if, were that window-space not there, the work would in no wise have been complete. Wherefore it may be truly credited to him that in the invention and composition of every kind of painted story, no one has ever been more dexterous, facile, and able than Raffaello.

COLORPLATE 66

This he also proved in another scene in the same place, opposite to the last-named, of S. Peter in the hands of Herod, and guarded in prison by men-at-arms; wherein he showed such a grasp of architecture, and such judgment in the buildings of the prison, that in truth the others after him seem to have more confusion than he has beauty. For he was ever seeking to represent stories just as they are written, and to paint in them things gracious and excellent; as is proved in this one by the horror of the prison, wherein that old man is seen bound in chains of iron between the two men-at-arms, by the deep slumber of the guards, and by the dazzling splendour of the Angel, which, in the thick darkness of the night, reveals with its light every detail of the prison, and makes the arms of the soldiers shine resplendent, in such a way that their burnished lustre seems more lifelike than if they were real, although they are only painted. No less art and genius are there in the action of S. Peter, when, freed from his chains, he goes forth from the prison, accompanied by the Angel, wherein one sees in the face of the Saint a belief that it is rather a dream than a reality; and so, also, terror and dismay are shown in some other armed guards without the prison, who hear the noise of the iron door, while a sentinel with a torch in his hand rouses the others, and, as he gives them light with it, the blaze of the torch is reflected in all their armour; and all that its glow does not reach is illumined by the light of the moon. This composition Raffaello painted over the window, where the wall is darkest; and thus, when you look at the picture, the light strikes you in the face, and the real light conflicts so well with the different lights of the night in the painting, that the smoke of the torch, the splendour of the Angel, and the thick darkness of the night seem to you to be wholly real and natural, and you would never say that it was all painted, so vividly did he express this difficult conception. In it are seen shadows playing on the armour, other shadows projected, reflections, and a vaporous glare from the lights, all executed with darkest shade, and so well, that it may be truly said that he was

COLORPLATE 67

the master of every other master; and as an effect of night, among all those that painting has ever produced, this is the most real and most divine, and is held by all the world to be the rarest.

On one of the unbroken walls, also, he painted the Divine Worship and the Ark of the Hebrews, with the Candlestick; and likewise Pope Julius driving Avarice out of the Temple, a scene as beautiful and as excellent as the Night described above. Here, in some bearers who are carrying Pope Julius, a most lifelike figure, in his chair, are portraits of men who were living at that time. And while the people, some women among them, are making way for the Pope, so that he may pass, one sees the furious onset of an armed man on horseback, who, accompanied by two on foot, and in an attitude of the greatest fierceness, is smiting and riding down the proud Heliodorus, who is seeking, at the command of Antiochus, to rob the Temple of all the wealth stored for the widows and orphans. Already the riches and treasures could be seen being removed and taken away, when, on account of the terror of the strange misfortune of Heliodorus, so rudely struck down and smitten by the three figures mentioned above (although, this being a vision, they are seen and heard by him alone), behold, they are all dropped and upset on the ground, those who were carrying them falling down through the sudden terror and panic that had come upon all the following of Heliodorus. Apart from these may be seen the holy Onias, the High Priest, dressed in his robes of office, with his eyes and hands raised to Heaven, and praying most fervently, being seized with pity for the poor innocents who were thus nearly losing their possessions, and rejoicing at the help that he feels has come down from on high. Besides this, through a beautiful fancy of Raffaello's, one sees many who have climbed on to the socles of the column-bases, and, clasping the shafts, stand looking in most uncomfortable attitudes; with a throng of people showing their amazement in various ways, and awaiting the result of this event.

This work is in every part so stupendous, that even the cartoons are held in the greatest veneration; wherefore Messer Francesco Masini, a gentleman of Cesena—who, without the help of any master, but giving his attention by himself from his earliest childhood, guided by an extraordinary instinct of nature, to drawing and painting, has painted pictures that have been much extolled by good judges of art—possesses, among his many drawings and some ancient reliefs in marble, certain pieces of the cartoon which Raffaello made for this story of Heliodorus, and he holds them in the estimation that they truly deserve. Nor will I refrain from saying that Messer Niccolò Masini, who has given me information about these matters, is as much a true lover of our arts as he is a man of real culture in all other things.

But to return to Raffaello; on the ceiling above these works, he then executed four scenes, God appearing to Abraham and promising him the multiplication of his seed, the Sacrifice of Isaac, Jacob's Ladder, and the Burning Bush of Moses: wherein may be recognized no less art, invention, draughtsmanship, and grace, than in the other works that he painted.

While the happy genius of this craftsman was producing such marvels, the envy of fortune cut short the life of Julius II, who had fostered such abilities, and had been a lover of every excellent work. Whereupon a new Pope was elected in Leo X, who desired that the work begun should be carried on; and Raffaello thereby soared with his genius into the heavens, and received endless favours from him, fortunate in having come upon a Prince so great, who had by the inheritance of blood a strong inclination for such an art. Raffaello, therefore, thus encouraged to pursue the work, painted on the other wall the Coming of Attila to Rome, and his encounter at the foot of Monte Mario with Leo I, who drove him away with his mere benediction. In this scene Raffaello made S. Peter and S. Paul in the air, with swords in their hands, coming to defend the Church; and while the story of Leo I says nothing of this, nevertheless it was

Contrary to the description, Julius is depicted as a spectator here. Raphael portrayed one of his assistants at the time, Giulio Romano (1499–1546), and the engraver Marcantonio Raimondi (c. 1480–1534) among the bearers of the papal sedan chair.

COLORPLATE 63

The drawing reproduced on page 166 is one of the surviving fragments of the cartoon.

COLORPLATE 65

The unusual colors and cloud- and fire-forms in the frescoed ceiling of the Stanza di Eliodoro were apparently inspired by rare Chinese fabrics that Raphael had seen in the papal collection.

The encounter took place in the year 452. History does not record what St. Leo the Great said to Attila that induced the Hun to spare Rome.

thus that he chose to represent it, perchance out of fancy, for it often happens that painters, like poets, go straying from their subject in order to make their work the more ornate, although their digressions are not such as to be out of harmony with their first intention. In those Apostles may be seen that celestial wrath and ardour which the Divine Justice is wont often to impart to the features of its ministers, charged with defending the most holy Faith; and of this we have proof in Attila, who is to be seen riding a black horse with white feet and a star on its forehead, as beautiful as it could be, for in an attitude of the utmost terror he throws up his head and turns his body in flight. There are other most beautiful horses, particularly a dappled jennet, which is ridden by a figure that has all the body covered with scales after the manner of a fish; which is copied from the Column of Trajan, wherein the figures have armour of that kind; and it is thought that such armour is made from the skins of crocodiles. There is Monte Mario, all aflame, showing that when soldiers march away, their quarters are always left a prey to fire. He made portraits from nature, also, in some mace-bearers accompanying the Pope, who are marvellously lifelike, as are the horses on which they are riding; and the same is true of the retinue of Cardinals, and of some grooms who are holding the palfrey on which rides the Pope in full pontificals (a portrait of Leo X, no less lifelike than those of the others), with many courtiers; the whole being a most pleasing spectacle and well in keeping with such a work, and also very useful to our art, particularly for those who have no such objects at their command.

At this same time he painted a panel containing Our Lady, S. Jerome robed as a Cardinal, and an Angel Raphael accompanying Tobias, which was placed in S. Domenico at Naples, in that chapel wherein is the Crucifix that spoke to S. Thomas Aquinas. For Signor Leonello da Carpi, Lord of Meldola, who is still alive, although more than ninety years old, he executed a picture that was most marvellous in colouring, and of a singular beauty, for it is painted with such force, and also with a delicacy so pleasing, that I do not think it is possible to do better. In the countenance of the Madonna may be seen such a divine air, and in her attitude such a dignity, that no one would be able to improve her;

Raphael. *Head of an Avenging Angel* (fragment of cartoon for *The Expulsion of Heliodorus from the Temple*). 1511. Black chalk, heightened with white on brown paper. 10½ × 13" (268 × 329 mm). The Louvre, Paris.

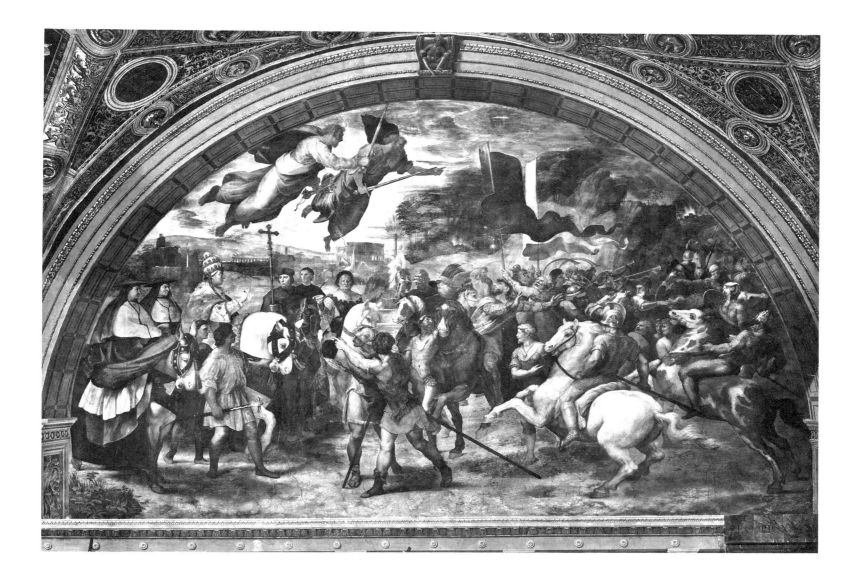

Raphael. *The Encounter between Attila the Hun and St. Leo the Great.* 1514. Fresco. Stanza di Eliodoro, Vatican, Rome.

and he made her with the hands clasped, adoring her Son, who is seated on her knees, caressing a S. John, a little boy, who is adoring Him, in company with S. Elizabeth and Joseph. This picture was once in the possession of the very reverend Cardinal da Carpi, the son of the said Signor Leonello, and a great lover of our arts; and it should be at the present day in the hands of his heirs.

Afterwards, Lorenzo Pucci, Cardinal of Santi Quattro, having been created Grand Penitentiary, Raffaello was favoured by him with a commission to paint a panel for S. Giovanni in Monte at Bologna, which is now set up in the chapel wherein lies the body of the Blessed Elena dall' Olio: in which work it is evident how much grace, in company with art, could accomplish by means of the delicate hands of Raffaello. In it is a S. Cecilia, who, entranced by a choir of angels on high, stands listening to the sound, wholly absorbed in the harmony; and in her countenance is seen that abstraction which is found in the faces of those who are in ecstasy. Scattered about the ground, moreover, are musical instruments, which have the appearance of being, not painted, but real and true; and such, also, are some veils that she is wearing, with vestments woven in silk and gold, and, below these, a marvellous hair-shirt. And in a S. Paul, who has the right arm leaning on his naked sword, and the head resting on the hand, one sees his profound air of knowledge, no less well expressed than the transformation of his pride of aspect into dignity. He is clothed in a simple red garment by way of mantle, below which is a green tunic, after the manner of the Apostles, and his feet are bare. There is also S. Mary Magdalene, who is holding in her hands a most delicate vase of stone, in an attitude of marvellous grace; turning her head, she seems full of joy at her conversion; and indeed,

COLORPLATE 69

167

in that kind of painting, I do not think that anything better could be done. Very beautiful, likewise, are the heads of S. Augustine and S. John the Evangelist. Of a truth, other pictures may be said to be pictures, but those of Raffaello life itself, for in his figures the flesh quivers, the very breath may be perceived, the pulse beats, and the true presentment of life is seen in them; on which account this picture gave him, in addition to the fame that he had already, an even greater name. Wherefore many verses were written in his honour, both Latin and in the vulgar tongue, of which, in order not to make my story longer than I have set out to do, I will cite only the following:

> *Though others were content to paint the*
> *Face, and mirror its colours; 'twas*
> *Raffaello who revealed Cecilia's soul.*

After this he also painted a little picture with small figures, which is likewise at Bologna, in the house of Count Vincenzio Ercolano, containing a Christ after the manner of Jove in Heaven, surrounded by the four Evangelists as Ezekiel describes them, one in the form of a man, another as a lion, the third an eagle, and the fourth an ox, with a little landscape below to represent the earth: which work, in its small proportions, is no less rare and beautiful than his others in their greatness.

Not Christ, but God the Father.

COLORPLATE 75

To the Counts of Canossa in Verona he sent a large picture of equal excellence, in which is a very beautiful Nativity of Our Lord, with a daybreak that is much extolled, as is also the S. Anne, and, indeed, the whole work, which cannot be more highly praised than by saying that it is by the hand of Raffaello da Urbino. Wherefore those Counts rightly hold it in supreme veneration, nor have they ever consented, for all the vast prices that have been offered to them by many Princes, to sell it to anyone.

For Bindo Altoviti, he made a portrait of him when he was a young man, which is held to be extraordinary; and likewise a picture of Our Lady, which he sent to Florence, and which is now in the Palace of Duke Cosimo, in the chapel of the new apartments, which were built and painted by me, where it serves as altar-piece. In it is painted a very old S. Anne, seated, and holding out to Our Lady her Son, the features of whose countenance, as well as the whole of His nude form, are so beautiful that with His smile He rejoices whoever beholds Him; besides which, Raffaello depicted, in painting the Madonna, all the beauty that can be imparted to the aspect of a Virgin, with the complement of chaste humility in the eyes, honour in the brow, grace in the nose, and virtue in the mouth; not to mention that her raiment is such as to reveal infinite simplicity and dignity. And, indeed, I do not think that there is anything better to be seen than this whole work. There is a nude S. John, seated, with a female saint, who is likewise very beautiful; and for background there is a building, in which he painted a linen-covered window that gives light to the room wherein are the figures.

COLORPLATE 71

In Rome he made a picture of good size, in which he portrayed Pope Leo, Cardinal Giulio de' Medici, and Cardinal de' Rossi. In this the figures appear to be not painted, but in full relief; there is the pile of the velvet, with the damask of the Pope's vestments shining and rustling, the fur of the linings soft and natural, and the gold and silk so counterfeited that they do not seem to be in colour, but real gold and silk. There is an illuminated book of parchment, which appears more real than the reality; and a little bell of wrought silver, which is more beautiful than words can tell. Among other things, also, is a ball of burnished gold on the Pope's chair, wherein are reflected, as if it were a mirror (such is its brightness), the light from the windows, the shoulders of the Pope, and the walls around the room. And all these things are executed with such diligence, that one may believe without any manner of doubt that no

COLORPLATE 76

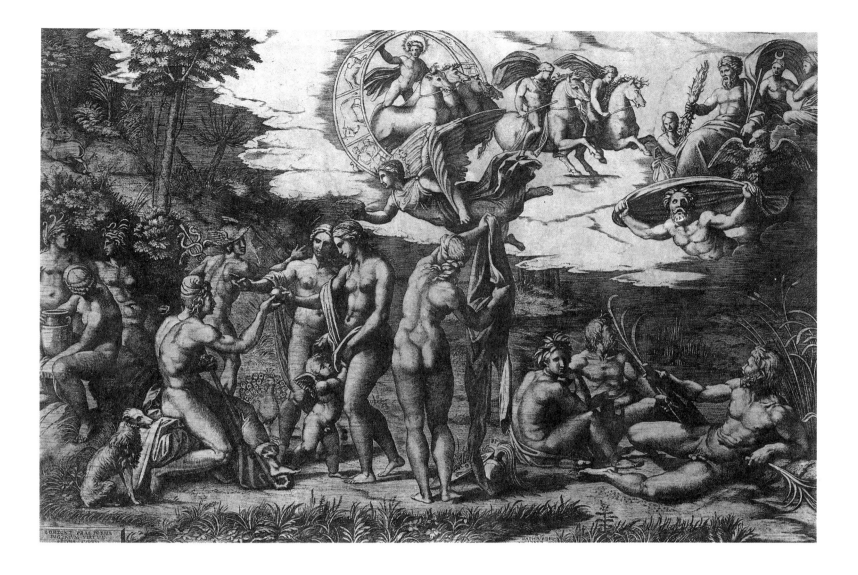

master is able, or is ever likely to be able, to do better. For this work the Pope was pleased to reward him very richly; and the picture is still to be seen in Florence, in the guardaroba of the Duke. In like manner he executed portraits of Duke Lorenzo and Duke Giuliano, with a perfect grace of colouring not achieved by any other than himself, which are in the possession of the heirs of Ottaviano de' Medici at Florence.

Thereupon there came to Raffaello a great increase of glory, and likewise of rewards; and for this reason, in order to leave some memorial of himself, he caused a palace to be built in the Borgo Nuovo at Rome, which Bramante executed with castings. Now, the fame of this most noble craftsman, by reason of the aforesaid works and many others, having passed into France and Flanders, Albrecht Dürer, a most marvellous German painter, and an engraver of very beautiful copperplates, rendered tribute to Raffaello out of his own works, and sent to him a portrait of himself, a head, executed by him in gouache on a cloth of fine linen, which showed the same on either side, the lights being transparent and obtained without lead-white, while the only grounding and colouring was done with water-colours, the white of the cloth serving for the ground of the bright parts. This work seemed to Raffaello to be marvellous, and he sent him, therefore, many drawings executed by his own hand, which were received very gladly by Albrecht. That head was among the possessions of Giulio Romano, the heir of Raffaello, in Mantua.

Raffaello, having thus seen the manner of the engravings of Albrecht Dürer, and desiring on his own behalf to show what could be done with his work by such an art, caused Marc' Antonio Bolognese to make a very thorough study of the method; and that master became so excellent, that Raffaello commis-

Marcantonio Raimondi (after Raphael). *The Judgment of Paris*. Copperplate engraving. National Gallery of Art, Washington, Gift of W. G. Russell Allen.

Surviving buildings attributed to Raphael are discussed and illustrated further on in this Life.

Albrecht Dürer (1471–1528), perhaps the greatest German artist. He was in Italy from mid-1505 until January 1507, but apparently the two artists never met. The works they exchanged are lost.

Marcantonio Raimondi made many copperplate engravings copied from Dürer's woodcuts; these, as well as Dürer's own prints, influenced a number of Italian artists of the time.

sioned him to make prints of his first works, such as the drawing of the Innocents, a Last Supper, the Neptune, and the S. Cecilia being boiled in oil. Marc' Antonio afterwards made for Raffaello a number of other engravings, which Raffaello finally gave to Baviera, his assistant, who had charge of a mistress whom Raffaello loved to the day of his death. Of her he made a very beautiful portrait, wherein she seemed wholly alive: and this is now in Florence, in the possession of that most gentle of men, Matteo Botti, a Florentine merchant, and an intimate friend of every able person, and particularly of painters, who treasures it as a relic, on account of the love that he bears to art, and above all to Raffaello. And no less esteem is shown to the works of our arts and the craftsmen by his brother, Simon Botti, who, besides being held by us all to be one of the most loving spirits that show favour to the men of our professions, is held in estimation by me in particular as the best and greatest friend that ever man loved after a long experience; not to mention the good judgment that he has and shows in matters of art.

But to return to the engravings; the favour shown by Raffaello to Baviera was the reason that there afterwards sprang up Marco da Ravenna and a host of others, insomuch that the dearth of copper engravings was changed into that abundance that we see at the present day. Thereupon Ugo da Carpi, having a brain inclined to ingenious and fanciful things, and showing beautiful invention, discovered the method of wood-engraving, whereby, with three blocks, giving the middle values, the lights, and the shadows, it is possible to imitate drawings in chiaroscuro, which was certainly a thing of beautiful and fanciful invention; and from this, also, there afterwards came an abundance of prints, as will be related with greater detail in the Life of Marc' Antonio Bolognese.

Raffaello then painted for the Monastery of the Monks of Monte Oliveto, called S. Maria dello Spasmo, at Palermo, a panel-picture of Christ bearing the Cross, which is held to be a marvellous work. In this may be seen the impious ministers of the Crucifixion, leading Him with wrath and fury to His death on Mount Calvary; and Christ, broken with agony at the near approach of death, has fallen to the ground under the weight of the Tree of the Cross, and, bathed with sweat and blood, turns towards the Maries, who are in a storm of weeping. Moreover, there is seen among them Veronica, who stretches out her arms and offers Him a cloth, with an expression of the tenderest love, not to mention that the work is full of men-at-arms both on horseback and on foot, who are pouring forth from the gate of Jerusalem with the standards of justice in their hands, in various most beautiful attitudes. This panel, when completely finished, but not yet brought to its resting-place, was very near coming to an evil end, for the story goes that after it had been put on shipboard, in order that it might be carried to Palermo, a terrible storm dashed against a rock the ship that was carrying it, in such a manner that the timbers broke asunder, and all the men were lost, together with the merchandise, save only the panel, which, safely packed in its case, was washed by the sea on to the shore of Genoa. There, having been fished up and drawn to land, it was found to be a thing divine, and was put into safe keeping; for it had remained undamaged and without any hurt or blemish, since even the fury of the winds and the waves of the sea had respect for the beauty of such a work. The news of this being then bruited abroad, the monks took measures to recover it, and no sooner had it been restored to them, by the favour of the Pope, than they gave satisfaction, and that liberally, to those who had rescued it. Thereupon it was once more put on board ship and brought at last to Sicily, where they set it up in Palermo; in which place it has more fame and reputation than the mount of Vulcan [Etna] itself.

While Raffaello was engaged on these works, which, having to gratify great and distinguished persons, he could not refuse to undertake—not to mention that his own private interests prevented him from saying them nay—yet for all

COLORPLATE 73

The identity of this "mistress" remains unknown. Many experts, however, believe La Donna Velata *(colorplate 73) is her portrait.*

The multiple-block technique Ugo da Carpi (1479–1532) invented was the first successful attempt at color reproduction. Such works are called chiaroscuro woodcuts; using this technique, Da Carpi made a number of prints of Raphael's work.

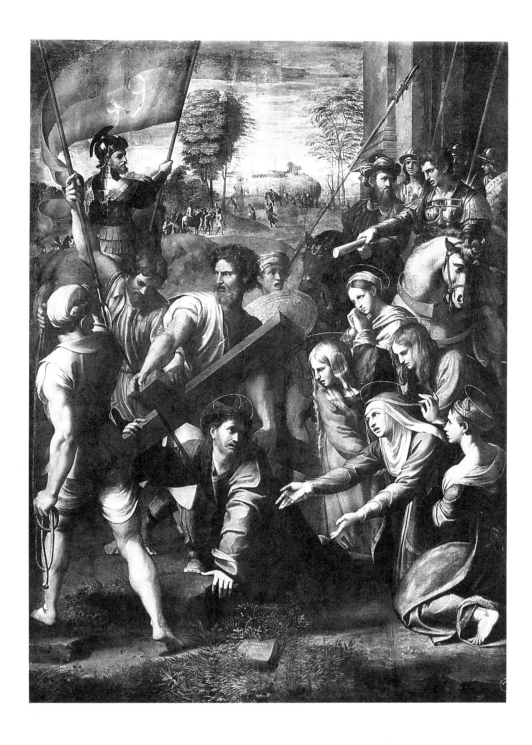

Raphael. *The Way to Calvary* (so-called *Spasimo di Sicilia*). 1517. Canvas. 125½ × 169½″ (318 × 229 cm). The Prado, Madrid.

this he never ceased to carry on the series of pictures that he had begun in the Papal apartments and halls; wherein he always kept men who pursued the work from his own designs, while he himself, continually supervising everything, lent to so vast an enterprise the aid of the best efforts of which he was capable. No long time passed, therefore, before he threw open the apartment of Borgia Tower in which he had painted a scene on every wall, two above the windows, and two others on the unbroken walls. In one was the Burning of the Borgo Vecchio of Rome, when, all other methods having failed to put out the fire, S. Leo IV presents himself at the Loggia of his Palace and extinguishes it completely with his benediction. In this scene are represented various perils. On one side are women who are bearing vessels filled with water in their hands and on their heads, whereby to extinguish the flames; and their hair and draperies are blown about by the terrible fury of a tempestuous wind. Others, who are seeking to throw water on the fire, are blinded by the smoke and wholly bewildered. On the other side, after the manner of Virgil's story of Anchises being carried by Aeneas, is shown an old sick man, overcome by his infirmity and the

COLORPLATE 68

According to the Liber Pontificalis, *St. Leo IV (r. 847–55) made the sign of the cross, thus miraculously extinguishing a fire that was devastating the Borgo district.*

Here Raphael introduced an episode from Virgil's epic poem, The Aeneid: *Anchises (Aeneas's father) is rescued by his son from the ruins of burning Troy. (According to legend, Aeneas founded Rome.)*

flames of the fire; and in the figure of the young man are seen courage and strength, and great effort in all his limbs under the weight of the old man, who lies helpless on the young man's back. He is followed by an old woman with bare feet and disordered garments, who is flying from the fire; and a little naked boy runs before them. On top of some ruins, likewise, may be seen a naked woman, with hair all dishevelled, who has her child in her hands and is throwing him to a man of her house, who, having escaped from the flames, is standing in the street on tiptoe, with arms outstretched to receive the child wrapped in swathing-bands; wherein the eager anxiety of the woman to save her son may be recognized no less clearly than her torment in the peril of the fierce flames, which are already licking around her. And no less suffering is evident in him who is receiving the child, both for its sake and on account of his own fear of death. Nor is it possible to describe the imagination that this most ingenious and most marvellous craftsman showed in a mother with her feet bare, her garments in disorder, her girdle unbound, and her hair dishevelled, who has gathered her children before her and is driving them on, holding part of her clothing in one hand, that they may escape from the ruins and from that blazing furnace; not to mention that there are also some women who, kneeling before the Pope, appear to be praying to his Holiness that he should make the fire cease.

The next scene is from the life of the same S. Leo IV, wherein Raffaello depicted the port of Ostia occupied by the fleet of the Turks, who had come to take the Pope prisoner. The Christians may be seen fighting against that fleet on the sea; and already there has come to the harbour an endless number of prisoners, who are disembarking from a boat and being dragged by the beard by some soldiers, who are very beautiful in features and most spirited in their attitudes. The prisoners, dressed in the motley garb of galley-slaves, are being led before S. Leo, whose figure is a portrait of Pope Leo X. Here Raffaello painted his Holiness in pontificals, between Cardinal Santa Maria in Portico, who was Bernardo Divizio of Bibbiena, and Cardinal Giulio de' Medici, who afterwards became Pope Clement. Nor is it possible to describe in detail the beautiful conceptions that this most ingenious craftsman showed in the expressions of the prisoners, wherein one can recognize, without speech, their grief and the fear of death.

In the first of the other two scenes is Pope Leo X consecrating the most Christian King, Francis I of France, chanting the Mass in his pontificals, and blessing the oil for the anointing of the King, and likewise the royal crown. There, besides the great number of Cardinals and Bishops in their robes, who are assisting, he portrayed from life many Ambassadors and other persons, and also some figures dressed in the French fashion, according to the style of that time. In the other scene he painted the Crowning of the same King, wherein are portraits from life of the Pope and of Francis, one in armour and the other in his pontificals; besides which, all the Cardinals, Bishops, Chamberlains, Esquires, and Grooms of the Chamber are seated in due order in their places, as is the custom in the chapel, all in their robes and portrayed from life, among them being Giannozzo Pandolfini, Bishop of Troia, a close friend of Raffaello, with many others who were distinguished at that time. Near the king is a little boy kneeling, who is holding the royal crown—a portrait of Ippolito de' Medici, who afterwards became Cardinal and Vice-Chancellor, a man of great repute, and much the friend not only of this art, but of all others, to whose blessed memory I acknowledge a vast obligation, seeing that my first steps, such as they were, were taken under his auspices.

It is not possible to write of every detail in the works of this craftsman, wherein every least thing, although dumb, appears to have speech: save only of the bases executed below these pictures, with various figures of defenders and benefactors of the Church, and various terminal figures on either side of them,

This fresco actually depicts the coronation of the Emperor Charlemagne (742–814). Here again, Raphael portrays contemporary individuals as protagonists from a bygone era.

Titian's portrait of Ippolito is reproduced on page 357.

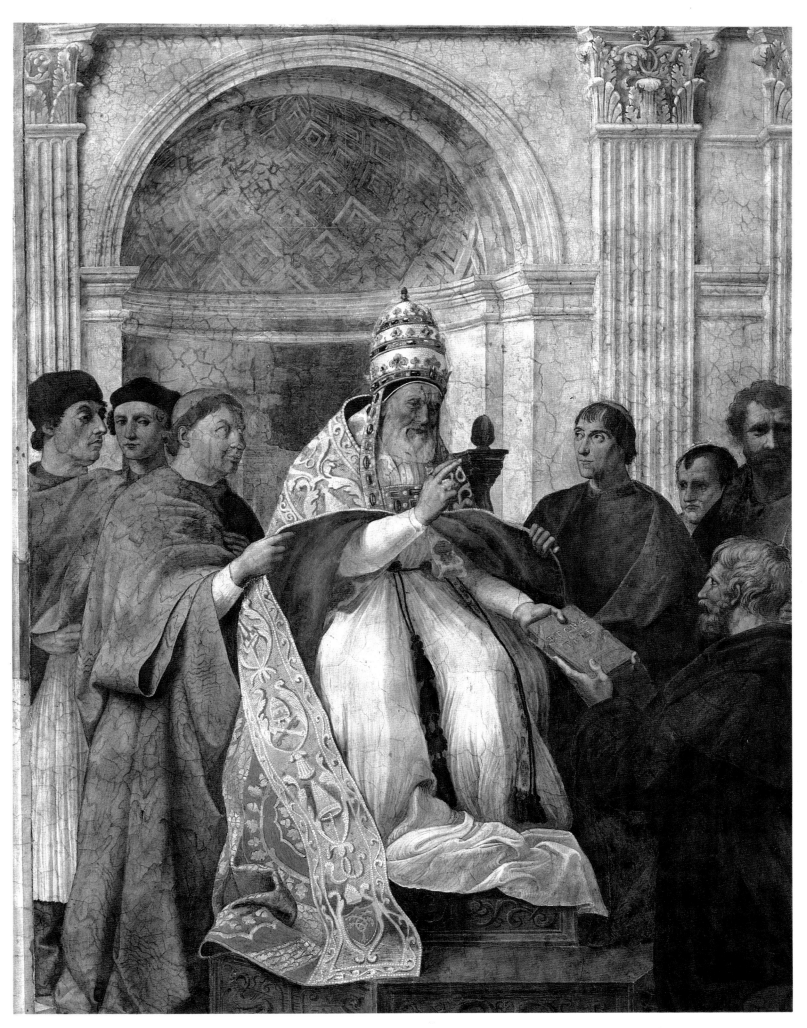

COLORPLATE 62. Raphael. *Pope Gregory Dispensing Canonic Laws.* 1511. Fresco.
Stanza della Segnatura, Vatican, Rome.

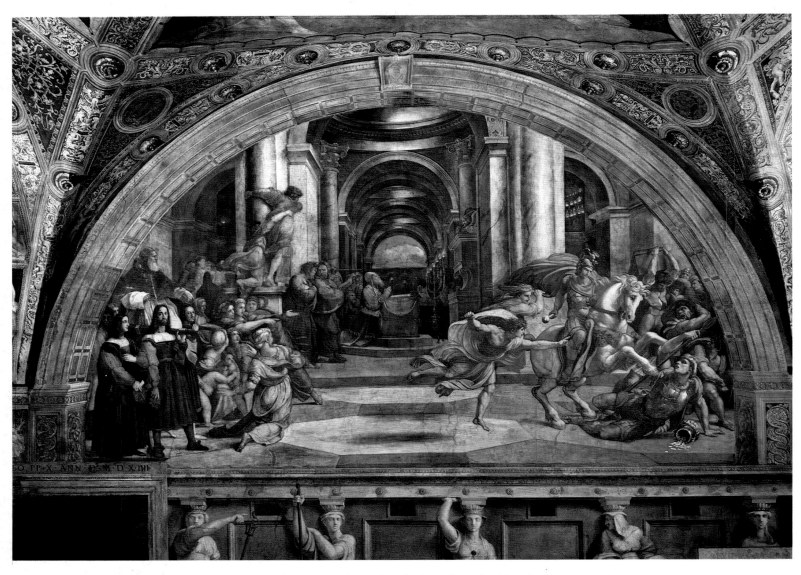

COLORPLATE 63. Raphael. *Expulsion of Heliodorus from the Temple.* 1511–12. Fresco.
Stanza di Eliodoro, Vatican, Rome.

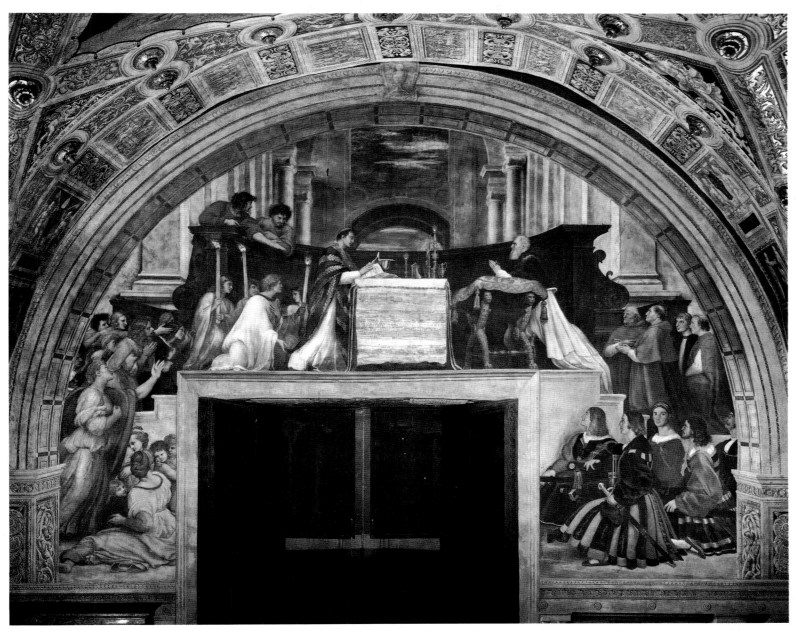

COLORPLATE 66. Raphael. *The Mass of Bolsena*. 1512. Fresco.
Stanza di Eliodoro, Vatican, Rome.

COLORPLATE 67. Raphael. *The Deliverance of St. Peter.* 1513–14. Fresco.
Stanza di Eliodoro, Vatican, Rome.

the whole being wrought in such a manner that everything reveals spirit, feeling, and thought, and with such a harmony and unity of colouring that nothing better can be conceived. And since the ceiling of that apartment had been painted by Pietro Perugino, his master, Raffaello would not destroy it, moved by respect for his memory and by the love that he bore to the man who had been the origin of the rank that he held in his art.

Such was the greatness of the master, that he kept designers all over Italy, at Pozzuolo, and even in Greece; and he was for ever searching out everything of the good that might help his art.

Now, continuing his work, he also painted a hall, wherein were some figures of the Apostles and other saints in tabernacles, executed in terretta; and there he caused to be made by Giovanni da Udine, his disciple, who has no equal in the painting of animals, all the animals that Pope Leo possessed, such as the chameleon, the civet-cats, the apes, the parrots, the lions, the elephants, and other beasts even more strange. And besides embellishing the Palace greatly with grotesques and varied pavements, he also gave the designs for the Papal staircases, as well as for the loggie begun by the architect Bramante, but left

Raphael (executed by Raphael's assistants). *Portion of Vaulting with Scenes from Genesis.* 1518–19. Loggia of Raphael, Vatican, Rome.

unfinished on account of his death, and afterwards carried out with the new design and architecture of Raffaello, who made for this a model of wood with better proportion and adornment than had been accomplished by Bramante. The Pope wishing to demonstrate the greatness and magnificence of his generous ambition, Raffaello made the designs for the ornaments in stucco and for the scenes that were painted there, and likewise for the compartments; and as for the stucco and the grotesques, he placed at the head of that work Giovanni da Udine, and the figures he entrusted to Giulio Romano, although that master worked but little at them; and he also employed Giovanni Francesco, Il Bologna, Perino del Vaga, Pellegrino da Modena, Vincenzio da San Gimignano, and Polidoro da Caravaggio, with many other painters, who executed scenes and figures and other things that were required throughout the work, which Raffaello caused to be completed with such perfection, that he even sent to Florence for pavements by the hand of Luca della Robbia. Wherefore it is certain that with regard to the paintings, the stucco-ornaments, the arrangement, or any of the beautiful inventions, no one would be able to execute or even to imagine a more marvellous work; and its beauty was the reason that Raffaello received the charge of all the works of painting and architecture that were in progress in the Palace.

It is said that the courtesy of Raffaello was such that he prevailed upon the masons, in order that he might accommodate his friends, not to build the walls absolutely solid and unbroken, but to leave, above the old rooms below, various openings and spaces for the storage of barrels, flasks, and wood; which holes and spaces so weakened the lower part of the masonry, that afterwards they had to be filled in, because the whole was beginning to show cracks. He commissioned Gian Barile to adorn all the doors and ceilings of woodwork with a good number of carvings, which he executed and finished with beautiful grace.

He gave architectural designs for the Vigna [Villa Madama] of the Pope, and for many houses in the Borgo; in particular, for the Palace of Messer Giovanni Battista dall' Aquila, which was a very beautiful work. He also designed one for the Bishop of Troia, who had it built in the Via di S. Gallo at Florence. For the Black Friars of S. Sisto in Piacenza, he painted the picture for their high-altar, containing the Madonna with S. Sisto and S. Barbara, a truly rare and extraordinary work. He executed many pictures to be sent into France, and in particular, for the King, a S. Michael fighting with the Devil, which was held to be a marvellous thing. In this work he painted a fire-scarred rock, to represent the centre of the earth, from the fissures of which were issuing sulphurous flames; and in Lucifer, whose scorched and burned limbs are painted with various tints of flesh-colour, could be seen all the shades of anger that his venomous and swollen pride calls up against Him who overbears the greatness of him who is deprived of any kingdom where there might be peace, and doomed to suffer perpetual punishment. The opposite may be perceived in the S. Michael, clad in armour of iron and gold, who, although he is painted with a celestial air, yet has valour, force, and terror in his aspect, and has already thrown Lucifer down and hurled him backwards with his spear. In a word, this work was of such a kind that he won for it, and rightly, a most honourable reward from that King. He made portraits of Beatrice of Ferrara and other ladies, and in particular that of his own mistress, with an endless number of others.

Raffaello was a very amorous person, delighting much in women, and ever ready to serve them; which was the reason that, in the pursuit of his carnal pleasures, he found his friends more complacent and indulgent towards him than perchance was right. Wherefore, when his dear friend Agostino Chigi commissioned him to paint the first loggia in his palace, Raffaello was not able to give much attention to his work, on account of the love that he had for his mistress; at which Agostino fell into such despair, that he so contrived by means

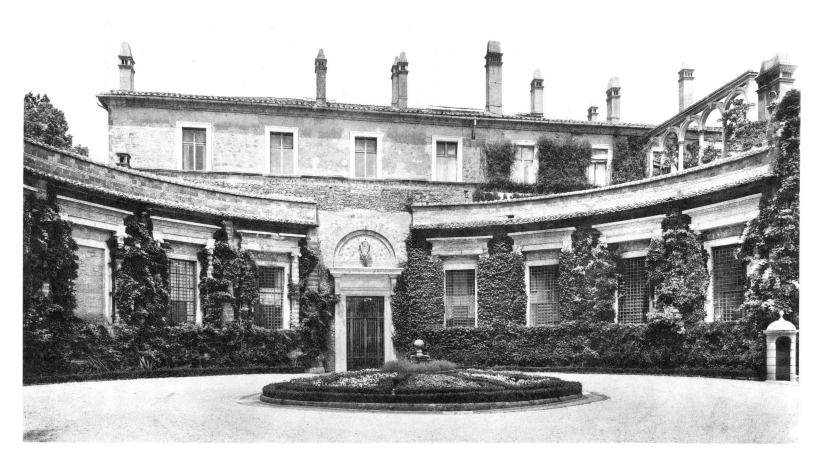

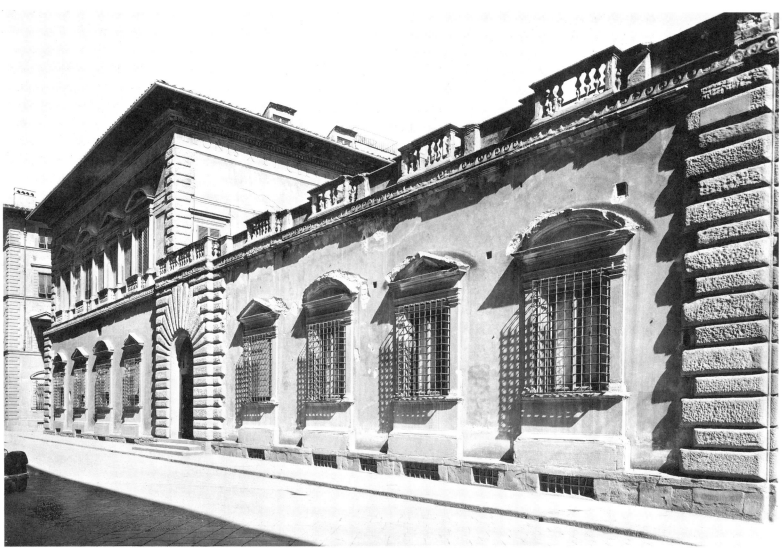

183

Raphael. *St. Michael Overcoming the Devil.*
1518. Panel. 184¾ × 63″ (268 × 160 cm).
The Louvre, Paris.

of others, by himself, and in other ways, as to bring it about, although only
with difficulty, that this lady should come to live continually with Raffaello in
that part of the house where he was working; and in this manner the work was
brought to completion. For this work he made all the cartoons, and he col-
oured many of the figures in fresco with his own hand. And on the ceiling he
made the Council of the Gods in Heaven, wherein, in the forms of the Gods,
are seen many vestments and lineaments copied from the antique, and exe-
cuted with very beautiful grace and draughtsmanship. In like manner he made
the Marriage of Psyche, with ministers serving Jove, and the Graces scattering
flowers over the table. In the spandrels of the vaulting he executed many scenes,

*This fresco was most probably executed by
Raphael's assistants.*

COLORPLATE 74

in one of which is Mercury with his flute, who, as he flies, has all the appearance of descending from Heaven; and in another is Jove with an air of celestial dignity, kissing Ganymede; and in another, likewise, lower down, is the Car of Venus, and the Graces, with Mercury, drawing Psyche up to Heaven; with many other scenes from the poets in the other spandrels. And in the spherical triangles of the vaulting above the arches, between the spandrels, are many most beautiful little boys in foreshortening, hovering in the air and carryng all the instruments of the gods; Jove's lightnings and thunderbolts, the helmet, sword, and shield of Mars, Vulcan's hammers, the club and lion-skin of Hercules, the caduceus of Mercury, Pan's pipes, and the agricultural rakes of Vertumnus. All are accompanied by animals appropriate to their character; and the whole work, both as picture and as poem, is truly beautiful. Round these scenes he caused Giovanni da Udine to make a border of all kinds of flowers, foliage, and fruits, in festoons, which are as beautiful as they could be.

Raffaello made the designs for the architecture of the stables of the Chigi, and the design for the chapel of the aforesaid Agostino in S. Maria del Popolo, wherein, besides painting it, he made agreements for the erection of a marvellous tomb, causing Lorenzetto, a sculptor of Florence, to execute two figures, which are still in his house in the Macello de' Corbi at Rome; but the death of Raffaello, followed by that of Agostino, brought it about that this work was given to Sebastiano [del Piombo].

Meanwhile Raffaello had risen to such greatness, that Leo X ordained that he should set to work on the Great Hall on the upper floor, wherein are the Victories of Constantine; and with this he made a beginning. A fancy likewise took the Pope to have some very rich tapestries made in gold and floss-silk; whereupon Raffaello drew and coloured with his own hand, of the exact form and size, all the cartoons, which were sent to Flanders to be woven; and the tapestries, when finished, were brought to Rome. This work was executed so marvellously, that it arouses astonishment in whoever beholds it, wondering how it could have been possible to weave the hair and beards in such detail, and to give softness to the flesh with mere threads; and it is truly rather a miracle than the work of human art, seeing that in these tapestries are animals, water, and buildings, all made in such a way that they seem to be not woven, but really wrought with the brush. The work cost 70,000 crowns, and it is still preserved in the Papal Chapel.

For Cardinal Colonna he painted a S. John on canvas, for which, on account of its beauty, that Cardinal had an extraordinary love; but happening to be attacked by illness, he was asked by Messer Jacopo da Carpi, the physician who cured him, to give it to him as a present; and because of this desire of Messer Jacopo, to whom he felt himself very deeply indebted, he gave it up. It is now in the possession of Francesco Benintendi, in Florence.

For Giulio de' Medici, Cardinal and Vice-Chancellor, he painted a panel-picture, to be sent into France, of the Transfiguration of Christ, at which he laboured without ceasing, and brought it to the highest perfection with his own hand. In this scene he represented Christ Transfigured on Mount Tabor, at the foot of which are the eleven Disciples awaiting Him. There may be seen a young man possessed by a spirit, who has been brought thither in order that Christ, after descending from the mountain, may deliver him; which young man stretches himself out in a distorted attitude, crying and rolling his eyes, and reveals his suffering in his flesh, his veins, and the beat of his pulse, all infected by that malignant spirit; and the colour of his flesh, as he makes those violent and fearsome gestures, is very pale. This figure is supported by an old man, who, having embraced him and taken heart, with his eyes wide open and the light shining in them, is raising his brows and wrinkling his forehead, showing at one and the same time both strength and fear; gazing intently, however, at the Apostles, he appears to be encouraging himself by trusting in them.

Lorenzo Lotti, called Il Lorenzetto (from a design by Raphael). *Jonah*. c. 1520. Marble. Height: 76″ (193 cm). Chigi Chapel, Church of Santa Maria del Popolo, Rome.

Among many women is one, the principal figure in that panel, who, having knelt down before the Apostles, and turning her head towards them, stretches her arms in the direction of the maniac and points out his misery; besides which the Apostles, some standing, some seated, and others kneeling, show that they are moved to very great compassion by such misfortune. And, indeed, he made therein figures and heads so fine in their novelty and variety, to say nothing of their extraordinary beauty, that it is the common opinion of all craftsmen that this work, among the vast number that he painted, is the most glorious, the most lovely, and the most divine. For whoever wishes to know how Christ Transfigured and made Divine should be represented in painting, must look at this work, wherein Raffaello made Him in perspective over that mount, in a sky of exceeding brightness, with Moses and Elias, who, illumined by a dazzling splendour, burst into life in His light. Prostrate on the ground, in attitudes of great beauty and variety, are Peter, James, and John; one has his head

to the earth, and another, shading his eyes with his hands, is defending himself from the rays and intense light of the splendour of Christ. He, clothed in snow-white raiment, with His arms outstretched and His head raised, appears to reveal the Divine essence and nature of all the Three Persons united and concentrated in Himself by the perfect art of Raffaello, who seems to have summoned up all his powers in such a manner, in order to show the supreme force of his art in the countenance of Christ, that, after finishing this, the last work that he was to do, he never again touched a brush, being overtaken by death.

Now, having described the works of this most excellent craftsman, before I come to relate other particulars of his life and death, I do not wish to grudge the labour of saying something, for the benefit of the men of our arts, about the various manners of Raffaello. He, then, after having imitated in his boyhood the manner of his master, Pietro Perugino, which he made much better in draughtsmanship, colouring, and invention, believed that he had done enough; but he recognized, when he had reached a riper age, that he was still too far from the truth. For, after seeing the works of Leonardo da Vinci, who had no peer in the expressions of heads both of men and of women, had surpassed all other painters in giving grace and movement to his figures, he was left marvelling and amazed; and in a word, the manner of Leonardo pleasing him more

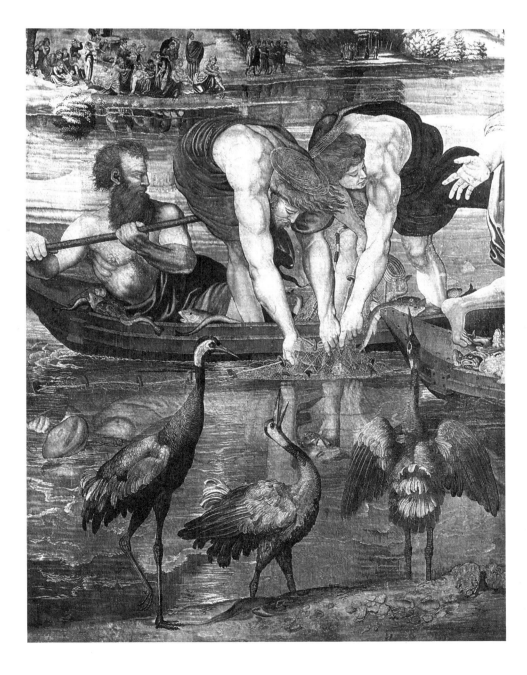

Raphael. *The Miraculous Draught of Fishes* (portion). 1519. Tapestry. Vatican, Rome.

Raphael. *The Youthful St. John the Baptist in the Wilderness.* 1518–19. Canvas. 33½ × 23½″ (85 × 60 cm). Accademia di Belle Arti, Florence.

than any other that he had ever seen, he set himself to study it, and abandoning little by little, although with great difficulty, the manner of Pietro, he sought to the best of his power and knowledge to imitate that of Leonardo. But for all his diligence and study, in certain difficulties he was never able to surpass Leonardo; and although it appears to many that he did surpass him in sweetness and in a kind of natural facility, nevertheless he was by no means superior to him in that sublime groundwork of conceptions and that grandeur of art in which few have been the peers of Leonardo. Yet Raffaello came very near to him, more than any other painter, and above all in grace of colouring. But to return to Raffaello himself; in time he found himself very much hindered and impeded by the manner that he had adopted from Pietro when he was quite young, which he acquired with ease, since it was over-precise, dry, and feeble in draughtsmanship. His being unable to forget it was the reason that he had great difficulty in learning the beauties of the nude and the methods of difficult foreshortenings from the cartoon that Michelagnolo Buonarroti made for the Council Hall in Florence; and another might have lost heart, believing that he had been previously wasting his time, and would never have achieved, however lofty his genius, what Raffaello accomplished. But he, having purged himself of Pietro's manner, and having thoroughly freed himself of it, in order to learn the manner of Michelagnolo, so full of difficulties in every part, was changed, as it were, from a master once again into a disciple; and he forced himself with incredible study, when already a man, to do in a few months what

The drawing reproduced on page 198 is considered as the most accurate copy of the central figure of the long-lost Leonardo Leda.

For an account of Michelangelo's project for a fresco in the Council Hall of the Palazzo Vecchio, see page 229.

COLORPLATE 70. Raphael. *Portrait of Baldassare Castiglione*. 1514–15. Canvas. 32⅜ × 26⅜″ (82 × 67 cm).
The Louvre, Paris.

COLORPLATE 71. Raphael. *Portrait of Bindo Altoviti.* c. 1515. Panel. 23½ × 17¼″ (60.0 × 44.0 cm).
National Gallery of Art, Washington, Samuel H. Kress Collection.

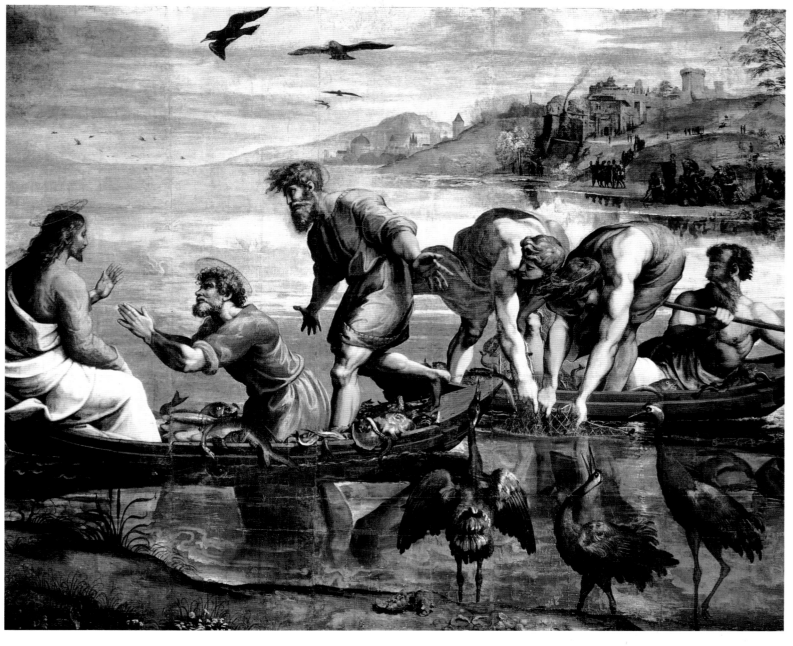

COLORPLATE 72. Raphael. *The Miraculous Draught of Fishes* (tapestry cartoon). 1515. Tempera on paper. 142 × 158″ (360 × 400 cm). The Victoria and Albert Museum, London.

COLORPLATE 73. Raphael. *La Donna Velata*. 1516. Oil on Panel. 33½ × 25¼″ (85 × 64 cm).
Pitti Gallery, Florence.

COLORPLATE 74. Raphael. *Ceiling of the Loggia di Psiche*. 1517. Fresco.
Villa Farnesina, Rome.

COLORPLATE 75. Raphael. *The Vision of Ezekiel*. 1518. Panel. 15¾ × 12″ (40 × 30 cm).
Pitti Gallery, Florence.

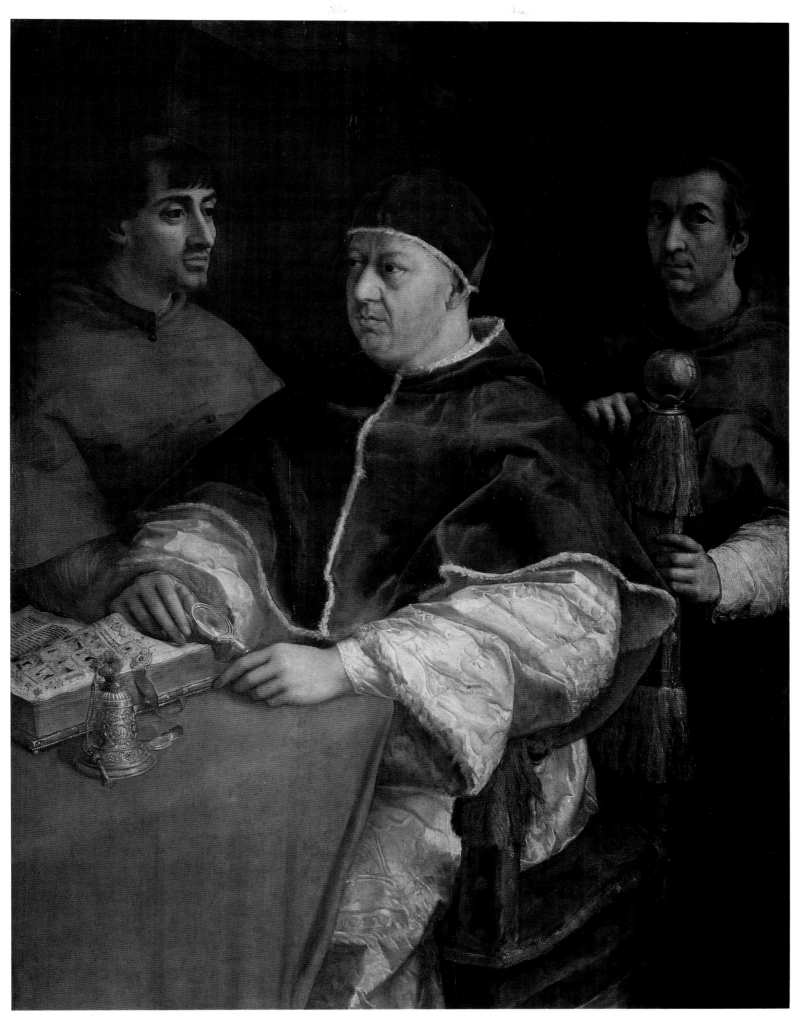

COLORPLATE 76. Raphael. *Pope Leo X with Cardinals Giulio de'Medici and Luigi de'Rossi.* 1518–19. Panel.
60¾ × 47″ (154 × 119 cm). Uffizi Gallery, Florence.

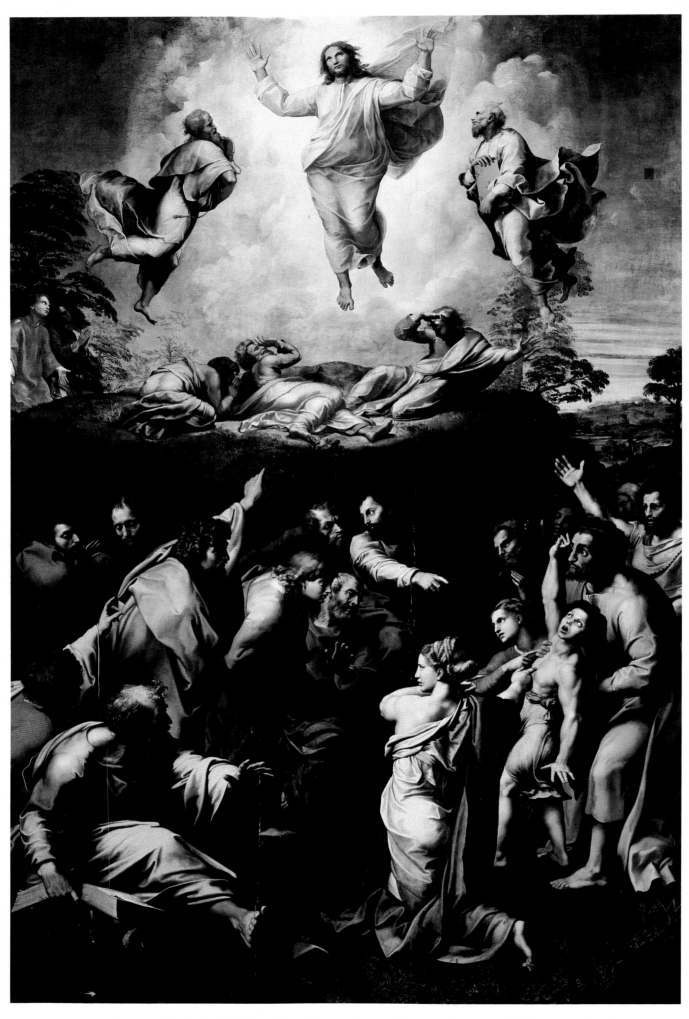

COLORPLATE 77. Raphael. *The Transfiguration*. 1518–20. Canvas. 160 × 139¾″ (405 × 278 cm).
Pinacoteca Vaticana, Rome.

might have called for the tender age at which all things are best acquired, and for a space of many years. For in truth he who does not learn in good time right principles and the manner that he wishes to follow, and does not proceed little by little to solve the difficulties of the arts by means of experience, seeking to understand every part, and to put it into practice, can scarcely ever become perfect; and even if he does, that can only be after a longer space of time and much greater labour.

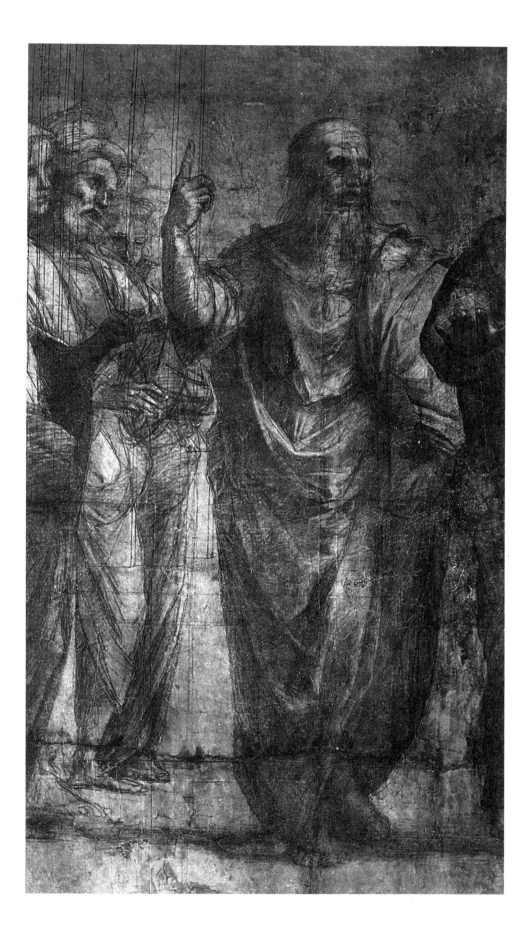

Raphael. *Leonardo da Vinci as Plato* (detail from cartoon for *The School of Athens*. 1509. Charcoal, pencil, and wash, highlighted with white, on joined sheets of paper. Pinacoteca Ambrosiana, Milan.

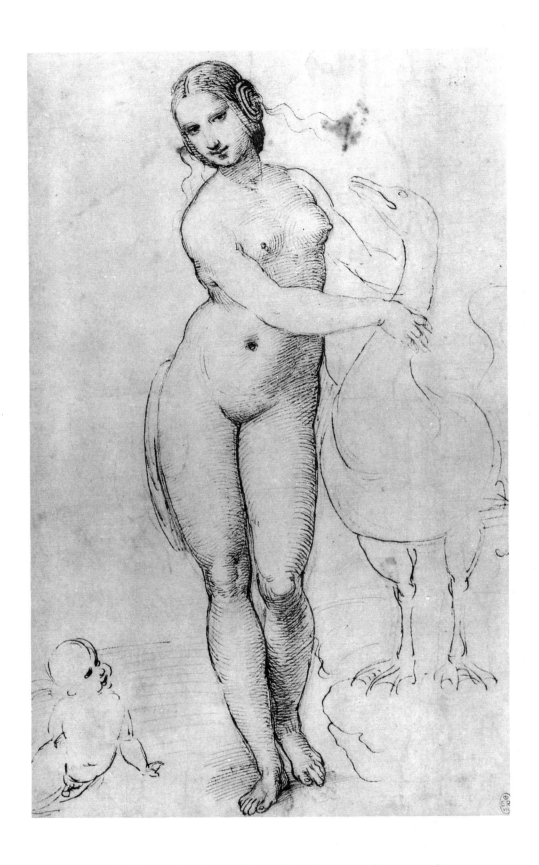

Raphael. *Leda and the Swan* (after Leonardo
da Vinci's now-lost painting). c. 1506. Pen
and ink over stylus sketch. 12 × 7½″ (208
× 192 mm). Royal Library, Windsor
Castle.

When Raffaello resolved to set himself to change and improve his manner,
he had never given his attention to nudes with that zealous study which is nec-
essary, and had only drawn them from life in the manner that he had seen
practised by his master Pietro, imparting to them the grace that he had from
nature. He then devoted himself to studying the nude and to comparing the
muscles of anatomical subjects and of flayed human bodies with those of the
living, which, being covered with skin, are not clearly defined, as they are when
the skin has been removed; and going on to observe in what way they acquire
the softness of flesh in the proper places, and how certain graceful flexures are
produced by changing the point of view, and also the effect of inflating, low-
ering, or raising either a limb or the whole person, and likewise the concaten-

ation of the bones, nerves, and veins, he became excellent in all the points that are looked for in a painter of eminence. Knowing, however, that in this respect he could never attain to the perfection of Michelagnolo, he reflected, like a man of supreme judgment, that painting does not consist only in representing the nude human form, but has a wider field; that one can enumerate among the perfect painters those who express historical inventions well and with facility, and who show fine judgment in their fancies; and that he who, in the composition of scenes, can make them neither confused with too much detail nor poor with too little, but distributed with beautiful invention and order, may also be called an able and judicious craftsman. To this, as Raffaello was well aware, may be added the enriching those scenes with a bizarre variety of perspectives, buildings, and landscapes, the method of clothing figures gracefully, the making them fade away sometimes in the shadows, and sometimes come forward into the light, the imparting of life and beauty to the heads of women, children, young men and old, and the giving them movement and boldness, according to necessity. He considered, also, how important is the furious flight of horses in battles, fierceness in soldiers, the knowledge how to depict all the sorts of animals, and above all the power to give such resemblance to portraits that they seem to be alive, and that it is known whom they represent; with an endless number of other things, such as the adornment of draperies, foot-wear, helmets, armour, women's head-dresses, hair, beards, vases, trees, grottoes, rocks, fires, skies turbid or serene, clouds, rain, lightning, clear weather, night, the light of the moon, the splendour of the sun, and innumerable other things, which are called for every moment by the require-

Raphael. *Four Horsemen and a Captive Soldier* (study after Pinturicchio's *Piccolomini Cycle*). c. 1503. Pen and ink and watercolor. 10¾ × 15¾" (272 × 400 mm). Gabinetto Disegni e Stampe, Uffizi, Florence.

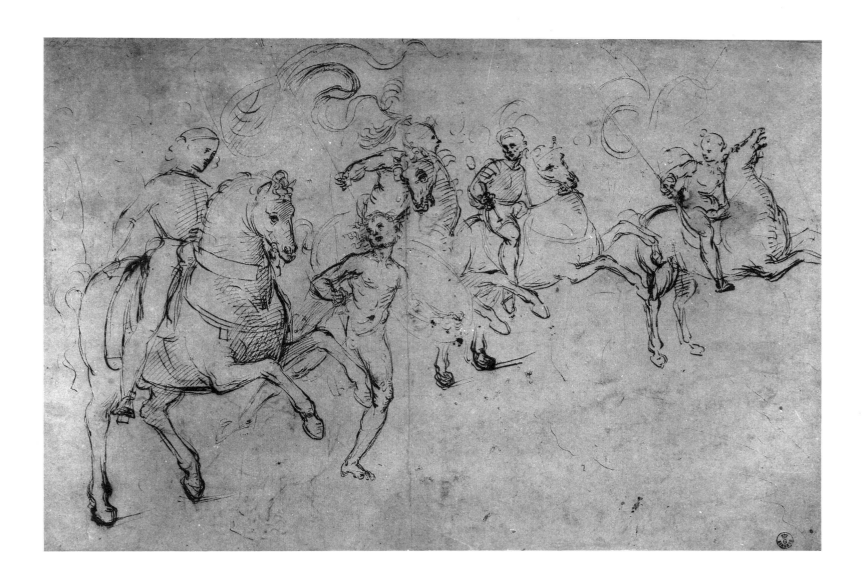

ments of the art of painting. Pondering over these things, I say, Raffaello resolved, since he could not approach Michelagnolo in that branch of art to which he had set his hand, to seek to equal, and perchance to surpass him, in these others; and he devoted himself, therefore, not to imitating the manner of that master, but to the attainment of a catholic excellence in the other fields of art that have been described. And if the same had been done by many craftsmen of our own age, who, having determined to pursue the study of Michelagnolo's works alone, have failed to imitate him and have not been able to reach his extraordinary perfection, they would not have laboured in vain nor acquired a manner so hard, so full of difficulty, wanting in beauty and colouring, and poor in invention, but would have been able, by aiming at catholicity and at imitation in the other fields of art, to render service both to themselves and to the world.

Raffaello, then, having made this resolution, and having recognized that Fra Bartolommeo di San Marco had a passing good method of painting, well-grounded draughtsmanship, and a pleasing manner of colouring, although at times, in order to obtain stronger relief, he made too much use of darks, took from him what appeared to him to suit his need and his fancy—namely, a middle course, both in drawing and colouring; and mingling with that method certain others selected from the best work of other masters, out of many manners he made one, which was looked upon ever afterwards as his own, and which was and always will be vastly esteemed by all craftsmen. This was then seen perfected in the Sibyls and Prophets of the work that he executed, as has been related, in S. Maria della Pace; in the carrying out of which work he was greatly assisted by having seen the paintings of Michelagnolo in the Chapel of the Pope. And if Raffaello had remained content with this same manner, and had not sought to give it more grandeur and variety in order to prove that he had as good a knowledge of the nude as Michelagnolo, he would not have lost a part of the good name that he had acquired; but the nudes that he made in that apartment of the Borgia Tower where there is the Burning of the Borgo, although they are fine, are not in every way excellent. In like manner, those that were painted likewise by him on the ceiling of the Palace of Agostino Chigi in the Trastevere did not give complete satisfaction, for they are wanting in that grace and sweetness which were peculiar to Raffaello; the reason of which, in great part, was the circumstance that he had them coloured by others after his design. However, repenting of this error, like a man of judgment, he resolved afterwards to execute by himself, without assistance from others, the panel-picture of the Transfiguration of Christ that is in S. Pietro a Montorio, wherein all those qualities which, as has already been described, are looked for and required in a good picture. And if he had not employed in this work, as it were from caprice, printer's smoke-black, the nature of which, as has been remarked many times, is to become ever darker with time, to the injury of the other colours with which it is mixed, I believe that the picture would still be as fresh as when he painted it; whereas it now appears to be rather a mass of shadows than aught else.

I have thought fit, almost at the close of this Life, to make this discourse, in order to show with what labour, study, and diligence this honoured craftsman always pursued his art; and even more for the sake of other painters, to the end that they may learn how to avoid those hindrances from which the wisdom and genius of Raffaello were able to deliver him. I must add this as well, that every man should be satisfied and contented with doing that work to which he feels himself drawn by a natural inclination, and should not seek, out of emulation, to put his hand to that for which nature has not adapted him; for otherwise he will labour in vain, and often to his own shame and loss. Moreover, where striving is enough, no man should aim at super-striving, merely in order to surpass those who, by some great gift of nature, or by some special grace be-

After more than 450 years, The Transfiguration was finally cleaned, revealing Raphael's bright colors.

Raphael. *Portrait of Cardinal Bibbiena*. 1516. Canvas. 33¾ × 25½″ (86 × 65 cm). Pitti Gallery, Florence.

stowed on them by God, have performed or are performing miracles in art; for the reason that he who is not suited to any particular work, can never reach, let him labour as he may, the goal to which another, with the assistance of nature, has attained with ease. Of this, among the old craftsmen, we may see an example in Paolo Uccello, who, striving against the limitations of his powers, in order to advance, did nothing but go backwards. The same has been done in our own day, no long time since, by Jacopo da Pontormo, and it has been proved by the experience of many others, as we have shown before and will point out yet again. And this, perchance, happens because Heaven always distributes its favours, to the end that every man may rest content with that which falls to him.

But now, having discoursed on these matters of art, perchance at greater length than was needful, let us return to the life and death of Raffaello. He had a strait friendship with Cardinal Bernardo Divizio of Bibbiena, who had importuned him for many years to take a wife of his choosing; and Raffaello, while not directly refusing to obey the wishes of the Cardinal, had yet put the matter off, saying that he would rather wait till three or four years had passed. This term came upon Raffaello when he was not expecting it, and he was re-

Paolo Uccello (1397–1475), major Florentine painter noted as the first to concentrate on a meticulous study of the science of perspective.

Other than this account, nothing is known of this incident in Raphael's life.

201

minded by the Cardinal of his promise; whereupon, seeing himself bound, like the courteous man that he was, he would not break his word, and thus accepted as his wife a niece of that Cardinal. And because he was always very ill content with this entanglement, he continued to delay the matter in such a way that many months passed without the marriage being brought to pass. But it was with no dishonorable motive that he did this, for, having been so many years in the service of the Court, and being the creditor of Leo for a good sum, it had been hinted to him that when the hall on which he was engaged was finished, the Pope proposed to reward him for his labours and abilities by giving him a red hat, of which he had already determined to distribute a good number, and some of them to men of less merit than Raffaello.

Meanwhile, pursuing his amours in secret, Raffaello continued to divert himself beyond measure with the pleasures of love; whence it happened that, having on one occasion indulged in more than his usual excess, he returned to his house in a violent fever. The physicians, therefore, believing that he had overheated himself, and receiving from him no confession of the excess of which he had been guilty, imprudently bled him, insomuch that he was weakened and felt himself sinking; for he was in need rather of restoratives. Thereupon he made his will: and first, like a good Christian, he sent his mistress out of the house, leaving her the means to live honourably. Next, he divided his possessions among his disciples, Giulio Romano, whom he had always loved dearly, and the Florentine Giovanni Francesco, called Il Fattore, with a priest of Urbino, his kinsman, whose name I do not know. Then he gave orders that some of his wealth should be used for restoring with new masonry one of the ancient tabernacles in S. Maria Ritonda [the Pantheon], and for making an altar, with a marble statue of Our Lady, in that church, which he chose as his place of repose and burial after death; and he left all the rest to Giulio and Giovanni Francesco, appointing as executor of his will Messer Baldassare da Pescia, then [President of the Chancery]. Finally, he confessed and was penitent, and ended the course of his life at age thirty-seven, on the same day that he was born, which was Good Friday. And even as he embellished the world with his talents, so, it may be believed, does his soul adorn Heaven by its presence.

As he lay dead in the hall where he had been working, there was placed at his head the picture of the Transfiguration, which he had executed for Cardinal de' Medici; and the sight of that living picture, in contrast with the dead body, caused the hearts of all who beheld it to burst with sorrow. That work, in memory of the loss of Raffaello, was placed by the Cardinal on the high-altar of S. Pietro a Montorio; and on account of the nobility of his every action, it was held ever afterwards in great estimation. His body received that honourable burial which his noble spirit had deserved, for there was no craftsman who did not weep with sorrow and follow him to the grave. His death was also a great grief to the whole Court of the Pope, first because he had held in his lifetime the office of Groom of the Chamber, and likewise because he had been so dear to the Pope that his loss caused him to weep bitterly.

O happy and blessed spirit, in that every man is glad to speak of thee, to celebrate thy actions, and to admire every drawing that thou didst leave to us! When this noble craftsman died, the art of painting might well have died also, seeing that when he closed his eyes, she was left as it were blind. And now for us who have survived him, it remains to imitate the good, nay, the supremely excellent method bequeathed to us by him as a pattern, and, as is called for by his merit and our obligations, to hold a most grateful remembrance of this in our minds, and to pay the highest honour to his memory with our lips. For in truth we have from him art, colouring, and invention harmonized and brought to such a pitch of perfection as could scarcely be hoped for; nor may any intellect ever think to surpass him. And in addition to this benefit that he con-

The Pantheon is the best-preserved major building of ancient Imperial Rome; it was consecrated as a church in 609.

ferred on art, like a true friend to her, as long as he lived he never ceased to show how one should deal with great men, with those of middle station, and with the lowest. And, indeed, among his extraordinary gifts, I perceive one of such value that I for my part am amazed at it, in that Heaven gave him the power to produce in our art an effect wholly contrary to the nature of us painters, which was that our craftsmen—I do not mean only the lesser, but also those whose humour it was to be great persons; and of this humour art creates a vast number—while working in company with Raffaello, felt themselves naturally united and in such accord, that all evil humours vanished at the sight of him, and every vile and base thought fell away from their minds. Such unity was never greater at any other time than his; and this happened because they were overcome both by his courtesy and by his art, and even more by the good disposition of his nature, which was so full of gentleness and so overflowing with loving-kindness, that it was seen that the very animals, not to speak of men, honoured him. It is said that if any painter who knew him, and even any who did not know him, asked him for some drawing that he needed, Raffaello would leave his own work in order to assist him. And he always kept a vast number of them employed, aiding them and teaching them with such a love as might have been the due rather of his own children than of fellow-craftsmen; for which reason he was never seen to go to Court without having with him, as he left his house, some fifty painters, all able and excellent, who kept him company in order to do him honour. In short, he lived not like a painter, but like a prince. Wherefore, O art of painting, thou couldst then esteem thyself indeed most blessed, in possessing a craftsman who, both with his genius and his virtues, exalted thee higher than Heaven! Truly happy mightest thou call thyself, in that thy disciples, following in the footsteps of so great a man, have seen how life should be lived, and how important is the union of art and virtue, which, wedded in Raffaello, had strength to prevail on the magnificent Julius II and the magnanimous Leo X, exalted as they were in rank and dignity, to make him their most intimate friend and show him all possible generosity, insomuch that by their favour and by the wealth that they bestowed upon him, he was enabled to do vast honour both to himself and to art. Blessed, also, may be called all those who, employed in his service, worked under him, since whoever imitated him found that he had reached an honourable haven; and in like manner all those who imitate his labours in art will be honoured by the world, even as, by resembling him in uprightness of life, they will win rewards from Heaven.

Raffaello received from Bembo the following epitaph:

D.O.M.
[To God, The Best And Greatest]
RAFFAELLO SANTI, THE SON OF GIOVANNI OF URBINO.
EMINENT PAINTER. RIVAL OF THE ANCIENTS.
LOOKING UPON HIS LIFELIKE IMAGES
YOU CAN THUS BEHOLD
THE UNIFICATION OF NATURE AND ART.
THROUGH HIS PAINTINGS AND ARCHITECTURE
HE INCREASED THE GLORY OF
POPES JULIUS II AND LEO X.
HE LIVED FOR 37 YEARS IN COMPLETE PERFECTION
AND DIED ON THE DAY OF HIS BIRTH,
7 APRIL, 1520.
THIS THEN IS RAFFAELLO. THE GREAT MOTHER OF ALL THINGS,
FEARED THAT SHE WOULD BE SURPASSED BY HIM WHILE HE LIVED,
AND FEARED THAT SHE WOULD DIE WHEN HE DIED.

And Count Baldassarre Castiglione wrote of his death in the following manner:

Because through the art of medicine he dared
 To heal the mutilated Hippolytus's wounds,
And bring him back from the shores of River Styx,
 Asclepius was himself thrust into that selfsame flood.
Death was this master's reward for the saving of another's life.
 With the genius of your art, Raffaello,
You likewise healed Rome's mutilated city:
 It was an empty husk, destroyed through sword and
Fire, and decayed through age.
 You, nonetheless, restored its life
And revived its ancient beauty.
 Your act aroused the envy of the jealous gods;
Their penalty was your death—untimely and undeserved.
 What time eroded, you dared revive,
And thus defied the law of mortal death.
 Your sad demise while in the bloom of youth
Stands as grim warning to us all of death's dark doom.

Baldassare Castiglione (1478–1529). Famed for his book The Courtier, *Castiglione served many years as a diplomat in the service of the Gonzagas. He was a close friend of Raphael's, who painted his portrait (Colorplate 70).*

MICHELAGNO BVONAR. PIT.
SCVLTORE ET ARCHITET.

THE LIFE OF MICHELAGNOLO BUONARROTI

Michelangelo

[1475–1564]

THE FLORENTINE PAINTER, SCULPTOR, AND ARCHITECT

WHILE THE MOST NOBLE and industrious spirits were striving, by the light of the famous Giotto and of his followers, to give to the world a proof of the ability that the benign influence of the stars and the proportionate admixture of humours had given to their intellects, and while, desirous to imitate with the excellence of their art the grandeur of Nature in order to approach as near as possible to that supreme knowledge that many call understanding, they were universally toiling, although in vain, the most benign Ruler of Heaven in His clemency turned His eyes to the earth, and, having perceived the infinite vanity of all those labours, the ardent studies without any fruit, and the presumptuous self-sufficiency of men, which is even further removed from truth than is darkness from light, and desiring to deliver us from such great errors, became minded to send down to earth a spirit with universal ability in every art and every profession, who might be able, working by himself alone, to show what manner of thing is the perfection of the art of design in executing the lines, contours, shadows, and high lights, so as to give relief to works of painting, and what it is to work with correct judgment in sculpture, and how in architecture it is possible to render habitations secure and commodious, healthy and cheerful, well-proportioned, and rich with varied ornaments. He was pleased, in addition, to endow him with the true moral philosophy and with the ornament of sweet poesy, to the end that the world might choose him and admire him as its highest exemplar in the life, works, saintliness of character, and every action of human creatures, and that he might be acclaimed by us as a being rather divine than human. And since He saw that in the practice of these rare exercises and arts—namely, in painting, in sculpture, and in architecture—the Tuscan intellects have always been exalted and raised high above all others, from their being diligent in the labours and studies of every faculty beyond no matter what other people of Italy, He chose to give him Florence, as worthy beyond all other cities, for his country, in order to bring all the talents to their highest perfection in her, as was her due, in the person of one of her citizens.

There was born a son, then, in the Casentino, in the year 1474, under a fateful and happy star, from an excellent and noble mother, to Lodovico di-Leonardo Buonarroti Simoni, a descendant, so it is said, of the most noble and most ancient family of the Counts of Canossa. To that Lodovico, I say, who was in that year Podestà of the township of Chiusi and Caprese, near the Sasso della Vernia, where S. Francis received the Stigmata, in the Diocese of Arezzo, a son was born on the 6th of March, a Sunday, about the eighth hour of the night, to which son he gave the name Michelagnolo, because, inspired by some influence from above, and giving it no more thought, he wished to suggest that he was something celestial and divine beyond the use of mortals, as was afterwards seen from the figures of his horoscope, he having had Mercury and Venus in the second house of Jupiter, with happy augury, which showed that from the art of his brain and of his hand there would be

Actually 1475. (The error could be attributed to the fact that, as Vasari mentions later in this Life, the Roman and Florentine calendars differed.)

A podestà is a civic post similar to that of chief magistrate or mayor.

The translator has retained Vasari's spelling of Michelangelo's name. The artist himself appears to have spelled it "Michlagniolo" in his signature.

207

seen to issue forth works marvellous and stupendous. Having finished his office as Podestà, Lodovico returned to Florence and settled in the village of Settignano, at a distance of three miles from the city, where he had a farm that had belonged to his forefathers; which place abounds with stone and is all full of quarries of grey-stone, which is constantly being worked by stone-cutters and sculptors, who for the most part are born in the place. Michelagnolo was put out to nurse by Lodovico in that village with the wife of a stone-cutter: wherefore the same Michelagnolo, discoursing once with Vasari, said to him jestingly, "Giorgio, if I have anything of the good in my brain, it has come from my being born in the pure air of your country of Arezzo, even as I also sucked in with my nurse's milk the chisels and hammer with which I make my figures." In time Lodovico's family increased, and, being in poor circumstances, with slender revenues, he set about apprenticing his sons to the Guilds of Silk and Wool. Michelagnolo, who by that time was well grown, was placed to be schooled in grammar with Maestro Francesco da Urbino; but, since his genius drew him to delight in design, all the time that he could snatch he would spend in drawing in secret, being scolded for this by his father and his other elders, and at times beaten, they perchance considering that to give attention to that art, which was not known by them, was a mean thing and not worthy of their ancient house.

At this time Michelagnolo had formed a friendship with Francesco Granacci, who, likewise a lad, had placed himself with Domenico Ghirlandajo in order to learn the art of painting; wherefore Granacci, loving Michelagnolo, and perceiving that he was much inclined to design, supplied him daily with drawings by Ghirlandajo, who at that time was reputed to be one of the best masters that there were not only in Florence, but throughout all Italy. Whereupon, the desire to work at art growing greater every day in Michelagnolo, Lodovico, perceiving that he could not divert the boy from giving his attention to design, and that there was no help for it, and wishing to derive some advantage from it and to enable him to learn that art, resolved on the advice of friends to apprentice him with Domenico Ghirlandajo. Michelagnolo, when he was placed with Domenico Ghirlandajo, was fourteen years of age. Now he who wrote his life after the year 1550, when I wrote these Lives the first time, has said that some persons, through not having associated with him, have related things that never happened, and have left out many that are worthy to be recorded, and has touched on this circumstance in particular, taxing Domenico with jealousy and saying that he never offered any assistance to Michelagnolo; which is clearly false, as may be seen from an entry by the hand of Lodovico, the father of Michelagnolo, written in one of Domenico's books, which book is now in the possession of his heirs. That entry runs thus: "1448, I record, this first day of April, that I, Lodovico di Leonardo di Buonarrota, placed Michelagnolo my son with Domenico and David di Tommaso di Currado for the three years next to come, on these terms and conditions, that the said Michelagnolo shall remain with the above-named persons for the said period of time, in order to learn to paint and to exercise that vocation; that the said persons shall have command over him; and that the same Domenico and David shall be bound to give him in those three years twenty-four florins of full weight, the first year six florins, the second year eight florins, and the third ten florins; in all, the sum of ninety-six lire." And next, below this, is another record, or rather, entry, also written in the hand of Lodovico: "The aforesaid Michelagnolo has received of that sum, this sixteenth day of April, two gold florins in gold. I, Lodovico di Leonardo, his father, have received twelve lire and twelve soldi as cash due to him." These entries I have copied from the book itself, in order to prove that all that was written at that time, as well as all that is about to be written, is the truth; nor do I know that anyone has been more associated with him than I have been,

Francesco Granacci (1477–1543), Florentine painter.

As previously noted, the florin has a value equivalent to $40.00; the gold lira had a value of about a third less.

or has been a more faithful friend and servant to him, as can be proved even to one who knows not the facts, neither do I believe that there is anyone who can show a greater number of letters written by his own hand, or any written with greater affection than he has expressed to me. I have made this digression for the sake of truth, and it must suffice for all the rest of his Life. Let us now return to our story.

When the ability as well as the person of Michelagnolo had grown in such a manner, that Domenico, seeing him execute some works beyond the scope of a boy, was astonished, since it seemed to him that he not only surpassed the other disciples, of whom he had a great number, but very often equalled the things done by himself as master, it happened that one of the young men who were learning under Domenico copied with the pen some draped figures of women from works by Ghirlandajo; whereupon Michelagnolo took that drawing and with a thicker pen outlined one of those women with new lineaments, in the manner that it should have been in order to be perfect. And it is a marvellous thing to see the difference between the two manners, and the judgment and excellence of a mere lad who was so spirited and bold, that he had the courage to correct the work of his master. That sheet is now in my possession, treasured as a relic; and I received it from Granacci to put in my book of drawings together with others by the same hand, which I received from Michelagnolo. In the year 1550, when Giorgio was in Rome, he showed it to Michelagnolo, who recognized it and was pleased to see it again, saying modestly that he knew more of the art when he was a boy than he did at that time, when he was an old man.

Now it happened that when Domenico was at work on the great chapel of S. Maria Novella, one day that he was out Michelagnolo set himself to draw the staging from the reality, with some desks and all the appliances of art, and some of the young men who were working there. Whereupon, when Domenico had returned and seen Michelagnolo's drawing, he said, "This boy knows more about it than I do;" and he was struck with amazement at the novel manner and the novel method of imitation that a mere boy of such tender age displayed by reason of the judgment bestowed upon him by Heaven, for these, in truth, were as marvellous as could have been looked for in the workmanship of a craftsman who had laboured for many years. And this was because all the power and knowledge of the gracious gifts of his nature were exercised by study and by the practice of art, wherefore these gifts produced every day fruits more divine in Michelagnolo, as began to be made clearly manifest in the copy that he executed of a printed sheet by the German [Martin Schongauer], which gave him a very great name. For there had come to Florence at that time a scene by the above-named Martin, of the Devils beating S. Anthony, engraved on copper, and Michelagnolo copied it with the pen in such a manner that it could not be detected, and then painted that same sheet in colours, going at times, in order to counterfeit certain strange forms of devils, to buy fishes that had scales bizarre in colouring; and in that work he showed so much ability, that he acquired thereby credit and fame. He also counterfeited sheets by the hands of various old masters, making them so similar that they could not be detected, for, tinting them and giving them the appearance of age with smoke and various other materials, he made them so dark that they looked old, and, when compared with the originals, one could not be distinguished from the other. Nor did he do this with any other purpose but to obtain the originals from the hands of their owners by giving them the copies, for he admired them for the excellence of their art and sought to surpass them in his own practice; on which account he acquired a very great name.

At that time the Magnificent Lorenzo de' Medici kept the sculptor Bertoldo in his garden on the Piazza di S. Marco, not so much as custodian or

Martin Schongauer (c. 1430/45–1491), eminent German painter and engraver. Michelangelo's copy of The Temptation of St. Anthony *is lost.*

Bertoldo di Giovanni (c. 1420–1491), Florentine sculptor.

guardian of the many beautiful antiques that he had collected and gathered together at great expense in that place, as because, desiring very earnestly to create a school of excellent painters and sculptors, he wished that these should have as their chief and guide the above-named Bertoldo, who was a disciple of Donato. Bertoldo, although he was so old that he was not able to work, was nevertheless a well-practised master and in much repute, not only because he had polished with great diligence the pulpits cast by his master Donato, but also on account of many castings in bronze that he had executed himself, of battles and certain other small works, in the execution of which there was no one to be found in Florence at that time who surpassed him. Now Lorenzo, who bore a very great love to painting and to sculpture, was grieved that there were not to be found in his time sculptors noble and famous enough to equal the many painters of the highest merit and reputation, and he determined, as I have said, to found a school. To this end he besought Domenico Ghirlandajo that, if he had among the young men in his workshop any that were inclined to sculpture, he might send them to his garden, where he wished to train and form them in such a manner as might do honour to himself, to Domenico, and to the whole city. Whereupon there were given to him by Domenico as the best of his young men, among others, Michelagnolo and Francesco Granacci; and they, going to the garden, found there that Torrigiano, a young man of the Torrigiani family, was executing in clay some figures in the round that had been given to him by Bertoldo. Michelagnolo, seeing this, made some out of emulation; wherefore Lorenzo, seeing his fine spirit, always regarded him with much expectation. And he, thus encouraged, after some days set himself to counterfeit from a piece of marble an antique head of a Faun that was there, old and wrinkled, which had the nose injured and the mouth laughing. Michelagnolo, who had never yet touched marble or chisels, succeeded so well in counterfeiting it, that the Magnificent Lorenzo was astonished; and then, perceiving that, departing from the form of the antique head, he had opened out the mouth after his own fancy and had made a tongue, with all the teeth showing, that lord, jesting pleasantly, as was his wont, said to him, "Surely you should have known that old folks never have all their teeth, and that some are always wanting." It appeared to Michelagnolo, in his simplicity, both fearing and loving that lord, that he had spoken the truth; and no sooner had Lorenzo departed than he straightway broke one of the teeth and hollowed out the gum, in such a manner, that it seemed as if the tooth had dropped out. And then he awaited with eagerness the return of the Magnificent Lorenzo, who, when he had come and had seen the simplicity and excellence of Michelagnolo, laughed at it more than once, relating it as a miracle to his friends. Moreover, having made a resolve to assist and favour Michelagnolo, he sent for his father Lodovico and asked for the boy from him, saying that he wished to maintain him as one of his own children; and Lodovico gave him up willingly. Thereupon the Magnificent Lorenzo granted him a chamber in his own house and had him attended, and he ate always at his table with his own children and with other persons of quality and of noble blood who lived with that lord, by whom he was much honoured. This was in the year after he had been placed with Domenico, when Michelagnolo was about fifteen or sixteen years of age; and he lived in that house four years, which was until the death of the Magnificent Lorenzo in 1492. During that time, then, Michelagnolo had five ducats a month from that lord as an allowance and also to help his father; and for his particular gratification Lorenzo gave him a violet cloak, and to his father an office in the Customs. Truth to tell, all the young men in the garden were salaried, some little and some much, by the liberality of that magnificent and most noble citizen, and rewarded by him as long as he lived.

At this time, at the advice of Poliziano, a man eminent in letters, Michel-

agnolo executed from a piece of marble given to him by that lord the Battle of Hercules with the Centaurs, which was so beautiful that now, to those who study it from time to time, it appears as if by the hand not of a youth but of a master of repute, perfected by study and well practised in that art. It is now jin his house, treasured in memory of him by his nephew Leonardo as a rare thing, which indeed it is. That Leonardo, not many years since, had in his house in memory of his uncle a Madonna of marble in low-relief by the hand of Michelagnolo, little more than one braccio in height, in which when a lad, at this same time, wishing to counterfeit the manner of Donatello, he acquitted himself so well that it seems as if by Donatello's hand, save that there may be seen in it more grace and more design. That work Leonardo afterwards gave to Duke Cosimo de' Medici, who treasures it as a unique thing, for we have no other low-relief in sculpture by his hand save that one.

Now, returning to the garden of the Magnificent Lorenzo; that garden was full of antiques and richly adorned with excellent pictures, all gathered together in that place for their beauty, for study, and for pleasure. Michelagnolo always had the keys, and he was much more earnest than the others in his every action, and showed himself always alert, bold, and resolute. He drew for many months from the pictures of Masaccio in the Carmine, where he copied those works with so much judgment, that the craftsmen and all other men were astonished, in such sort that envy grew against him together with his fame. It is said that Torrigiano, after contracting a friendship with him, mocked him, being moved by envy at seeing him more honoured than himself and more able in art, and struck him a blow of the fist on the nose with such force, that he broke and crushed it very grievously and marked him for life; on which account Torrigiano was banished from Florence, as has been related in another place.

When the Magnificent Lorenzo died, Michelagnolo returned to his father's house in infinite sorrow at the death of so great a man, the friend of every talent. There he bought a great piece of marble, and from it carved a Hercules of

Not Hercules but Lapiths, a legendary tribe of ancient Thessaly.

Lionardo's (the accepted current spelling) home was the Casa Buonarroti, and the relief is still there.

Michelangelo. *The Battle of Lapiths and Centaurs*. c. 1492. Marble. 33¼ × 35½" (84.5 × 90 cm). Casa Buonarroti, Florence.

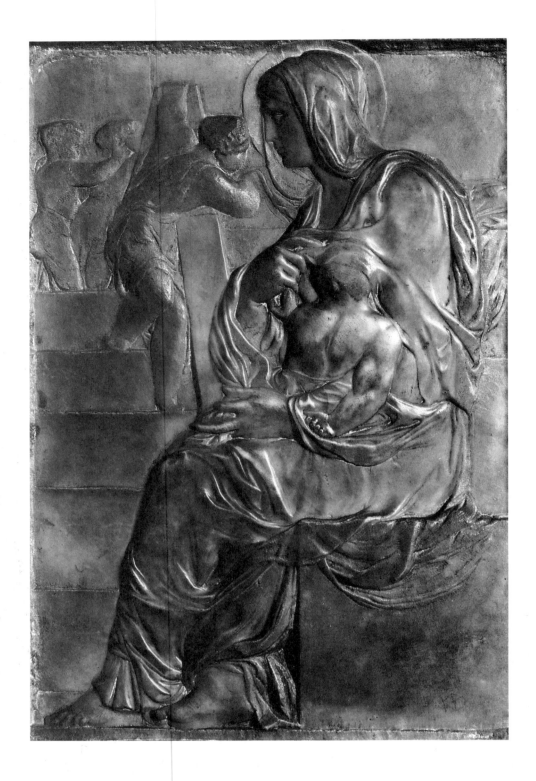

Michelangelo. *The Madonna of the Stairs.*
1489–92. Marble. 21¾ × 15¾" (55
× 40 cm). Casa Buonarroti, Florence.

four braccia, which stood for many years in the Palace of the Strozzi; this was
esteemed an admirable work, and afterwards, in the year of the siege, it was
sent into France to King Francis by Giovan Battista della Palla. It is said that
Piero de' Medici, who had been left heir to his father Lorenzo, having long been
intimate with Michelagnolo, used often to send for him when he wished to buy
antiques, such as cameos and other carved stones. One winter, when much
snow fell in Florence, he caused him to make in his courtyard a statue of snow,
which was very beautiful; and he honoured Michelagnolo on account of his
talents in such a manner, that his father, beginning to see that he was esteemed
among the great, clothed him much more honourably than he had been wont
to do.

For the Church of S. Spirito in the city of Florence Michelagnolo made a
Crucifix of wood, which was placed, as it still is, above the lunette of the high-
altar; doing this to please the Prior, who placed rooms at his disposal, in which

*The nearly eight-foot-high statue of
Hercules is lost.*

*Believed lost in the eighteenth century, the
crucifix was found in 1963—still in Santo
Spirito.*

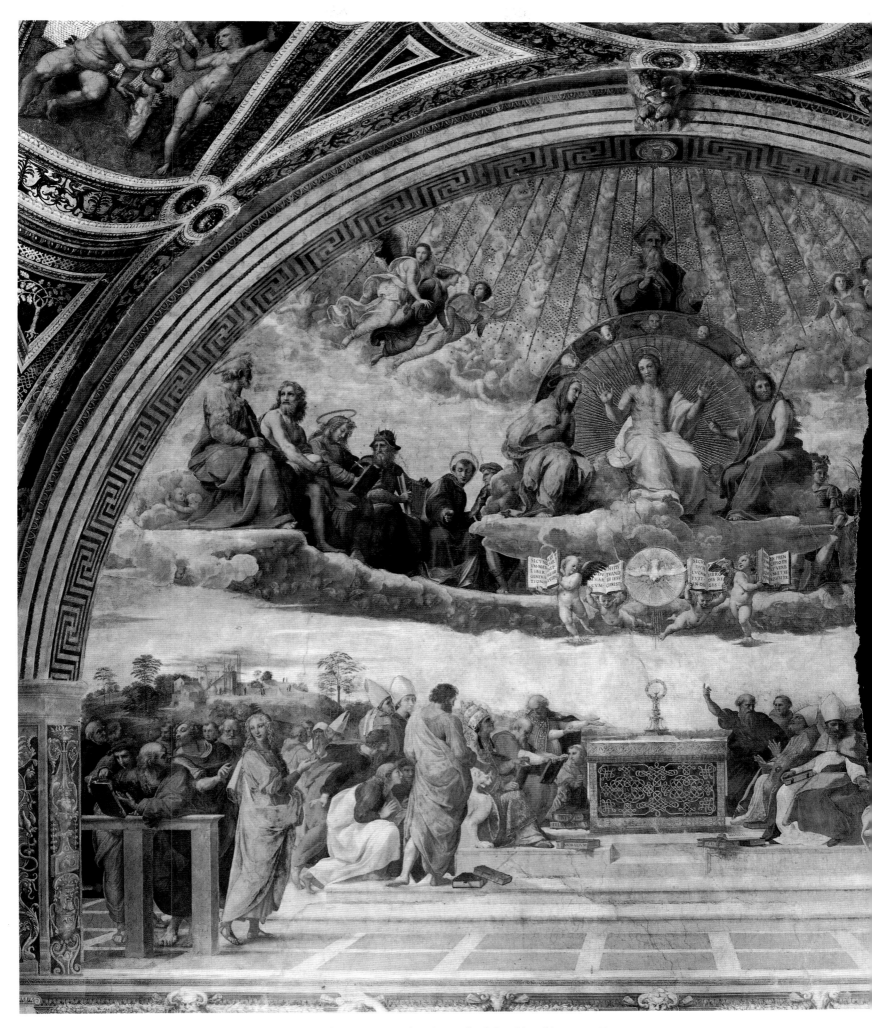

COLORPLATE 78. Raphael. *The Disputa (The Triumph of the Church).* 1509. Fresco.
Stanza della Segnatura, Vatican, Rome.

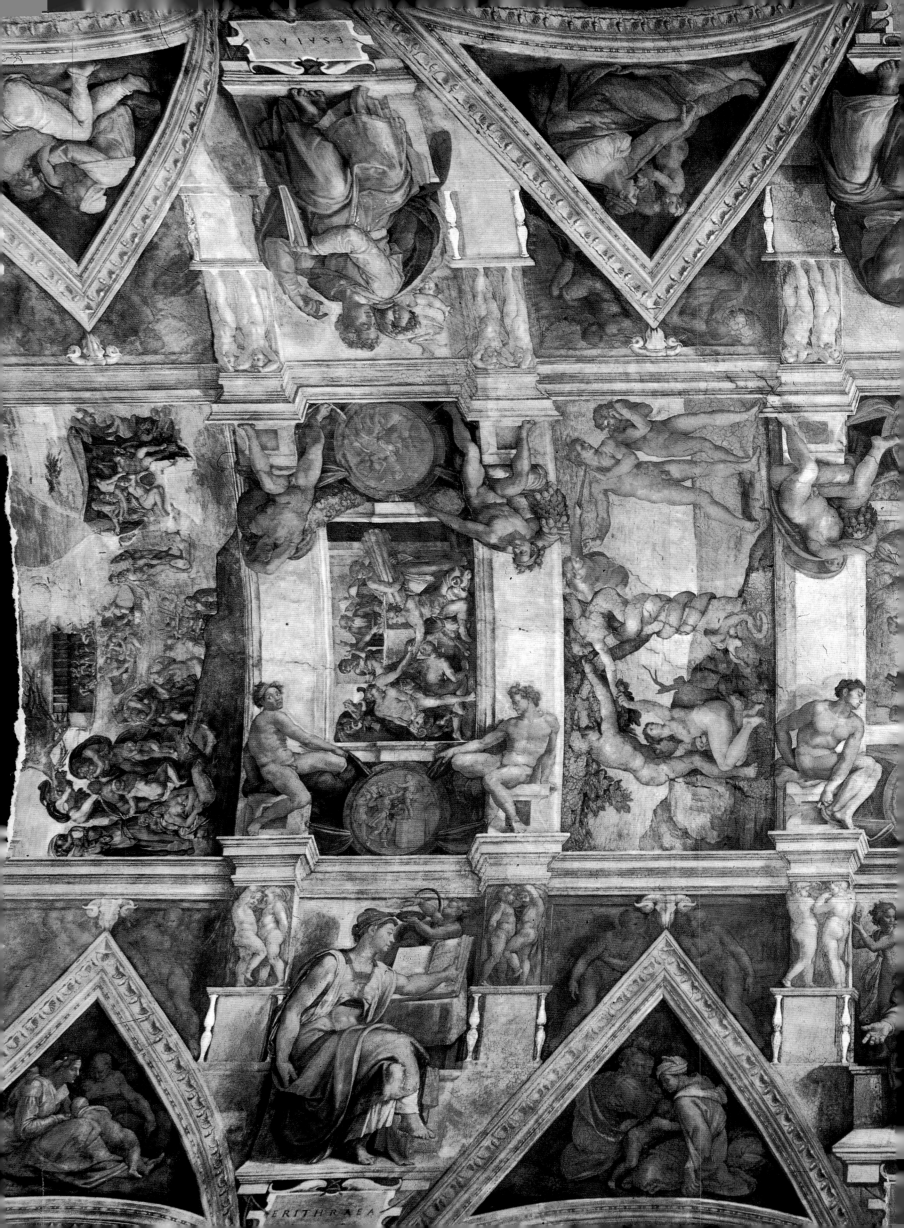

ESAIAS

ERITHRÆA

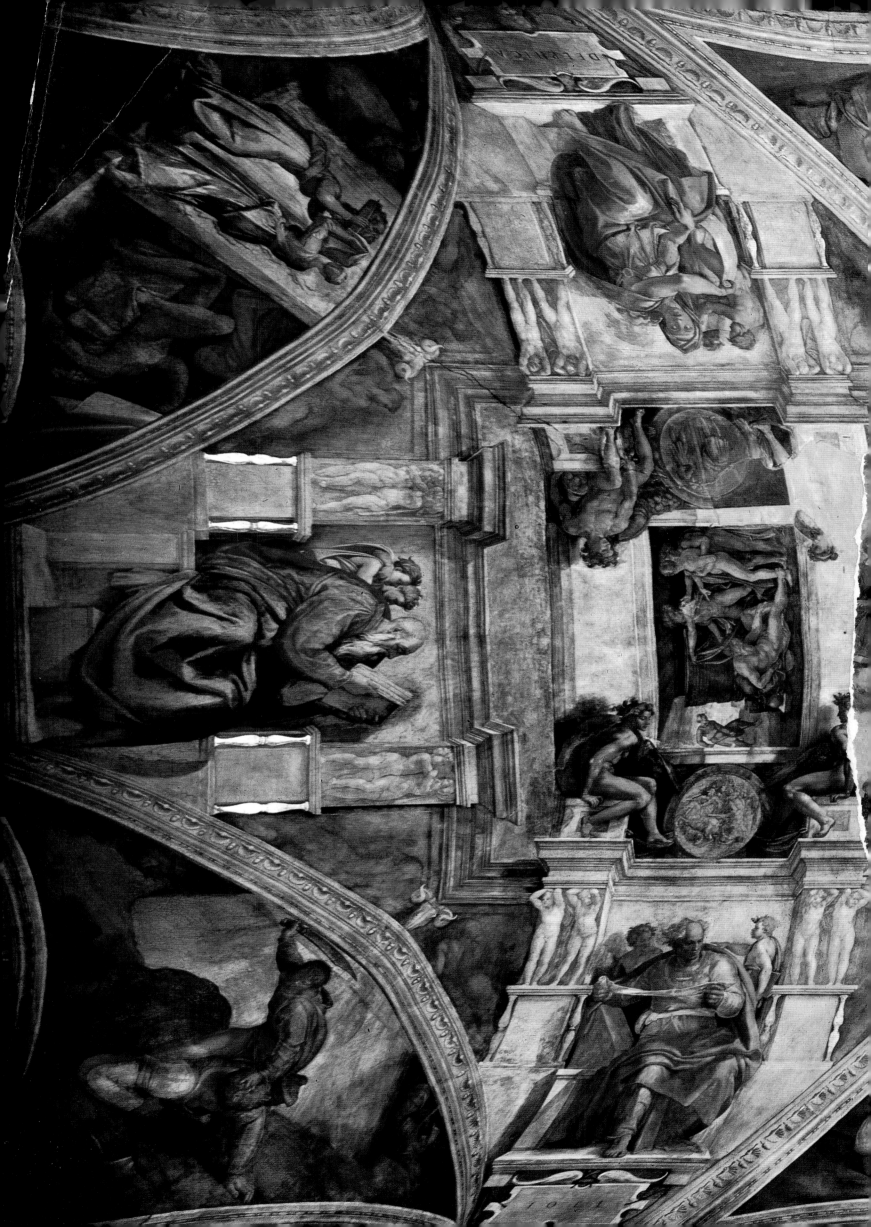

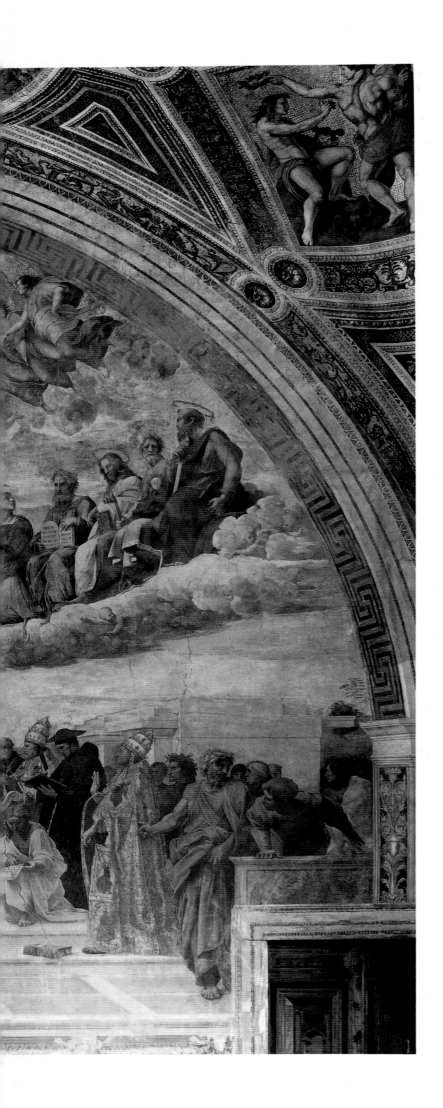

OVERLEAF:

COLORPLATE 79.
Michelangelo. *The Sistine Ceiling*
(general view).
1509–12. Fresco. Sistine Chapel,
Vatican, Rome.

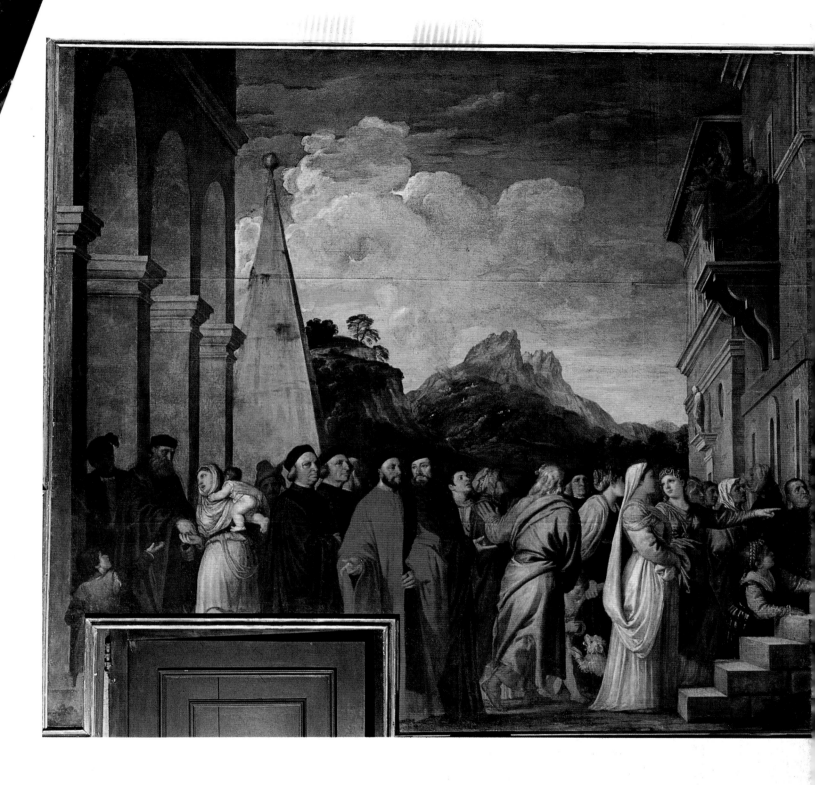

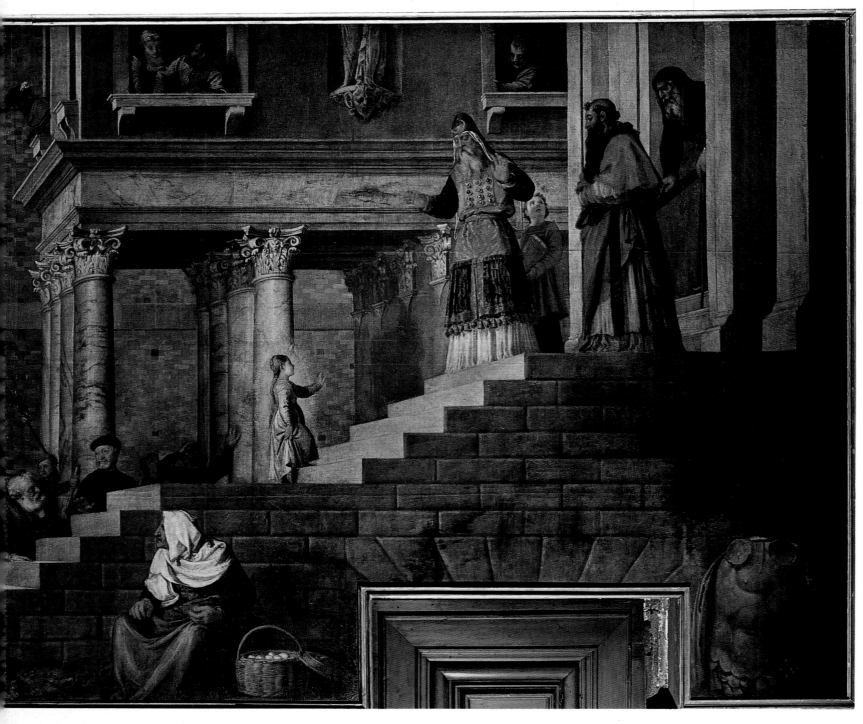

COLORPLATE 80. Titian. *The Presentation in the Temple*. 1534–38. Canvas. 136½ × 306″ (345 × 775 cm).
Accademia, Venice.

he was constantly flaying dead bodies, in order to study the secrets of anatomy, thus beginning to give perfection to the great knowledge of design that he afterwards acquired. It came about that the Medici were driven out of Florence, and a few weeks before that Michelagnolo had gone to Bologna, and then to Venice, fearing, as he saw the insolence and bad government of Piero de' Medici, lest some evil thing might befall him from his being the servant of that family; but, not having found any means of living in Venice, he returned to Bologna. There he had the misfortune to neglect, through lack of thought, when entering by the gate, to learn the countersign for going out again, a command having been issued at that time, as a precaution, at the desire of Messer Giovanni Bentivogli, that all strangers who had not the countersign should be fined fifty Bolognese lire; and having fallen into such a predicament, nor having the means to pay, Michelagnolo by chance was seen by Messer Giovan Francesco Aldovrandi, one of the Sixteen of the Government, who had compassion on him, and, having made him tell his story, liberated him, and then kept him in his house for more than a year. One day Aldovrandi took him to see the tomb of S. Dominic, made, as has been related, by [Nicola] Pisano and then by Maestro Niccolò dell' Arca, sculptors of olden days. In that work there were wanting a S. Petronio and an Angel holding a candelabrum, figures of about one braccio, and Aldovrandi asked him if he felt himself able to make them; and he answered Yes. Whereupon he had the marble given to him, and Michelagnolo executed them in such a manner, that they are the best figures that are there; and Messer Francesco Aldovrandi caused thirty ducats to be given to him for the two. Michelagnolo stayed a little more than a year in Bologna, and he would have stayed there even longer, in order to repay the courtesy of Aldovrandi, who loved him both for his design and because, liking Michelagnolo's Tuscan pronunciation in reading, he was pleased to hear from his lips the works of Dante, Petrarch, Boccaccio, and other Tuscan poets. But, since he knew that he was wasting his time, he was glad to return to Florence.

There he made for Lorenzo di Pier Francesco de' Medici a S. Giovannino of marble, and then set himself to make from another piece of marble a Cupid that was sleeping, of the size of life. This, when finished, was shown by means of Baldassarre del Milanese to Lorenzo di Pier Francesco as a beautiful thing, and he, having pronounced the same judgment, said to Michelagnolo: "If you were to bury it under ground and then sent it to Rome treated in such a manner as to make it look old, I am certain that it would pass for an antique, and you would thus obtain much more for it than by selling it here." It is said that Michelagnolo handled it in such a manner as to make it appear an antique; nor is there any reason to marvel at that, seeing that he had genius enough to do it, and even more. Others maintain that Milanese took it to Rome and buried it in a vineyard that he had there, and then sold it as an antique to Cardinal San Giorgio for two hundred ducats. Others, again, say that Milanese sold to the Cardinal one that Michelagnolo had made for him, and that he wrote to Lorenzo di Pier Francesco that he should cause thirty crowns to be given to Michelagnolo, saying that he had not received more for the Cupid, and thus deceiving the Cardinal, Lorenzo di Pier Francesco, and Michelagnolo; but afterwards, having received information from one who had seen that the boy was fashioned in Florence, the Cardinal contrived to learn the truth by means of a messenger, and so went to work that Milanese's agent had to restore the money and take back the Cupid. That work, having come into the possession of Duke Valentino, was presented by him to the Marchioness of Mantua, who took it to her own country, where it is still to be seen at the present day. This affair did not happen without some censure attaching to Cardinal San Giorgio, in that he did not recognize the value of the work, which consisted in its perfection; for modern works, if only they be excellent, are as good as the ancient. What greater vanity is there than that of those who concern themselves more with the

Nicola Pisano (fl. 1260–1278) Italian sculptor. Niccolo dell'Arca (1435–1494), a sculptor, possibly born in Bari, who was active in Bologna.

The youthful St. John ("S. Giovannino") and the cupid are lost. Pierfrancesco belonged to a cadet branch of the Medici family.

Michelangelo. *Angel*. 1494–95. Marble. Height (incl. base): 22¼″ (56.5 cm). Tomb of St. Dominic, Church of San Domenico, Bologna.

name than the fact? But of that kind of men, who pay more attention to the appearance than to the reality, there are some to be found at any time.

Now this event brought so much reputation to Michelagnolo, that he was straightway summoned to Rome and engaged by Cardinal San Giorgio, with whom he stayed nearly a year, although, as one little conversant with our arts, he did not commission Michelagnolo to do anything. At that time a barber of the Cardinal, who had been a painter, and could paint with great diligence in distemper-colours, but knew nothing of design, formed a friendship with Michelagnolo, who made for him a cartoon of S. Francis receiving the Stigmata. That cartoon was painted very carefully in colours by the barber on a little panel; and the picture is now to be seen in S. Pietro a Montorio in the first chapel on the left hand as one enters the church. The talent of Michelagnolo was then clearly recognized by a Roman gentleman named Messer Jacopo Galli, an ingenious person, who caused him to make a Cupid of marble as large as life, and then a figure of a Bacchus ten palms high, who has a cup in the right hand, and in the left hand the skin of a tiger, with a bunch of grapes at which a little

Both cartoon and panel are lost; the life-size cupid, as well.

A Florentine palma *("palm's length") was about eight inches.*

222

satyr is trying to nibble. In that figure it may be seen that he sought to achieve a certain fusion in the members that is marvellous, and in particular that he gave it both the youthful slenderness of the male and the fullness and roundness of the female—a thing so admirable, that he proved himself excellent in statuary beyond any other modern that had worked up to that time. On which account, during his stay in Rome, he made so much proficience in the studies of art, that it was a thing incredible to see his exalted thoughts and the difficulties of the manner exercised by him with such supreme facility; to the amazement not only of those who were not accustomed to see such things, but also of those familiar with good work, for the reason that all the works executed up to that

Michelangelo. *Bacchus.* c. 1496–97. Marble. Height (incl. base): 79½″ (201 cm). Museo Nazionale (Bargello), Florence.

time appeared as nothing in comparison with his. These things awakened in Cardinal [Bilhères de Lagraulas], a Frenchman, a desire to leave in a city so famous some worthy memorial of himself by the hand of so rare a craftsman; and he caused him to make a Pietà of marble in the round, which, when finished, was placed in the Chapel of the Vergine Maria della Febbre in S. Pietro, where the Temple of Mars used to be. To this work let no sculptor, however rare a craftsman, ever think to be able to approach in design or in grace, or ever to be able with all the pains in the world to attain to such delicacy and smoothness or to perforate the marble with such art as Michelagnolo did therein, for in it may be seen all the power and worth of art. Among the lovely things to be seen in the work, to say nothing of the divinely beautiful draperies, is the body of Christ; nor let anyone think to see greater beauty of members or more mastery of art in any body, or a nude with more detail in the muscles, veins, and nerves over the framework of the bones, nor yet a corpse more similar than this to a real corpse. Here is perfect sweetness in the expression of the head, harmony in the joints and attachments of the arms, legs, and trunk, and the pulses and veins so wrought, that in truth Wonder herself must marvel that the hand of a craftsman should have been able to execute so divinely and so perfectly, in

Michelangelo. *The Rome Pietà.* 1498–99/1500. Marble. Height: 68½" (174 cm). St. Peter's, Rome.

so short a time, a work so admirable; and it is certainly a miracle that a stone without any shape at the beginning should ever have been reduced to such perfection as Nature is scarcely able to create in the flesh. Such were Michelagnolo's love and zeal together in this work, that he left his name—a thing that he never did again in any other work—written across a girdle that encircles the bosom of Our Lady. And the reason was that one day Michelagnolo, entering the place where it was set up, found there a great number of strangers from Lombardy, who were praising it highly, and one of them asked one of the others who had done it, and he answered, "Our Gobbo from Milan" [Andrea Solari]. Michelagnolo stood silent, but thought it something strange that his labours should be attributed to another; and one night he shut himself in there, and, having brought a little light and his chisels, carved his name upon it. And truly the work is such, that an exalted spirit has said, as to a real and living figure—

> Beauty and goodness, piety and grief,
> Live in the dead marble. Mourn not so loudly,
> Be comforted, Time shall resurrect the dead.
> Cease then to weep with unmeasured tears.
> Our Lord, and thine, thy father, son, and spouse,
> His daughter, thou His mother and sole bride.

From this work he acquired very great fame, and although certain persons, rather fools than otherwise, say that he has made Our Lady too young, are these so ignorant as not to know that unspotted virgins maintain and preserve their freshness of countenance a long time without any mark, and that persons afflicted as Christ was do the contrary? That circumstance, therefore, won an even greater increase of glory and fame for his genius than all his previous works.

Letters were written to him from Florence by some of his friends, saying that he should return, because it was not unlikely that he might obtain the spoiled block of marble lying in the Office of Works, which Piero Soderini, who at that time had been made Gonfalonier of the city for life, had very often talked of having executed by Leonardo da Vinci, and was then arranging to give to Maestro Andrea Contucci of Monte Sansovino, an excellent sculptor, who was seeking to obtain it. Now, however difficult it might be to carve a complete figure out of it without adding pieces (for which work of finishing it without adding pieces none of the others, save Buonarroti alone, had courage enough), Michelagnolo had felt a desire for it for many years back; and, having come to Florence, he sought to obtain it. This block of marble was nine braccia high, and from it, unluckily, one Maestro [Agostino di Duccio] had begun a giant, and he had managed to work so ill, that he had hacked a hole between his legs, and it was altogeher misshapen and reduced to ruin, insomuch that the Wardens of Works of S. Maria del Fiore, who had the charge of the undertaking, had placed it on one side without troubling to have it finished; and so it had remained for many years past, and was likely to remain. Michelagnolo measured it all anew, considering whether he might be able to carve a reasonable figure from that block by accommodating himself as to the attitude to the marble as it had been left all misshapen by Maestro [Agostino]; and he resolved to ask for it from Soderini and the Wardens, by whom it was granted to him as a thing of no value, they thinking that whatever he might make of it would be better than the state in which it was at that time, seeing that neither in pieces nor in that condition could it be of any use to their building. Whereupon Michelagnolo made a model of wax, fashioning in it, as a device for the Palace, a young David with a sling in his hand, to the end that, even as he had defended his people and governed them with justice, so those govern-

A gobbo is a hunchback. In this instance the reference was to Cristoforo Solari (d. 1527), called Il Gobbo, a Milanese sculptor whose best-known work is the tomb of Lodovico Sforza and Beatrice d'Este.

That is, Andrea Sansovino (1460–1529), Tuscan sculptor and architect.

Agostino di Duccio (1418–c. 1481), Florentine sculptor and architect.

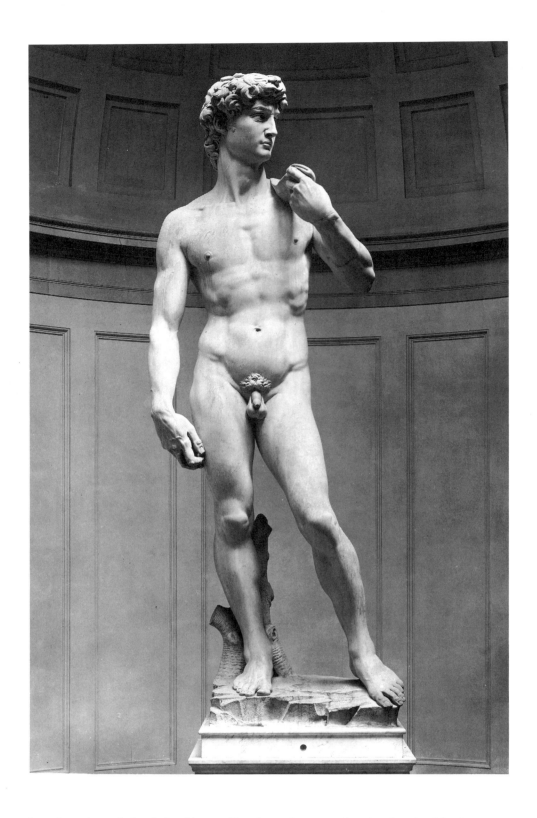

Michelangelo. *David*. 1501–04. Marble.
Height (incl. base): 161 ½″ (202 cm).
Accademia di Belle Arti, Florence.

ing that city might defend her valiantly and govern her justly. And he began it
in the Office of Works of S. Maria del Fiore, in which he made an enclosure of
planks and masonry, thus surrounding the marble; and, working at it contin-
uously without anyone seeing it, he carried it to perfect completion. The mar-
ble had already been spoilt and distorted by Maestro [Agostino], and in some
places it was not enough to satisfy the wishes of Michelagnolo for what he
would have liked to do with it; and he therefore suffered certain of the first
marks of Maestro [Agostino's] chisel to remain on the extremity of the mar-
ble, some of which are still to be seen. And truly it was a miracle on the part of
Michelagnolo to restore to life a thing that was dead.

This statue, when finished, was of such a kind that many disputes took place
as to how to transport it to the Piazza della Signoria. Whereupon Giuliano da
San Gallo and his brother Antonio made a very strong framework of wood and

suspended the figure from it with ropes, to the end that it might not hit against the wood and break it to pieces, but might rather keep rocking gently; and they drew it with windlasses over flat beams laid upon the ground, and then set it in place. On the rope which held the figure suspended he made a slip-knot which was very easy to undo but tightened as the weight increased, which is a most beautiful and ingenious thing; and I have in my book a drawing of it by his own hand—an admirable, secure, and strong contrivance for suspending weights.

It happened at this time that Piero Soderini, having seen it in place, was well pleased with it, but said to Michelagnolo, at a moment when he was retouching it in certain parts, that it seemed to him that the nose of the figure was too thick. Michelagnolo noticed that the Gonfalonier was beneath the Giant, and that his point of view prevented him from seeing it properly; but in order to satisfy him he climbed upon the staging, which was against the shoulders, and quickly took up a chisel in his left hand, with a little of the marble-dust that lay upon the planks of the staging, and then, beginning to strike lightly with the chisel, let fall the dust little by little, nor changed the nose a whit from what it was before. Then, looking down at the Gonfalonier, who stood watching him, he said, "Look at it now." "I like it better," said the Gonfalonier, "you have given it life." And so Michelagnolo came down, laughing to himself at having satisfied the lord, for he had compassion on those who, in order to appear full of knowledge, talk about things of which they know nothing.

The "Giant" is the David.

When it was built up, and all was finished, he uncovered it, and it cannot be denied that this work has carried off the palm from all other statues, modern or ancient, Greek or Latin; and it may be said that neither the Marforio at Rome, nor the Tiber and the Nile of the Belvedere, nor the Giants of Monte Cavallo, are equal to it in any respect, with such just proportion, beauty and excellence did Michelagnolo finish it. For in it may be seen most beautiful contours of legs, with attachments of limbs and slender outlines of flanks that are divine; nor has there ever been seen a pose so easy, or any grace to equal that in this work, or feet, hands and head so well in accord, one member with another, in harmony, design, and excellence of artistry. And, of a truth, whoever has seen this work need not trouble to see any other work executed in sculpture, either in our own or in other times, by no matter what craftsman. Michelagnolo received from Piero Soderini in payment for it four hundred crowns; and it was set in place in the year 1504. In consequence of the fame that he thereby won as a sculptor, he made for the above-named Gonfalonier a most beautiful David of bronze, which Soderini sent to France; and at this time, also, he began, but did not finish, two medallions of marble—one for Taddeo Taddei, which is now in his house, and another that he began for Bartolommeo Pitti, which was presented by Fra Miniato Pitti of Monte Oliveto, a man with a rare knowledge in cosmography and many other sciences, and particularly in painting, to Luigi Guicciardini, who was much his friend. These works were held to be admirable in their excellence; and at this same time, also, he blocked out a statue of S. Matthew in marble in the Office of Works of S. Maria del Fiore, which statue, rough as it is, reveals its full perfection and teaches sculptors in what manner figures can be carved out of marble without their coming out misshapen, so that it may be possible to go on ever improving them by removing more of the marble with judgment, and also to draw back and change some part, according as the necessity may arise. He also made a medallion in bronze of a Madonna, which he cast in bronze at the request of certain Flemish merchants of the [Mouscron] family, persons of high nobility in their own country, who paid him a hundred crowns for it, and intended to send it to Flanders.

These are ancient Roman monumental sculptures.

There came to Agnolo Doni, a Florentine citizen and a friend of Michelagnolo, who much delighted to have beautiful things both by ancient and by

For Doni's portrait by Raphael, see page 146.

227

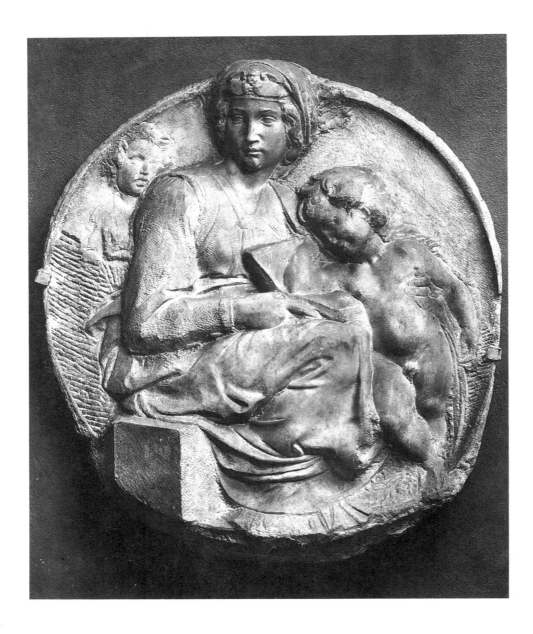

Michelangelo. *The Pitti Madonna.* c. 1506.
Marble. 32½″ (82.5 cm) in diam. Museo
Nazionale (Bargello), Florence.

COLORPLATE 81

modern craftsmen, a desire to possess some work by Michelagnolo; where-
fore that master began for him a round picture containing a Madonna, who,
kneeling on both knees, has an Infant in her arms and presents Him to Joseph,
who receives Him. Here Michelagnolo expresses in the turn of the head of the
Mother of Christ and in the gaze of her eyes, which she keeps fixed on the su-
preme beauty of her Son, her marvellous contentment and her lovingness in
sharing it with that saintly old man, who receives Him with equal affection,
tenderness, and reverence, as may be seen very readily in his countenance,
without considering it long. Nor was this enough for Michelagnolo, who, the
better to show how great was his art, made in the backround of his work a
number of nudes, some leaning, some standing, and some seated; and with such
diligence and finish he executed this work, that without a doubt, of his pic-
tures on panel, which indeed are but few, it is held to be the most finished and
the most beautiful work that there is to be found. When it was completed, he
sent it covered up to Agnolo's house by a messenger, with a note demanding
seventy ducats in payment. It seemed strange to Agnolo, who was a careful
person, to spend so much on a picture, although he knew that it was worth
more, and he said to the messenger that forty was enough, which he gave to
him. Thereupon Michelagnolo sent them back to him, with a message to say
that he should send back either one hundred ducats or the picture. Then Ag-
nolo, who liked the work, said, "I will give him these seventy," but he was not
content; indeed, angered by Agnolo's breach of faith, he demanded the double

of what he had asked the first time, so that, if Agnolo wanted the picture, he was forced to send him a hundred and forty.

It happened that while Leonardo da Vinci, that rare painter, was painting in the Great Council Hall, as has been related in his Life, Piero Soderini, who was then Gonfalonier, moved by the great ability that he saw in Michelagnolo, caused a part of that Hall to be allotted to him; which was the reason that he executed the other façade in competition with Leonardo, taking as his subject the War of Pisa. To this end Michelagnolo was given a room in the Hospital of the Dyers at S. Onofrio, and there he began a vast cartoon, but would never consent that anyone should see it. And this he filled with naked men that were bathing in the River Arno on account of the heat, when suddenly the alarm sounded in the camp, announcing that the enemy were attacking; and, as the soldiers were springing out of the water to dress themselves, there could be seen, depicted by the divine hands of Michelagnolo, some hastening to arm themselves in order to give assistance to their companions, others buckling on their cuirasses, many fastening other armour on their bodies, and a vast number beginning the fray and fighting on horseback. There was, among other figures, an old man who had a garland of ivy on his head to shade it, and he, having sat down in order to put on his hose, into which his legs would not go because they were wet with water, and hearing the cries and tumult of the soldiers and the uproar of the drummers, was struggling to draw on one stocking by force; and, besides that all the muscles and nerves of his figure could be perceived, his mouth was so distorted as to show clearly how he was straining and struggling even to the very tips of his toes. There were also drummers, and

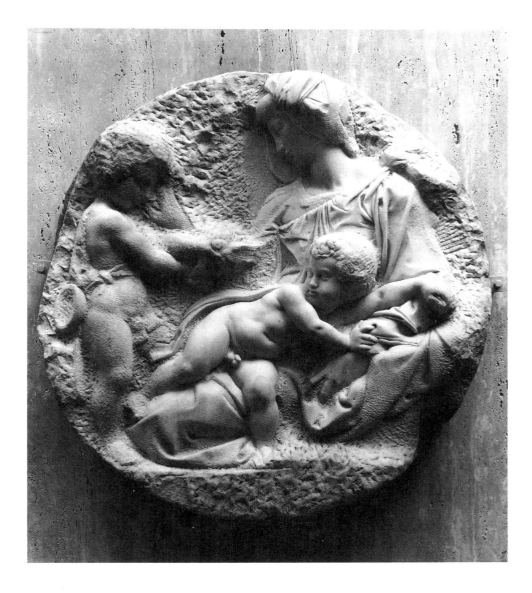

Michelangelo. *The Taddei Madonna*. c. 1500–02. Marble. 42½″ (108 cm) in diam. Royal Academy, London.

figures with their clothes in their arms running to the combat; and there were to be seen the most extravagant attitudes, some standing, some kneeling or bent double, others stretched horizontally and struggling in mid-air, and all with masterly foreshortenings. There were also many figures in groups, all sketched in various manners, some outlined with charcoal, some drawn with strokes, others stumped in and heightened with lead-white, Michelagnolo desiring to show how much he knew in his profession. Wherefore the craftsmen were seized with admiration and astonishment, seeing the perfection of art revealed to them in that drawing by Michelagnolo; and some who saw them, after beholding figures so divine, declare that there has never been seen any work, either by his hand or by the hands of others, no matter how great their genius, that can equal it in divine beauty of art. And, in truth, it is likely enough, for the reason that since the time when it was finished and carried to the Sala del Papa with great acclamation from the world of art and extraordinary glory for Michelagnolo, all those who studied from that cartoon and drew those figures—as was afterwards the custom in Florence for many years both for strangers and natives—became persons eminent in art, as we have since seen. For among those who studied the cartoon were Aristotile da San Gallo, the

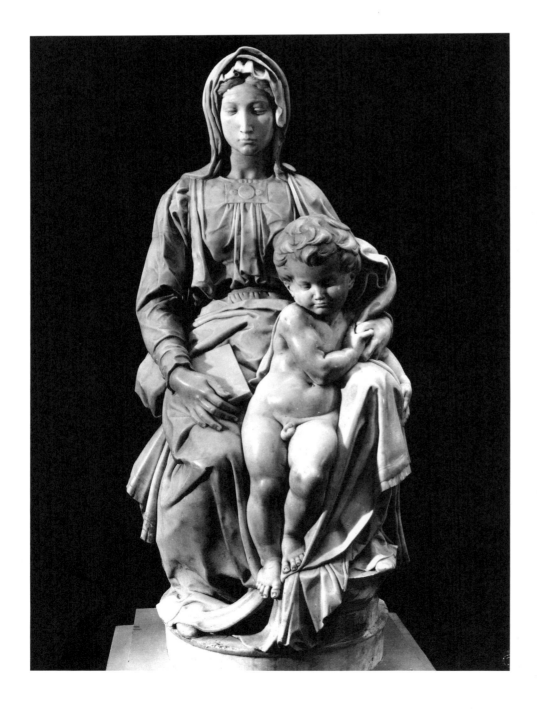

Michelangelo. *The Bruges Madonna.* c. 1503–04. Marble. Height (incl. base): 48″ (122 cm). Onze Lieve Vrouwkerk (Church of Our Lady), Bruges.

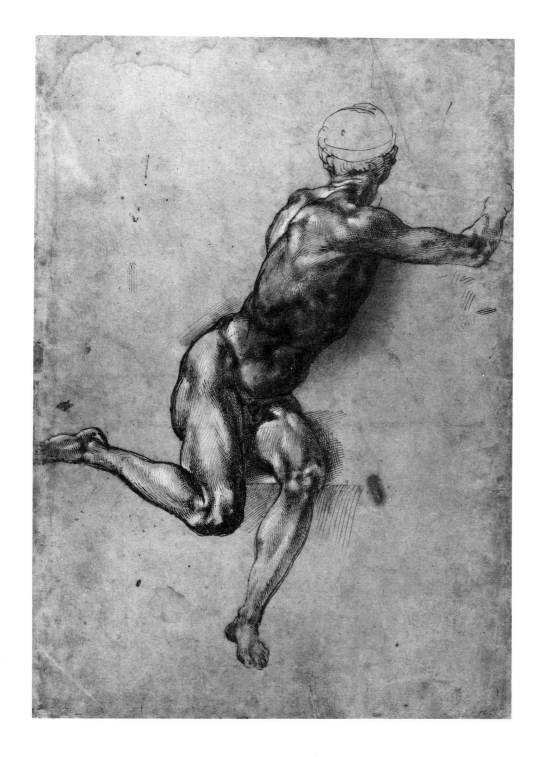

Michelangelo. *Figure for the Battle of Cascina.* 1504. Pen, brush, brown and gray ink, highlighted with white. 16½ × 11¾" (423 × 286 mm). The British Museum, London.

friend of Michelagnolo, Ridolfo Ghirlandajo, Raffaello Sanzio of Urbino, Francesco Granacci, Baccio Bandinelli, and the Spaniard Alonzo Berughetta, and then there followed Andrea del Sarto, Franciabigio, Jacopo Sansovino, Rosso, Maturino, Lorenzetto, Tribolo, who was then a boy, Jacopo da Pontormo, and Perino del Vaga; and all these became excellent Florentine masters. The cartoon having thus become a school for craftsmen, it was taken into the Great Upper Hall in the house of the Medici; and this was the reason that it was left with too little caution in the hands of the craftsmen, insomuch that during the illness of Duke Giuliano, while no one was expecting such a thing, it was torn up and divided into many pieces, as has been related elsewhere, and scattered over various places, to which some pieces bear witness that are still to be seen in Mantua, in the house of M. Uberto Strozzi, a gentleman of that city, where they are treasured with great reverence; and, indeed, they seem to the eye things rather divine than human.

The name of Michelagnolo, by reason of the Pietà that he had made, the Giant in Florence, and the cartoon, had become so famous, that in the year

1503, Pope Alexander VI having died and Julius II having been elected, at which time Michelagnolo was about twenty-nine years of age, he was summoned with much graciousness by Julius II, who wished to set him to make his tomb; and for the expenses of the journey a hundred crowns were paid to him by the Pope's representatives. Having made his way to Rome, he spent many months there before he was made to set his hand to any work. But finally the Pope's choice fell on a design that he had made for that tomb, an excellent testimony to the genius of Michelagnolo, which in beauty and magnificence, abundance of ornamentation and richness of statuary, surpassed every ancient or imperial tomb. Whereupon Pope Julius took courage, and thus resolved to set his hand to make anew the Church of S. Pietro in Rome, in order to erect the tomb in it, as has been related in another place. And so Michelagnolo set to work with high hopes; and, in order to make a beginning, he went to Carrara to excavate all the marble, with two assistants, receiving a thousand crowns on that account from Alamanno Salviati in Florence. There, in those mountains, he spent eight months without other moneys or supplies; and he had many fantastic ideas of carving great statues in those quarries, in order to leave memorials of himself, as the ancients had done before him, being invited by those masses of stone. Then, having picked out the due quantity of marbles, he caused them to be loaded on board ship at the coast and then conveyed to Rome, where they filled half the Piazza di S. Pietro, round about S. Caterina, and between the church and the corridor that goes to the Castello. In that place Michelagnolo had prepared his room for executing the figures and the rest of the tomb; and, to the end that the Pope might be able to come at his convenience to see him at work, he had caused a drawbridge to be constructed between the corridor and that room, which led to a great intimacy between them. But in time these favours brought much annoyance and even persecution upon him, and stirred up much envy against him among his fellow-craftsmen.

Of this work Michelagnolo executed during the lifetime and after the death of Julius four statues completely finished and eight only blocked out, as will be related in the proper place; and since the work was designed with extraordinary invention, we will describe here below the plan that he adopted. In order to produce an effect of supreme grandeur, he decided that it should be wholly isolated, so as to be seen from all four sides, each side in one direction being twelve braccia and each in the other eighteen, so that the proportions were a square and a half. It had a range of niches running right round the outer side, which were divided one from another by terminal figures clothed from the middle upwards, which with their heads supported the first cornice, and each terminal figure had bound to it, in a strange and bizarre attitude, a naked captive, whose feet rested on a projection of the base. These captives were all provinces subjugated by that Pontiff and rendered obedient to the Apostolic Church; and there were various other statues, likewise bound, of all the noble arts and sciences, which were thus shown to be subject to death no less than was that Pontiff, who made such honorable use of them. On the corners of the first cornice were to go four large figures, the Active and the Contemplative Life, S. Paul, and Moses. The structure rose above the cornice in steps gradually diminishing, with a frieze of scenes in bronze, and with other figures, children and ornaments all around, and at the summit, as a crown to the work, were two figures, one of which was Heaven, who, smiling, was supporting a bier on her shoulder, together with Cybele, the Goddess of Earth, who appeared to be grieving that she was left in a world robbed of all virtue by the death of such a man; and Heaven appeared to be smiling with gladness that his soul had passed to celestial glory. The work was so arranged that one might enter and come out again by the ends of the quadrangular structure, between the niches, and the interior curved in the form of an oval after the manner of a temple, in the centre of which was the sarcophagus wherein was to be laid the dead body of that

Alexander VI was the notorious Roderigo Borgia (father of Lucrezia and Cesare), who became pope in 1492.

The "corridor" is the elevated passage built as an escape route from the Apostolic Palace to Castel Sant'Angelo.

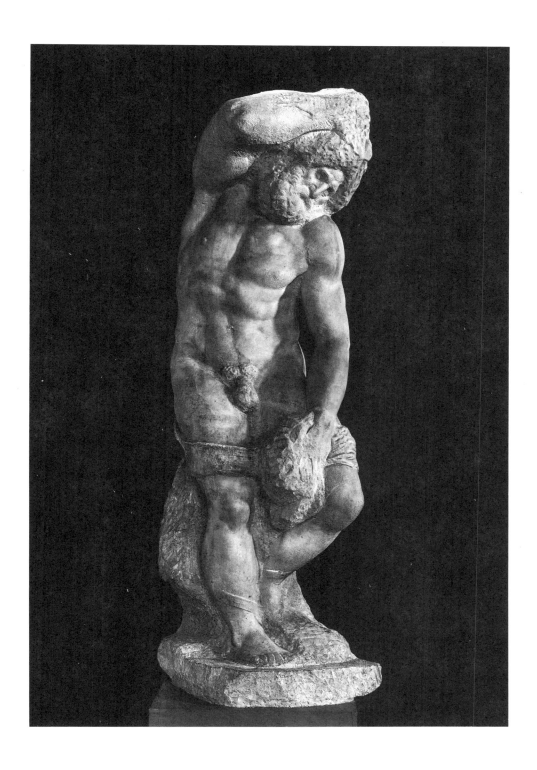

Michelangelo. *Bearded Slave*. 1527–28. Marble. Height (incl. base): 100¾" (246 cm). Accademia di Belle Arti, Florence.

Pope. And, finally, there were to be in this whole work forty statues of marble, without counting the other scenes, children, and ornaments, the carvings covering the cornices, and the other architectural members of the work. Michelagnolo ordained, to expedite the labour, that a part of the marbles should be conveyed to Florence, where he intended at times to spend the summer months in order to avoid the malaria of Rome; and there he executed one side of the work in many pieces, complete in every detail. In Rome he finished entirely with his own hand two of the captives, figures divinely beautiful, and other statues, than which none better have ever been seen; but in the end they were never placed in position, and those captives were presented by him to S. Ruberto Strozzi, when Michelagnolo happened to be lying ill in his house; which captives were afterwards sent as presents to King Francis, and they are now at Ecouen in France. Eight statues, likewise, he blocked out in Rome, and in Florence he blocked out five and finished a Victory with a captive beneath, which are now in the possession of Duke Cosimo, having been presented by

Michelagnolo's nephew, Leonardo, to his Excellency, who has placed the Victory in the Great Hall of his Palace, which was painted by Vasari.

He finished the Moses, a statue in marble of five braccia, which no modern work will ever equal in beauty; and of the ancient statues, also, the same may be said. For, seated in an attitude of great dignity, he rests one arm on the Tables, which he holds with one hand, and with the other he holds his beard, which is long and waving, and carved in the marble in such sort, that the hairs—in which the sculptor finds such difficulty—are wrought with the greatest deli-

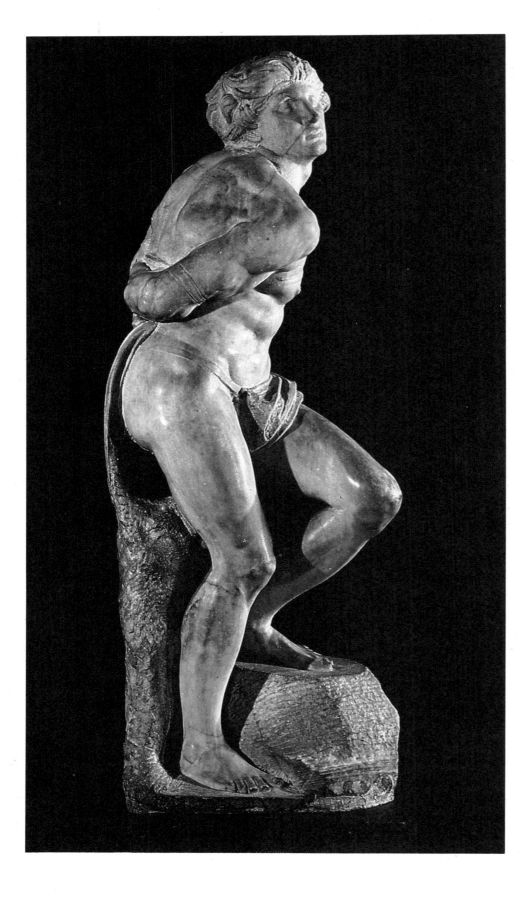

Michelangelo. *The Rebellious Slave.* c. 1513–16 (?). Marble. Height: 84¾″ (215.5 cm). The Louvre, Paris.

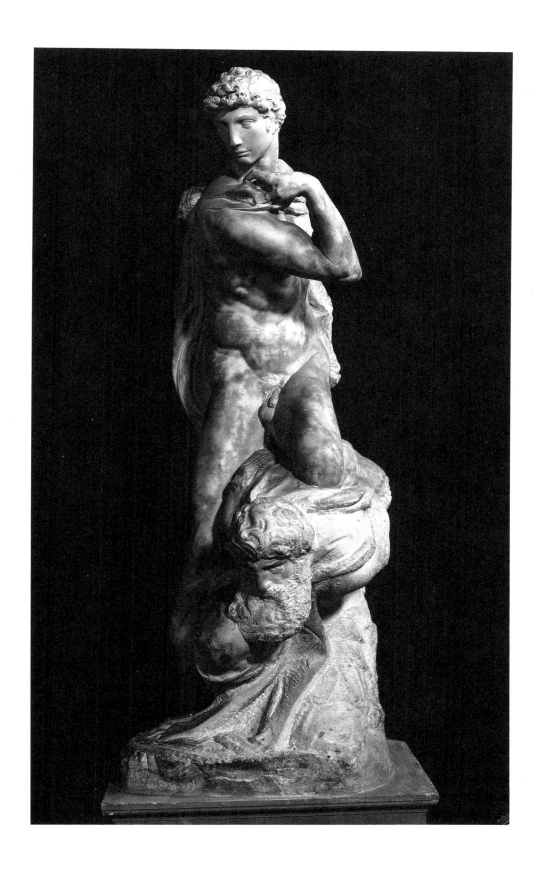

Michelangelo. *Victory*. c. 1527–28. Marble.
Height: 112¾″ (276.5 cm). Palazzo
Vecchio, Florence.

cacy, soft, feathery, and detailed in such a manner, that one cannot but believe
that his chisel was changed into a pencil. To say nothing of the beauty of the
face, which has all the air of a true Saint and most dread Prince, you seem,
while you gaze upon it, to wish to demand from him the veil wherewith to
cover that face, so resplendent and so dazzling it appears to you, and so well has
Michelagnolo expressed the divinity that God infused in that most holy coun-
tenance. In addition, there are draperies carved out and finished with most
beautiful curves of the borders; while the arms with their muscles, and the
hands with their bones and nerves, are carried to such a pitch of beauty and
perfection, and the legs, knees, and feet are covered with buskins so beauti-

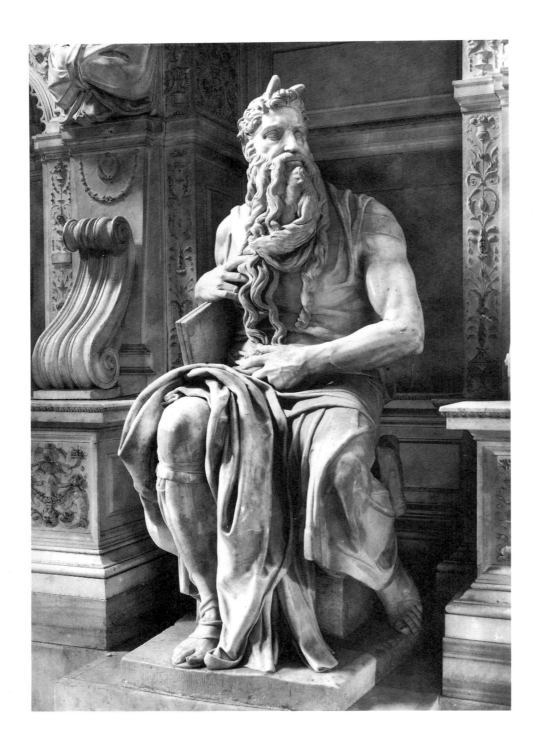

Michelangelo. *Moses.* c. 1515. Marble. Height: 92½″ (235.5 cm). Tomb of Pope Julius II, Church of San Pietro in Vincoli, Rome.

fully fashioned, and every part of the work is so finished, that Moses may be called now more than ever the friend of God, seeing that He has deigned to assemble together and prepare his body for the Resurrection before that of any other, by the hands of Michelagnolo. Well may the Hebrews continue to go there, as they do every Sabbath, both men and women, like flocks of starlings, to visit and adore that statue; for they will be adoring a thing not human but divine.

Finally all the agreements for this work were made, and the end came into view; and of the four sides one of the smaller ones was afterwards erected in S. Pietro in Vincola. It is said that while Michelagnolo was executing the work, there came to the Ripa all the rest of the marbles for the tomb that had remained at Carrara, which were conveyed to the Piazza di S. Pietro, where the others were; and, since it was necessary to pay those who had conveyed them, Michelagnolo went, as was his custom, to the Pope. But, his Holiness having on his hands that day some important business concerning Bologna, he returned to his house and paid for those marbles out of his own purse, thinking

The "Ripa" is the embankment on the river Tiber.

to have the order for them straightaway from his Holiness. He returned another day to speak of them to the Pope, but found difficulty in entering, for one of the grooms told him that he had orders not to admit him, and that he must have patience. A Bishop then said to the groom, "Perhaps you do not know this man?" "Only too well do I know him," answered the groom; "but I am here to do as I am commanded by my superiors and by the Pope." This action displeased Michelagnolo, and, considering that it was contrary to what he had experienced before, he said to the Pope's groom that he should tell his Holiness that from that time forward, when he should want him, it would be found that he had gone elsewhere; and then, having returned to his house, at the second hour of the night he set out on post-horses, leaving two servants to sell all the furniture of his house to the Jews and to follow him to Florence, whither he was bound. Having arrived at Poggibonzi, a place in the Florentine territory, and therefore safe, he stopped; and almost immediately five couriers arrived with letters from the Pope to bring him back. Despite their entreaties and also the letters, which ordered him to return to Rome under threat of punishment, he would not listen to a word; but finally the prayers of the couriers induced him to write a few words in reply to his Holiness, asking for pardon, but saying that he would never again return to his presence, since he had caused him to be driven away like a criminal, that his faithful service had not deserved such treatment, and that his Holiness should look elsewhere for someone to serve him.

After arriving at Florence, Michelagnolo devoted himself during the three months that he stayed there to finishing the cartoon for the Great Hall, which Piero Soderini, the Gonfalonier, desired that he should carry into execution. During that time there came to the Signoria three Briefs commanding them to send Michelagnolo back to Rome: wherefore he, perceiving this vehemence on the part of the Pope, and not trusting him, conceived the idea, so it is said, of going to Constantinople to serve the Grand Turk, who desired to secure him, by means of certain Friars of S. Francis, to build a bridge crossing from Constantinople to Pera. However, he was persuaded by Piero Soderini, although very unwilling, to go to meet the Pope as a person of public importance with the title of Ambassador of the city, to reassure him; and finally the Gonfalonier recommended him to his brother Cardinal Soderini for presentation to the Pope, and sent him off to Bologna, where his Holiness had already arrived from Rome. His departure from Rome is also explained in another way—namely, that the Pope became angered against Michelagnolo, who would not allow any of his works to be seen; that Michelagnolo suspected his own men, doubting (as happened more than once) that the Pope disguised himself and saw what he was doing on certain occasions when he himself was not at home or at work; and that on one occasion, when the Pope had bribed his assistants to admit him to see the chapel of his uncle Sixtus, which, as was related a little time back, he caused Buonarroti to paint, Michelagnolo, having waited in hiding because he suspected the treachery of his assistants, threw planks down at the Pope when he entered the chapel, not considering who it might be, and drove him forth in a fury. It is enough for us to know that in the one way or the other he fell out with the Pope and then became afraid, so that he had to fly from his presence.

Now, having arrived in Bologna, he had scarcely drawn off his riding-boots when he was conducted by the Pope's servants to his Holiness, who was in the Palazzo de' Sedici; and he was accompanied by a Bishop sent by Cardinal Soderini, because the Cardinal, being ill, was not able to go himself. Having come into the presence of the Pope, Michelagnolo knelt down, but his Holiness looked askance at him, as if in anger, and said to him, "Instead of coming yourself to meet us, you have waited for us to come to meet you!" meaning to infer that Bologna is nearer to Florence than Rome. Michelagnolo, with a courtly gesture of his hands, but in a firm voice, humbly begged

for pardon, saying in excuse that he had acted as he had done in anger, not being able to endure to be driven away so abruptly, but that, if he had erred, his Holiness should once more forgive him. The Bishop who had presented Michelagnolo to his Holiness, making excuse for him, said to the Pope that such men were ignorant creatures, that they were worth nothing save in their own art, and that he should freely pardon him. The Pope, seized with anger, belaboured the Bishop with a staff that he had in his hand, saying to him, "It is you that are ignorant, who level insults at him that we ourselves do not think of uttering;" and then the Bishop was driven out by the groom with fisticuffs. When he had gone, the Pope, having discharged his anger upon him, gave Michelagnolo his benediction; and the master was detained in Bologna with gifts and promises, until finally his Holiness commanded him that he should make a statue of bronze in the likeness of Pope Julius, five braccia in height. In this work he showed most beautiful art in the attitude, which had an effect of much majesty and grandeur, and displayed richness and magnificence in the draperies, and in the countenance, spirit, force, resolution, and stern dignity; and it was placed in a niche over the door of S. Petronio. It is said that while Michelagnolo was working at it, he received a visit from Francia, a most excellent goldsmith and painter, who wished to see it, having heard so much praise and fame of him and of his works, and not having seen any of them, so that agents had been set to work to enable him to see it, and he had obtained permission. Whereupon, seeing the artistry of Michelagnolo, he was amazed: and then, being asked by Michelagnolo what he thought of that figure, Francia answered that it was a most beautiful casting and a fine material. Wherefore Michelagnolo, considering that he had praised the bronze rather than the workmanship, said to him, "I owe the same obligation to Pope Julius, who has given it to me, that you owe to the apothecaries who give you your colours for painting;" and in his anger, in the presence of all the gentlemen there, he declared that Francia was a fool. In the same connection, when a son of Francia's came before him and was announced as a very beautiful youth, Michelagnolo said to him, "Your father's living figures are finer than those that he paints." Among the same gentlemen was one, whose name I know not, who asked Michelagnolo which he thought was the larger, the statue of the Pope or a pair of oxen; and he answered, "That depends on the oxen. If they are these Bolognese oxen, then without a doubt our Florentine oxen are not so big."

Francesco Francia (fl. 1482–1517), Bolognese painter who began his career as a goldsmith.

Michelagnolo had the statue finished in clay before the Pope departed from Bologna for Rome, and his Holiness, having gone to see it, but not knowing what was to be placed in his left hand, and seeing the right hand raised in a proud gesture, asked whether it was pronouncing a benediction or a curse. Michelagnolo answered that it was admonishing the people of Bologna to mind their behaviour, and asked his Holiness to decide whether he should place a book in the left hand; and he said, "Put a sword there, for I know nothing of letters." The Pope left a thousand crowns in the bank of M. Anton Maria da Lignano for the completion of the statue, and at the end of the sixteen months that Michelagnolo toiled over the work it was placed on the frontispiece in the façade of the Church of S. Petronio, as has been related; and we have also spoken of its size. This statue was destroyed by the Bentivogli, and the bronze was sold to Duke Alfonso of Ferrara, who made with it a piece of artillery called La Giulia; saving only the head, which is to be found in his guardaroba.

The head is lost.

When the Pope had returned to Rome and Michelagnolo was at work on the statue, Bramante, the friend and relative of Raffaello da Urbino, and for that reason little the friend of Michelagnolo, perceiving that the Pope held in great favour and estimation the works that he executed in sculpture, was constantly planning with Raffaello in Michelagnolo's absence to remove from the mind of his Holiness the idea of causing Michelagnolo, after his return, to devote himself to finishing his tomb; saying that for a man to prepare himself a tomb

during his own lifetime was an evil augury and a hurrying on of his death. And they persuaded his Holiness that on the return of Michelagnolo, he should cause him to paint in memory of his uncle Sixtus the vaulting of the chapel that he had built in the Palace. In this manner it seemed possible to Bramante and other rivals of Michelagnolo to draw him away from sculpture, in which they saw him to be perfect, and to plunge him into despair, they thinking that if they compelled him to paint, he would do work less worthy of praise, since he had no experience of colours in fresco, and that he would prove inferior to Raffaello, and, even if he did succeed in the work, in any case it would make him angry against the Pope; so that in either event they would achieve their object of getting rid of him. And so, when Michelagnolo returned to Rome, the Pope was not disposed at that time to finish his tomb, and requested him to paint the vaulting of the chapel. Michelagnolo, who desired to finish the tomb, believing the vaulting of that chapel to be a great and difficult labour, and considering his own want of practice in colours, sought by every means to shake such a burden from his shoulders, and proposed Raffaello for the work. But the more he refused, the greater grew the desire of the Pope, who was headstrong in his undertakings, and, in addition, was being spurred on anew by the rivals of Michelagnolo, and especially by Bramante; so that his Holiness, who was quick-tempered, was on the point of becoming enraged with Michelagnolo. Whereupon Michelagnolo, perceiving that his Holiness was determined in the matter, resolved to do it; and the Pope commanded Bramante to erect the scaffolding from which the vaulting might be painted. Bramante made it all supported by ropes, piercing the vaulting; which having perceived, Michelagnolo inquired of Bramante how he was to proceed to fill up the holes when he had finished painting it, and he replied that he would think of that afterwards, and that it could not be done otherwise. Michelagnolo recognized that Bramante was either not very competent for such a work or else little his friend, and he went to the Pope and said to him that the scaffolding was not satisfactory, and that Bramante had not known how to make it; and the Pope answered, in the presence of Bramante, that he should make it after his own fashion. And so he commanded that it should be erected upon props so as not to touch the walls, a method of making scaffoldings for vaults that he taught afterwards to Bramante and others, whereby many fine works have been executed. Thus he enabled a poor creature of a carpenter, who rebuilt the scaffolding, to dispense with so many of the ropes, that, after selling them (for Michelagnolo gave them to him), he made up a dowry for his daughter.

He then set his hand to making the cartoons for that vaulting; and the Pope decided, also, that the walls which the masters before him in the time of Sixtus had painted should be scraped clean, and decreed that he should have fifteen thousand ducats for the whole cost of the work; which price was fixed through Giuliano da San Gallo. Thereupon, forced by the magnitude of the undertaking to resign himself to obtaining assistance, Michelagnolo sent for men to Florence; and he determined to demonstrate in such a work that those who had painted there before him were destined to be vanquished by his labours, and also resolved to show to the modern craftsmen how to draw and paint. Having begun the cartoons, he finished them; and the circumstances of the work spurred him to soar to great heights, both for his own fame and for the welfare of art. And then, desiring to paint it in fresco-colours, and not having any experience of them, there came from Florence to Rome certain of his friends who were painters, to the end that they might give him assistance in such a work, and also that he might learn from them the method of working in fresco, in which some of them were well-practised; and among these were Granaccio, Giuliano Bugiardini, Jacopo di Sandro, the elder Indaco, Agnolo di Donnino, and Aristotile. Having made a commencement with the work, he caused them to begin some things as specimens; but, perceiving that their efforts were very

The frescoes were not removed.

The equivalent of about $200,000.

"Granaccio" is Francesco Granacci. Jacopo di Sandro was a minor master. Giuliano Bugiardini (1475–1554), Florentine painter. Jacopo L'Indaco (1476–1534), painter and sculptor whose surviving work is mostly in Spain. Most of the artists mentioned here were transitional figures of minor importance.

far from what he desired, and not being satisfied with them, he resolved one morning to throw to the ground everything that they had done. Then, shutting himself up in the chapel, he would never open to them, nor even allowed himself to be seen by them when he was at home. And so, when the jest appeared to them to be going too far, they resigned themselves to it and returned in shame to Florence. Thereupon Michelagnolo, having made arrangements to paint the whole work by himself, carried it well on the way to completion with the utmost solicitude, labour, and study; nor would he ever let himself be seen, lest he should give any occasion to compel him to show it, so that the desire in the minds of everyone to see it grew greater every day.

Pope Julius was always very desirous to see any undertakings that he was having carried out, and therefore became more eager than ever to see this one, which was hidden from him. And so one day he resolved to go to see it, but was not admitted, for Michelagnolo would never have consented to show it to him; out of which affair arose the quarrel that has been described, when he had to depart from Rome because he would not show his work to the Pope. Now, when a third of the work was finished (as I ascertained from him in order to clear up all doubts), it began to throw out certain spots of mould, one winter that the north wind was blowing. The reason of this was that the Roman lime, which is made of travertine and white in colour, does not dry very readily, and, when mixed with pozzolana, which is of a tawny colour, makes a dark mixture which, when soft, is very watery; and when the wall has been well soaked, it often breaks out into an efflorescence in the drying; and thus the salt efflorescence of moisture came out in many places, but in time the air consumed it. Michelagnolo was in despair over this, and was unwilling to continue the work, asking the Pope to excuse him, since he was not succeeding; but his Holiness sent Giuliano da San Gallo to see him, and he, having told him whence the defect arose and taught him how to remove the spots of mould, encouraged him to persevere.

Now, when he had finished half of it, the Pope, who had subsequently gone to see it several times (mounting certain ladders with the assistance of Michelagnolo), insisted that it should be thrown open, for he was hasty and impatient by nature, and could not wait for it to be completely finished and to receive, as the saying is, the final touch. No sooner was it thrown open than all Rome was drawn to see it, and the Pope was the first, not having the patience to wait until the dust caused by the dismantling of the scaffolding had settled. Thereupon Raffaello da Urbino, who was very excellent in imitation, after seeing it straightway changed his manner, and without losing any time, in order to display his ability, painted the Prophets and Sibyls in the work of the Pace; and at the same time Bramante sought to have the other half of the chapel entrusted by the Pope to Raffaello. Which hearing, Michelagnolo complained of Bramante, and revealed to the Pope without any reserve many faults both in his life and in his architectural works; of which last, in the building of S. Pietro, as was seen afterwards, Michelagnolo became the corrector. But the Pope, recognizing more clearly every day the ability of Michelagnolo, desired that he should continue the work, judging, after he had seen it uncovered, that he could make the second half considerably better; and so in [six years] he carried that work to perfect completion by himself alone, without the assistance even of anyone to grind his colours. Michelagnolo complained at times that on account of the haste that the Pope imposed on him he was not able to finish it in his own fashion, as he would have liked; for his Holiness was always asking him importunately when he would finish it. On one occasion, among others, he replied, "It will be finished when I shall have satisfied myself in the matter of art." "But it is our pleasure," answered the Pope, "that you should satisfy us in our desire to have it done quickly;" and he added, finally, that if Michelagnolo did not finish the work quickly he would have him thrown down from

Pozzolana is a type of fine volcanic sand, originally found in Pozzuoli, near Naples.

the scaffolding. Whereupon Michelagnolo, who feared and had good reason to fear the anger of the Pope, straightway finished all that was wanting, without losing any time, and, after taking down the rest of the scaffolding, threw it open to view on the morning of All Saints' Day, when the Pope went into the chapel to sing Mass, to the great satisfaction of the whole city. Michelagnolo desired to retouch some parts "a secco," as the old masters had done on the scenes below, painting backgrounds, draperies, and skies in ultramarine, and ornaments in gold in certain places, to the end that this might produce greater richness and a more striking effect; and the Pope, having learned that this ornamentation was wanting, and hearing the work praised so much by all who had seen it, wished him to finish it; but, since it would have been too long a labour for Michelagnolo to rebuild the scaffolding, it was left as it was. His Holiness, often seeing Michelagnolo, would say to him that the chapel should be enriched with colours and gold, since it looked poor. And Michelagnolo would answer familiarly, "Holy Father, in those times men did not bedeck themselves with gold, and those that are painted there were never very rich, but rather holy men, on which account they despised riches."

Painting à secco *is the overpainting of a fresco after the surface has dried.*

For this work Michelagnolo was paid by the Pope three thousand crowns on several occasions, of which he had to spend twenty-five on colours. The work was executed with very great discomfort to himself, from his having to labour with his face upwards, which so impaired his sight that for a time, which was not less than several months, he was not able to read letters or look at drawings save with his head backwards. And to this I can bear witness, having painted five vaulted chambers in the great apartments in the Palace of Duke Cosimo, when, if I had not made a chair on which I could rest my head and lie down at my work, I would never have finished it; even so, it has so ruined my sight and injured my head, that I still feel the effects, and I am astonished that Michelagnolo endured all that discomfort so well. But in truth, becoming more and more kindled every day by his fervour in the work, and encouraged by the proficience and improvement that he made, he felt no fatigue and cared nothing for discomfort.

The value of the crown varied according to the kingdom, principality, or state. Its present-day equivalent could be anywhere from $50 to $100.

"The Palace" is the Palazzo Vecchio (Palazzo della Signoria).

The distribution of this work is contrived with six pendentives on either side, with one in the centre of the walls at the foot and at the head, and on these he painted Sibyls and Prophets, six braccia in height; in the centre of the vault the history of the world from Creation down to the Deluge and the Drunkenness of Noah, and in the lunettes all the Genealogy of Christ. In these compartments he used no rule of perspectives in foreshortening, nor is there any fixed point of view, but he accommodated the compartments to the figures rather than the figures to the compartments, being satisfied to execute those figures, both the nude and the draped, with the perfection of design, so that another such work has never been and never can be done, and it is scarcely possible even to imitate his achievement. This work, in truth, has been and still is the lamp of our art, and has bestowed such benefits and shed so much light on the art of painting, that it has served to illuminate a world that had lain in darkness for so many hundreds of years. And it is certain that no man who is a painter need think any more to see new inventions, attitudes, and draperies for the clothing of figures, novel manners of expression, and things painted with greater variety and force, because he gave to this work all the perfection that can be given to any work executed in such a field of art. And at the present day everyone is amazed who is able to perceive in it the excellence of the figures, the perfection of the foreshortenings, and the extraordinary roundness of the contours, which have in them slenderness and grace, being drawn with the beauty of proportion that is seen in beautiful nudes; and these, in order to display the supreme perfection of art, he made of all ages, different in expression and in form, in countenance and in outline, some more slender and some fuller in the members; as may also be seen in the beautiful attitudes, which are all different,

COLORPLATE 79

some seated, some moving, and others upholding certain festoons of oak-leaves and acorns, placed there as the arms and device of Pope Julius, and signifying that at that time and under his government was the age of gold; for Italy was not then in the travail and misery that she has since suffered. Between them, also, they hold some medallions containing stories in relief in imitation of bronze and gold, taken from the Book of Kings.

Besides this, in order to display the perfection of art and also the greatness of God, he painted in a scene God dividing Light from Darkness, wherein may be seen His Majesty as He rests self-sustained with the arms outstretched, and reveals both love and power. In the second scene he depicted with most beautiful judgment and genius God creating the Sun and Moon, in which He is supported by many little Angels, in an attitude sublime and terrible by reason of the foreshortenings in the arms and legs. In the same scene Michelagnolo depicted Him after the Blessing of the Earth and the Creation of the Animals, when He is seen on that vaulting as a figure flying in foreshortening; and wherever you go throughout the chapel, it turns constantly and faces in every direction. So, also, in the next scene, where He is dividing the Water from the Earth; and both these are very beautiful figures and refinements of genius such as could be produced only by the divine hands of Michelagnolo. He then went on, beyond that scene, to the Creation of Adam, wherein he figured God as borne by a group of nude Angels of tender age, which appear to be supporting not one figure only, but the whole weight of the world; this effect being produced by the venerable majesty of His form and by the manner of the movement with which He embraces some of the little Angels with one arm, as if to support Himself, and with the other extends the right hand towards Adam, a figure of such a kind in its beauty, in the attitude, and in the outlines, that it appears as if newly fashioned by the first and supreme Creator rather than by the brush and design of a mortal man. Beyond this, in another scene, he made God taking our mother Eve from Adam's side, in which may be seen those two nude figures, one as it were dead from his being the thrall of sleep, and the other become alive and filled with animation by the blessing of God. Very clearly do we see from the brush of this most gifted craftsman the difference that there is between sleep and wakefulness, and how firm and stable, speaking humanely, the Divine Majesty may appear.

Next to this there follows the scene when Adam, at the persuasion of a figure half woman and half serpent, brings death upon himself and upon us by the Forbidden Fruit; and there, also, are seen Adam and Eve driven from Paradise. In the figure of the Angel is shown with nobility and grandeur the execution of the mandate of a wrathful Lord, and in the attitude of Adam the sorrow for his sin together with the fear of death, as likewise in the woman may be seen shame, abasement, and the desire to implore pardon, as she presses the arms to the breast, clasps the hands palm to palm, and sinks the neck into the bosom, and also turns the head towards the Angel, having more fear of the justice of God than hope in His mercy. Nor is there less beauty in the story of the sacrifice of Cain and Abel, wherein are some who are bringing up wood, some who are bent down and blowing at the fire, and others who are cutting the throat of the victim; which certainly is all executed with not less consideration and attention than the others. He showed the same art and the same judgment in the story of the Deluge, wherein are seen various deaths of men, who, terrified by the horror of those days, are striving their utmost in different ways to save their lives. For in the faces of those figures may be seen life a prey to death, not less than fear, terror, and disregard of everything; and compassion is visible in many that are assisting one another to climb to the summit of a rock in search of safety, among them one who, having embraced one half dead, is striving his utmost to save him, than which Nature herself could show nothing better. Nor can I tell how well expressed is the story of Noah, who,

The family name of Pope Julius was Della Rovere, which means "of the oak."

COLORPLATE 86

COLORPLATE 87

COLORPLATE 88

COLORPLATE 89

COLORPLATE 90

242

drunk with wine, is sleeping naked, and has before him one son who is laughing at him and two who are covering him up—a scene incomparable in the beauty of the artistry, and not to be surpassed save by himself alone.

Then, as if his genius had taken courage from what it had achieved up to that time, it soared upwards and proved itself even greater in the five Sibyls and seven Prophets that are painted there, each five braccia or more in height. In all these are well-varied attitudes, beautiful draperies, and different vestments; and all, in a word, are wrought with marvellous invention and judgment, and to him who can distinguish their expressions they appear divine. Jeremiah is seen with the legs crossed, holding one hand to the beard, and resting that elbow on the knee; the other hand rests in his lap, and he has the head bowed in a manner that clearly demonstrates the melancholy, cogitation, anxious thought and bitterness of soul that his people cause him. Equally fine, also, are two little children that are behind him, and likewise the first Sibyl, beyond him in the direction of the door, in which figure, wishing to depict old age, in addition to enveloping her in the draperies, he sought to show that her blood is already frozen by time; besides which, since her sight has become feeble, he has made her as she reads bring the book very close to her eyes. Beyond this figure follows the Prophet Ezekiel, an old man, who has a grace and movement that are most beautiful, and is much enveloped in draperies, while with one hand he holds a roll of prophecies, and with the other uplifted, turning his head, he appears to be about to utter great and lofty words; and behind him he has two boys who hold his books. Next to him follows a Sibyl, who is doing the contrary to the Erythræan Sibyl that we described above, for, holding her book away from her, she seeks to turn a page, while with one knee over the other she sits sunk within herself, pondering gravely over what she is to write; and then a boy who is behind her, blowing on a burning brand, lights her lamp. This figure is of extraordinary beauty in the expression of the face, in the head-dress, and in the arrangement of the draperies; besides which she has the arms nude, which are equal to the other parts. Beyond this Sibyl he painted the Prophet Joel, who, sunk within himself, has taken a scroll and reads it with great attention and appreciation: and from his aspect it is so clearly evident that he is satisfied with that which he finds written there, that he looks like a living person who has applied his thoughts intently to some matter. Over the door of the chapel, likewise, he placed the aged Zaccharias, who, seeking through his written book for something that he cannot find, stands with one leg on high and the other low; and, while the ardour of the search after something that he cannot find causes him to stand thus, he takes no notice of the discomfort that he suffers in such a posture. This figure is very beautiful in its aspect of old age, and somewhat full in form, and has draperies with few folds, which are most beautiful. In addition, there is another Sibyl, who is next in the direction of the altar on the other side, displaying certain writings, and, with her boys in attendance, is no less worthy of praise than are the others. Beyond her is the Prophet Isaiah, who, wholly absorbed in his own thoughts, has the legs crossed over one another, and, holding one hand in his book to mark the place where he was reading, has placed the elbow of the other arm upon the book, with the cheek pressed against the hand; and, being called by one of the boys that he has behind him, he turns only the head, without disturbing himself otherwise. Whoever shall consider his countenance, shall see touches truly taken from Nature herself, the true mother of art, and a figure which, when well studied in every part, can teach in liberal measure all the precepts of the good painter. Beyond this Prophet is an aged Sibyl of great beauty, who, as she sits, studies from a book in an attitude of extraordinary grace, not to speak of the beautiful attitudes of the two boys that are about her. Nor may any man think with all his imaginings to be able to attain to the excellence of the figure of a youth representing Daniel, who, writing in a great book, is taking certain things from

The sibyls were legendary prophetesses of the ancient world; their mystical writings, or "books," were believed to have incorporated prophetic passages on the coming of Christ.

COLORPLATE 84

COLORPLATE 82

COLORPLATE 83

243

other writings and copying them with extraordinary attention; and as a support for the weight of the book Michelagnolo painted a boy between his legs, who is upholding it while he writes, all which no brush held by a human hand, however skilful, will ever be able to equal. And so, also, with the beautiful figure of the Libyan Sibyl, who, having written a great volume drawn from many books, is in an attitude of womanly grace, as if about to rise to her feet; and in one and the same movement she makes as if to rise and to close the book—a thing most difficult, not to say impossible, for any other but the master of the work.

And what can be said of the four scenes at the corners, on the spandrels of that vaulting; in one of which David, with all the boyish strength that he can exert in the conquest of a giant, is cutting off his head, bringing marvel to the faces of some soldiers who are about the camp. And so, also, do men marvel at the beautiful attitudes that Michelagnolo depicted in the story of Judith, at the opposite corner, in which may be seen the trunk of Holofernes, robbed of life but still quivering, while Judith is placing the lifeless head in a basket on the head of her old serving-woman, who, being tall in stature, is stooping to the end that Judith may be able to reach up to her and adjust the weight well; and the servant, while upholding the burden with her hands, seeks to conceal it, and, turning her head towards the trunk, which, although dead, draws up an arm and a leg and makes a noise in the tent, she shows in her expression fear of the camp and terror of the dead body—a picture truly full of thought. But more beautiful and more divine than this or any of the others is the story of the Serpents of Moses, which is above the left-hand corner of the altar; for the reason that in it is seen the havoc wrought by death, the rain of serpents, their stings and their bites, and there may also be perceived the serpent of brass that Moses placed upon a pole. In this scene are shown vividly the various deaths that those die who are robbed of all hope by the bite of the serpents, and one sees the deadly venom causing vast numbers to die in terror and convulsions, to say nothing of the rigid legs and twisted arms of those who remain in the attitudes in which they were struck down, unable to move, and the marvellous heads that are shrieking and thrown backwards in despair. Not less beautiful than all these are those who, having looked upon the serpent, and feeling their pains alleviated by the sight of it, are gazing on it with profound emotion; and among them is a woman who is supported by another figure in such a manner that the assistance rendered to her by him who upholds her is no less manifest than her pressing need in such sudden alarm and hurt. In the next scene, likewise, in which Ahasuerus, reclining in a bed, is reading his chronicles, are figures of great beauty, and among them three figures eating at a table, which represent the council that was held for the deliverance of the Jewish people and the hanging of Haman. The figure of Haman was executed by Michelagnolo in an extraordinary manner of foreshortening, for he counterfeited the trunk that supports his person, and that arm which comes forward, not as painted things but as real and natural, standing out in relief, and so also that leg which he stretches outwards and other parts that bend inwards: which figure, among all that are beautiful and difficult, is certainly the most beautiful and the most difficult.

It would take too long to describe all the beautiful fantasies in the different actions in the part where there is all the Genealogy of the Fathers, beginning with the sons of Noah, to demonstrate the Genealogy of Jesus Christ, in which figures is a variety of things that it is not possible to enumerate, such as draperies, expressions of heads, and an infinite number of novel and extraordinary fancies, all most beautifully considered. Nothing there but is carried into execution with genius: all the figures there are masterly and most beautifully foreshortened, and everything that you look at is divine and beyond praise. And who will not be struck dumb with admiration at the sight of the sublime force

It has been postulated that the figure of David is a self-portrait.

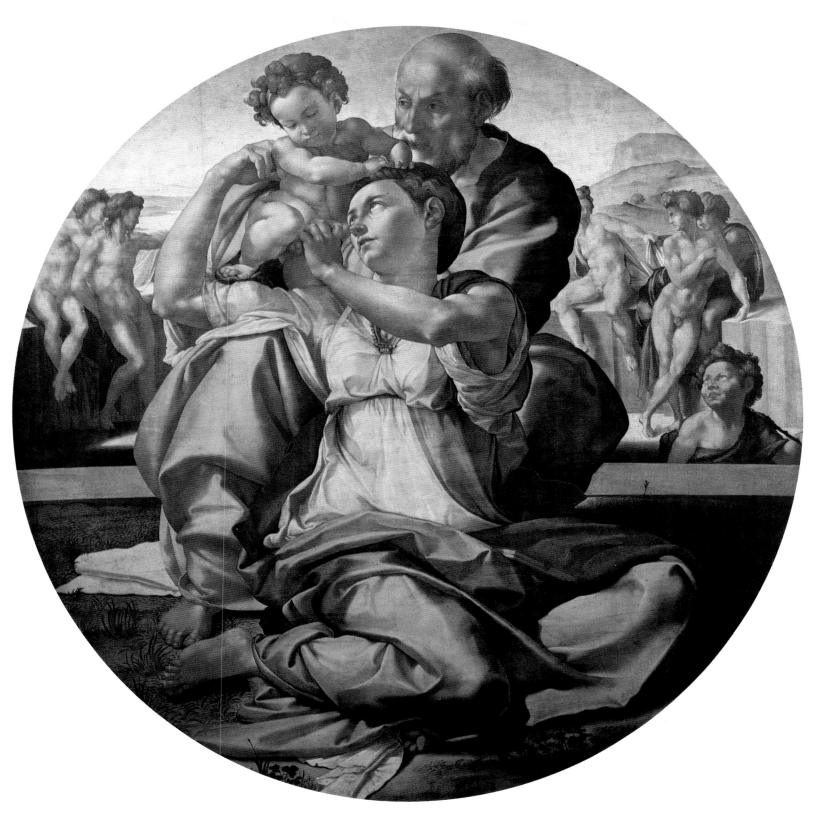

COLORPLATE 81. Michelangelo. *The Doni Tondo.* c. 1503. 47¼ ″ (120 cm) in diam. Panel.
Uffizi Gallery, Florence.

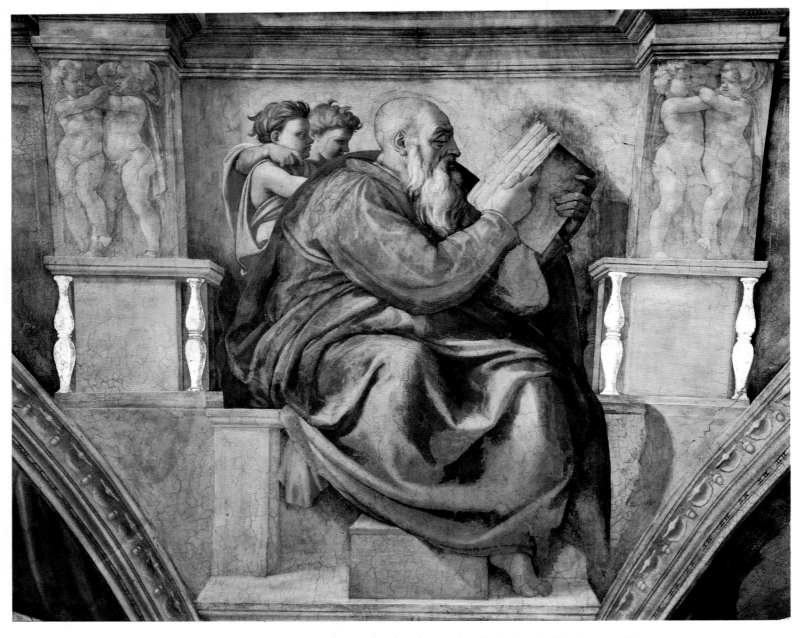

COLORPLATE 82. Michelangelo. *The Prophet Zaccharia* (detail, Sistine Ceiling). 1509. Fresco.
Sistine Chapel, Vatican, Rome.

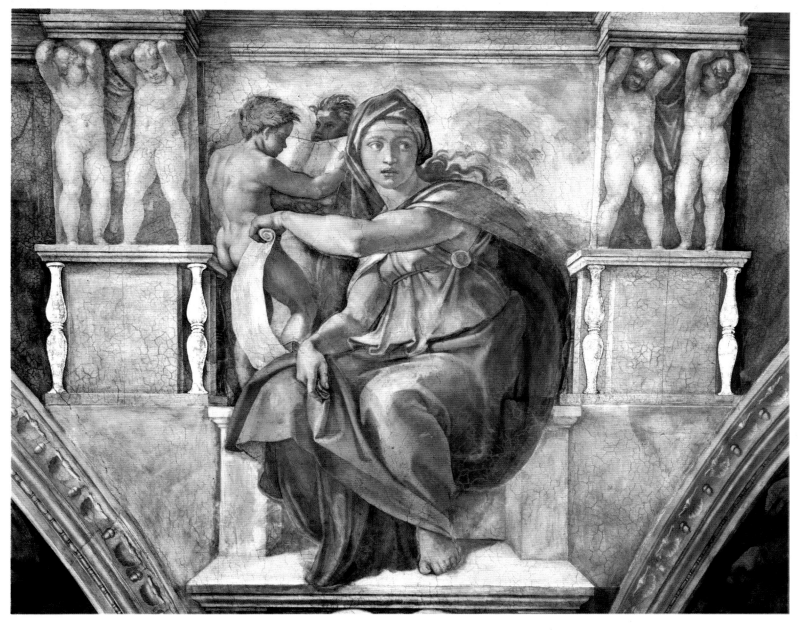

COLORPLATE 83. Michelangelo. *The Delphic Sibyl* (detail, Sistine Ceiling). 1509. Fresco.
Sistine Chapel, Vatican, Rome.

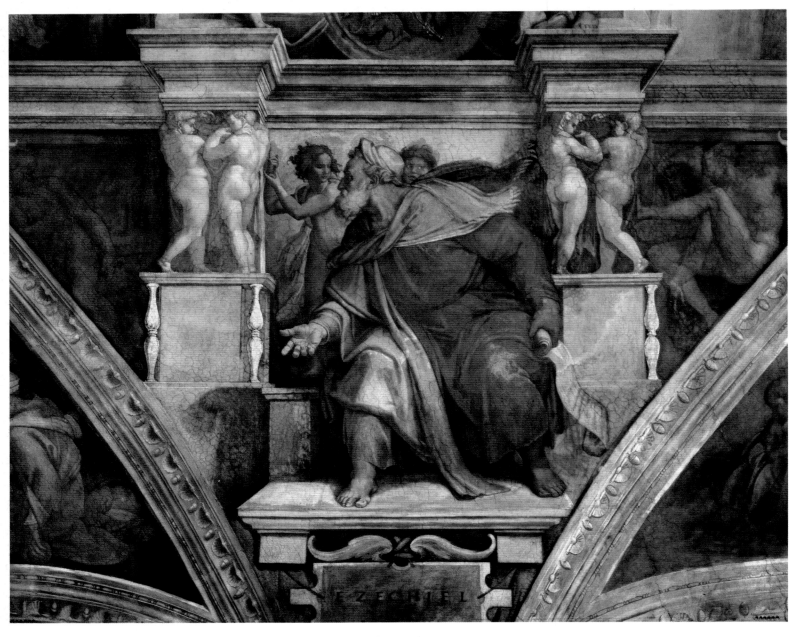

COLORPLATE 84. Michelangelo. *The Prophet Ezekiel* (detail, Sistine Ceiling). 1510. Fresco.
Sistine Chapel, Vatican, Rome.

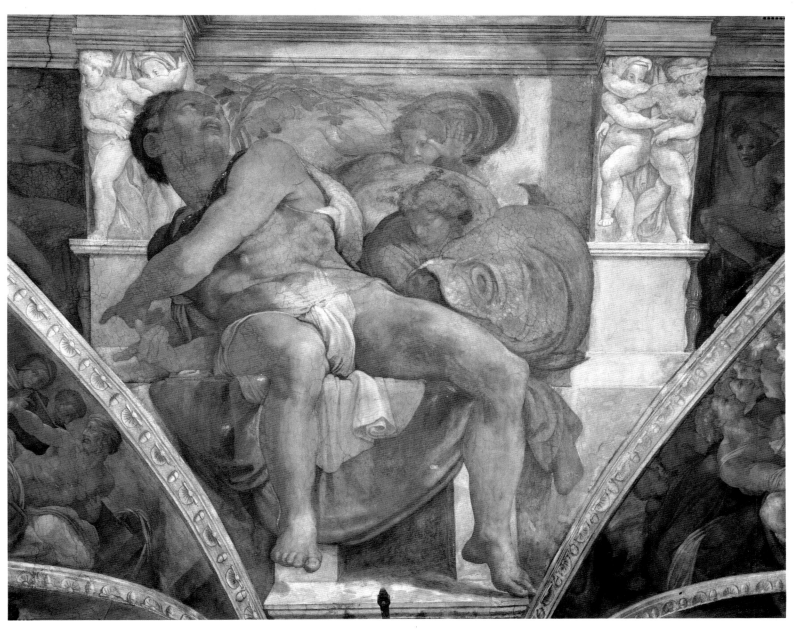

COLORPLATE 85. Michelangelo. *The Prophet Jonah* (detail, Sistine Ceiling). 1511. Fresco.
Sistine Chapel, Vatican, Rome.

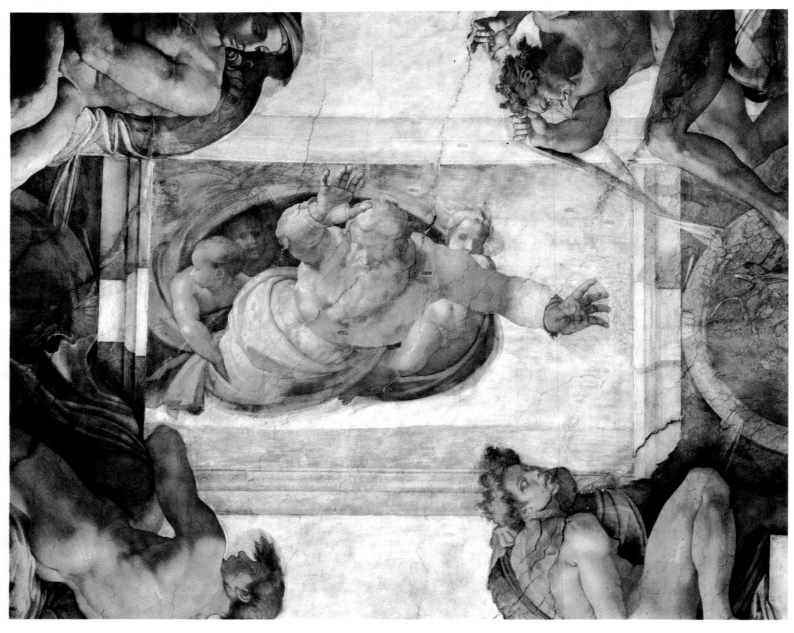

COLORPLATE 86. Michelangelo. *The Separation of the Earth from the Waters* (detail, Sistine Ceiling). 1511. Fresco. Sistine Chapel, Vatican, Rome.

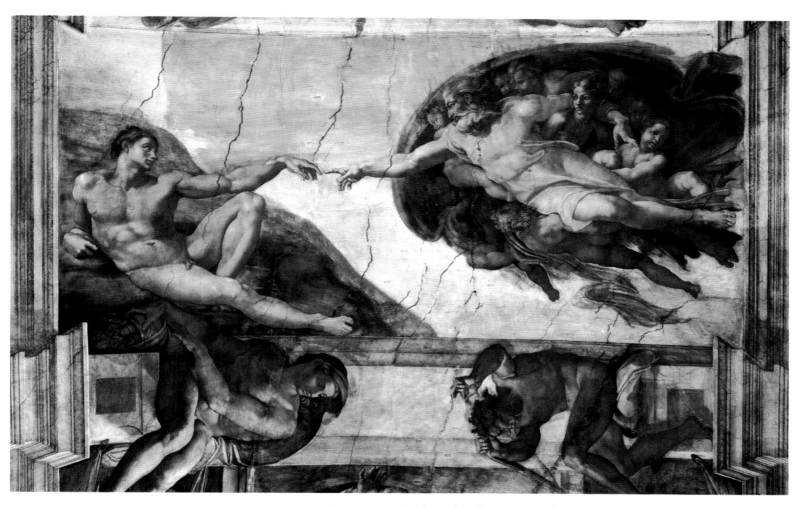

COLORPLATE 87. Michelangelo. *The Creation of Adam* (detail, Sistine Ceiling). 1510. Fresco.
Sistine Chapel, Vatican, Rome.

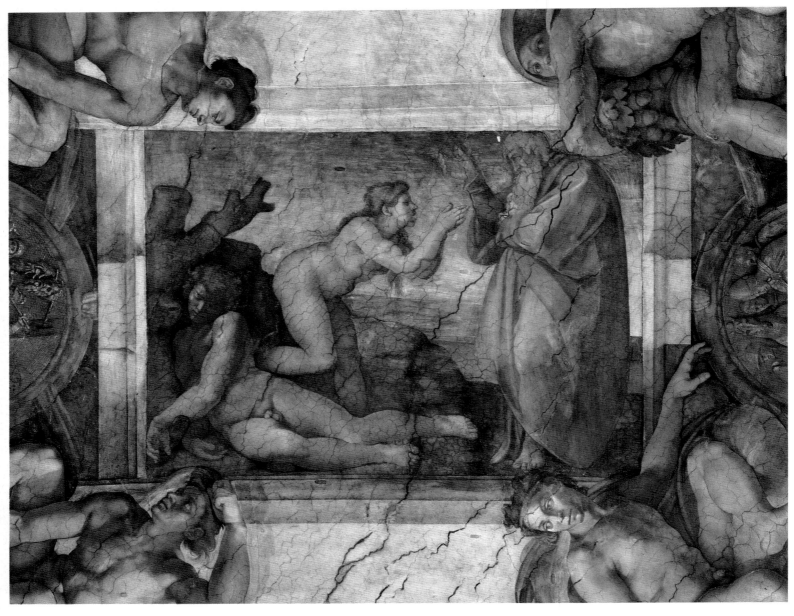

COLORPLATE 88. Michelangelo. *The Creation of Eve* (detail, Sistine Ceiling). 1509–10. Fresco.
Sistine Chapel, Vatican, Rome.

of Jonas, the last figure in the chapel, wherein by the power of art the vaulting, which in fact springs forward in accord with the curve of the masonry, yet, being in appearance pushed back by that figure, which bends inwards, seems as if straight, and, vanquished by the art of design with its lights and shades, even appears in truth to recede inwards? Oh, truly happy age of ours, and truly blessed craftsmen! Well may you be called so, seeing that in our time you have been able to illumine anew in such a fount of light the darkened sight of your eyes, and to see all that was difficult made smooth by a master so marvellous and so unrivalled! Certainly the glory of his labours makes you known and honoured, in that he has stripped from you that veil which you had over the eyes of your minds, which were so full of darkness, and has delivered the truth from the falsehood that overshadowed your intellects. Thank Heaven, therefore, for this, and strive to imitate Michelagnolo in everything.

When the work was thrown open, the whole world could be heard running up to see it, and, indeed, it was such as to make everyone astonished and dumb. Wherefore the Pope, having been magnified by such a result and encouraged in his heart to undertake even greater enterprises, rewarded Michelagnolo liberally with money and rich gifts: and Michelagnolo would say at times of the extraordinary favours that the Pope conferred upon him, that they showed that he fully recognized his worth, and that, if by way of proving his friendliness he sometimes played him strange tricks, he would heal the wound with signal gifts and favours. As when, Michelagnolo once demanding from him leave to go to Florence for the festival of S. John, and asking money for that purpose, the Pope said, "Well, but when will you have this chapel finished?" "As soon as I can, Holy Father." The Pope, who had a staff in his hand, struck Michelagnolo, saying, "As soon as I can! As soon as I can! I will soon make you finish it!" Whereupon Michelagnolo went back to his house to get ready to go to Florence; but the Pope straightway sent Cursio, his Chamberlain, to Michelagnolo with five hundred crowns to pacify him, fearing lest he might commit one of his caprices, and Cursio made excuse for the Pope, saying that such things were favours and marks of affection. And Michelagnolo, who knew the Pope's nature and, after all, loved him, laughed over it all, for he saw that in the end everything turned to his profit and advantage, and that the Pontiff would do anything to keep a man such as himself as his friend.

When the chapel was finished, before the Pope was overtaken by death, his Holiness commanded Cardinal Santiquattro and Cardinal Aginense, his nephew, in the event of his death, that they should cause his tomb to be finished, but on a smaller scale than before. To this work Michelagnolo set himself once again, and so made a beginning gladly with the tomb, hoping to carry it once and for all to completion without so many impediments; but he had from it ever afterwards vexations, annoyances, and travails, more than from any other work that he did in all his life, and it brought upon him for a long time, in a certain sense, the accusation of being ungrateful to that Pope, who had so loved and favoured him. Thus, when he had returned to the tomb, and was working at it continually, and also at times preparing designs from which he might be able to execute the façades of the chapel, envious Fortune decreed that that memorial, which had been begun with such perfection, should be left unfinished. For at that time there took place the death of Pope Julius, and the work was abandoned on account of the election of Pope Leo X, who, being no less splendid than Julius in mind and spirit, had a desire to leave in his native city (of which he was the first Pope), in memory of himself and of a divine craftsman who was his fellow-citizen, such marvels as only a mighty Prince like himself could undertake. Wherefore he gave orders that the façade of S. Lorenzo, a church built by the Medici family in Florence, should be erected for him, which was the reason that the work of the tomb of Julius was left unfinished; and he demanded advice and designs from Michelagnolo, and

desired that he should be the head of that work. Michelagnolo made all the resistance that he could, pleading that he was pledged in the matter of the tomb to Santiquattro and Aginense, but the Pope answered him that he was not to think of that, and that he himself had already seen to it and contrived that Michelagnolo should be released by them; promising, also, that he should be able to work in Florence, as he had already begun to do, at the figures for that tomb. All this was displeasing to the Cardinals, and also to Michelagnolo, who went off in tears.

Many and various were the discussions that arose on this subject, on the ground that such a work as that façade should have been distributed among several persons, and in the matter of the architecture many craftsmen flocked to Rome to see the Pope, and made designs; Baccio d'Agnolo, [Giuliano] San Gallo, Andrea Sansovino and Jacopo Sansovino, and the gracious Raffaello da Urbino, who was afterwards summoned to Florence for that purpose at the time of the Pope's visit. Thereupon Michelagnolo resolved to make a model and not to accept anyone beyond himself as his guide or superior in the architecture of such a work; but this refusal of assistance was the reason that neither he nor any other executed the work, and that those masters returned in despair to their customary pursuits. Michelagnolo, going to Carrara, had an order authorizing that a thousand crowns should be paid to him by Jacopo Salviati; but on his arrival Jacopo was shut up in his room on business with some citizens, and Michelagnolo, refusing to wait for an audience, departed without saying a word and went straightway to Carrara. Jacopo heard of Michelagnolo's arrival, and, not finding him in Florence, sent him a thousand crowns to Carrara. The messenger demanded that Michelagnolo should write him a receipt, to which he answered that the money was for the expenses of the Pope and not for his own interest, and that the messenger might take it back, but that he was not accustomed to write out quittances or receipts for others; whereupon the other returned in alarm to Jacopo without a receipt.

While Michelagnolo was at Carrara and was having marble quarried for the tomb of Julius, thinking at length to finish it, no less than for the façade, a letter was written to him saying that Pope Leo had heard that in the mountains of

Jacopo Sansovino; his original surname was Tatti, but he took the name under which he is known from his teacher Andrea.

Michelangelo. *Model for Façade of San Lorenzo.* 1517. Wood. Casa Buonarroti, Florence.

Pietrasanta near Seravezza, in the Florentine dominion, at the summit of the highest mountain, which is called Monte Altissimo, there were marbles of the same excellence and beauty as those of Carrara. This Michelagnolo already knew, but it seems that he would not take advantage of it because of his friendship with the Marchese Alberigo, Lord of Carrara, and, in order to do him a good service, chose to quarry those of Carrara rather than those of Seravezza; or it may have been that he judged it to be a long undertaking and likely to waste much time, as indeed it did. However, he was forced to go to Seravezza, although he pleaded in protest that it would be more difficult and costly, as in truth it was, especially at the beginning, and, moreover, that the report about the marble was perhaps not true; but for all that the Pope would not hear a word of objection. Thereupon it was decided to make a road for several miles through the mountains, breaking down rocks with hammers and pickaxes to obtain a level, and sinking piles in the marshy places; and there Michelagnolo spent many years in executing the wishes of the Pope. Finally five columns of the proper size were excavated, one of which is on the Piazza di S. Lorenzo in Florence, and the others are on the sea-shore. And for this reason the Marchese Alberigo, who saw his business ruined, became the bitter enemy of Michelagnolo, who was not to blame. Michelagnolo, in addition to these columns, excavated many other marbles there, which are still in the quarries, abandoned there for more than thirty years. But at the present day Duke Cosimo has given orders for the road to be finished, of which there are still two miles to make over very difficult ground, for the transportation of these marbles, and also a road from another quarry of excellent marble that was discovered at that time by Michelagnolo, in order to be able to finish many beautiful undertakings. In the same district of Seravezza he discovered a mountain of variegated marble that is very hard and very beautiful, below Stazema, a village in those mountains; where the same Duke Cosimo has caused a paved road of more than four miles to be made, for conveying the marble to the sea.

But to return to Michelagnolo: having gone back to Florence, he lost much time now in one thing and now in another. And he made at that time for the Palace of the Medici a model for the knee-shaped windows of those rooms that are at the corner, where Giovanni da Udine adorned the chamber in stucco and painting, which is a much extolled work; and he caused to be made for them by the goldsmith Piloto, but under his own direction, those jalousies of perforated copper, which are certainly admirable things. Michelagnolo consumed many years in quarrying marbles, although it is true that while they were being excavated he made models of wax and other things for the work. But this undertaking was delayed so long, that the money assigned by the Pope for the purpose was spent on the war in Lombardy; and at the death of Leo the work was left unfinished, nothing being accomplished save the laying of a foundation in front to support it, and the transportation of a large column of marble from Carrara to the Piazza di S. Lorenzo.

The death of Leo completely dismayed the craftsmen and the arts both in Rome and in Florence; and while Adrian VI was alive Michelagnolo gave his attention in Florence to the tomb of Julius. But after the death of Adrian Clement VII was elected, who was no less desirous than Leo and his other predecessors to leave his fame established by the arts of architecture, sculpture, and painting. At this time, which was the year 1525, Giorgio Vasari was taken as a little boy to Florence by the Cardinal of Cortona, and placed with Michelagnolo to learn art. But Michelagnolo was then summoned to Rome by Pope Clement VII, who had made a beginning with the library of S. Lorenzo and also the new sacristy, in which he proposed to place the marble tombs that he was having made for his forefathers; and he resolved that Vasari should go to work with Andrea del Sarto until he should himself be free again, and went in person to Andrea's workshop to present him.

The façade was never started. The wooden model that survives lacks the rich sculptured ornamentation planned by Michelangelo.

Adrian VI reigned briefly, from 1522 to 1523.

Michelagnolo departed for Rome in haste, harassed once again by Francesco Maria, Duke of Urbino, the nephew of Pope Julius, who complained of him, saying that he had received sixteen thousand crowns for the above-named tomb, yet was living a life of pleasure in Florence; and he threatened in his anger that, if Michelagnolo did not give his attention to the work, he would make him rue it. Having arrived in Rome, Pope Clement, who wished to make use of him, advised him to draw up his accounts with the agents of the Duke, believing that after all that he had done he must be their creditor rather than their debtor; and so the matter rested. After discussing many things together, they resolved to finish completely the library and new sacristy of S. Lorenzo in Florence. Michelagnolo therefore departed from Rome, and raised the cupola that is now to be seen, causing it to be wrought in various orders of composition; and he had a ball with seventy-two faces made by the goldsmith Piloto, which is very beautiful. It happened, while Michelagnolo was raising the cupola, that he was asked by some friends, "Should you not make your lantern very different from that of Filippo Brunelleschi?" And he answered them, "Different it can be made with ease, but better, no." He made four tombs in that sacristy, to adorn the walls and to contain the bodies of the fathers of the two Popes, the elder Lorenzo and his brother Giuliano, and those of Giuliano, the brother of Leo, and of Duke Lorenzo, his nephew. And since he wished to execute the work in imitation of the old sacristy that Filippo Brunelleschi had built, but with another manner of ornamentation, he made in it an ornamentation in a composite order, in a more varied and more original manner than any other master at any time, whether ancient or modern, had been able to achieve, for in the novelty of the beautiful cornices, capitals, bases, doors, tabernacles, and tombs, he departed not a little from the work regulated by measure, order, and rule, which other men did according to a common use and after Vitruvius and the antiquities, to which he would not conform. That licence has done much to give courage to those who have seen his methods to set themselves to imitate him, and new fantasies have since been seen which have more of the grotesque than of reason or rule in their ornamentation. Wherefore the craftsmen owe him an infinite and everlasting obligation, he having broken the bonds and chains by reason of which they had always followed a beaten path in the execution of their works. And even more did he demonstrate and seek to make known such a method afterwards in the library of S. Lorenzo, at the same place; in the beautiful distribution of the windows, in the pattern of the ceiling, and in the marvellous entrance of the vestibule. Nor was there ever seen a more resolute grace, both in the whole and in the parts, as in the consoles, tabernacles, and cornices, nor any staircase more commodious; in which last he made such bizarre breaks in the outlines of the steps, and departed so much from the common use of others, that everyone was amazed.

At this time he sent his disciple Pietro Urbano of Pistoia to Rome to carry to completion a nude Christ holding the Cross, a most admirable figure, which was placed beside the principal chapel of the Minerva, at the commission of Messer Antonio Metelli. About the same time there took place the sack of Rome and the expulsion of the Medici from Florence; by reason of which upheaval those who governed the city of Florence resolved to rebuild the fortifications, and therefore made Michelagnolo Commissary General over all that work. Whereupon he made designs and caused fortifications to be built for several parts of the city, and finally encircled the hill of San Miniato with bastions, which he made not with sods of earth, wood, and bundles of brushwood, as is generally done, but with a stout base of chestnut, oak, and other good materials interwoven, and in place of sods he took unbaked bricks made with tow and the dung of cattle, squared with very great diligence. And for this reason he was sent by the Signoria of Florence to Ferrara, to inspect the fortifications of Duke Alfonso I, and so also his artillery and munitions; where he

Giovanni di Baldassare (fl. early c. 1500–1536), known as Il Piloto, Florentine goldsmith and sculptor.

Filippo Brunelleschi (1377–1446), noted Florentine architect whose masterwork is the dome of the Florence Cathedral (Santa Maria del Fiore).

Vitruvius (fl. first century B.C.), Roman architect and engineer. His masterpiece is a ten-book treatise, De architectura, *which had a profound influence in the Renaissance.*

This is correctly spelled Urbino; Pietro's importance seems solely as Michelangelo's assistant.

The name is actually Metello Vari Porcari, and he was but one of several individuals who commissioned the work. The figure's nudity was subsequently concealed by a disfiguring metal loincloth.

Michelangelo. *Interior of Dome.* 1534.
Medici Chapel, Church of San Lorenzo,
Florence.

received many courtesies from that lord, who besought him that he should do
something for him with his own hand at his leisure, and Michelagnolo prom-
ised that he would. After his return, he was continually engaged in fortifying
the city, but, although he was thus occupied, nevertheless he kept working at
a picture of a Leda for that Duke, painted with his own hand in distemper-col-
ours, which was a divine thing, as will be related in the proper place; also con-
tinuing the statues for the tombs of S. Lorenzo, but in secret. At this time
Michelagnolo spent some six months on the hill of San Miniato in order to
press on the fortification of that hill, because if the enemy became master of
it, the city was lost; and so he pursued these undertakings with the utmost
diligence.

 At this same time he continued the work in the above-mentioned sacristy,
in which were seven statues that were left partly finished and partly not. With
these, and with the architectural inventions of the tombs, it must be confessed
that he surpassed every man in these three professions; to which testimony is
borne by the statues of marble, blocked out and finished by him, which are to
be seen in that place. One is Our Lady, who is in a sitting attitude, with the
right leg crossed over the left and one knee placed upon the other, and the
Child, with the thighs astride the leg that is uppermost, turns in a most beau-

Michelangelo. *Medici Chapel*. 1519–34.
Church of San Lorenzo. Florence.

tiful attitude towards His Mother, hungry for her milk, and she, while hold-
ing Him with one hand and supporting herself with the other, bends forward
to give it to Him; and although the figure is not equal in every part, and it was
left rough and showing the marks of the gradine, yet with all its imperfections
there may be recognized in it the full perfection of the work. Even more did he
cause everyone to marvel by the circumstance that in making the tombs of
Duke Giuliano and Duke Lorenzo de' Medici he considered that earth alone was
not enough to give them honourable burial in their greatness, and desired that
all phases of the world should be there, and that their sepulchres should be sur-
rounded and covered by four statues; wherefore he gave to one Night and Day,
and to the other Dawn and Twilight; which statues, most beautifully wrought
in form, in attitude, and in the masterly treatment of the muscles, would suf-
fice, if that art were lost, to restore her to her pristine lustre. There, among the
other statues, are the two Captains, armed; one the pensive Duke Lorenzo, the
very presentment of wisdom, with legs so beautiful and so well wrought, that
there is nothing better to be seen by the mortal eye; and the other is Duke Giu-
liano, so proud a figure, with the head, the throat, the setting of the eyes, the
profile of the nose, the opening of the mouth, and the hair all so divine, to say
nothing of the hands, arms, knees, feet, and, in short, every other thing that he
carved therein, that the eye can never be weary or have its fill of gazing at them;
and, of a truth, whoever studies the beauty of the buskins and the cuirass, be-
lieves it to be celestial rather than mortal. But what shall I say of the Dawn, a

nude woman, who is such as to awaken melancholy in the soul and to render impotent the style of sculpture? In her attitude may be seen her effort, as she rises, heavy with sleep, and raises herself from her downy bed; and it seems that in awakening she has found the eyes of that great Duke closed in death, so that she is agonized with bitter grief, weeping in her own unchangeable beauty in token of her great sorrow. And what can I say of the Night, a statue not rare only, but unique? Who is there who has ever seen in that art in any age, ancient or modern, statues of such a kind? For in her may be seen not only the stillness of one sleeping, but the grief and melancholy of one who has lost a great and honoured possession; and we must believe that this is that night of darkness that obscures all those who thought for some time, I will not say to surpass, but to equal Michelagnolo in sculpture and design. In that statue is infused all the somnolence that is seen in sleeping forms; wherefore many verses in Latin and rhymes in the vulgar tongue were written in her praise by persons

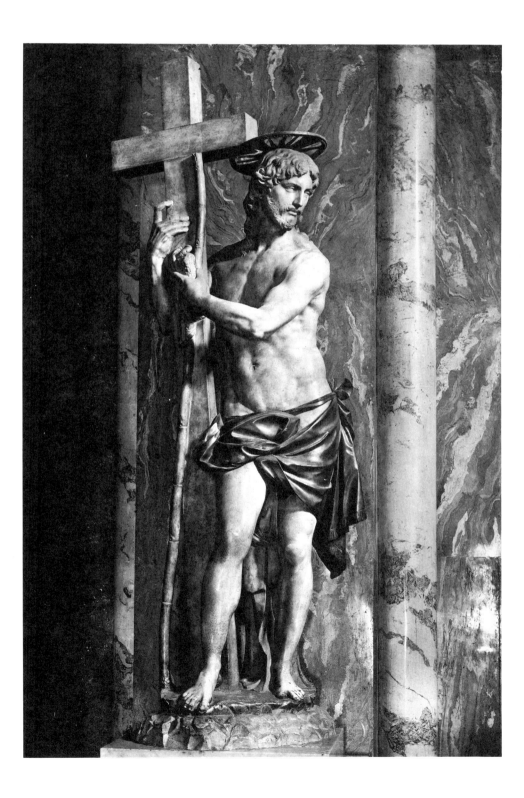

Michelangelo. *The Resurrected Christ Holding the Cross.* 1519–20. Marble. Height: 80¾″ (205 cm). Church of Santa Maria Sopra Minerva, Rome.

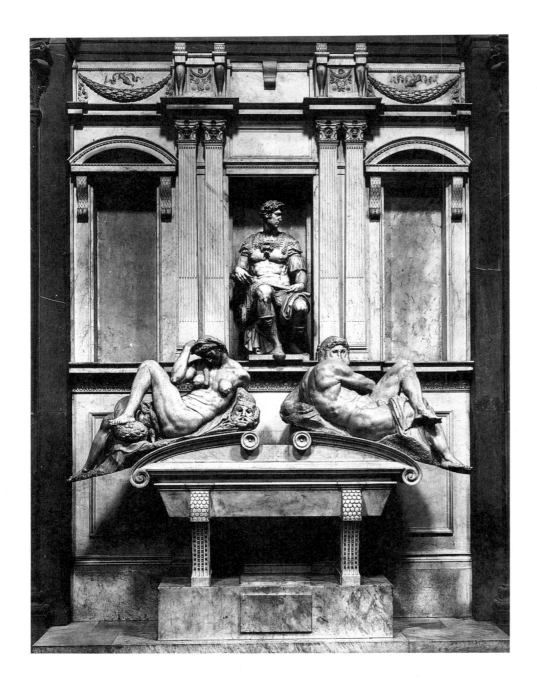

Michelangelo. *Tomb of Giuliano de'Medici* (with figures personifying Night and Day). 1519–34. Medici Chapel, Church of San Lorenzo, Florence.

of great learning, such as these, of which the author is [Giovanni Battista Strozzi]—

> *That Night that here thou seest in grateful guise*
> *Thus sleeping, was by an Angel's hand thus carved*
> *In purest stone. Tho' sleeping, still she lives;*
> *If this thou doubt, awake her, and she'll speak.*

To which Michelagnolo, speaking in the person of the Night, answered thus—

> *Grateful am I to be asleep; and e'en more grateful*
> *That I am stone, while grief and shame endure.*
> *Neither to see nor feel remains my blessed fate.*
> *Therefore speak softly and awake me not.*

Truly, if the enmity that there is between Fortune and Genius, between the envy of the one and the excellence of the other, had not prevented such a work from being carried to completion, Art was like to prove to Nature that she surpassed her by a great measure in every conception.

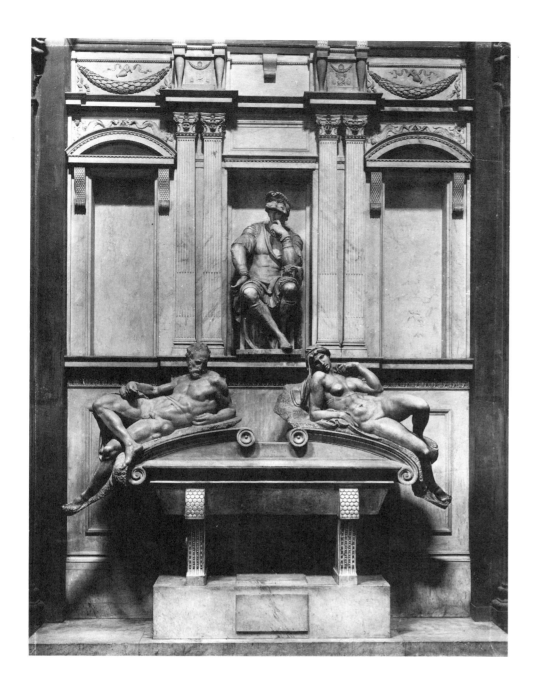

Michelangelo. *Tomb of Lorenzo de'Medici* (with figures personifying Dawn and Twilight). 1519–34. Medici Chapel, Church of San Lorenzo, Florence.

While Michelagnolo was labouring with the greatest solicitude and love at these works, there came in 1529 the siege of Florence, which hindered their completion only too effectually, and was the reason that he did little or no more work upon them, the citizens having laid upon him the charge of fortifying not only the hill of S. Miniato, but also the city, as we have related. And thus, having lent a thousand crowns to that Republic, and being elected one of the Nine, a military Council appointed for the war, he turned all his mind and soul to perfecting those fortifications. But in the end, when the enemy had closed round the city, and all hope of assistance was failing little by little, and the difficulties of maintaining the defence were increasing, and it appeared to Michelagnolo that he was in a sorry pass with regard to his personal safety, he determined to leave Florence and make his way to Venice, without making himself known to anyone on the road. He set out secretly, therefore, by way of the hill of S. Miniato, without anyone knowing of it, taking with him Antonio Mini, his disciple, and the goldsmith Piloto, his faithful friend; and each of them carried a number of crowns on his person, sewn into his quilted doublet. Having arrived in Ferrara, they rested there; and it happened that on account of the alarm caused by the war and the league of the Emperor and the Pope, who were besieging Florence, Duke Alfonso d'Este was keeping strict

Mini was a minor artist, whose only importance is as one of Michelangelo's assistants.

261

watch in Ferrara, and required to be secretly informed by the hosts who gave lodging to travellers of the names of all those who lodged with them from one day to another; and he caused a list of all foreigners, with their nationality, to be brought to him every day. It came to pass, then, that when Michelagnolo had dismounted with his companions, intending to stay there without revealing himself, this became known in that way to the Duke, who was very glad, because he had already become his friend. That Prince was a man of lofty mind, delighting constantly in persons of ability all his life long, and he straightway sent some of the first men of his Court with orders to conduct him in the name of his Excellency to the Palace, where the Duke was, to remove thither his horses and all his baggage, and to give him a handsome lodging in that Palace. Michelagnolo, finding himself in the power of another, was constrained to obey and to make the best of a bad business, and he went with those courtiers to the Duke, but without removing his baggage from the inn. Thereupon the Duke, after first complaining of his reserve, gave him a great reception; and then, making him rich and honourable presents, he sought to detain him in Ferrara

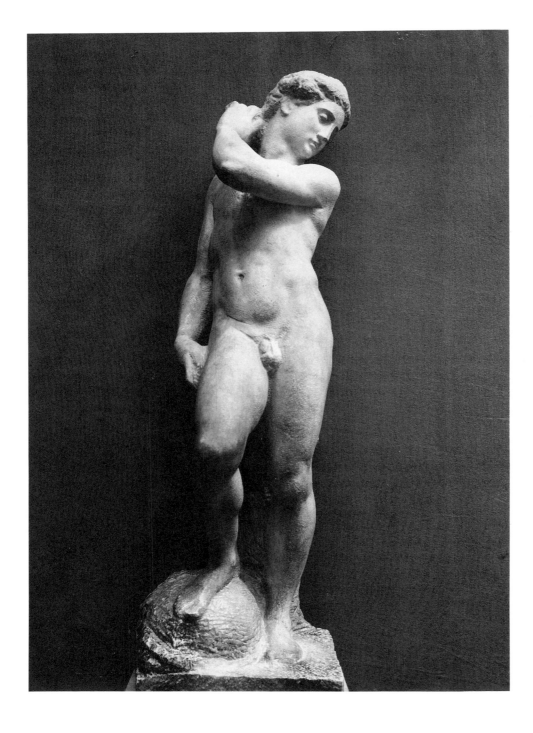

Michelangelo. *David-Apollo*. 1525–32. Marble. Height: 57½" (146 cm). Museo Nazionale (Bargello), Florence.

with the promise of a fine salary. He, having his mind set on something else, would not consent to remain; but the Duke again made him a free offer of all that was in his power, praying him that he should at least not depart as long as the war continued. Whereupon Michelagnolo, not wishing to be outdone in courtesy, thanked him warmly, and, turning towards his two companions, said that he had brought twelve thousand crowns to Ferrara, and that, if the Duke had need of them, they were at his disposal, together with himself. The Duke then took him through the Palace to divert him, as he had done on another occasion, and showed him all the beautiful things that he had there, including a portrait of himself by Tiziano, which was much commended by Michelagnolo. However, his Excellency was not able to keep him in the Palace, for he insisted on returning to the inn; wherefore the host who was lodging him received from the Duke a great abundance of things wherewith to do him honour, and also orders that at his departure he should not accept anything for his lodging. From Ferrara he made his way to Venice, where many gentlemen sought to become known to him; but he, who always had a very poor opinion of their knowledge of his profession, departed from the Giudecca, where he had his lodging. There, so it is said, he made for that city at that time, at the request of the Doge Gritti, a design for the bridge of the Rialto, which was very rare in invention and in ornamentation.

This design has not survived.

Michelagnolo was invited with great insistence to go back to his native country, being urgently requested not to abandon his undertaking there, and receiving a safe-conduct; and finally, vanquished by love of her, he returned, but not without danger to his life. At this time he finished the Leda that he was painting, as has been related, at the request of Duke Alfonso; and it was afterwards taken to France by Antonio Mini, his disciple. And at this same time he saved the campanile of S. Miniato, a tower which sorely harassed the enemy's forces with its two pieces of artillery, so that their artillerists, having set to work to batter it with heavy cannon, had half ruined it, and were like to destroy it completely, when Michelagnolo protected it so well with bales of wool and stout mattresses suspended by cords, that it is still standing. It is said, also, that at the time of the siege there came to him an opportunity to acquire, according to a desire that he had long had, a block of marble of nine braccia which had come from Carrara, and which Pope Clement, after much rivalry and contention between him and Baccio Bandinelli, had given to Baccio. But Michelagnolo, now that such a matter was in the hands of the commonwealth, asked for it from the Gonfalonier, who gave it to him that he might likewise try his hand upon it, although Baccio had already made a model and hacked away much of the stone in blocking it out. Thereupon Michelagnolo made a model, which was held to be a marvellous and very beautiful thing; but on the return of the Medici the marble was restored to Baccio.

The Leda *is fully discussed below.*

When peace had been made, Baccio Valori, the Pope's Commissioner, received orders to have some of the most partisan citizens arrested and imprisoned in the Bargello, and the same tribunal sought out Michelagnolo at his house; but he, fearing that, had fled secretly to the house of one who was much his friend, where he remained hidden many days. Finally, when the first fury had abated, Pope Clement, remembering the ability of Michelagnolo, caused a diligent search to be made for him, with orders that nothing should be said to him, but rather that his former appointments should be restored to him, and that he should attend to the work of S. Lorenzo, over which he placed as proveditor M. Giovan Battista Figiovanni, the old servant of the Medici family and Prior of S. Lorenzo. Thus reassured, Michelagnolo, in order to make Baccio Valori his friend, began a figure of three braccia in marble, which was an Apollo drawing an arrow from his quiver, and carried it almost to completion. It is now in the apartment of the Prince of Florence, and is a very rare work, although it is not completely finished.

The Bargello, or Palazzo della Podestà (the palace of the mayor); today it houses the Museo Nazionale.

This has long been considered to represent David rather than Apollo.

At this time a certain gentleman was sent to Michelagnolo by Duke Alfonso of Ferrara, who, having heard that the master had made some rare work for him with his own hand, did not wish to lose such a jewel. Having arrived in Florence and found Michelagnolo, the envoy presented to him letters of recommendation from that lord; whereupon Michelagnolo, receiving him courteously, showed him the Leda embracing the Swan that he had painted, with Castor and Pollux issuing from the Egg, in a large picture executed in distemper, as it were with the breath. The Duke's envoy, thinking from the praise that he heard everywhere of Michelagnolo that he should have done something great, and not recognizing the excellence and artistry of that figure, said to Michelagnolo: "Oh, this is but a trifle." Michelagnolo, knowing that no one is better able to pronounce judgment on works than those who have had long practise in them, asked him what was his vocation. And he answered, with a sneer, "I am a merchant"; believing that he had not been recognized by Michelagnolo as a gentleman, and as it were making fun of such a question, and at the same time affecting to despise the industry of the Florentines. Michelagnolo, who had understood perfectly the meaning of his words, at once replied: "You will find you have made a bad bargain this time for your master. Get you gone out of my sight."

Now in those days Antonio Mini, his disciple, who had two sisters waiting to be married, asked him for the Leda, and he gave it to him willingly, with the greater part of the designs and cartoons that he had made, which were divine things, and also two chests full of models, with a great number of finished cartoons for making pictures, and some of works that had been painted.

Rosso Fiorentino. *Copy of Michelangelo's Leda and the Swan.* After 1530. Black chalk on sheets of paper. 67 × 98″ (170 × 248 cm). Royal Academy, London.

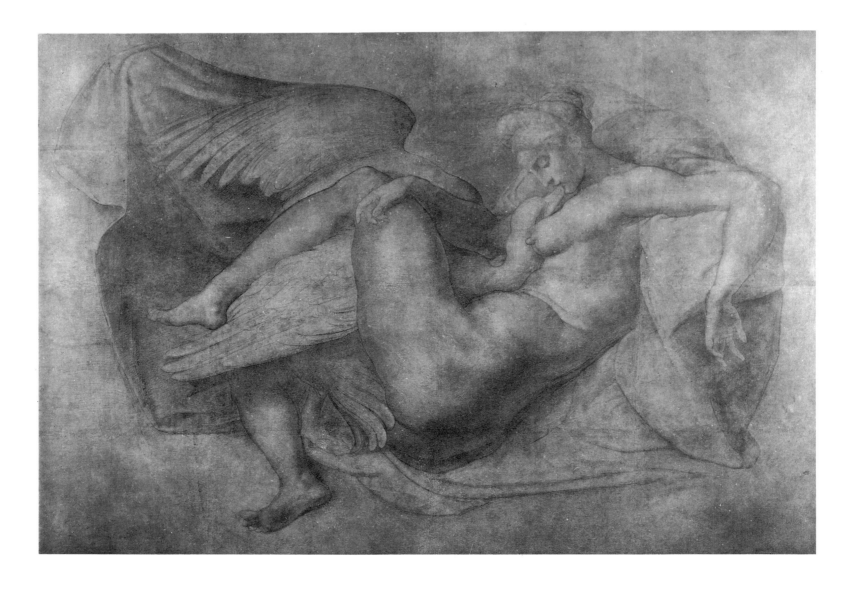

When Antonio took it into his head to go to France, he carried all these with him; the Leda he sold to King Francis by means of some merchants, and it is now at Fontainebleau, but the cartoons and designs were lost, for he died there in a short time, and some were stolen; and so our country was deprived of all these valuable labours, which was an incalculable loss. The cartoon of the Leda has since come back to Florence, and Bernardo Vecchietti has it; and so also four pieces of the cartoons for the chapel, with nudes and Prophets, brought back by the sculptor Benvenuto Cellini, and now in the possession of the heirs of Girolamo degli Albizzi.

It became necessary for Michelagnolo to go to Rome to see Pope Clement, who, although angry with him, yet, as the friend of every talent, forgave him everything, and gave him orders that he should return to Florence and have the library and sacristy of S. Lorenzo completely finished; and, in order to shorten that work, a vast number of statues that were to be included in it were distributed among other masters. Two he allotted to Tribolo, one to Raffaello da Montelupo, and one to Fra Giovanni Agnolo, the Servite friar, all sculptors; and he gave them assistance in these, making rough models in clay for each of them. Whereupon they all worked valiantly, and he, also, caused work to be pursued on the library, and thus the ceiling was finished in carved woodwork, which was executed after his models by the hands of the Florentines Carota and Tasso, excellent carvers and also masters of carpentry; and likewise the shelves for the books, which were executed at that time by Battista del Cinque and his friend Ciappino, good masters in that profession. And in order to give the work its final perfection there was summoned to Florence the divine Giovanni da Udine, who, together with others his assistants and also some Florentine masters, decorated the tribune with stucco; and they all sought with great solicitude to give completion to that vast undertaking.

Now, just as Michelagnolo was about to have the statues carried into execution, at that very time the Pope took it into his head to have him near his person, being desirous to have the walls of the Chapel of Sixtus painted, where Michelagnolo had painted the vaulting for Julius II, his nephew. On the principal wall, where the altar is, Clement wished him to paint the Universal Judgment, to the end that he might display in that scene all that the art of design could achieve, and opposite to it, on the other wall, over the principal door, he had commanded that he should depict the scene when Lucifer was expelled for his pride from Heaven, and all those Angels who sinned with him were hurled after him into the centre of Hell: of which inventions it was found that Michelagnolo many years before had made various sketches and designs, one of which was afterwards carried into execution in the Church of the Trinità at Rome by a Sicilian painter, who stayed many months with Michelagnolo, to serve him and to grind his colours. This work, painted in fresco, is in the Chapel of S. Gregorio, in the cross of the church, and, although it is executed badly, there is a certain variety and terrible force in the attitudes and groups of those nudes that are raining down from Heaven, and of the others who, having fallen into the centre of the earth, are changed into various forms of Devils, very horrible and bizarre; and it is certainly an extraordinary fantasy. While Michelagnolo was directing the preparation of the designs and cartoons of the Last Judgment on the first wall, he never ceased for a single day to be at strife with the agents of the Duke of Urbino, by whom he was accused of having received sixteen thousand crowns from Julius II for the tomb. This accusation was more than he could bear, and he desired to finish the work some day, although he was already an old man, and he would have willingly stayed in Rome to finish it, now that he had found, without seeking it, such a pretext for not returning any more to Florence, since he had a great fear of Duke Alessandro de' Medici, whom he regarded as little his friend; for, when the Duke had given him to understand through Signor Alessandro Vitelli that he should

The Leda *was burned as obscene during the reign of Louis XIII of France. The copy reproduced is considered variously as a copy of the painting or of the (also lost) cartoon. The other cartoons mentioned are lost as well.*

Benvenuto Cellini (1500–1571), celebrated Florentine goldsmith annd sculptor, also known for his highly romanticized Autobiography.

Raffaello da Montelupo (1505?–1566), Italian sculptor and architect. Giovanni Agnolo is Montorsoli (c. 1507–1563), Florentine sculptor who executed the St. Matthew *in the Medici Chapel.*

select the best site for the building of the castle and citadel of Florence, he answered that he would not go save at the command of Pope Clement.

Finally an agreement was formed in the matter of the tomb, that it should be finished in the following manner: there was no longer to be an isolated tomb in a rectangular shape, but only one of the original façades, in the manner that best pleased Michelagnolo, and he was to be obliged to place in it six statues by his own hand. In this contract that was made with the Duke of Urbino, his Excellency consented that Michelagnolo should be at the disposal of Pope Clement for four months in the year, either in Florence or wherever he might think fit to employ him. But, although it seemed to Michelagnolo that at last he had obtained some peace, he was not to be quit of it so easily, for Pope Clement, desiring to see the final proof of the force of his art, kept him occupied with the cartoon of the Judgment. However, contriving to convince the Pope that he was thus engaged, at the same time he kept working in secret, never relaxing his efforts, at the statues that were going into the above-named tomb.

In the year 1534 came the death of Pope Clement, whereupon the work of the library and sacristy in Florence, which had remained unfinished in spite of all the efforts made to finish it, was stopped. Then, at length, Michelagnolo thought to be truly free and able to give his attention to finishing the tomb of Julius II. But Paul III, not long after his election, had him summoned to his presence, and, besides paying him compliments and making him offers, requested him to enter his service and remain near his person. Michelagnolo refused, saying that he was not able to do it, being bound by contract to the Duke of Urbino until the tomb of Julius should be finished. The Pope flew into a rage and said: "I have had this desire for thirty years, and now that I am Pope do you think I shall not satisfy it? I shall tear up the contract, for I am determined to have you serve me, come what may." Michelagnolo, hearing this resolution, was tempted to leave Rome and in some way find means to give completion to the tomb; however, fearing, like a wise man, the power of the Pope, he resolved to try to keep him pacified with words, seeing that he was so old, until something should happen. The Pope, who wished to have some extraordinary work executed by Michelagnolo, went one day with ten Cardinals to visit him at his house, where he demanded to see all the statues for the tomb of Julius, which appeared to him marvellous, and particularly the Moses, which figure alone was said by the Cardinal of Mantua to be enough to do honour to Pope Julius. And after seeing the designs and cartoons that he was preparing for the wall of the chapel, which appeared to the Pope to be stupendous, he again besought Michelagnolo with great insistence that he should enter his service, promising that he would persuade the Duke of Urbino to content himself with three statues, and that the others should be given to other excellent masters to execute after his models. Whereupon, his Holiness having arranged this with the agents of the Duke, a new contract was made, which was confirmed by the Duke; and Michelagnolo of his own free will bound himself to pay for the other three statues and to have the tomb erected, depositing for this purpose in the bank of the Strozzi one thousand five hundred and eighty ducats. This he might have avoided, and it seemed to him that he had truly done enough to be free of such a long and troublesome undertaking; and afterwards he caused the tomb to be erected in S. Pietro in Vincola in the following manner. He erected the lower base, which was all carved, with four pedestals which projected outwards as much as was necessary to give space for the captive that was originally intended to stand on each of them, instead of which there was left a terminal figure; and since the lower part had thus a poor effect, he placed at the feet of each terminal figure a reversed console resting on the pedestal. Those four terminal figures had between them three niches, two of which (those at the sides) were round, and were to have contained the Victories. Instead of the

Paul III's extremely brief reign was during the year 1503.

As it stands, the tomb in San Pietro in Vincoli is a hybrid work, hardly suggesting the splendor of Michelangelo's grandiose plans.

Victories, he placed in one Leah, the daughter of Laban, to represent the Active Life, with a mirror in her hand to signify the consideration that we should give to our actions, and in the other hand a garland of flowers, to denote the virtues that adorn our life during its duration, and make it glorious after death; and the other figure was her sister Rachel, representing the Contemplative Life, with the hands clasped and one knee bent, and on the countenance a look as of ecstasy of spirit. These statues Michelagnolo executed with his own hand in less than a year. In the centre is the other niche, rectangular in shape, which in the original design was to have been one of the doors that were to lead into the little oval temple of the rectangular tomb; this having become a niche, there is placed in it, upon a dado of marble, the gigantic and most beautiful statue of Moses, of which we have already said enough. Above the heads of the terminal figures, which form capitals, are architrave, frieze, and cornice, which project beyond those figures and are carved with rich ornaments, foliage, ovoli, dentils, and other rich members, distributed over the whole work. Over that cornice rises another course, smooth and without carvings, but with different terminal figures standing directly above those below, after the manner of pilasters, with a variety of cornice-members; and since this course accompanies that below and resembles it in every part, there is in it a space similar to the

Michelangelo. *Active Life (Leah)*. 1542. Marble. Height: 84¼″ (215 cm). Tomb of Pope Julius II, Church of San Pietro in Vincoli, Rome.

267

Michelangelo. *Contemplative Life (Rachel)*. 1542. Marble. Height: 77½″ (186 cm). Tomb of Pope Julius II, Church of San Pietro in Vincoli, Rome.

other, forming a niche like that in which there is now the Moses, and in the niche, resting on projections of the cornice, is a sarcophagus of marble with the recumbent statue of Pope Julius, executed by the sculptor Maso dal Bosco, while in that niche, also, there stands a Madonna who is holding her Son in her arms, wrought by the sculptor Scherano da Settignano from a model by Michelagnolo; which statues are passing good. In two other rectangular niches, above the Active and the Contemplative Life, are two larger statues, a Prophet and a Sibyl seated, which were both executed by Raffaello da Montelupo [. . .], but little to the satisfaction of Michelagnolo. For its crowning completion this work had a different cornice, which, like those below, projected over the whole work; and above the terminal figures, as a finish, were candelabra of marble, with the arms of Pope Julius in the centre. Above the Prophet and the Sibyl, in the recess of each niche, he made a window for the convenience of the friars who officiate in that church, the choir having been made behind; which windows serve to send their voices into the church when they say the divine office, and permit the celebration to be seen. Truly this whole work has turned out very well, but not by a great measure as it had been planned in the original design.

Michelagnolo resolved, since he could not do otherwise, to serve Pope Paul,

"Maso" and "Scherano" are minor sculptors of the time.

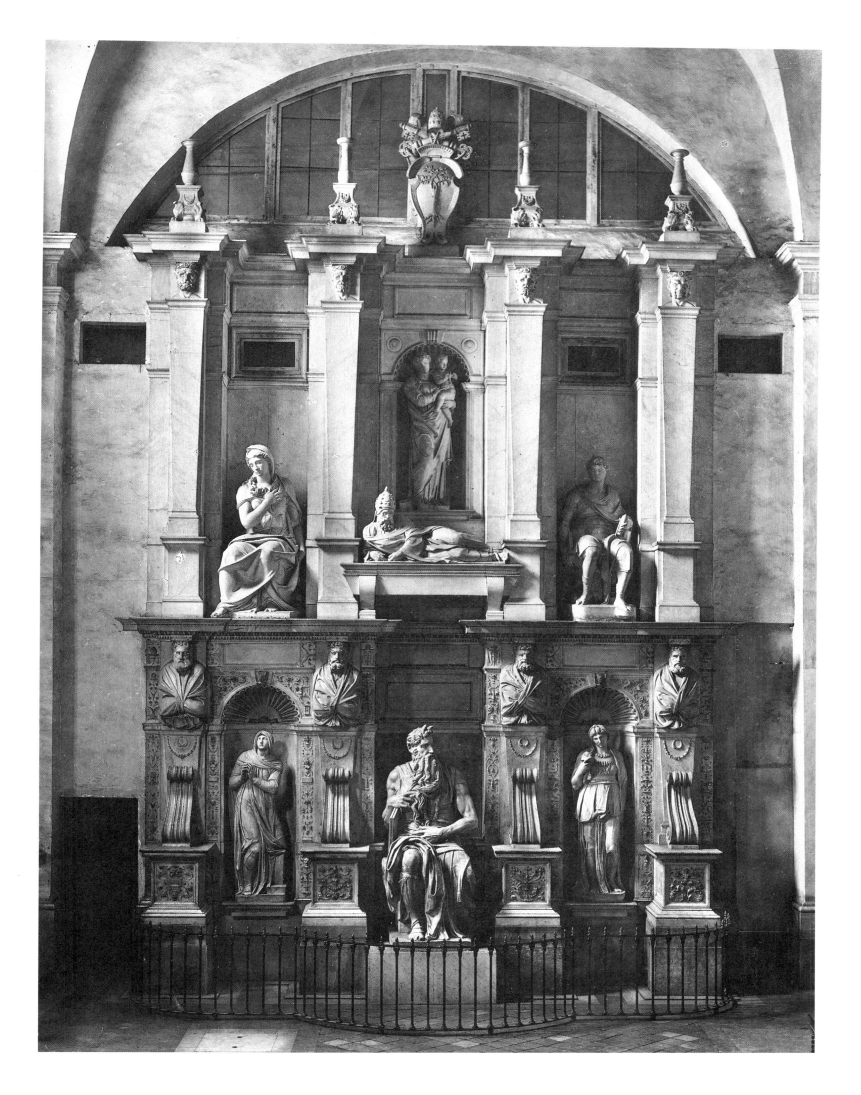

who allowed him to continue the work as ordered by Clement, without changing anything in the inventions and the general conception that had been laid before him, thus showing respect for the genius of that great man, for whom he felt such reverence and love that he sought to do nothing but what pleased him; of which a proof was soon seen. His Holiness desired to place his own arms beneath the Jonas in the chapel, where those of Pope Julius II had previously been put; but Michelagnolo, being asked to do this, and not wishing to do a wrong to Julius and Clement, would not place them there, saying that they would not look well; and the Pope, in order not to displease him, was content to have it so, having recognized very well the excellence of such a man, and how he always followed what was just and honourable without any adulation or respect of persons—a thing that the great are wont to experience very seldom. Michelagnolo, then, caused a projection of well baked and chosen bricks to be carefully built on the wall of the above-named chapel (a thing which was not there before), and contrived that it should overhang half a braccio from above, so that neither dust nor any other dirt might be able to settle upon it. But I will not go into the particulars of the invention and composition of this scene, because so many copies of it, both large and small, have been printed, that it does not seem necessary to lose time in describing it. It is enough for us to perceive that the intention of this extraordinary man has been to refuse to paint anything but the human body in its best proportioned and most perfect forms and in the greatest variety of attitudes, and not this only, but likewise the play of the passions and contentments of the soul, being satisfied with justifying himself in that field in which he was superior to all his fellow-craftsmen, and to lay open the way of the grand manner in the painting of nudes, and his great knowledge in the difficulties of design; and, finally, he opened out the way to facility in this art in its principal province, which is the human body, and, attending to this single object, he left on one side the charms of colouring and the caprices and new fantasies of certain minute and delicate refinements which many other painters, perhaps not without some show of reason, have not entirely neglected. For some, not so well grounded in design, have sought with variety of tints and shades of colouring, with various new and bizarre inventions, and, in short, with the other method, to win themselves a place among the first masters; but Michelagnolo, standing always firmly rooted in his profound knowledge of art, has shown to those who know enough how they should attain to perfection.

But to return to the story: Michelagnolo had already carried to completion more than three-fourths of the work, when Pope Paul went to see it. And Messer Biagio da Cesena, the master of ceremonies, a person of great propriety, who was in the chapel with the Pope, being asked what he thought of it, said that it was a very disgraceful thing to have made in so honourable a place all those nude figures showing their nakedness so shamelessly, and that it was a work not for the chapel of a Pope, but for a bagnio or tavern. Michelagnolo was displeased at this, and, wishing to revenge himself, as soon as Biagio had departed he portrayed him from life, without having him before his eyes at all, in the figure of Minos with a great serpent twisted round the legs, among a heap of Devils in Hell; nor was Messer Biagio's pleading with the Pope and with Michelagnolo to have it removed of any avail, for it was left there in memory of the occasion, and it is still to be seen at the present day.

It happened at this time that Michelagnolo fell no small distance from the staging of this work, and hurt his leg; and in his pain and anger he would not be treated by anyone. Now there was living at this same time the Florentine Maestro Baccio Rontini, his friend, an ingenious physician, who had a great affection for his genius; and he, taking compassion on him, went one day to knock at his door. Receiving no answer either from the neighbours or from him, he so contrived to climb by certain secret ways from one room to an-

OPPOSITE:

Marcello Venusti. *Copy of Michelangelo's Last Judgment.* 1549. Panel. 74¾ × 57″ (190 × 145 cm). Museo e Gallerie Nazionali di Capodimonte, Naples.

A bagnio (literally, "bathhouse") is a brothel.

*In 1564, following a decree issued by the Congregation of the Council of Trent, the "obscene" and "immoral" nudes were made "decent" by painted draperies added by Daniele da Volterra (1509–1566). Daniele (ironically, one of Michelangelo's closest companions) was later stigmatized for these additions and became known as the Breeches Painter (*Il bragghetone*).*

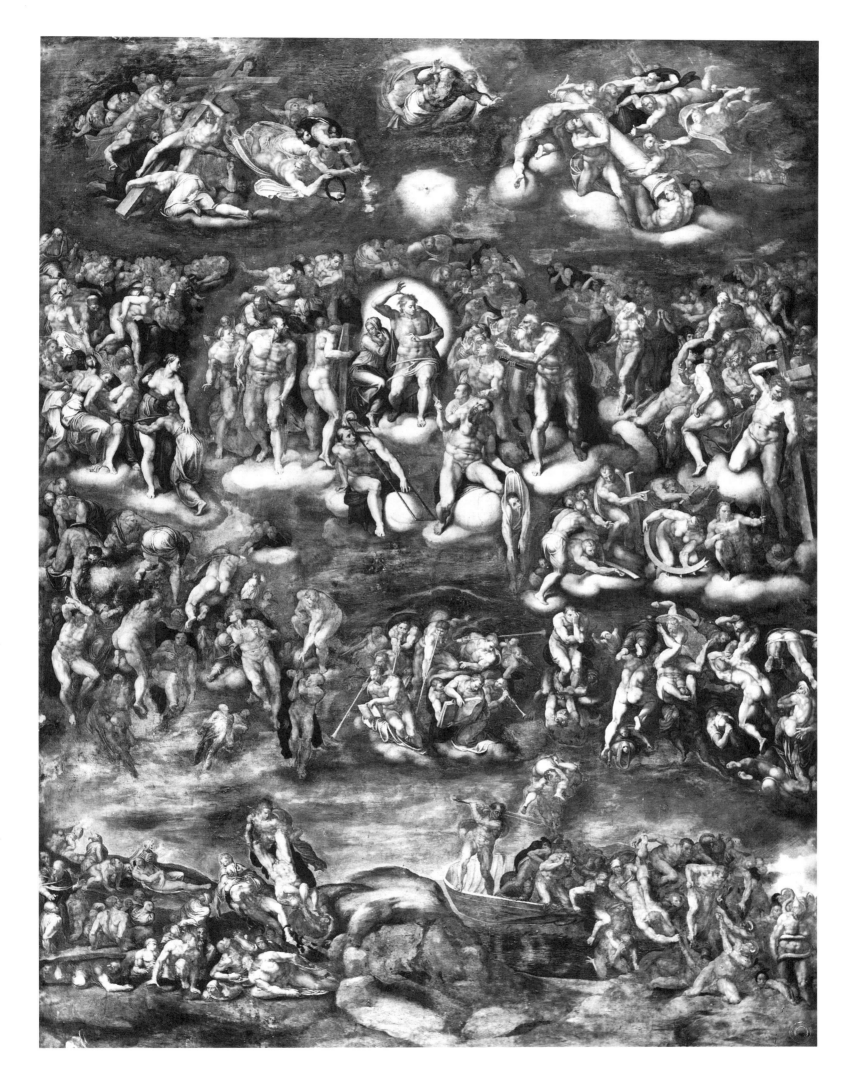

other, that he came to Michelagnolo, who was in a desperate state. And then Maestro Biagio would never abandon him or take himself off until he was cured.

Having recovered from this injury, he returned to his labour, and, working at it continually, he carried it to perfect completion in a few months, giving such force to the paintings in the work, that he justified the words of Dante—

Dead are the dead; the living seem to live.

And here, also, may be seen the misery of the damned and the joy of the blessed. Wherefore, when this Judgment was thrown open to view, it proved that he had not only vanquished all the earlier masters who had worked there, but had sought to surpass the vaulting that he himself had made so famous, excelling it by a great measure and outstripping his own self. For he imagined to himself the terror of those days, and depicted, for the greater pain of all who have not lived well, the whole Passion of Christ, causing various naked figures in the air to carry the Cross, the Column, the Lance, the Sponge, the Nails, and the Crown of Thorns, all in different attitudes, executed to perfection in a triumph of facility over their difficulties. In that scene is Christ seated, with a countenance proud and terrible, turning towards the damned and cursing them; not without great fear is Our Lady, who, hearing and beholding that vast havoc, draws her mantle close around her. There are innumerable figures, Prophets and Apostles, that form a circle about Him, and in particular Adam and S. Peter, who are believed to have been placed there, one as the first parent of those thus brought to judgment, and the other as having been the first foundation of the Christian Church; and at His feet is a most beautiful S. Bartholomew, who is displaying his flayed skin. There is likewise a nude figure of S. Laurence; besides which, there are multitudes of Saints without number, both male and female, and other figures, men and women, around Him, near or distant, who embrace one another and make rejoicing, having received eternal blessedness by the grace of God and as the reward of their works. Beneath the feet of Christ are the Seven Angels with the Seven Trumpets described by S. John the Evangelist, who, as they sound the call to judgment, cause the hair of all who behold them to stand on end at the terrible wrath that their countenances reveal. Among others are two Angels that have each the Book of Life in the hands: and near them, on one side, not without beautiful consideration, are seen the Seven Mortal Sins in the forms of Devils, assailing and striving to drag down to Hell the souls that are flying towards Heaven, all with very beautiful attitudes and most admirable foreshortenings. Nor did he hesitate to show to the world, in the resurrection of the dead, how they take to themselves flesh and bones once more from the same earth, and how, assisted by others already alive, they go soaring towards Heaven, whence succour is brought to them by certain souls already blessed; not without evidence of all those marks of consideration that could be thought to be required in so great a work. For studies and labours of every kind were executed by him, which may be recognized throughout the whole work without exception; and this is manifested with particular clearness in the barque of Charon, who, in an attitude of fury, strikes with his oars at the souls dragged down by the Devils into the barque, after the likeness of the picture that the master's best-beloved poet, Dante, described when he said—

The demon Charon, with brazen eyes,
 Summons the sad troops; and having gathered all,
 With raiséd oar he smites each wretch who dares delay.

Nor would it be possible to imagine how much variety there is in the heads of those Devils, which are truly monsters from Hell. In the sinners may be seen sin and the fear of eternal damnation; and, to say nothing of the beauty of every detail, it is extraordinary to see so great a work executed with such harmony of painting, that it appears as if done in one day, and with such finish as was never achieved in any miniature. And, of a truth, the terrible force and grandeur of the work, with the multitude of figures, are such that it is not possible to describe it, for it is filled with all the passions known to human creatures, and all expressed in the most marvellous manner. For the proud, the envious, the avaricious, the wanton, and all the other suchlike sinners can be distinguished with ease by any man of fine perception, because in figuring them Michelagnolo observed every rule of Nature in the expressions, in the attitudes, and in every other natural circumstance; a thing which, although great and marvellous, was not impossible to such a man, for the reason that he was always observant and shrewd and had seen men in plenty, and had acquired by commerce with the world that knowledge that philosophers gain from cogitation and from writings. Wherefore he who has judgment and understanding in painting perceives there the most terrible force of art, and sees in those figures such thoughts and passions as were never painted by any other but Michelagnolo. So, also, he may see there how the variety of innumerable attitudes is accomplished, in the strange and diverse gestures of young and old, male and female; and who is there who does not recognize in these the terrible power of his art, together with the grace that he had from Nature, since they move the hearts not only of those who have knowledge in that profession, but even of those who have none? There are foreshortenings that appear as if in relief, a harmony of painting that gives great softness, and fineness in the parts painted by him with delicacy, all showing in truth how pictures executed by good and true painters should be; and in the outlines of the forms turned by him in such a way as could not have been achieved by any other but Michelagnolo, may be seen the true Judgment and the true Damnation and Resurrection. This is for our art the exemplar and the grand manner of painting sent down to men on earth by God, to the end that they may see how Destiny works when intellects descend from the heights of Heaven to earth, and have infused in them divine grace and knowledge. This work leads after it bound in chains those who persuade themselves that they have mastered art; and at the sight of the strokes drawn by him in the outlines of no matter what figure, every sublime spirit, however mighty in design, trembles and is afraid. And while the eyes gaze at his labours in this work, the senses are numbed at the mere thought of what manner of things all other pictures, those painted and those still unpainted, would appear if placed in comparison with such perfection. Truly blessed may he be called, and blessed his memories, who has seen this truly stupendous marvel of our age! Most happy and most fortunate Paul III, in that God granted that under thy protection should be acquired the renown that the pens of writers shall give to his memory and thine! How highly are thy merits enhanced by his genius! And what good fortune have the craftsmen had in this age from his birth, in that they have seen the veil of every difficulty torn away, and have beheld in the pictures, sculptures, and architectural works executed by him all that can be imagined and achieved!

He toiled eight years over executing this work, and threw it open to view in the year 1541, I believe, on Christmas day, to the marvel and amazement of all Rome, nay, of the whole world; and I, who was that year in Venice, and went to Rome to see it, was struck dumb by its beauty.

Pope Paul, as has been related, had caused a chapel called the Pauline to be erected on the same floor by Antonio da San Gallo, in imitation of that of Nicholas V; and in this he resolved that Michelagnolo should paint two great pictures with two large scenes. In one he painted the Conversion of S. Paul, with

Marcello Venusti's contemporaneous copy of The Last Judgment *(which Michelangelo saw and approved) reproduced on page 271 offers an idea of its original appearance. Planned restoration will doubtless return the fresco to its unretouched state.*

The Pauline Chapel is adjacent to the Sistine. Nicholas V (1398–1455) became Pope in 1447. He was a notable Humanist and patron of the arts, founded the Vatican Library, and was instrumental in the planning of Renaissance Rome.

Jesus Christ in the air and a multitude of nude Angels making most beautiful movements, and below, all dazed and terrified, Paul fallen from his horse to the level of the ground, with his soldiers about him, some striving to raise him up, and others, struck with awe by the voice and splendour of Christ, are flying in beautiful attitudes and marvellous movements of panic, while the horse, taking to flight, appears to be carrying away in its headlong course him who seeks to hold it back; and this whole scene is executed with extraordinary design and art. In the other picture is the Crucifixion of S. Peter, who is fixed, a nude figure of rare beauty, upon the cross; showing the ministers of the crucifixion, after they have made a hole in the ground, seeking to raise the cross on high, to the end that he may remain crucified with his feet in the air; and there are many remarkable and beautiful considerations. Michelagnolo, as has been said elsewhere, gave his attention only to the perfection of art, and therefore there are no landscapes to be seen there, nor trees, nor buildings, nor any other distracting graces of art, for to these he never applied himself, as one, perchance, who would not abase his great genius to such things. These, executed by him at the age of seventy-five, were his last pictures, and, as he used himself to tell me, they cost him much fatigue, for the reason that painting, and particularly working in fresco, is no art for men who have passed a certain age. Michelagnolo arranged that Perino del Vaga, a very excellent painter, should decorate the vaulting with stucco and with many things in painting, after his designs, and such, also, was the wish of Pope Paul III; but the work was afterwards delayed, and nothing more was done, even as many undertakings are left unfinished, partly by fault of want of resolution in the craftsmen, and partly by that of Princes little zealous in urging them on.

Pope Paul had made a beginning with the fortifying of the Borgo, and had summoned many gentlemen, together with Antonio da San Gallo, to a conference; but he wished that Michelagnolo also should have a part in this, knowing that the fortifications about the hill of S. Miniato in Florence had been constructed under his direction. After much discussion, Michelagnolo was asked what he thought; and he, having opinions contrary to San Gallo and many others, declared them freely. Whereupon San Gallo said to him that his arts were sculpture and painting, and not fortification. Michelagnolo replied that of sculpture and painting he knew little, but of fortification, what with the thought that he had devoted to it for a long time, and his experience in what he had done, it appeared to him that he knew more than either Antonio or any of his family; showing him in the presence of the company that he had made many errors in that art. Words rising high on either side, the Pope had to command silence; but no long time passed before Michelagnolo brought a design for all the fortifications of the Borgo, which laid open the way for all that has since been ordained and executed; and this was the reason that the great gate of S. Spirito, which was approaching completion under the direction of San Gallo, was left unfinished.

The spirit and genius of Michelagnolo could not rest without doing something; and, since he was not able to paint, he set to work on a piece of marble, intending to carve from it four figures in the round and larger than life, including a Dead Christ, for his own delight and to pass the time, and because, as he used to say, the exercise of the hammer kept him healthy in body. This Christ, taken down from the Cross, is supported by Our Lady, by Nicodemus, who bends down and assists her, planted firmly on his feet in a forceful attitude, and by one of the Maries, who also gives her aid, perceiving that the Mother, overcome by grief, is failing in strength and not able to uphold Him. Nor is there anywhere to be seen a dead form equal to that of Christ, who, sinking with the limbs hanging limp, lies in an attitude wholly different, not only from that of any other work by Michelagnolo, but from that of any other figure that was ever made. A laborious work is this, a rare achievement in a single stone,

COLORPLATE 95

COLORPLATE 96

The figure of Nicodemus in The Florence Pietà *is considered to be a self-portrait.*

and truly divine; but, as will be related hereafter, it remained unfinished, and suffered many misfortunes, although Michelagnolo had intended that it should serve to adorn his own tomb, at the foot of that altar where he thought to place it.

It happened in the year 1546 that Antonio da San Gallo died; whereupon, there being now no one to direct the building of S. Pietro, many suggestions were made by the superintendents to the Pope as to who should have it. Finally his Holiness, inspired, I believe, by God, resolved to send for Michelagnolo. But he, when asked to take Antonio's place, refused it, saying, in order to avoid such a burden, that architecture was not his proper art; and in the end, entreaties not availing, the Pope commanded that he should accept it, whereupon, to his great displeasure and against his wish, he was forced to undertake that enterprise. And one day among others that he went to S. Pietro to see the wooden model that San Gallo had made, and to examine the building, he found there the whole San Gallo faction, who, crowding before Michelagnolo, said to him in the best terms at their command that they rejoiced that the charge of the building was to be his, and that the model was a field where there would never be any want of pasture. "You speak the truth," answered Michelagnolo, meaning to infer, as he declared to a friend, that it was good for sheep and

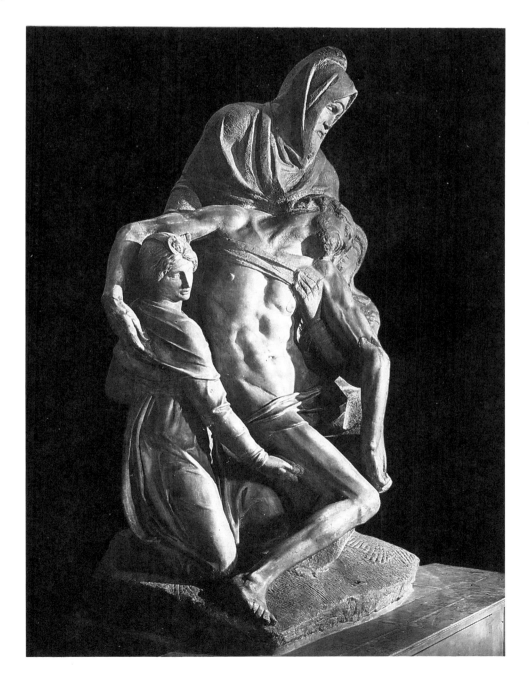

Michelangelo. *The Florence Pietà.*
Before 1555. Marble. Height: 89″ (236 cm).
Cathedral (Santa Maria del Fiore),
Florence.

oxen, who knew nothing of art. And afterwards he used to say publicly that San Gallo had made it wanting in lights, that it had on the exterior too many ranges of columns one above another, and that, with its innumerable projections, pinnacles, and subdivisions of members, it was more akin to the German manner than to the good method of the ancients or to the gladsome and beautiful modern manner; and, in addition to this, that it was possible to save fifty years of time and more than three hundred thousand crowns of money in finishing the building, and to execute it with more majesty, grandeur, and facility, greater beauty and convenience, and better ordered design. This he afterwards proved by a model that he made, in order to bring it to the form in which the work is now seen constructed; and thus he demonstrated that what he said was nothing but the truth. This model cost him twenty-five crowns, and was made in a fortnight; that of San Gallo, as has been related, cost four thousand, and took many years to finish. From this and other circumstances it became evident that that fabric was but a shop and a business for making money, and that it would be continually delayed, with the intention of never finishing it, by those who had undertaken it as a means of profit.

Such methods did not please our upright Michelagnolo, and in order to get rid of all these people, while the Pope was forcing him to accept the office of architect to the work, he said to them openly one day that they should use all the assistance of their friends and do all that they could to prevent him from entering on that office, because, if he were to undertake such a charge, he would not have one of them about the building. Which words, spoken in public, were

"Lights" is another term for windows.

The model is lost. Michelangelo's original plan was later modified by the addition of a nave.

Antonio da Sangallo the Younger. *Model for St. Peter's.* 1539–46. Wood. Museo Petriano, Vatican, Rome.

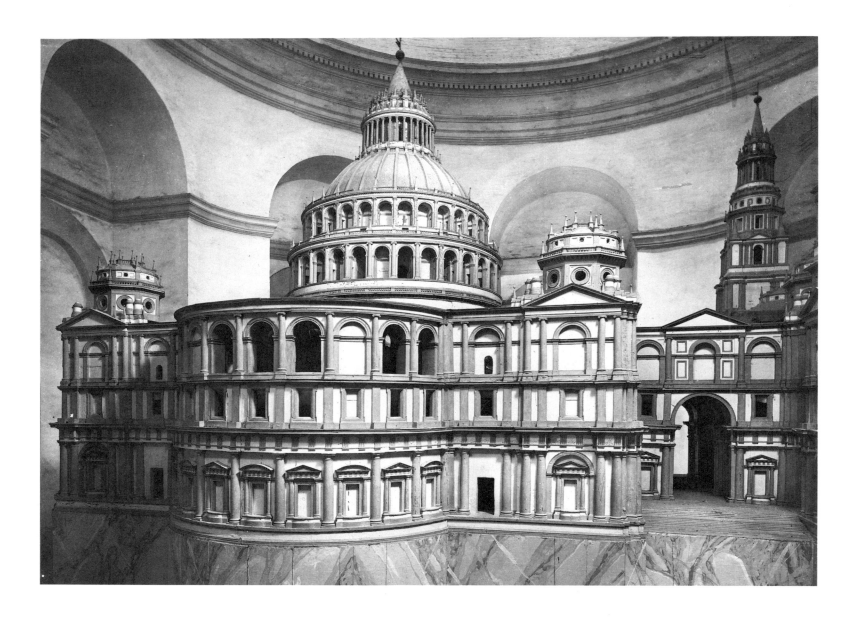

taken very ill, as may be believed, and were the reason that they conceived a great hatred against him, which increased every day as they saw the whole design being changed, both within and without, so that they would scarcely let him live, seeking out daily new and various devices to harass him, as will be related in the proper place. Finally the Pope issued a Motu-proprio creating him head of that fabric, with full authority, and giving him power to do or undo whatever he chose, and to add, take away, or vary anything at his pleasure; and he decreed that all the officials employed in the work should be subservient to his will. Whereupon Michelagnolo, seeing the great confidence and trust that the Pope placed in him, desired, in order to prove his generosity, that it should be declared in the Motu-proprio that he was serving in the fabric for the love of God and without any reward. It is true that the Pope had formerly granted to him the ferry over the river at Piacenza, which yielded him about six hundred crowns; but he lost it at the death of Duke Pier Luigi Farnese, and in exchange for it he was given a Chancellery at Rimini, a post of less value. About that he showed no concern; and, although the Pope sent him money several times by way of salary, he would never accept it, to which witness is borne by Messer Alessandro Ruffini, Chamberlain to the Pope at that time, and by M. Pier Giovanni Aliotti, Bishop of Forlì. Finally the model that had been made by Michelagnolo was approved by the Pope; which model diminished S. Pietro in size, but gave it greater grandeur, to the satisfaction of all those who have judgment, although some who profess to be good judges, which in fact they are not, do not approve of it. He found that the four principal piers built by Bramante, and left by Antonio da San Gallo, which had to support the weight of the tribune, were weak; and these he partly filled up, and beside them he made two winding or spiral staircases, in which is an ascent so easy that the beasts of burden can climb them, carrying all the materials to the very top, and men on horseback, likewise, can go up to the uppermost level of the arches. The first cornice above the arches he constructed of travertine, curving in a round, which is an admirable and graceful thing, and very different from any other; nor could anything better of that kind be done. He also made a beginning with the two great recesses of the transepts; and whereas formerly, under the direction of Bramante, Baldassarre [Peruzzi], and Raffaello, as has been related, eight tabernacles were being made on the side towards the Camposanto, and that plan was afterwards followed by San Gallo, Michelagnolo reduced these to three, with three chapels in the interior, and above them a vaulting of travertine, and a range of windows giving a brilliant light, which are varied in form and of a sublime grandeur. But, since these things are in existence, and are also to be seen in engraving, not only those of Michelagnolo, but those of San Gallo as well, I will not set myself to describe them, for it is in no way necessary. Let it suffice to say that he set himself, with all possible diligence, to cause the work to be carried on in those parts where the fabric was to be changed in design, to the end that it might remain so solid and stable that it might never be changed by another; which was the wise provision of a shrewd and prudent intellect, because it is not enough to do good work, if further precautions be not taken, seeing that the boldness and presumption of those who might be supposed to have knowledge if credit were placed rather in their words than in their deeds, and at times the favour of such as know nothing, may give rise to many misfortunes.

The Roman people, with the sanction of that Pope, had a desire to give some useful, commodious and beautiful form to the Campidoglio, and to furnish it with colonnades, ascents, and inclined approaches with and without steps, and also with the further adornment of the ancient statues that were already there, in order to embellish that place. For this purpose they sought the advice of Michelagnolo, who made them a most beautiful and very rich design, in which, on the side where the Senatore stands, towards the east, he ar-

Motu proprio *(literally "by one's own volition"), a papal decree.*

In this instance "tribune" means the dome.

277

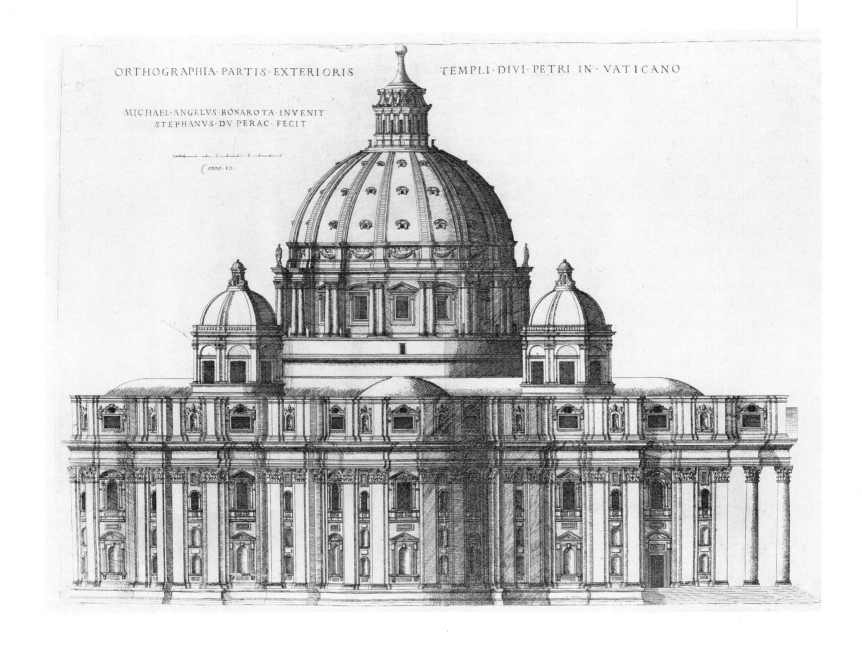

ranged a façade of travertine, and a flight of steps that ascends from two sides to meet on a level space, from which one enters into the centre of the hall of that Palace, with rich curving wings adorned with balusters that serve as supports and parapets. And there, to enrich that part, he caused to be placed on certain bases the two ancient figures in marble of recumbent River Gods, each of nine braccia, and of rare workmanship, one of which is the Tiber and the other the Nile; and between them, in a niche, is to go a Jove. On the southern side, where there is the Palace of the Conservatori, in order that it might be made rectangular, there followed a rich and well varied façade, with a loggia at the foot full of columns and niches, where many ancient statues are to go; and all around are various ornaments, doors, windows, and the like, of which some are already in place. On the other side from this, towards the north, below the Araceli, there is to follow another similar façade, and before it, towards the west, is to be an ascent of baston-like steps, which will be almost level, with a border and parapet of balusters; here will be the principal entrance, with a colonnade, and bases on which will be placed all that wealth of noble statues in which the Campidoglio is now so rich. In the middle of the Piazza, on a base in the form of an oval, is placed the famous bronze horse on which is the statue of Marcus Aurelius, which the same Pope Paul caused to be removed from the Piazza di Laterano, where Sixtus IV had placed it. This edifice is now being made so beautiful that it is worthy to be numbered among the finest works that Mi-

Etienne Dupérac. *South Elevation of Saint Peter's* (after Michelangelo's plan). After 1569. Engraving. The Metropolitan Museum of Art, New York; Harris Brisbane Dick Fund, 1941.

chelagnolo has executed, and it is being carried to completion at the present day under the direction of M. Tommaso de' Cavalieri, a Roman gentleman who was, and still is, one of the greatest friends that Michelagnolo ever had, as will be related hereafter.

Pope Paul II had caused San Gallo, while he was alive, to carry forward the Palace of the Farnese family, but the great upper cornice, to finish the roof on the outer side, had still to be constructed, and His Holiness desired that Michelagnolo should execute it from his own designs and directions. Michelagnolo, not being able to refuse the Pope, who so esteemed and favoured him, caused a model of wood to be made, six braccia in length, and of the size that it was to be; and this he placed on one of the corners of the Palace, so that it might show what effect the finished work would have. It pleased his Holiness and all Rome, and that part of it has since been carried to completion which is now to be seen, proving to be the most varied and the most beautiful of all that have ever been known, whether ancient or modern. On this account, after San Gallo was dead, the Pope desired that Michelagnolo should have charge of the whole fabric as well; and there he made the great marble window with the beautiful columns of variegated marble, which is over the principal door of the Palace, with a large escutcheon of great beauty and variety, in marble, of Pope Paul III, the founder of that Palace. Within the Palace he continued, above the first range of the court, the two other ranges, with the most varied, graceful, and beautiful windows, ornaments and upper cornice that have ever been seen, so that, through the labours and the genius of that man that court has now become the most handsome in Europe. He widened and enlarged the Great Hall,

The model is lost.

Etienne Dupérac. *View of the Campidoglio* (after Michelangelo's plan). 1569. Engraving. The Metropolitan Museum of Art, New York; Harris Brisbane Dick Fund, 1941.

and set in order the front vestibule, and caused the vaulting of that vestibule to be constructed in a new variety of curve, in the form of a half oval.

Now in that year there was found at the Baths of Antoninus a mass of marble seven braccia in every direction, in which there had been carved by the ancients a Hercules standing upon a mound, who was holding the Bull by the horns, with another figure assisting him, and around that mound various figures of Shepherds, Nymphs, and different animals—a work of truly extraordinary beauty, showing figures so perfect in one single block without any added pieces, which was judged to have been intended for a fountain. Michelagnolo advised that it should be conveyed into the second court, and there restored so as to make it spout water in the original manner; all which advice was approved, and the work is still being restored at the present day with great diligence, by order of the Farnese family, for that purpose. At that time, also, Michelagnolo made a design for the building of a bridge across the River Tiber in a straight line with the Farnese Palace, to the end that it might be possible to go from that palace to another palace and gardens that they possessed in the Trastevere, and also to see at one glance in a straight line from the principal door which faces the Campo di Fiore, the court, the fountain, the Strada Giulia, the bridge, and the beauties of the other garden, even to the other door which opened on the Strada di Trastevere—a rare work, worthy of that Pontiff and of the judgment, design, and art of Michelagnolo.

The design is lost.

In the year 1547 died Sebastiano [del] Piombo; and, Pope Paul proposing that the ancient statues of his Palace should be restored, Michelagnolo willingly favoured the Milanese sculptor Guglielmo della Porta, a young man of promise, who had been recommended by the above-named Fra Sebastiano to Michelagnolo, who, liking his work, presented him to Pope Paul for the restoration of those statues. And the matter went so far forward that Michelagnolo obtained for him the office of the Piombo, and he then set to work on restoring the statues, some of which are to be seen in that Palace at the present day. But Guglielmo, forgetting the benefits that he had received from Michelagnolo, afterwards became one of his opponents.

The office of the Piombo *supervised the lead seals of pontifical documents.*

Fra Guglielmo della Porta (c. 1490–1577). A lay brother, he was Sebastiano's successor to the post of Piombo.

In the year 1549 there took place the death of Pope Paul III; whereupon,

Antonio da Sangallo and Michelangelo. *Inner Court of the Palazzo Farnese.* 16th century. Engraving by Beatrizet from Antonio Lefreri's *Speculum Romanae.* The Metropolitan Museum of Art, New York; Harris Brisbane Dick Fund, 1941.

after the election of Pope Julius III, Cardinal Farnese gave orders for a grand tomb to be made for his kinsman Pope Paul by the hand of Fra Guglielmo, who arranged to erect it in S. Pietro, below the first arch of the new church, beneath the tribune, which obstructed the floor of the church, and was, in truth, not the proper place. Michelagnolo advised, most judiciously, that it could not and should not stand there, and the Frate, believing that he was doing this out of envy, became filled with hatred against him; but afterwards he recognized that Michelagnolo had spoken the truth, and that the fault was his, in that he had had the opportunity and had not finished the work. And to this I can bear witness, for the reason that in the year 1550 I had gone by order of Pope Julius III to Rome to serve him (and very willingly, for love of Michelagnolo), and I took part in that discussion. Michelagnolo desired that the tomb should be erected in one of the niches, where there is now the Column of the Possessed, which was the proper place, and I had so gone to work that Julius III was resolving to have his own tomb made in the other niche with the same design as that of Pope Paul, in order to balance that work; but the Frate, who set himself against this, brought it about that his own was never finished after all, and that the tomb of the other Pontiff was also not made; which had all been predicted by Michelagnolo.

Julius III (r. 1550–55).

In the same year Pope Julius turned his attention to having a chapel of marble with two tombs constructed in the Church of S. Pietro a Montorio for Cardinal Antonio di Monte, his uncle, and Messer Fabiano, his grandfather, the first founder of the greatness of that illustrious house. For this work Vasari having made designs and models, Pope Julius, who always esteemed the genius of Michelagnolo and loved Vasari, desired that Michelagnolo should fix the price between them; and Vasari besought the Pope that he should prevail upon him to take it under his protection. Now Vasari had proposed Simone Mosca for the carvings of this work, and Raffaello da Montelupo for the statues; but Michelagnolo advised that no carvings of foliage should be made in it, not even in the architectural parts of the work, saying that where there are to be figures of marble there must not be any other thing. On which account Vasari feared that the work should be abandoned, because it would look poor; but in fact, when he saw it finished, he confessed that Michelagnolo had shown great judgment. Michelagnolo would not have Montelupo make the statues, remembering how badly he had acquitted himself in those of his own tomb of Julius II, and he was content, rather, that they should be entrusted to Bartolommeo Ammanati, whom Vasari had proposed, although Buonarroti had something of a private grievance against him, as also against Nanni di Baccio Bigio, caused by a reason which, if one considers it well, seems slight enough; for when they were very young, moved rather by love of art than by a desire to do wrong, they had entered with great pains into his house, and had taken from Antonio Mini, the disciple of Michelagnolo, many sheets with drawings; but these were afterwards all restored to him by order of the Tribunal of Eight, and, at the intercession of his friend Messer Giovanni Norchiati, Canon of S. Lorenzo, he would not have any other punishment inflicted on them. Vasari, when Michelagnolo spoke to him of this matter, said to him, laughing, that it did not seem to him that they deserved any blame, and that he himself, if he had been able, would have not taken a few drawings only, but robbed him of everything by his hand that he might have been able to seize, merely for the sake of learning art. One must look kindly, he said, on those who seek after excellence, and also reward them, and therefore such men must not be treated like those who go about stealing money, household property, and other things of value; and so the matter was turned into a jest. This was the reason that a beginning was made with the work of the Montorio, and that in the same year Vasari and Ammanati went to have the marble conveyed from Carrara to Rome for the execution of that work.

Simone Mosca (fl. sixteenth century) was born in Settignano. His Life by Vasari is perhaps the artist's only detailed biography.

Bartolommeo Ammanati (1511–1592), Florentine sculptor and architect. Among his many notable achievements are the Ponte Santa Trinità and the enlargement of the Pitti Palace in Florence.

Nanni di Baccio Bigio (d. 1568), a minor Tuscan architect who worked in Rome.

At that time Vasari was with Michelagnolo every day; and one morning the Pope in his kindness gave them both leave that they might visit the Seven Churches on horseback (for it was Holy Year), and receive the Pardon in company. Whereupon, while going from one church to another, they had many useful and beautiful conversations on art and every industry, and out of these Vasari composed a dialogue, which will be published at some more favourable opportunity, together with other things concerning art. In that year Pope Julius III confirmed the Motu-proprio of Pope Paul III with regard to the building of S. Pietro; and although much evil was spoken to him of Michelagnolo by the friends of the San Gallo faction, in the matter of that fabric of S. Pietro, at that time the Pope would not listen to a word, for Vasari had demonstrated to him (as was the truth) that Michelagnolo had given life to the building, and also persuaded his Holiness that he should do nothing concerned with design without the advice of Michelagnolo. This promise the Pope kept ever afterwards, for neither at the Vigna Julia did he do anything without his counsel, nor at the Belvedere, where there was built the staircase that there is now, in place of the semicircular staircase that came forward, ascending in eight steps, and turned inwards in eight more steps, erected in former times by Bramante in the great recess in the centre of Belvedere. And Michelagnolo designed and caused to be built the very beautiful quadrangular staircase, with balusters of peperino-stone, which is there at the present day.

Vasari had finished in that year the printing of his work, the Lives of the Painters, Sculptors, and Architects, in Florence. Now he had not written the Life of any living master, although some who were old were still alive, save

The first edition of the Lives, *which was published in 1550.*

Etienne Dupérac. *Michelangelo's Groundplan for St. Peter's.* After 1569. Engraving. The Metropolitan Museum of Art, New York; Harris Brisbane Dick Fund, 1941.

only of Michelagnolo; and in the book were many records of circumstances that Vasari had received from his lips, his age and his judgment being the greatest among all the craftsmen. Giorgio therefore presented the work to him, and he received it very gladly; and not long afterwards, having read it, Michelagnolo sent to him the following sonnet, written by himself, which I am pleased to include in this place in memory of his loving-kindness:

> *If, with thy chisel and thy paints, thou*
> *Mad'st Art to equal Nature; thy hand*
> *Hath now surpassed her, giving us her beauties*
> *Rendered in forms more fair. Now, with sage thought*
> *Thou hast set thyself on worthier labours,*
> *And that which once was wanting thou hast now supplied*
> *In giving life to others: thus denying*
> *Nature's final boast of her claim to rise above thee.*
> *Is there an age whose labours strive not to*
> *Attain the topmost pinnacle? Yet by thy word*
> *All reach the limit to their toils.*
> *Else-extinguished memories are thus revived*
> *To new and shining life by thee, and shall now*
> *Endure, with thine own fame, to last out time.*

Vasari departed for Florence, and left to Michelagnolo the charge of having the work founded in the Montorio. Now Messer Bindo Altoviti, the Consul of the Florentine colony at that time, was much the friend of Vasari, and on this occasion Giorgio said to him that it would be well to have this work erected in the Church of S. Giovanni de' Fiorentini, and that he had already spoken of it with Michelagnolo, who would favour the enterprise; and that this would be a means of giving completion to that church. This proposal pleased Messer Bindo, and, being very intimate with the Pope, he urged it warmly upon him, demonstrating that it would be well that the chapel and the tombs which his Holiness was having executed for the Montorio should be placed in the Church of S. Giovanni de' Fiorentini; adding that the result would be that with this occasion and this spur the Florentine colony would undertake such expenditure that the church would receive its completion, and, if his Holiness were to build the principal chapel, the other merchants would build six chapels, and then little by little all the rest. Whereupon the Pope changed his mind, and, although the model for the work was already made and the price arranged, went to the Montorio and sent for Michelagnolo, to whom Vasari was writing every day, receiving answers from him according to the opportunities presented in the course of affairs. Michelagnolo then wrote to Vasari, on the first day of August in 1550, of the change that the Pope had made; and these are his words, written in his own hand:

Bindo's portrait by Raphael is reproduced in colorplate 71.

The church was never built and the model has been lost.

Rome.

"My dear Messer Giorgio,

"With regard to the founding of the work at S. Pietro a Montorio, and how the Pope would not listen to a word, I wrote you nothing, knowing that you are kept informed by your man here. Now I must tell you what has happened, which is as follows. Yesterday morning the Pope, having gone to the said Montorio, sent for me. I met him on the bridge, on his way back, and had a long conversation with him about the tombs allotted to you; and in the end he told me that he was resolved that he would not place those tombs on that mount, but in the Church of the Florentines. He sought from me my opinion

Michelangelo. *Sketches for the Staircase of the Laurentian Library; Profiles of Bases.* 1525. Pen, red chalk, black chalk, and wash. 15½ × 11" (395 × 280 mm). Casa Buonarroti, Florence.

and also designs, and I encouraged him not a little, considering that by this means the said church would be finished. Respecting your three letters received, I have no pen wherewith to answer to such exalted matters, but if I should rejoice to be in some sort what you make me, I should rejoice for no other reason save that you might have a servant who might be worth something. But I do not marvel that you, who restore dead men to life, should lengthen the life of the living, or rather, that you should steal from death for an unlimited period those barely alive. To cut this short, such as I am, I am wholly yours,

"Michelagnolo Buonarroti."

While these matters were being discussed, and the Florentine colony was seeking to raise money, certain difficulties arose, on account of which they came to no decision, and the affair grew cold. Meanwhile, Vasari and Ammanati having by this time had all the marbles quarried at Carrara, a great part of them were sent to Rome, and with them Ammanati, through whom Vasari wrote to Buonarroti that he should ascertain from the Pope where he wanted the tomb, and, after receiving his orders, should have the work begun. The mo-

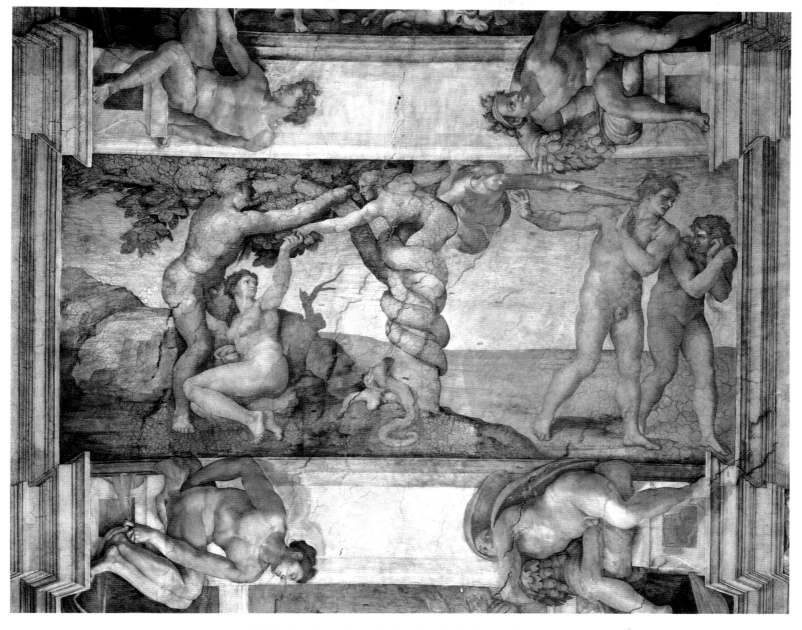

COLORPLATE 89. Michelangelo. *Original Sin* (detail, Sistine Ceiling). 1509–10. Fresco.
Sistine Chapel, Vatican, Rome.

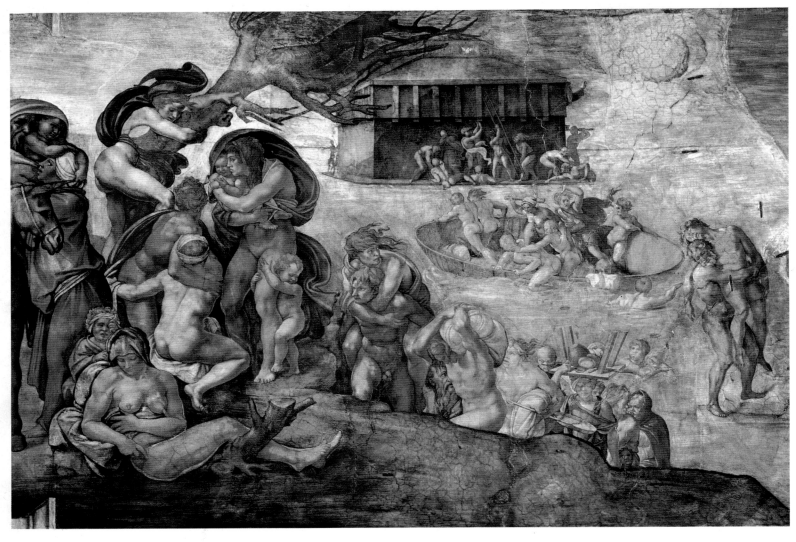

COLORPLATE 90. Michelangelo. *The Flood* (detail, Sistine Ceiling). 1508–09. Fresco.
Sistine Chapel, Vatican, Rome.

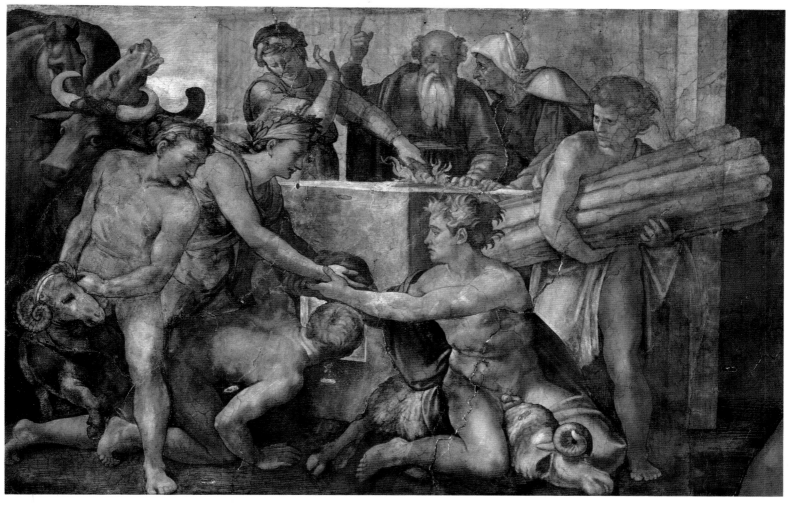

COLORPLATE 91. Michelangelo. *The Sacrifice of Noah* (detail, Sistine Ceiling). 1509. Fresco. Sistine Chapel, Vatican, Rome.

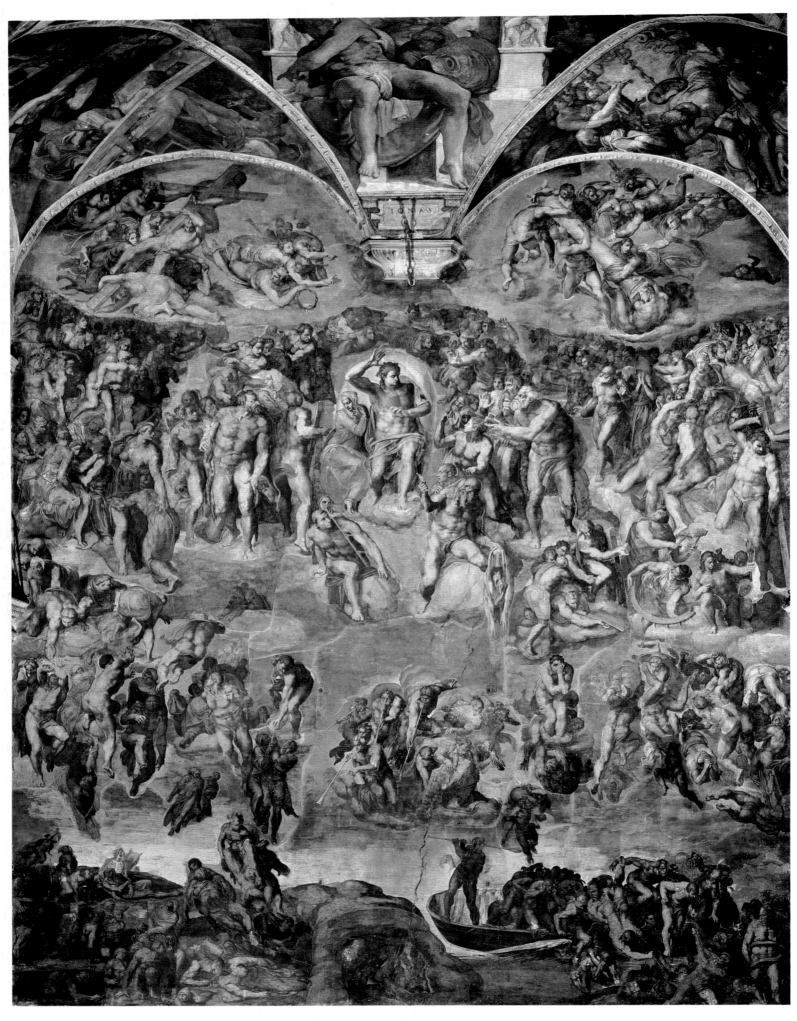

COLORPLATE 92. Michelangelo. *The Last Judgment*. 1537–41. Fresco.
Sistine Chapel, Vatican, Rome.

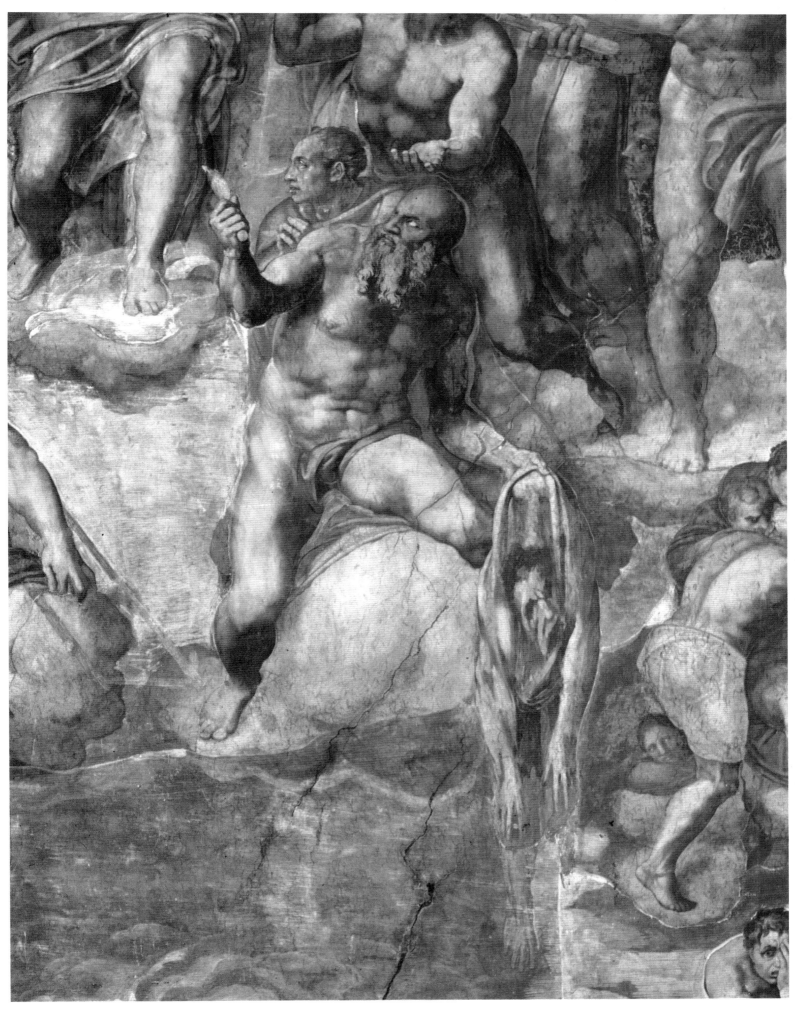

COLORPLATE 93. Michelangelo. *St. Bartholomew* (detail from *The Last Judgment*). 1537–41. Fresco.
Sistine Chapel, Vatican, Rome.

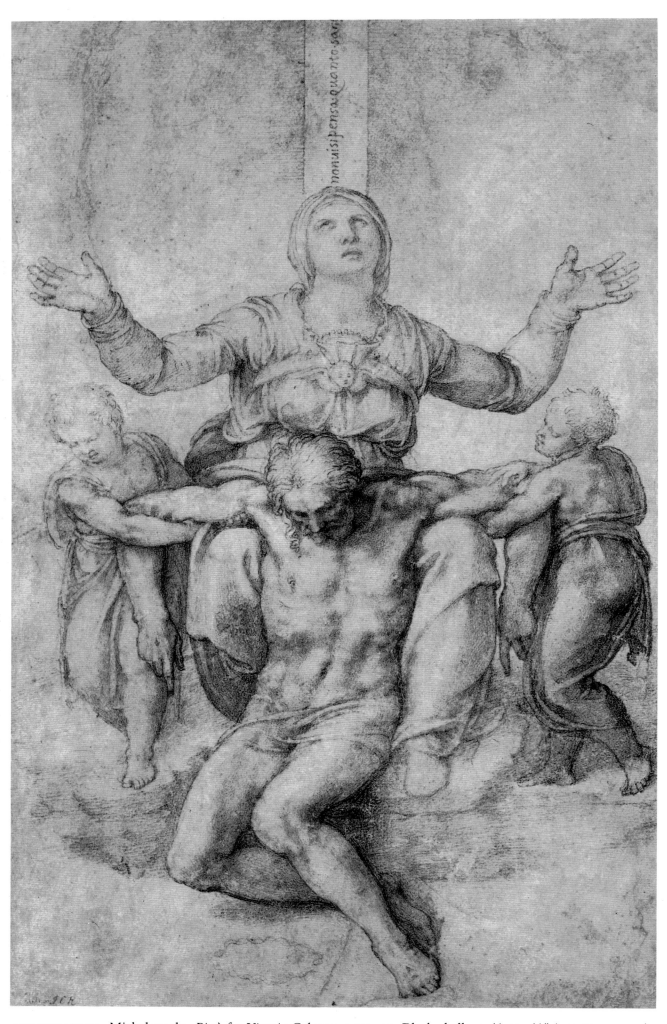

COLORPLATE 94. Michelangelo. *Pietà for Vittoria Colonna*. 1540–44. Black chalk. 11½ × 7½″ (290 × 190 mm).
Isabella Stewart Gardner Museum, Boston.

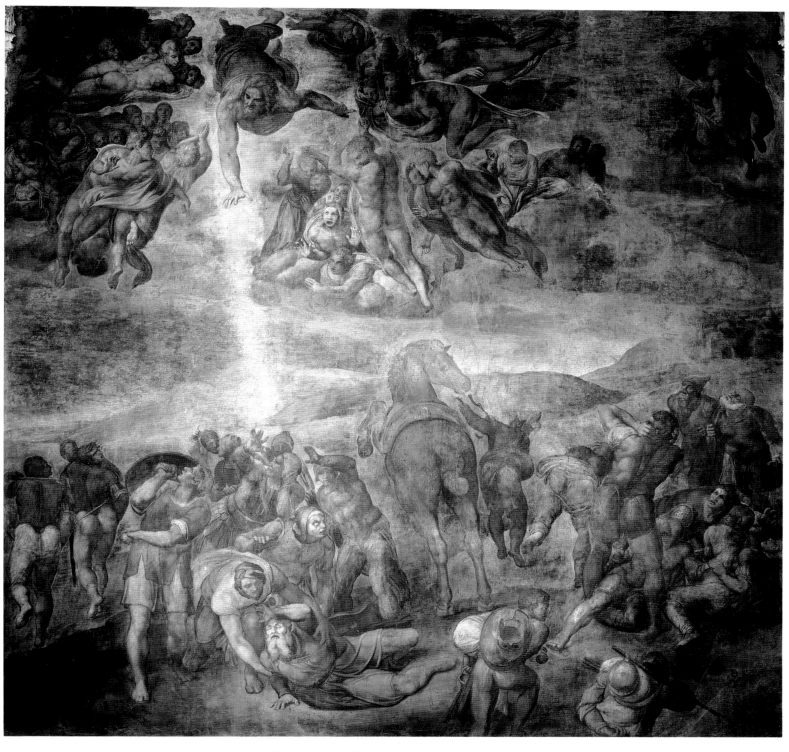

COLORPLATE 95. Michelangelo. *The Conversion of St. Paul.* c. 1542–45. Fresco.
Pauline Chapel, Vatican, Rome.

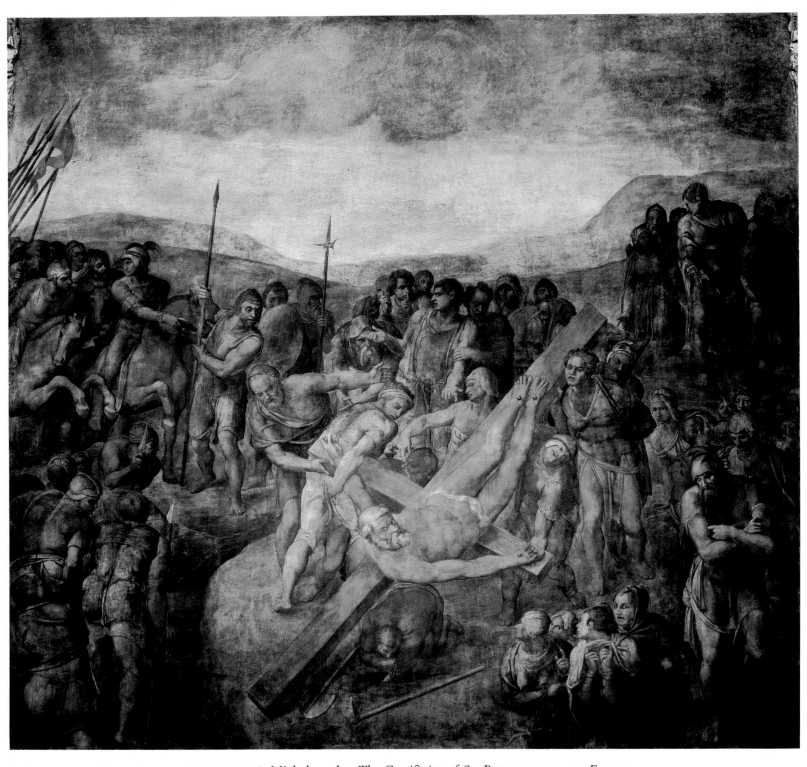

COLORPLATE 96. Michelangelo. *The Crucifixion of St. Peter.* c. 1545–50. Fresco.
Pauline Chapel, Vatican, Rome.

ment that Michelagnolo received the letter, he spoke to his Holiness; and with his own hand he wrote the following resolution to Vasari:

<div style="text-align: center">"13th of October, 1550.</div>

"My dear Messer Giorgio,

"The instant that Bartolommeo arrived here, I went to speak to the Pope, and, having perceived that he wished to begin the work once more at the Montorio, in the matter of the tombs, I looked for a mason from S. Pietro. 'Tantecose' heard this, and insisted on sending one of his choosing, and I, to avoid contending with a man who commands the winds, have retired from the matter, because, he being a light-minded person, I would not care to be drawn into any entanglement. Enough that in my opinion there is no more thought to be given to the Church of the Florentines. Fare you well, and come back soon. Nothing else occurs to me."

Michelagnolo used to call Monsignor di Forlì "Tantecose," ["Do-it-all" or "Busybody"] because he insisted on doing everything himself. Being Chamberlain to the Pope, he had charge of the medals, jewels, cameos, little figures in bronze, pictures, and drawings, and desired that everything should depend on him. Michelagnolo was always anxious to avoid the man, because he had been constantly working against the master's interests, and therefore Buonarroti feared lest he might be drawn into some entanglement by the intrigues of such a man. In short, the Florentine colony lost a very fine opportunity for that church, and God knows when they will have such another; and to me it was an indescribable grief. I have desired not to omit to make this brief record, to the end that it may be seen that our Michelagnolo always sought to help his fellow-countrymen and his friends, and also art.

Vasari had scarcely returned to Rome, when, before the beginning of the year 1551, the San Gallo faction arranged a conspiracy against Michelagnolo, whereby the Pope was to hold an assembly in S. Pietro, and to summon together the superintendents and all those who had the charge of the work, in order to show to the Pope, by means of false calumnies, that Michelagnolo had ruined the fabric, because, he having already built the apse of the King, where there are the three chapels, and having executed these with the three windows above, they, not knowing what was to be done with the vaulting, with feeble judgment had given the elder Cardinal Salviati and Marcello Cervini, who afterwards became Pope, to understand that S. Pietro was being left with little light. Whereupon, all being assembled, the Pope said to Michelagnolo that the deputies declared that the apse would give little light, and he answered: "I would like to hear those deputies speak in person." Cardinal Marcello replied: "We are here." Then Michelagnolo said to him: "Monsignore, above these windows, in the vaulting, which is to be made of travertine, there are to be three others." "You have never told us that," said the Cardinal. And Michelagnolo answered: "I am not obliged, nor do I intend to be obliged, to say either to your Highness or to any other person what I am bound or desirous to do. Your office is to obtain the money and guard it from thieves, and the charge of the design for the building you must leave to me." And then, turning to the Pope, he said: "Holy Father, you see what my gains are, and that if these fatigues that I endure do not profit me in my mind, I am wasting my time and my work." The Pope, who loved him, laid his hands on his shoulders, and said: "You shall profit both in mind and in body; do not doubt it." Michelagnolo having thus been able to get rid of those persons, the Pope came to love him even more; and he commanded him and Vasari that on the day following they should both present themselves at the Vigna Julia, in which place his Holiness

This project remained unrealized.

293

had many discussions with him, and they carried that work almost to the condition of perfect beauty in which it now is; nor did the Pope discuss or do anything in the matter of design without Michelagnolo's advice and judgment. And, among other things, since Michelagnolo went often with Vasari to visit him, the Pope insisted, once when he was at the fountain of the Acqua Vergine with twelve Cardinals, after Buonarroti had come up; the Pope, I say, insisted very strongly that he should sit beside him, although he sought most humbly to excuse himself; thus always honouring his genius as much as lay in his power.

The Pope caused him to make the model of a façade for a palace that his Holiness desired to build beside S. Rocco, intending to avail himself of the Mausoleum of Augustus for the rest of the masonry; and, as a design for a façade, there is nothing to be seen that is more varied, more ornate, or more novel in manner and arrangement, for the reason that, as has been seen in all his works, he never consented to be bound by any law, whether ancient or modern, in matters of architecture, as one who had a brain always able to discover things new and well-varied, and in no way less beautiful. That model is now in the possession of Duke Cosimo de' Medici, who had it as a present from Pope Pius IV when he went to Rome; and he holds it among his dearest treasures. That Pope had such respect for Michelagnolo, that he was constantly taking up his defence against Cardinals and others who sought to calumniate him, and he desired that other craftsmen, however able and renowned they might be, should always go to seek him at his house; such, indeed, were the regard and reverence that he felt for him, that his Holiness did not venture, lest he might annoy him, to call upon Michelagnolo for many works which, although he was old, he could have executed.

As far back as the time of Paul III Michelagnolo had made a beginning with the work of refounding, under his own direction, the Ponte S. Maria at Rome, which had been weakened by the constant flow of water and by age, and was falling into ruin. The refounding was contrived by Michelagnolo by means of caissons, and by making stout reinforcements against the piers; and already he had carried a great part of it to completion, and had spent large sums on wood and travertine on behalf of the work, when, in the time of Julius III, an assembly was held by the Clerks of the Chamber with a view to making an end of it, and a proposal was made among them by the architect Nanni di Baccio Bigio, saying that if it were allotted by contract to him it would be finished in a short time and without much expense; and this they suggested on the pretext, as it were, of doing a favour to Michelagnolo and relieving him of a burden, because he was old, alleging that he gave no thought to it, and that if matters remained as they were the end would never be seen. The Pope, who little liked being troubled, not thinking what the result might be, gave authority to the Clerks of the Chamber that they should have charge of the work, as a thing pertaining to them; and then, without Michelagnolo hearing another word about it, they gave it with all those materials, without conditions, to Nanni, who gave no attention to the reinforcements, which were necessary for the refounding, but relieved the bridge of some weight, in consequence of having seen a great quantity of travertine wherewith it had been flanked and faced in ancient times, the result of which was to give weight to the bridge and to make it stouter, stronger, and more secure. In place of that he used gravel and other materials cast with cement, in such a manner that no defect could be seen in the inner part of the work, and on the outer side he made parapets and other things, insomuch that to the eye it appeared as if made altogether new; but it was made lighter all over and weakened throughout. Five years afterwards, when the flood of the year 1557 came down, it happened that the bridge collapsed in such a manner as to make known the little judgment of the Clerks of the Chamber and the loss that Rome suffered by departing from the counsel of Michelag-

nolo, who predicted the ruin of the bridge many times to me and to his other friends. Thus I remember that he said to me, when we were passing there together on horseback, "Giorgio, this bridge is shaking under us; let us spur our horses, or it may fall while we are upon it."

But to return to the narrative interrupted above; when the work of the Montorio was finished, and that much to my satisfaction, I returned to Florence to re-enter the service of Duke Cosimo, which was in the year 1554. The departure of Vasari grieved Michelagnolo, and likewise Giorgio, for the reason that Michelagnolo's adversaries kept harassing him every day, now in one way and now in another; wherefore they did not fail to write to one another daily. And in April of the same year, Vasari giving him the news that Leonardo, the nephew of Michelagnolo, had had a male child, that they had accompanied him to baptism with an honourable company of most noble ladies, and that they had revived the name of Buonarroto, Michelagnolo answered in a letter to Vasari in these words:

"Dear Friend Giorgio,

"I have had the greatest pleasure from your letter, seeing that you still remember the poor old man, and even more because you were present at the triumph which, as you write, you witnessed in the birth of another Buonarroto; for which intelligence I thank you with all my heart and soul. But so much pomp does not please me, for man should not be laughing when all the world is weeping. It seems to me that Leonardo should not make so much rejoicing over a new birth, with all that gladness which should be reserved for the death of one who has lived well. Do not marvel if I delay to answer; I do it so as not to appear a merchant. As for the many praises that you send me in your letter, I tell you that if I deserved a single one of them, it would appear to me that in giving myself to you body and soul, I had truly given you something, and had discharged some infinitesimal part of the debt that I owe you; whereas I recognize you every hour as my creditor for more than I can repay, and, since I am an old man, I can now never hope to be able to square the account in this life, but perhaps in the next. Wherefore I pray you have patience, and remain wholly yours. Things here are much as usual."

Already, in the time of Paul III, Duke Cosimo had sent Tribolo to Rome to see if he might be able to persuade Michelagnolo to return to Florence, in order to give completion to the Sacristy of S. Lorenzo. But Michelagnolo excused himself because, having grown old, he could not support the burden of such fatigues, and demonstrated to him with many reasons that he could not leave Rome. Whereupon Tribolo finally asked him about the staircase of the library of S. Lorenzo, for which Michelagnolo had caused many stones to be prepared, but there was no model of it nor any certainty as to the exact form, and, although there were some marks on a pavement and some other sketches in clay, the true and final design could not be found. However, no matter how much Tribolo might beseech him and invoke the name of the Duke, Michelagnolo would never answer a word save that he remembered nothing of it. Orders were given to Vasari by Duke Cosimo that he should write to Michelagnolo, requesting him to write saying what final form that staircase was to have; in the hope that through the friendship and love that he bore to Vasari, he would say something that might lead to some solution and to the completion of the work. Vasari wrote to Michelagnolo the mind of the Duke, saying that the execution of all that was to be done would fall to him; which he would do with that fidelity and care with which, as Michelagnolo knew, he was wont to treat such of his works as he had in charge. Wherefore Michelagnolo sent the directions for making the above-named staircase in a letter by his own hand on the 28th of September, 1555.

"Messer Giorgio, dear Friend,

"Concerning the staircase for the library, of which so much has been said to me, you may believe that if I could remember how I had designed it, I would not need to be entreated. There does, indeed, come back to my mind, like a dream, a certain staircase; but I do not believe that it is exactly the one which I conceived at that time, because it comes out so stupid. However, I will describe it here. Take a quantity of oval boxes, each one palm in depth, but not of equal length and breadth. The first and largest place on the pavement at such a distance from the wall of the door as may make the staircase easy or steep, according to your pleasure. Upon this place another, which must be so much smaller in every direction as to leave on the first one below as much space as the foot requires in ascending; diminishing and drawing back the steps one after another towards the door, in accord with the ascent. And the diminution of the last step must reduce it to the proportion of the space of the door. The said part of the staircase with the oval steps must have two wings, one on one side and

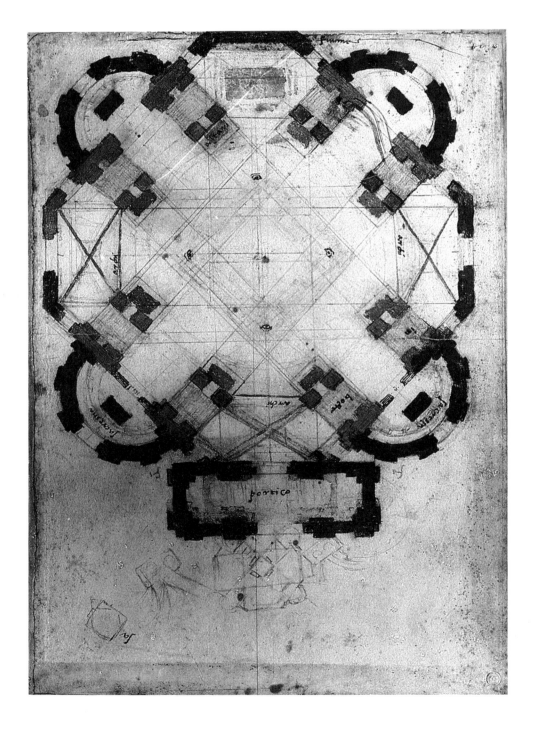

Michelangelo. *Groundplan for San Giovanni dei Fiorentini.* 1559. Pen and wash with black chalk. 16⅝ × 11½" (460 × 292 mm). Casa Buonarroti, Florence.

296

one on the other, with corresponding steps but not oval. Of these the central flight shall serve as the principal staircase, and from the centre of the staircase to the top the curves of the said wings shall meet the wall; but from the centre down to the pavement they shall stand, together with the whole staircase, at a distance of about three palms from the wall, in such a manner that the basement of the vestibule shall not be obstructed in any part, and every face shall be left free. I am writing nonsense; but I know well that you will find something to your purpose."

Michelagnolo also wrote to Vasari in those days that Julius III being dead, and Marcellus elected, the faction that was against him, in consequence of the election of the new Pontiff, had again begun to harass him. Which hearing, and not liking these ways, the Duke caused Giorgio to write and tell him that he should leave Rome and come to live in Florence, where the Duke did not desire more than his advice and designs at times for his buildings, and that he would receive from that lord all that he might desire, without doing anything with his own hand. Again, there were carried to him by M. Leonardo Marinozzi, the private Chamberlain of Duke Cosimo, letters written by his Excellency; and so also by Vasari. But then, Marcellus being dead, and Paul IV having been elected, by whom once again numerous offers had been made to

Michelangelo. *Staircase and Vestibule of Laurentian Library*. 1524–34; staircase completed 1559.

Marcellus reigned for a short time in 1555.

Paul IV (r. 1555–59).

him from the very beginning, when he went to kiss his feet, the desire to finish the fabric of S. Pietro, and the obligation by which he thought himself bound to that task, kept him back; and, employing certain excuses, he wrote to the Duke that for the time being he was not able to serve him, and to Vasari a letter in these very words:

"Messer Giorgio, my dear Friend,

"I call God to witness how it was against my will and under the strongest compulsion that I was set to the building of S. Pietro in Rome by Pope Paul III, ten years ago. Had they continued to work at that fabric up to the present day, as they were doing then, I would now have reached such a point in the undertaking that I might be thinking of returning home; but for want of money it has been much retarded, and is still being retarded at the time when it has reached the most laborious and difficult stage, insomuch that to abandon it now would be nothing short of the greatest possible disgrace and sin, losing the reward of the labours that I have endured in those ten years for the love of God. I have made you this discourse in answer to your letter, and also because I have a letter from the Duke that has made me marvel much that his Excellency should have deigned to write so graciously; for which I thank God and his Excellency to the best of my power and knowledge. I wander from the subject, because I have lost my memory and wits, and writing is a great affliction to me, for it is not my art. The conclusion is this: to make you understand what would be the result if I were to abandon the fabric and depart from Rome; firstly, I would please a number of thieves, and secondly, I would be the cause of its ruin, and perhaps, also, of its being suspended for ever."

Continuing to write to Giorgio, Michelagnolo said to him, to excuse himself with the Duke, that he had a house and many convenient things at his disposal in Rome, which were worth thousands of crowns, in addition to being in danger of his life from disease of the kidneys, colic, and the stone, as happens to every old person, and as could be proved by Maestro Realdo, his physician, from whom he congratulated himself on having his life, after God; that for these reasons he was not able to leave Rome, and, finally, that he had no heart for anything but death. He besought Vasari, as he did in several other letters that Giorgio has by his hand, that he should recommend him to the Duke for pardon, in addition to what he wrote to the Duke, as I have said, to excuse himself. If Michelagnolo had been able to ride, he would have gone straightway to Florence, whence, I believe, he would never have consented to depart in order to return to Rome, so much was he influenced by the tenderness and love that he felt for the Duke; but meanwhile he gave his attention to working at many parts of the above-named fabric, in order so to fix the form that it might never again be changed. During this time certain persons had informed him that Pope Paul IV was minded to make him alter the façade of the chapel where the Last Judgment is, because, he said, those figures showed their nakedness too shamelessly. When, therefore, the mind of the Pope was made known to Michelagnolo, he answered: "Tell the Pope that it is no great affair, and that it can be altered with ease. Let him put the world right, and every picture will be put right in a moment." The office of the Chancellery of Rimini was taken away from Michelagnolo, but he would never speak of this to the Pope, who did not know it; and it was taken away from him by the Pope's Cup-bearer, who sought to have a hundred crowns a month given to him in respect of the fabric of S. Pietro, and caused a month's payment to be taken to his house, but Michelagnolo would not accept it. In the same year took place the death of Urbino, his servant, or rather, as he may be called, and as he had been, his companion. This man came to live with Michelagnolo in Florence in

the year 1530, after the siege was finished, when his disciple Antonio Mini went to France; and he rendered very faithful service to Michelagnolo, insomuch that in twenty-six years that faithful and intimate service brought it about that Michelagnolo made him rich and so loved him, that in this, Urbino's last illness, old as he was, he nursed him and slept in his clothes at night to watch over him. Wherefore, after he was dead, Vasari wrote to Michelagnolo to console him, and he answered in these words:

"My dear Messer Giorgio,

"I am scarce able to write, but, in reply to your letter, I shall say something. You know how Urbino died, wherein God has shown me very great grace, although it is also a grave loss and an infinite grief to me. This grace is that whereas when living he kept me alive, dying he has taught me to die not with regret, but with a desire for death. I have had him twenty-six years, and have found him a very rare and faithful servant; and now, when I had made him rich and was looking to him as the staff and repose of my old age, he has flown from me, nor is any hope left to me but to see him again in Paradise. And of this God has granted a sign in the happy death that he died, in that dying grieved him much less than leaving me in this traitorous world with so many afflictions; although the greater part of me is gone with him, and nothing is left me but infinite misery. I commend myself to you."

Michelagnolo was employed in the time of Pope Paul IV on many parts of the fortifications of Rome, and also by Salustio Peruzzi, to whom that Pope, as has been related elsewhere, had given the charge of executing the great portal of the Castello di S. Angelo, which is now half ruined; and he occupied himself in distributing the statues of that work, examining the models of the sculptors, and correcting them. At that time the French army approached near to Rome, and Michelagnolo thought that he was like to come to an evil end together with that city; whereupon he resolved to fly from Rome with Antonio Franzese of Castel Durante, whom Urbino at his death had left in his house as his servant, and went secretly to the mountains of Spoleto, where he visited certain seats of hermits. Meanwhile Vasari wrote to him, sending him a little work that Carlo Lenzoni, a citizen of Florence, had left at his death to Messer Cosimo Bartoli, who was to have it printed and dedicated to Michelagnolo; which, when it was finished, Vasari sent in those days to Michelagnolo, and he, having received it, answered thus:

<div style="text-align: right">

September 18, 1556.

</div>

"Messer Giorgio, dear Friend,

"I have received Messer Cosimo's little book, which you send to me, and this shall be a letter of thanks. I pray you to give them to him, and send him my compliments.

"I have had in these days great discomfort and expense, but also great pleasure, in visiting the hermits in the mountains of Spoleto, insomuch that less than half of me has returned to Rome, seeing that in truth there is no peace to be found save in the woods. I have nothing more to tell you. I am glad that you are well and happy, and I commend myself to you."

Michelagnolo used to work almost every day, as a pastime, at that block with the four figures of which we have already spoken; which block he broke into four pieces at this time for these reasons, either because it was hard and full of emery, and the chisel often struck sparks from it, or it may have been that

Salustio Peruzzi was a minor architect; Bandini was a friend of Michelangelo's, and Calcagni, a pupil and assistant.

the judgment of the man was so great that he was never content with anything that he did. A proof that this is true is that there are few finished statues to be seen out of all that he executed in the prime of his manhood, and that those completely finished were executed by him in his youth, such as the Bacchus, the Pietà in S. Maria della Febbre, the Giant of Florence, and the Christ of the Minerva, which it would not be possible to increase or diminish by as little as a grain of millet without spoiling them; and the others, with the exception of the Dukes Giuliano and Lorenzo, Night, Dawn, and Moses, with the other two, the whole number of these statues not amounting in all to eleven, the others, I say, were all left unfinished, and, moreover, they are many, Michelagnolo having been wont to say that if he had had to satisfy himself in what he did, he would have sent out few, nay, not one. For he had gone so far with his art and judgment, that, when he had laid bare a figure and had perceived in it the slightest degree of error, he would set it aside and run to lay his hand on another block of marble, trusting that the same would not happen to the new block; and he often said that this was the reason that he gave for having executed so few statues and pictures. This Pietà, when it was broken, he pre-

Michelangelo. *The Milan (or Rondanini) Pietà.* 1564. Marble. Height: 76¾" (195 cm). Castello Sforzesco, Milan.

sented to Francesco Bandini. Now at this time Tiberio Calcagni, a Florentine sculptor, had become much the friend of Michelagnolo by means of Francesco Bandini and Messer Donato Giannotti; and being one day in Michelagnolo's house, where there was the Pietà, all broken, after a long conversation he asked him for what reason he had broken it up and destroyed labours so marvellous, and he answered that the reason was the importunity of his servant Urbino, who kept urging him every day to finish it, besides which, among other things, a piece of one of the elbows of the Madonna had been broken off, and even before that he had taken an aversion to it, and had had many misfortunes with it by reason of a flaw that was in the marble, so that he lost his patience and began to break it up; and he would have broken it altogether into pieces if his servant Antonio had not besought him that he should present it to him as it was. Whereupon Tiberio, having heard this, spoke to Bandini, who desired to have something by the hand of Michelagnolo, and Bandini contrived that Tiberio should promise to Antonio two hundred crowns of gold, and prayed Michelagnolo to consent that Tiberio should finish it for Bandini with the assistance of models by his hand, urging that thus his labour would not be thrown away. Michelagnolo was satisfied, and then made them a present of it. The work was carried away immediately, and then put together again and reconstructed with I know not what new pieces by Tiberio; but it was left unfinished by reason of the death of Bandini, Michelagnolo, and Tiberio. At the present day it is in the possession of Pier Antonio Bandini, the son of Francesco, at his villa on Monte Cavallo. But to return to Michelagnolo; it became necessary to find some work in marble on which he might be able to pass some time every day with the chisel, and another piece of marble was put before him, from which another Pietà had already been blocked out, different from the first and much smaller.

There had entered into the service of Paul IV, and also into the charge of the fabric of S. Pietro, the architect Pirro Ligorio, and he was now once more harassing Michelagnolo, going about saying that he had sunk into his second childhood. Wherefore, angered by such treatment, he would willingly have returned to Florence, and, having delayed to return, he was again urged in letters by Giorgio, but he knew that he was too old, having now reached the age of eighty-one. Writing at that time to Vasari by his courier, and sending him various spiritual sonnets, he said that he was come to the end of his life, that he must be careful where he directed his thoughts, that by reading he would see that he was at his last hour, and that there arose in his mind no thought upon which was not graved the image of death; and in one letter he said:

"It is God's will, Vasari, that I should continue to live in misery for some years. I know that you will tell me that I am an old fool to wish to write sonnets, but since many say that I am in my second childhood, I have sought to act accordingly. By your letter I see the love that you bear me, and you may take it as certain that I would be glad to lay these feeble bones of mine beside those of my father, as you beg me to do; but by departing from here I would be the cause of the utter ruin of the fabric of S. Pietro, which would be a great disgrace and a very grievous sin. However, when it is so firmly established that it can never be changed, I hope to do all that you ask me, if it be not a sin to keep in anxious expectation certain gluttons that await my immediate departure."

With this letter was the following sonnet, also written in his own hand:

> Now, in a frail craft upon the storm-tossed flood,
> Doth this my life draw nigh to the port we all must gain,
> And where we all must haste to render up account
> Of every act committed—both ill and good.
> Wherefore I now can see, that by that love
> Which rendered Art my idol and my lord,

Ligorio was a minor sixteenth-century architect and painter.

I greatly erred. Vain are the loves of mortal man,
And error lurks within his ev'ry thought.
Lighthouses of my life, where are ye?
When towards a twofold death I now draw nigh?
One death well-known, the other threat'ning loud.
Once-worshipped Art cannot now bring peace
To him whose soul strives to that love divine,
Whose arms shall raise him from the Cross to Heaven.

Whereby it was evident that he was drawing towards God, abandoning the cares of art on account of the persecution of his malignant fellow-craftsmen, and also through the fault of certain overseers of the fabric, who would have liked, as he used to say, to dip their hands in the chest. By order of Duke Cosimo, a reply was written to Michelagnolo by Vasari in a letter of few words, exhorting him to repatriate himself, with a sonnet corresponding in the rhymes. Michelagnolo would willingly have left Rome, but he was so weary and aged, that although, as will be told below, he was determined to go back, while the spirit was willing the flesh was weak, and that kept him in Rome. It happened in June of the year 1557, he having made a model for the vault that was to cover the apse, which was being built of travertine in the Chapel of the King, that, from his not being able to go there as he had been wont, an error arose, in that the capomaestro took the measurements over the whole body of the vault with one single centre, whereas there should have been a great number; and Michelagnolo, as the friend and confidant of Vasari, sent him designs by his own hand, with these words written at the foot of two of them:

"The centre marked with red was used by the capomaestro over the body of the whole vault; then, when he began to pass to the half-circle, which is at the summit of the vault, he became aware of the error which that centre was producing, as may be seen here in the design, marked in black. With this error the vault has gone so far forward, that we have to displace a great number of stones, for in that vault there is being placed no brick-work, but all travertine, and the diameter of the circle, without the cornice that borders it, is twenty-two palms. This error, after I had made an exact model, as I do of everything, has been caused by my not being able, on account of my old age, to go there often; so that, whereas I believed that the vault was now finished, it will not be finished all this winter, and, if it were possible to die of shame and grief, I should not be alive now. I pray you account to the Duke for my not being at this moment in Florence."

And continuing in the other design, where he had drawn the plan, he said this:

"*Messer Giorgio,*

"To the end that it may be easier to understand the difficulty of the vault by observing its rise from the level of the ground, let me explain that I have been forced to divide it into three vaults, corresponding to the windows below divided by pilasters; and you see that they go pyramidally into the centre of the summit of the vault, as also do the base and sides of the same. It was necessary to regulate them with an infinite number of centres, and there are in them so many changes in various directions, from point to point, that no fixed rule can be maintained. And the circles and squares that come in the middle of their deepest parts have to diminish and increase in so many directions, and to go to so many points, that it is a difficult thing to find the true method. Nevertheless, having the model, such as I make for everything, they should never have

The modern spelling is capomastro: *a master builder or master mason.*

committed so great an error as to seek to regulate with one single centre all those three shells; whence it has come about that we have been obliged with shame and loss to pull down, as we are still doing, a great number of stones. The vault, with its sections and hewn stone-work, is all of travertine, like all the rest below; a thing not customary in Rome."

Michelagnolo was excused by Duke Cosimo, hearing of these misfortunes, from coming to Florence; the Duke saying to him that his contentment and the continuation of S. Pietro were more dear to him than anything in the world, and that he should rest in peace. Whereupon Michelagnolo wrote to Vasari, on the same sheet in which he thanked the Duke to the best of his power and knowledge for such kindness, saying, "God give me grace that I may be able to serve him with this my poor person, for my memory and my brain are gone to await him elsewhere." The date of this letter was August in the year 1557. Thus, then, Michelagnolo learned that the Duke esteemed his life and his honour more than he did himself, who so revered him. All these things, and many more that it is not necessary to mention, we have in our possession, written in his hand.

Michelagnolo by this time was reduced to a feeble condition, and it was evident that little was being done in S. Pietro, now that he had carried on a great part of the frieze of the windows within, and of the double columns without, which curve above the great round cornice [or drum] where the cupola is to be placed, as will be related; and he was exhorted and urged by his greatest friends, such as the Cardinal of Carpi, Messer Donato Gianotti, Francesco Bandini, Tommaso de' Cavalieri, and Lottino that, since he saw the delay in the raising of the cupola, he should at least make a model of it. He stayed many months without making up his mind to this, but in the end he made a beginning, and then little by little constructed a small model in clay, from which, as an exemplar, and from the plans and profiles that he had drawn, it might be possible afterwards to make a larger one of wood. This, having made a beginning with it, he caused to be constructed in little more than a year by Maestro Giovanni Franzese, with much study and pains; and he made it on such a scale that the smaller proportions of the model, measured by the old Roman palm, corresponded with complete exactness to those of the large work, he having fashioned with diligence in that model all the members of columns, bases, capitals, doors, windows, cornices, projections, and likewise every least thing, knowing that in such a work no less should be done, for in all Christendom, nay, in all the world, there is not to be found or seen any fabric more ornate or more grand. And I cannot but think that, if we have given up time to noting smaller things, it is even more useful, and also our duty, to describe this manner of design for building the structure of this tribune with the form, order, and method that Michelagnolo thought to give it; wherefore with such brevity as we may we will give a simple description of it, to the end that, if it should ever be the fate of this work, which God forbid, to be disturbed by the envy and malice of presumptuous persons after the death of Michelagnolo, even as we have seen it disturbed up to the present during his lifetime, these my writings, such as they may be, may be able to assist the faithful who are to be the executors of the mind of that rare man, and also to restrain the malignant desires of those who may seek to alter it, and so at one and the same time assist, delight, and open the minds of those beautiful intellects that are the friends of this profession and regard it as their joy.

I must begin by saying that according to this model, made under the direction of Michelagnolo, I find that in the great work the whole space within the tribune will be one hundred and eighty-six palms, speaking of its width from wall to wall above the great cornice of travertine that curves in a round in the interior, resting on the four great double piers that rise from the ground with

An approximate equivalent would be 125 feet.

303

their capitals carved in the Corinthian Order, accompanied by their architrave, frieze, and cornice, likewise of travertine; which great cornice, curving right round over the great niches, rests supported upon the four great arches of the three niches and of the entrance, which form the cross of the building. Then there begins to spring the first part of the tribune, the rise of which commences in a basement of travertine with a platform six palms broad, where one can walk; and this basement curves in a round in the manner of a well, and its thickness is thirty-three palms and eleven inches, the height to the cornice eleven palms and ten inches, the cornice over it about eight palms, and its projection six and a half palms. Into this basement you enter, in order to ascend the tribune, by four entrances that are over the arches of the niches, and the thickness of the basement is divided into three parts; that on the inner side is fifteen palms, that on the outer side is eleven palms, and that in the centre is seven palms and eleven inches, which make up the thickness of thirty-three palms and eleven inches. The space in the centre is hollow and serves as a passage, which is two squares in height and curves in a continuous round, with a barrel-shaped vault; and in line with the four entrances are eight doors, each of which rises in four steps, one of them leading to the level platform of the cornice of the first basement, six palms and a half in breadth, and another leading to the inner cornice that curves round the tribune, eight palms and three-quarters broad, on which platforms, by each door, you can walk conveniently both within and without the edifice, and from one entrance to another in a curve of two hundred and one palms, so that, the sections being four, the whole circuit comes to be eight hundred and four palms. We now have to ascend from the level of this basement, upon which rest the columns and pilasters, and which forms the frieze of the windows within all the way round, being fourteen palms and one inch in height, and around it, on the outer side, there is at the foot a short order of cornice-work, and so also at the top, which does not project more than ten inches, and all of travertine; and so in the thickness of the third part, above that on the inner side, which we have described as fifteen palms thick, there is made in every quarter-section a staircase, one half of which ascends in one direction and the second half in another, the width being four palms and a quarter; and this staircase leads to the level of the columns. Above this level there begin to rise, in line with the solid parts of the basement, eighteen large piers all of travertine, each adorned with two columns on the outer side and pilasters on the inner, as will be described below, and between the piers are left the spaces where there are to be all the windows that are to give light to the tribune. These piers, on the sides pointing towards the central point of the tribune, are thirty-six palms in extent, and on the front sides nineteen and a half. Each of them, on the outer side, has two columns, the lowest dado of which is eight palms and three-quarters broad and one palm and a half high, the base five palms and eight inches broad and palms and eleven inches high, the shaft of the column forty-three and a half palms high, five palms and six inches thick at the foot and four palms and nine inches at the top, the Corinthian capital six palms and a half high, with the crown of mouldings nine palms. Of these columns three quarters are to be seen, and the other quarter is merged into the corner, with the accompaniment of the half of a pilaster that makes a salient angle on the inner side, and this is accompanied in the central inner space by the opening of an arched door, five palms wide and thirteen palms and five inches high, from the summit of which to the capitals of the pilasters and columns there is a filling of solid masonry, serving as a connection with two other pilasters that are similar to those that form a salient angle beside the columns. These two pilasters correspond to the others, and adorn the sides of sixteen windows that go right round the tribune, each with a light twelve palms and a half wide and about twenty-two palms high. These windows are to be adorned on the outer side with varied architraves two palms and three-quarters high,

The equivalents are again approximate: 6 palms = 4 feet; 33 palms, etc. = 23 feet; 11 palms, etc. = slightly over 8 feet; 8 palms = 5 ½-feet; 6 ½-palms = under 4 ½-feet; 15 palms = 10 feet; 7 palms = more than 4 ½-feet; and so forth.

Michelangelo. *Model for Dome of St. Peter's.*
1558–61. Wood. Museo Petriano, Vatican,
Rome.

and on the inner side they are to be adorned with orders likewise varied, with
pediments and quarter-rounds; and they are wide without and more narrow
within, and so, also, they are sloped away at the foot of the inner side, so that
they may give light over the frieze and cornice. Each of them is bordered by
two flat pilasters that correspond in height to the columns without, so that there
come to be thirty-six columns without and thirty-six pilasters within; over
which pilasters is the architrave, which is four palms and three-quarters in
height, the frieze four and a half, and the cornice four and two-thirds, with a
projection of five palms; and above this is to go a range of balusters, so that one
may be able to walk all the way round there with safety. And in order that it
may be possible to climb conveniently from the level where the columns be-
gin, another staircase ascends in the same line within the thickness of the part
that is fifteen palms wide, in the same manner and of the same width, with two
branches or ascents, all the way up to the summit of the columns, with their
capitals, architraves, friezes, and cornices; insomuch that, without obstructing
the light of the windows, these stairs pass at the top into a spiral staircase of the
same breadth, which finally reaches the level where the turning of the tribune
is to begin.

*These measurements relate only to the dome
as planned; by the time the dome was
completed in 1593, however, Michelangelo's
overall proportions had been changed. As it
stands, the dome is 138 feet in diameter,
390 feet high on the interior, and 435 feet
on the exterior.*

All this order, distribution, and ornamentation is so well varied, commodious, rich, durable, and strong, and serves so well to support the two vaults of the cupola that is to be turned upon it, that it is a very ingenious thing, and it is all so well considered and then executed in masonry, that there is nothing to be seen by the eyes of one who has knowledge and understanding that is more pleasing, more beautiful, or wrought with greater mastery, both on account of the binding together and mortising of the stones and because it has in it in every part strength and eternal life, and also because of the great judgment wherewith he contrived to carry away the rain-water by many hidden channels, and, finally, because he brought it to such perfection, that all other fabrics that have been built and seen up to the present day appear as nothing in comparison with the grandeur of this one. And it has been a very great loss that those whose duty it was did not put all their power into the undertaking, for the reason that, before death took away from us that rare man, we should have seen that beautiful and terrible structure already raised.

Up to this point has Michelagnolo carried the masonry of the work; and it only remains to make a beginning with the vaulting of the tribune, of which, since the model has come down to us, we shall proceed to describe the design that he has left to the end that it may be carried out. He turned the curve of this vault on three points that make a triangle, in this manner:

A B

C

The point C, which is the lowest, is the principal one, wherewith he turned the first half-circle of the tribune, with which he gave the form, height and breadth of this vault, which he ordered to be built entirely of bricks well baked and fired, laid herring-bone fashion. This shell he makes four palms and a half thick, and as thick at the top as at the foot, and leaving beside it, in the centre, a space four palms and a half wide at the foot, which is to serve for the ascent of the stairs that are to lead to the lantern, rising from the platform of the cornice where there are balusters. The arch of the interior of the other shell, which is to be wider at the foot and narrower at the top, is turned on the point marked B, and the thickness of the shell at the foot is four palms and a half. And the last arch, which is to be turned in order to make the exterior of the cupola, wider at the foot and narrowing towards the top, is to be raised on the point marked A, which arch turned, there remains at the top all the hollow space of the interior for the ascent of the stairs, which are eight palms high, so that one may climb them upright; and the thickness of that shell comes to diminish little by little, insomuch that, being as before four palms and a half at the foot, it decreases at the top to three palms and a half. And the outer shell comes to be so well bound to the inner shell with bonds and with the stairs, that the one supports the other; while of the eight parts into which the fabric is divided at the base, the four over the arches are left hollow, in order to put less weight upon the arches, and the other four are bound and chained together with bonds upon the piers, so that the structure may have everlasting life.

The stairs in the centre between one shell and the other are constructed in this form; from the level where the springing of the vault begins they rise in each of the four sections, and each ascends from two entrances, the stairs intersecting one another in the form of an X, until they have covered the half of the arch marked C, on the upper side of the shell, when, having ascended straight up the half of that arch, the remaining space is then easily climbed circle after circle and step after step in a direct line, until finally one arrives at the eye of the cupola, where the rise of the lantern begins, around which, in accord with the diminution of the compartments that spring above the piers, there is a smaller

range of double pilasters and windows similar to those that are constructed in the interior, as will be described below.

Over the first great cornice within the tribune there begin at the foot the compartments for the recesses that are in the vault of the tribune, which are formed by sixteen projecting ribs. These at the foot are as broad as the breadth of the two pilasters which at the lower end border each window below the vault of the tribune, and they rise, diminishing pyramidally, as far as the eye of the lantern; at the foot they rest on pedestals of the same breadth and twelve palms high, and these pedestals rest on the level platform of the cornice which goes in a circle right round the tribune. Above this, in the recessed spaces between the ribs, there are eight large ovals, each twenty-nine palms high, and over them a number of straight-sided compartments that are wider at the foot and narrower at the top, and twenty-four palms high, and then, the ribs drawing together, there comes above each straight-sided compartment a round four- teen palms high; so that there come to be eight ovals, eight straight-sided compartments, and eight rounds, each range forming recesses that grow more shallow in succession. The ground of all these displays extraordinary richness, for Michelagnolo intended to make the ribs and the ornaments of the said ovals, straight-sided compartments, and rounds, all corniced in travertine.

It remains for us to make mention of the surface and adornment of the arch on that side of the vault where the roofing is to go, which begins to rise from a base twenty-five palms and a half high, which has at the foot a basement that has a projection of two palms, as have the crowning mouldings at the top. The covering or roofing with which he proposed to cover it is of lead, such as cov- ers the roof of the old S. Pietro at the present day, and is divided into sixteen sections from one solid base to another, each base beginning where the two columns end, which are one on either side of it. In each of these sections, in the centre, he made two windows to give light to the inner space where the ascent of the stairs is, between the two shells, so that in all they are thirty-two. These, by means of brackets that support a quarter-round, he made projecting from the roof in such a manner as to protect the lofty and novel view-point from the rain. In a line with the centre of the solid base between each two columns, above which was the crowning cornice, sprang a rib, one to each, wider at the foot and narrowing at the top; in all sixteen ribs, five palms broad, in the centre of each of which was a quadrangular channel one palm and a half wide, within which is formed an ascent of steps about one palm high, by which to ascend or descend between the platform at the foot and the summit where the lantern begins. These are to be built of travertine and constructed with mortisings, to the end that the joins may be protected against water and ice during times of rain.

The design for the lantern is reduced in the same proportion as all the rest of the work, so that, taking lines round the circumference, everything comes to diminish in exact accord, and with proportionate measurements it rises as a simple temple with round columns two by two, like those on solid bases be- low. These have pilasters to correspond to them, and one can walk all the way round and see from the central spaces between the pilasters, where the win- dows are, the interior of the tribune and the church. Above this, architrave, frieze, and cornice curve in a round, projecting over each pair of columns; and over these columns, in a line with them, spring some caulicoles, which, to- gether with some niches that divide them, rise to find the end of the lantern, which, beginning to draw together, grows gradually narrower for a third of its height, in the manner of a round pyramid, until it reaches the ball, upon which, as the final crown of the structure, goes the cross. Many particulars and mi- nute details I might have mentioned, such as air-holes for protection against earthquakes, water-conduits, the various lights, and other conveniences, but I omit them because the work is not yet come to completion, being content to

Caulicoles are shafts or ribs. A "round pyramid" probably means cone-shaped.

have touched on the principal parts as well as I have been able. For, since every part is in existence and can be seen, it is enough to have made this brief sketch, which is a great light to him who has no knowledge of the structure.

The completion of this model caused the greatest satisfaction not only to all his friends, but to all Rome, the form of the fabric having been thus settled and established. It then came to pass that Paul IV died, and after him was elected Pius IV, who, while causing the building of the little palace in the wood of the Belvedere to be continued by Pirro Ligorio, who remained architect to the Palace, made many gracious offers and advances to Michelagnolo. The Motu-proprio originally received by Michelagnolo from Paul III, and then from Julius III and Paul IV, in respect of the fabric of S. Pietro, he confirmed in his favour, and he restored to him a part of the revenues and allowances taken away by Paul IV, employing him in many of his works of building; and in his time he caused the fabric of S. Pietro to be carried on vigorously. He made use of Michelagnolo, in particular, in preparing a design for the tomb of the Marchese Marignano, his brother, which, destined to be erected in the Duomo of Milan, was allotted by his Holiness to the Chevalier Leone Lioni of Arezzo, a most excellent sculptor and much the friend of Michelagnolo; the form of which tomb will be described in the proper place.

Leone Lioni (1509–1590), Tuscan sculptor, goldsmith, and medalist who worked chiefly in Lombardy.

At this time the Chevalier Leone made a very lively portrait of Michelagnolo in a medal, and to please him he fashioned on the reverse a blind man led by a dog, with these letters around:

> I SHALL TEACH THE WICKED THY WAYS, AND THE IMPIOUS
> SHALL BE THUS CONVERTED TO THEE

And Michelagnolo, since it pleased him much, presented him a model in wax of Hercules crushing Antæus, by his own hand, with certain of his designs. Of Michelagnolo we have no other portraits but two in painting, one by the hand of Bugiardini and the other by Jacopo del Conte, one in bronze executed in full-relief by Daniello [da Volterra], and this one by the Chevalier Leone; from which portraits so many copies have been made, that I have seen a good number in many places in Italy and in foreign parts.

The portraits mentioned have survived. Giuliano Bugiardini's and Jacopino del Conte's (1510–1598) are in the Casa Buonarroti (Jacopino's is attributed, however). The bronze head by Daniele da Volterra is reproduced.

The same year Cardinal Giovanni de' Medici, the son of Duke Cosimo, went to Rome to receive the hat from Pius IV, and it fell to Vasari, as his servant and familiar friend, to go with him; which Vasari went there willingly and stayed about a month, in order to enjoy Michelagnolo, who received him with great affection and was always with him. Vasari had taken with him, by order of his Excellency, a model in wood of the whole Ducal Palace of Florence, together with designs of the new apartments that had been built and painted by him; which Michelagnolo desired to see both in the model and in the designs, since, being old, he was not able to see the works themselves. These works, which were abundant and well varied, with different inventions and fancies, began with the Castration of Uranus and continued in stories of Saturn, Ops, Ceres, Jove, Juno, and Hercules, each room having one of these names, with the stories in various compartments; even as the other chambers and halls, which were beneath these, had the names of the heroes of the House of Medici, beginning with the elder Cosimo, and continuing with Lorenzo, Leo X, Clement VII, Signor Giovanni [delle Bande Nere], Duke Alessandro, and Duke Cosimo, in each of which were not only the stories of their actions, but also portraits of them, of their children, and of all the ancients renowned in statesmanship, in arms, and in letters, taken from the life. Of these Vasari had written a Dialogue in which he explained all the stories, the end of the whole invention, and how the fables above harmonized with the stories below; which was read to Michelagnolo by Annibale Caro, and he took the greatest pleasure in it. This Dialogue, when Vasari shall have more time, will be published.

That is, the Uffizi, of which Vasari was architect; he also painted extensive frescoes in the adjacent Palazzo della Signoria (which came to be called the Palazzo Vecchio, or "Old Palace").

This "Dialogue" is the so-called Raggionamenti, a sort of guided tour of the works, cast in the form of dialogues between the artist and Cosimo I de' Medici.

Annibale Caro (1507–1566), noted Humanist diplomat, poet, and playwright.

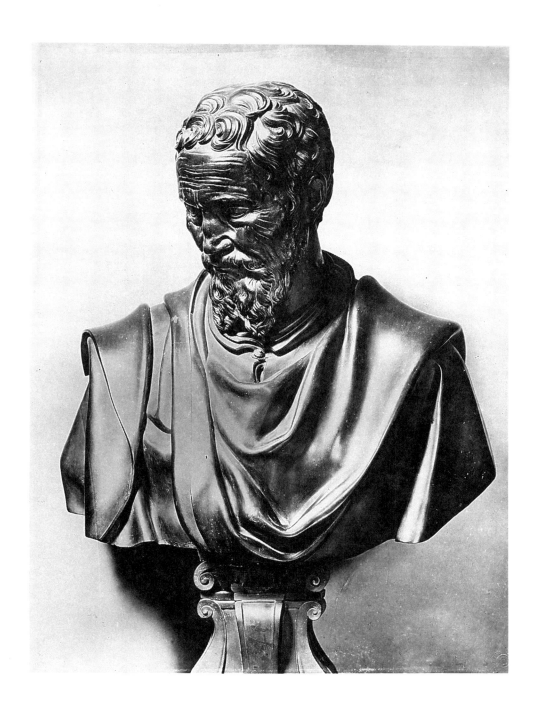

Daniele da Volterra. *Portrait Bust of Michelangelo*. c. 1564–65. Bronze. Height: 23¾″ (60 cm). Casa Buonarroti, Florence.

The result of all this was as follows. Vasari was desirous of setting his hand to the Great Hall, and since, as has been said elsewhere, the ceiling was low, making it stunted and wanting in lights, he had a desire to raise that ceiling. Now the Duke would not make up his mind to give him leave that it should be raised; not that the Duke feared the cost, as was seen afterwards, but rather the danger of raising the beams of the roof thirteen braccia. However, like a man of judgment, his Excellency consented that the advice of Michelagnolo should be taken, and Michelagnolo, having seen in that model the Hall as it then was, and afterwards, all the beams having been removed and replaced by other beams with a new invention in the ceiling and walls, the same Hall as it has since been made, with the invention of the stories likewise designed therein, liked it and straightway became not a judge but a supporter, and the rather as he saw the facile method of raising the beams and the roof, and the plan for executing the whole work in a short time. Wherefore, on Vasari's return, he wrote to the Duke that he should carry out that undertaking, since it was worthy of his greatness.

The same year Duke Cosimo went to Rome with the Lady Duchess Leonora, his consort, and Michelagnolo, after the Duke's arrival, went straightway

to see him. The Duke, after receiving him with many endearments, caused him, out of respect for his great genius, to sit by his side, and with much familiarity talked to him of all that he had caused to be done in painting and sculpture at Florence, and also of all that he was minded to have done, and in particular of the Hall; and Michelagnolo again encouraged and reassured him in that matter, lamenting, since he loved that Lord, that he was not young enough to be able to serve him. His Excellency said that he had discovered the way to work porphyry, a thing which Michelagnolo could not believe, and the Duke therefore sent him, as has been related in the first chapter of the Treatise on Theory, the head of Christ wrought by the sculptor Francesco del Tadda, at which he was astonished; and he visited the Duke several times the while that he stayed in Rome, to his vast satisfaction. He did the same a short time afterwards when the most Illustrious Don Francesco de' Medici, the Duke's son, went there, in whom Michelagnolo took much delight from the marks of regard and affection shown to him by his most Illustrious Excellency, who spoke with him always cap in hand, having infinite reverence for so rare a man; and Michelagnolo wrote to Vasari that it vexed him to be old and infirm, for he would have liked to do something for that Lord, but he was going about trying to buy some beautiful antique to send him in Florence.

Tadda is Francesco di Simone (1437–1493), considered one of the best Florentine sculptors of the sixteenth century.

Being requested at this time by the Pope for a design for the Porta Pia, Michelagnolo made three, all fantastic and most beautiful, of which the Pope chose the least costly for putting into execution; and it is now to be seen erected there, with much credit to him. Perceiving the inclinaton of the Pope, and hoping that he would restore the other gates of Rome, he made many other designs for him; and he did the like, at the request of the same Pontiff, in the matter of the new Church of S. Maria degli Angeli in the Baths of Diocletian, in order to convert them into a temple for the use of Christians. A design by his hand prevailed over many others made by excellent architects, being executed with such beautiful considerations for the convenience of the Carthusian Friars, who have now carried it almost to completion, that it caused his Holiness and all the prelates and lords of the Court to marvel at the judgment of the lovely conceptions that he had drawn, availing himself of all the skeleton of those baths, out of which was seen formed a most beautiful temple, with an entrance surpassing the expectations of all the architects; from which he acquired infinite praise and honour. For that place, also, he designed for his Holiness a Ciborium of the Sacrament in bronze, cast for the most part by Maestro Jacopo Ciciliano, an excellent bronze-caster, who makes his works come out very delicate and fine, without any roughness, so that they can be polished with very little labour; in which field he is a rare master, and gave much satisfaction to Michelagnolo.

The Florentine colony had often talked among themselves of giving a good beginning to the Church of S. Giovanni in the Strada Giulia. Finally, all the heads of the richest houses having assembled together, they each promised to contribute in due proportion according to their means towards that fabric, insomuch that they contrived to collect a good sum of money; and then it was discussed among them whether it were better to follow the old lines or to have something new and finer. It was determined that something new should be erected upon the old foundations, and finally they elected three men to have the charge of the fabric, who were Francesco Bandini, Uberto Ubaldini, and Tommaso de' Bardi; and these requested Michelagnolo for a design, recommending themselves to him on the ground that it was a disgrace to their colony to have thrown away so much money without any kind of profit, and that, if his genius did not avail to finish the work, they had no other resource. He promised them to do it, with as much lovingness as he had ever shown in any work in the past, because in his old age he readily gave his attention to sacred things, such as might redound to the honour of God, and also from affection

Bandini, Ubaldini, and Tommaso de' Bardi were minor architects of the time.

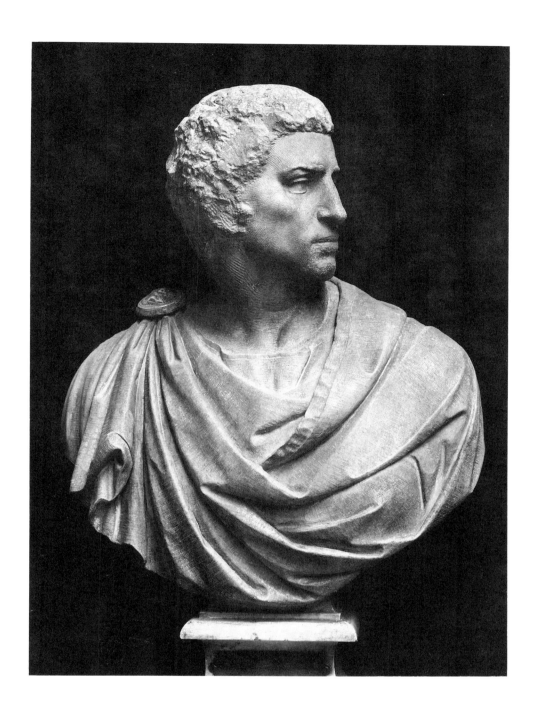

Michelangelo. *Brutus*. After 1537. Marble.
Height: 29″ (74 cm). Museo Nazionale
(Bargello), Florence.

for his fellow-Florentines, whom he loved always. Michelagnolo had with him
at this conference the Florentine sculptor Tiberio Calcagni, a young man very
ardent to learn art, who, after going to Rome, had turned his mind to the study
of architecture. Loving him, Michelagnolo had given him to finish, as has been
related, the Pietà in marble that he had broken, and, in addition, a head of
Brutus in marble with the breast, considerably larger than life, to the end that
he might finish it. Of this the head alone was carved, with certain most mi-
nute gradines, and he had taken it from a portrait of Brutus cut in a very ancient
cornelian that was in the possession of Signor Giuliano Cesarino; which Mi-
chelagnolo was doing for Cardinal Ridolfi at the entreaty of Messer Donato
Giannotti, his very dear friend, and it is a rare work. Michelagnolo, then, in
matters of architecture, not being able by reason of old age to draw any more
or to make accurate lines, was making use of Tiberio, because he was very
gentle and discreet; and thus, desiring to avail himself of him in such an under-
taking, he laid on him the charge of tracing the plan of the site of the above-
named church. That plan having been traced and carried straightway to Mi-
chelagnolo, at a time when it was not thought that he was doing anything, he
gave them to understand through Tiberio that he had carried out their wishes,

and finally showed them five most beautiful ground-plans of temples; which having seen, they marvelled. He said to them that they should choose one that pleased them, and they, not wishing to do it, left the matter to his judgment, but he insisted that they should decide of their own free will; wherefore they all with one accord chose the richest. This having been adopted, Michelagnolo said to them that if they carried such a design to completion, neither the Greeks nor the Romans ever in their times executed such a work; words that neither before nor afterwards ever issued from the mouth of Michelagnolo, for he was very modest. Finally it was agreed that the direction should be left entirely to Michelagnolo, and that the labour of executing that work should fall to Tiberio; with all which they were content, Buonarroti promising them that Tiberio would serve them excellently well. And so, having given the ground-plan to Tiberio to be drawn accurately and with correct measurements, he drew for him the profiles both within and without, and bade him make a model of clay, teaching him the way to execute it so that it might stand firm. In ten days Tiberio executed a model of eight palms, which much pleased the whole Florentine colony, so that afterwards they caused to be made from it a model of wood, which is now in the residence of the Consuls of that colony; a thing as rare in its beauty, richness, and great variety, as any temple that has ever been seen. A beginning was made with the building, and five thousand crowns were spent; but the funds for the fabric failed, and so it was abandoned, at which Michelagnolo felt very great displeasure. He obtained for Tiberio the commission to finish under his direction, at S. Maria Maggiore, a chapel begun for Cardinal Santa Fiore; but it was left unfinished, on account of the death of the Cardinal, of Michelagnolo, and of Tiberio himself, the death of which young man was a very great loss.

Michelagnolo had been seventeen years in the fabric of S. Pietro, and several times the deputies had tried to remove him from that position, but they had not succeeded, and they were seeking to oppose him in every matter now with one vexatious pretext and now with another, hoping that out of weariness, being now so old that he could do no more, he would retire before them. It happened in those days that Cesare da Castel Durante, who had been the overseer, died, and Michelagnolo, to the end that the fabric might not suffer, sent there Luigi Gaeta, who was too young but very competent, until he should find a man after his desire. The deputies (some of whom had many times made efforts to place there Nanni di Baccio Bigio, who was always urging them and promising great things), in order to be able to disturb the affairs of the fabric at their pleasure, sent Luigi Gaeta away, which having heard, Michelagnolo, as in anger, would no longer show himself at the fabric; whereupon they began to give out that he could do no more, that it was necessary to give him a substitute, and that he himself had said that he did not wish to be embroiled any longer with S. Pietro. All this came to the ears of Michelagnolo, who sent Daniello Ricciarelli of Volterra to Bishop Ferratino, one of the superintendents, who had said to the Cardinal of Carpi that Michelagnolo had told one of his servants that he did not wish to be mixed up with the fabric any longer; and Daniello said that this was by no means Michelagnolo's desire. Ferratino complained that Michelagnolo would not make his conception known, adding that it would be well for him to provide a substitute, and that he would have gladly accepted Daniello; and with this Michelagnolo appeared to be content. Thereupon Ferratino, having had the deputies informed in the name of Michelagnolo that they now had a substitute, presented not Daniello, but in his place Nanni di Baccio Bigio, who came in and was accepted by the superintendents. Before very long he gave orders to make a scaffolding of wood from the side of the Pope's stables, where the hill is, to rise above the great recess that is turned towards that side, and caused some stout beams of fir to be cut, saying that too many ropes were consumed in drawing up the materials, and that it

That is, Daniele da Volterra.

was better to raise them by his method. Which having heard, Michelagnolo went straight to the Pope, who was on the Piazza di Campidoglio, and made so much noise that his Holiness made him go at once into a room, where he said: "Holy Father, there has been appointed as my substitute by the deputies a man of whom I know nothing; but if they are convinced, and also your Holiness, that I am no longer the proper man, I will return to rest in Florence, where I will enjoy the favours of that great Duke who has so long desired me, and will finish my life in my own house; I therefore beg your gracious leave." The Pope was vexed at this, and, consoling him with kind words, ordained that he should come to speak with him on the following day at the Araceli. There, having caused the deputies of the fabric to be assembled together, he desired to be informed of the reasons of what had happened: whereupon their answer was that the fabric was going to ruin, and that errors were being made in it. Which having heard not to be the truth, the Pope commanded Signor Gabrio Scerbellone that he should go to see the fabric for himself, and that Nanni, who was making these assertions, should show it to him. This was carried out, and Signor Gabrio found that the whole story was a malicious slander, and not the truth; wherefore Nanni was dismissed from that fabric with no very flattering words in the presence of many lords, being also reproached that by his fault the bridge of Santa Maria fell into ruin, and that at Ancona, seeking to do great things at little cost in the matter of cleaning out the harbour, he filled it up more in one day than the sea had done in ten years. Such was the end of Nanni in the fabric of S. Pietro. For that work Michelagnolo for seventeen years attended constantly to nothing but to establishing it securely with directions, doubting on account of those envious persecutions lest it might come to be changed after his death; so that at the present day it is strong enough to allow the vaulting to be raised with perfect security. Thus it has been seen that God, who is the protector of the good, defended him as long as he lived, and worked for the benefit of the fabric and for the defence of the master until his death. Moreover, Pius IV, living after him, commanded the superintendents of the fabric that nothing of what Michelagnolo had directed should be changed; and with even greater authority his successor, Pius V, caused it to be carried out, who, lest disorder should arise, insisted that the designs made by Michelagnolo should be carried into execution with the utmost fidelity, so that, when the architects Pirro Ligorio and Jacopo Vignuola were in charge of it, and Pirro wished presumptuously to disturb and alter those directions, he was removed with little honour from that fabric, and only Vignuola remained. Finally, that Pontiff being full of zeal no less for the honour of the fabric of S. Pietro than for the Christian religion, in the year 1565, when Vasari went to kiss the feet of his Holiness, and in the year 1566, when he was again summoned, nothing was discussed save the means to ensure the observing of the designs left by Michelagnolo; and his Holiness, in order to obviate all chance of disorder, commanded Vasari that he should go with Messer Guglielmo Sangalletti, the private treasurer of his Holiness, to seek out Bishop Ferratino, the head of the superintendents of S. Pietro, with orders from the Pontiff that he should listen to all the suggestions and records of importance that Vasari might impart to him, to the end that no words of any malignant and presumptuous person might ever cause to be disturbed any line or order left by the excellent genius of Michelagnolo of happy memory; and at that interview was present Messer Giovan Battista Altoviti, who was much the friend of Vasari and these arts. And Ferratino, having heard a discourse that Vasari made to him, readily accepted every record, and promised to observe and to cause to be observed with the utmost fidelity in that fabric every order and design that Michelagnolo had left for that purpose, and, in addition, to be the protector, defender, and preserver of the labours of that great man.

But to return to Michelagnolo: I must relate that about a year before his

Jacopo (Barozzi) Vignola (1507–1573), Roman architect. In 1564 he was appointed Michelangelo's successor at St. Peter's. His most famous work is probably the Palazzo Farnese at Caprarola.

death, Vasari secretly prevailed upon Duke Cosimo de' Medici to persuade the Pope by means of Messer Averardo Serristori, his Ambassador, that, since Michelagnolo was much reduced, a diligent watch should be kept on those who were about him to take care of him, or who visited him at his house, and that, in the event of some sudden accident happening to him, such as might well happen to an old man, he should make arrangements for his property, designs, cartoons, models, money, and all his other possessions at the time of his death, to be set down in an inventory and placed in security, for the sake of the fabric of S. Pietro, so that, if there were things pertaining to that fabric, and also to the sacristy, library, and façade of S. Lorenzo, they might not be taken away, as is often wont to happen; and in the end, all this being duly carried out, such diligence had its reward. Leonardo, the nephew of Michelagnolo, was desirous to go during the coming Lent to Rome, as one who guessed that he was now come to the end of his life; and at this Michelagnolo was content. When, therefore, he fell sick of a slow fever, he straightway caused Daniello to write to Leonardo that he should come; but the illness grew worse, although Messer Federigo Donati, his physician, and his other attendants were about him, and with perfect consciousness he made his will in three sentences, leaving his soul in the hands of God, his body to the earth, and his substance to his nearest relatives, and enjoining on his friends that, at his passing from this life, they should recall to him the agony of Jesus Christ. And so at the twenty-third hour of the seventeenth day of February, in the year 1563 (after the Florentine reckoning, which according to the Roman would be 1564), he breathed his last, to go to a better life.

Michelagnolo was much inclined to the labours of art, seeing that everything, however difficult, succeeded with him, he having had from nature a genius very apt and ardent in these most noble arts of design. Moreover, in order to be entirely perfect, innumerable times he made anatomical studies, dissecting men's bodies in order to see the principles of their construction and the concatenation of the bones, muscles, veins, and nerves, the various movements and all the postures of the human body; and not of men only, but also of animals, and particularly of horses, which last he much delighted to keep. Of all these he desired to learn the principles and laws in so far as touched his art, and this knowledge he so demonstrated in the works that fell to him to handle, that those who attend to no other study than this do not know more. He so executed his works, whether with the brush or with the chisel, that they are almost inimitable, and he gave to his labours, as has been said, such art and grace, a loveliness of such a kind, that (be it said without offence to any) he surpassed and vanquished the ancients; having been able to wrest things out of the greatest difficulties with such facility, that they do not appear wrought with effort, although whoever draws his works after him finds enough in imitating them.

The genius of Michelagnolo was recognized in his lifetime, and not, as happens to many, after death, for it has been seen that Julius II, Leo X, Clement VIII, Paul III, Julius III, Paul IV, and Pius IV, all supreme Pontiffs, always wished to have him near them, and also, as is known, Suleiman, Emperor of the Turks, Francis of Valois, King of France, the Emperor Charles V, the Signoria of Venice, and finally, as has been related, Duke Cosimo de' Medici; all offering him honourable salaries, for no other reason but to avail themselves of his great genius. This does not happen save to men of great worth, such as he was; and it is evident and well known that all these three arts were so perfected in him, that it is not found that among persons ancient or modern, in all the many years that the sun has been whirling round, God has granted this to any other but Michelagnolo. He had imagination of such a kind, and so perfect, and the things conceived by him in idea were such, that often, through not being able to express with the hands conceptions so terrible and grand, he aban-

This could explain why Vasari misdated Michelangelo's birthdate (which would have been one of the few dates he might have known rather well).

doned his works—nay, destroyed many of them; and I know that a little before he died he burned a great number of designs, sketches, and cartoons made with his own hand, to the end that no one might see the labours endured by him and his methods of trying his genius, and that he might not appear less than perfect. Of such I have some by his hand, found in Florence, and placed in my book of drawings; from which, although the greatness of that brain is seen in them, it is evident that when he wished to bring forth Minerva from the head of Jove, he had to use Vulcan's hammer. Thus he used to make his figures in the proportion of nine, ten, and even twelve heads, seeking nought else but that in putting them all together there should be a certain harmony of grace in the whole, which nature does not present; saying that it was necessary to have the compasses in the eyes and not in the hand, because the hands work and the eye judges; which method he also used in architecture.

No one should think it strange that Michelagnolo delighted in solitude, he having been one who was enamoured of his art, which claims a man, with all his thoughts, for herself alone; moreover, it is necessary that he who wishes to attend to her studies should shun society, and, while attending to the considerations of art, he is never alone or without thoughts. And those who attributed it to caprice and eccentricity are wrong, because he who wishes to work well must withdraw himself from all cares and vexations, since art demands contemplation, solitude, and ease of life, and will not suffer the mind to wander. For all this, he prized the friendship of many great persons and of learned and ingenious men, at convenient times; and these he maintained. Thus the great Cardinal Ippolito de' Medici loved him greatly, and, having heard that a Turkish horse that he possessed pleased Michelagnolo because of its beauty, it was sent as a present to him by the liberality of that lord, with ten mules laden with fodder, and a serving-man to attend to it; and Michelagnolo accepted it willingly. The illustrious Cardinal Pole was much his friend, Michelagnolo being enamoured of his goodness and his talents; also Cardinal Farnese, and Santa Croce, which latter afterwards became Pope Marcellus, Cardinal Ridolfi, Cardinal Maffeo, Monsignor Bembo, Carpi, and many other Cardinals, Bishops, and Prelates, whom it is not necessary to name. Others were Monsignor Claudio Tolomei, the Magnificent Messer Ottaviano de' Medici, his gossip, whose son he held at baptism, and Messer Bindo Altoviti, to whom he presented that cartoon of the Chapel in which Noah, drunk with wine, is derided by one of his sons, and his nakedness is covered by the two others; M. Lorenzo Ridolfi, M. Annibale Caro, and M. Giovan Francesco Lottini of Volterra. But infinitely more than any of the others he loved M. Tommaso de' Cavalieri, a Roman gentleman, for whom, being a young man and much inclined to these arts, he made, to the end that he might learn to draw, many most superb drawings of divinely beautiful heads, designed in black and red chalk; and then he drew for him a Ganymede rapt to Heaven by Jove's Eagle, a Tityus with the Vulture devouring his heart, the Chariot of the Sun falling with Phaëthon into the Po, and a Bacchanal of children, which are all in themselves most rare things, and drawings the like of which have never been seen. Michelagnolo made a life-size portrait of Messer Tommaso in a cartoon, and neither before nor afterwards did he take the portrait of anyone, because he abhorred executing a resemblance to the living subject, unless it were of extraordinary beauty. These drawings, on account of the great delight that M. Tommaso took in them, were the reason that he afterwards obtained a good number, miraculous things, which Michelagnolo once drew for Fra Sebastiano Viniziano, who carried them into execution; and in truth he rightly treasures them as reliques, and he has courteously given craftsmen access to them. Of a truth Michelagnolo always placed his affections with persons noble, deserving, and worthy of them, for he had true judgment and taste in all things.

The "Bacchanal" and "Chariot of the Sun" reproduced on pages 316 and 317 are two of the presentation drawings for Tommaso de' Cavalieri. The portrait is lost.

Perhaps the best-known painting Sebastiano executed after a Michelangelo drawing is the Pietà *in Viterbo.*

315

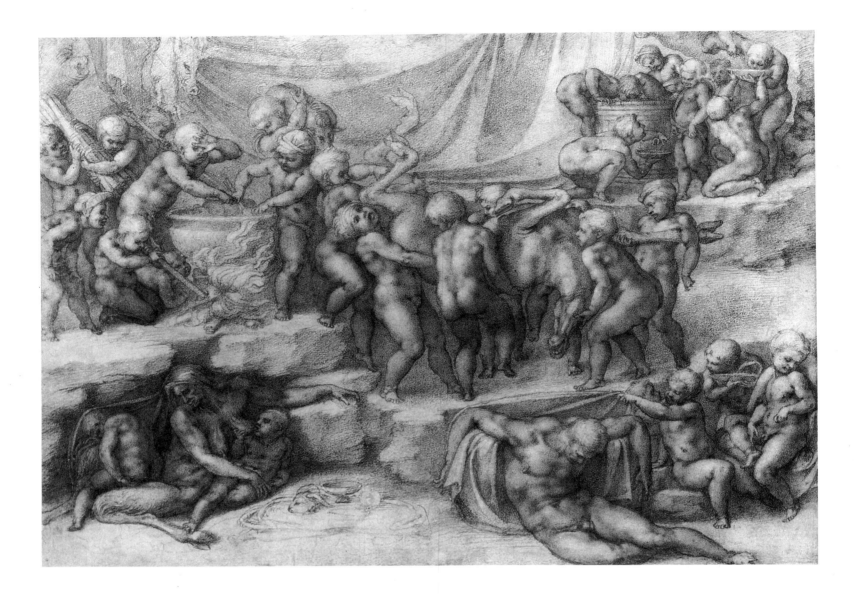

M. Tommaso afterwards caused Michelagnolo to make many designs for friends, such as that of the picture for Cardinal di Cesis, wherein is Our Lady receiving the Annunciation from the Angel, a novel thing, which was afterwards executed in colours by Marcello Mantovano and placed in the marble chapel which that Cardinal caused to be built in the Church of the Pace at Rome. So, also, with another Annunciation coloured likewise by the hand of Marcello in a picture in the Church of S. Giovanni Laterano, the design of which belongs to Duke Cosimo de' Medici, having been presented after Michelagnolo's death by his nephew Leonardo Buonarroti to his Excellency, who cherishes it as a jewel, together with a Christ praying in the Garden and many other designs, sketches, and cartoons by the hand of Michelagnolo, and likewise the statue of Victory with a captive beneath, five braccia in height, and four captives in the rough which serve to teach us how to carve figures from the marble by a method secure from any chance of spoiling the stone; which method is as follows. You take a figure in wax or some other solid material, and lay it horizontally in a vessel of water, which water being by its nature flat and level at the surface, as you raise the said figure little by little from the level, so it comes about that the more salient parts are revealed, while the lower parts— those, namely, on the under side of the figure—remain hidden, until in the end it all comes into view. In the same manner must figures be carved out of marble with the chisel, first laying bare the more salient parts, and then little by little the lower parts; and this method may be seen to have been followed by Michelagnolo in the above-mentioned captives, which his Excellency wishes to be used as exemplars for his Academicians.

Michelangelo. *Children's Bacchanal.* 1553 (?). Red chalk. 10¾ × 15¼" (274 × 388 mm). Royal Library, Windsor Castle.

Marcello Mantovano is Marcello Venusti (1512/15–1579), who was closely associated with Michelangelo in Rome. His copy of the Last Judgment *is reproduced on page 271.*

Michelagnolo loved his fellow-craftsmen, and held intercourse with them, as with Jacopo Sansovino, Rosso, Pontormo, Daniello da Volterra, and Giorgio Vasari of Arezzo, to which last he showed innumerable kindnesses; and he was the reason that Giorgio gave his attention to architecture, intending to make use of him some day, and he readily conferred and discussed matters of art with him. Those who say that he was not willing to teach are wrong, because he was always willing with his intimates and with anyone who asked him for counsel; and I have been present on many such occasions, but of these, out of consideration, I say nothing, not wishing to reveal the deficiencies of oth-

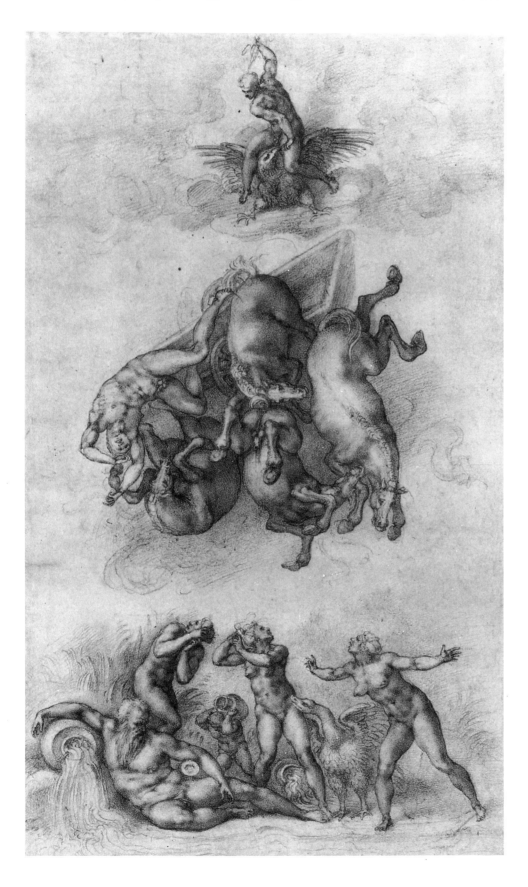

Michelangelo. *The Fall of Phaëthon*. 1533. Black chalk. 16¼ × 9¼″ (413 × 234 mm). Royal Library, Windsor.

ers. It may be urged that he had bad fortune with those who lived with him in his house, which was because he hit upon natures little able to imitate him. Thus, Pietro Urbano of Pistoia, his pupil, was a man of parts, but would never exert himself. Antonio Mini was willing, but had no aptitude of brain; and when the wax is hard it does not readily take an impression. Ascanio dalla Ripa Transone took great pains, but of this no fruits were ever seen either in designs or in finished works, and he toiled several years over a picture for which Michelagnolo had given him a cartoon. In the end, all the good expectation in which he was held vanished in smoke; and I remember that Michelagnolo would be seized with compassion for his toil, and would assist him with his own hand, but this profited him little. If he had found a nature after his heart, as he told me several times, in spite of his age he would often have made anatomical studies, and would have written upon them, for the benefit of his fellow-craftsmen; for he was disappointed by several. But he did not trust himself, through not being able to express himself in writing as he would have liked, because he was not practised in diction, although in the prose of his letters he explained his conceptions very well in a few words. He much delighted in readings of the poets in the vulgar tongue, and particularly of Dante, whom he much admired, imitating him in his conceptions and inventions; and so with Petrarca, having delighted to make madrigals and sonnets of great weight, upon which commentaries have been written. M. Benedetto Varchi gave a lecture in the Florentine Academy upon that sonnet which begins—

> The best of artists cannot strive to show
> What rough stone encases in its useless shell. . . .

Michelagnolo sent a vast number by his own hand—receiving answers in rhyme and in prose—to the most illustrious Marchioness of Pescara, of whose virtues he was enamoured, and she likewise of his; and she went many times to Rome from Viterbo to visit him, and Michelagnolo designed for her a Dead Christ in the lap of Our Lady, with two little Angels, all most admirable, and a Christ fixed on the Cross, who, with the head uplifted, is recommending His Spirit to the Father, a divine work; and also a Christ with the Woman of Samaria at the well. He much delighted in the sacred Scriptures, like the excellent Christian that he was; and he held in great veneration the works written by Fra Girolamo Savonarola, because he had heard the voice of that friar in the pulpit. He greatly loved human beauty for the sake of imitation in art, being able to select from the beautiful the most beautiful, for without this imitation no perfect work can be done; but not with lascivious and disgraceful thoughts, as he proved by his way of life, which was very frugal. Thus, when he was young, all intent on his work, he contented himself with a little bread and wine, and this he continued when old until the time when he was painting the Judgment in the Chapel, taking his refreshment in the evening when he had finished the day's work, but always very frugally. And, although he was rich, he lived like a poor man, nor did any friend ever eat at his table, or rarely; and he would not accept presents from anyone, because it appeared to him that if anyone gave him something, he would be bound to him for ever. This sober life kept him very active and in want of very little sleep, and often during the night, not being able to sleep, he would rise to labour with the chisel; having made a cap of thick paper, and over the centre of his head he kept a lighted candle, which in this way threw light over where he was working without encumbering his hands. Vasari, who had seen the cap several times, reflecting that he did not use wax, but candles of pure goat's tallow, which are excellent, sent him four bundles of these, which weighed forty libbre. And his servant with all courtesy carried them to him at the second hour of the evening, and presented them to him; but Michelagnolo refused them, declaring that he did

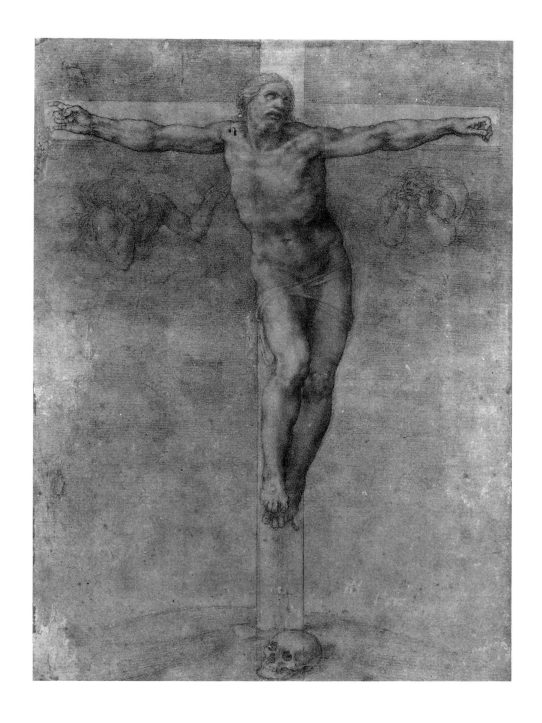

Michelangelo. *The Crucified Christ.*
c. 1538–40. Black chalk. 14½· × 10½"
(372 × 262 mm). The British Museum,
London.

not want them; and then the servant said: "They have broken my arms on the
way between the bridge and here, and I shall not carry them back to the house.
Now here in front of your door there is a solid heap of mud; they will stand in
it beautifully, and I will set them all alight." Michelagnolo said to him: "Put
them down here, for I will not have you playing pranks at my door."

He told me that often in his youth he slept in his clothes, being weary with
labour and not caring to take them off only to have to put them on again later.
There are some who have taxed him with being avaricious, but they are mis-
taken, for both with works of art and with his substance he proved the con-
trary. Of works of art, as has been seen and related, he presented to M.
Tommaso de' Cavalieri, to Messer Bindo, and to Fra Sebastiano, designs of
considerable value; and to Antonio Mini, his pupil, all his designs, all his car-
toons, and the picture of the Leda, and all the models in clay and wax that he
ever made, which, as has been related, were all left in France. To Gherardo
Perini, a Florentine gentleman who was very much his friend, he gave three
sheets with some divine heads in black chalk, which since Perini's death have
come into the hands of the most illustrious Don Francesco, Prince of Florence,
who treasures them as jewels, as indeed they are; for Bartolommeo Bettini he

made a cartoon, which he presented to him, of a Venus with a Cupid that is kissing her, a divine thing, which is now in the possession of Bettini's heirs in Florence, and for the Marchese del Vasto he made a cartoon of a "Noli me Tangere," a rare thing; and these two last were painted excellently well by Pontormo, as has been related. He presented the two Captives to Signor Ruberto Strozzi, and the Pietà in marble, which he broke, to Antonio, his servant, and to Francesco Bandini. I know not, therefore, how this man can be taxed with avarice, he having given away so many things for which he could have obtained thousands of crowns. What better proof can I give than this, that I know from personal experience that he made many designs and went to see many pictures and buildings, without demanding any payment? But let us come to the money earned by him by the sweat of his brow, not from revenues, not from traffickings, but from his own study and labour. Can he be called avaricious who succoured many poor persons, as he did, and secretly married off a good number of girls, and enriched those who served him and assisted him in his works, as with his servant Urbino, whom he made a very rich man? This Urbino was his man of all work, and had served him a long time; and Michelagnolo said to him: "If I die, what will you do?" And he answered: "I will serve another master." "You poor creature," said Michelagnolo, "I will save you from such misery"; and presented two thousand crowns to him in one sum, an act such as is generally left to Cæsars and Pontiffs. To his nephew, moreover, he gave three and four thousand crowns at a time, and at the end he left him with ten thousand crowns, besides the property in Rome.

Michelagnolo was a man of tenacious and profound memory, so that, on seeing the works of others only once, he remembered them perfectly, and could avail himself of them in such a manner, that scarcely anyone has ever noticed it; nor did he ever do anything that resembled another thing by his hand, because he remembered everything that he had done. In his youth, being once with his painter-friends, they played for a supper for him who should make a figure most completely wanting in design and clumsy, after the likeness of the puppet-figures which those make who know nothing, scrawling upon walls; and in this he availed himself of his memory, for he remembered having seen one of those absurdities on a wall, and drew it exactly as if he had had it before him, and thus surpassed all those painters—a thing difficult for a man so steeped in design, and accustomed to choice works, to come out of with credit. He was full of disdain, and rightly, against anyone who did him an injury, but he was never seen to run to take revenge; nay, rather, he was most patient, modest in all his ways, very prudent and wise in his speech, with answers full of weight, and at times sayings most ingenious, amusing, and acute. He said many things that have been written down by me, of which I shall include only a few, because it would take too long to give them all. A friend having spoken to him of death, saying that it must grieve him much, because he had lived in continual labour in matters of art, and had never had any repose, he answered that all that was nothing, because, if life is a pleasure to us, death, being likewise by the hand of one and the same master, should not displease us. To a citizen who found him by Orsanmichele in Florence, where he had stopped to gaze at Donato's statue of S. Mark, and who asked him what he thought of that figure, Michelagnolo answered that he had never seen a figure that had more of the air of a good man than that one, and that, if S. Mark was like that, one could give credence to what he had written. Being shown the drawing of a boy then beginning to learn to draw, who was recommended to him, some persons excusing him because it was not long since he had applied himself to art, he replied: "That is evident." He said a similar thing to a painter who had painted a Pietà, and had not acquitted himself well: "It is indeed a pitiful thing to see." Having heard that Sebastiano Viniziano had to paint a friar in the chapel of S. Pietro a Montorio, he said that this would spoil the work for him; and being

The extant cartoon is presumed to be a replica. The Noli Me Tangere (Christ's words to the Magdalen the morning of the Resurrection: "Touch me not") cartoon is lost. Pontormo's authorship of the Cupid and Venus painting has been questioned, but the Noli Me Tangere painting is generally accepted as his work. Del Vasto (Alfonso d'Avalos), incidentally, is portrayed in a painting by Titian, which is reproduced on page 364.

asked why he said that, he answered: "Since they have spoiled the world, which is so large, it would not be surprising if they were to spoil such a small thing as that chapel." A painter had executed a work with very great pains, toiling over it a long time; but when it was given to view he had made a considerable profit. Michelagnolo was asked what he thought of the craftsman, and he answered: "As long as this man strives to be rich, he will always remain a poor creature." One of his friends who was a churchman, and used formerly to say Mass, having arrived in Rome all covered with points and silk, saluted Michelagnolo; but he pretended not to see him, so that the friend was forced to declare his name to him. Michelagnolo expressed marvel that he should be in that habit, and then added, as it were to congratulate him: "Oh, but you are magnificent! If you were as fine within as I see you to be without, it would be well with your soul." The same man had recommended a friend to Michelagnolo (who had given him a statue to execute), praying him that he should have something more given to him, which Michelagnolo graciously did; but the envy of the friend, who had made the request to Michelagnolo only in the belief that he would not grant it, brought it about that, perceiving that the master had granted it after all, he complained of it. This matter was reported to Michelagnolo, and he answered that he did not like men made like sewers, using a metaphor from architecture, and meaning that it is difficult to have dealings with men who have two mouths. Being asked by a friend what he thought of one who had counterfeited in marble some of the most celebrated antique figures, and boasted that in his imitations he had surpassed the antiques by a great measure, Michelagnolo replied: "He who goes behind others can never go in front of them, and he who is not able to work well for himself cannot make good use of the works of others." A certain painter, I know not who, had executed a work wherein was an ox, which looked better than any other part; and Michelagnolo, being asked why the painter had made the ox more lifelike than the rest, said: "Any painter can make a good portrait of himself." Passing by S. Giovanni in Florence, he was asked his opinion of those doors, and he answered: "They are so beautiful that they would do well at the gates of Paradise." While serving a Prince who kept changing plans every day, and would never stand firm, Michelagnolo said to a friend: "This lord has a brain like a weather-cock, which turns round with every wind that blows on it." He went to see a work of sculpture which was about to be sent out because it was finished, and the sculptor was taking much trouble to arrange the lights from the windows, to the end that it might show up well; whereupon Michelagnolo said to him: "Do not trouble yourself; the important thing will be the light of the Piazza"; meaning to infer that when works are in public places, the people must judge whether they are good or bad. There was a great Prince in Rome who had a notion to play the architect, and he had caused certain niches to be built in which to place figures, each three squares high, with a ring at the top; and having tried to place various statues within these niches, which did not turn out well, he asked Michelagnolo what he should place in them, and he answered: "Hang bunches of eels from those rings." There was appointed to the government of the fabric of S. Pietro a gentleman who professed to understand Vitruvius, and to be a critic of the work done. Michelagnolo was told, "You have obtained for the fabric one who has a great intelligence"; and he answered, "That is true, but he has a bad judgment." A painter had executed a scene, and had copied many things from various other works, both drawings and pictures, nor was there anything in that work that was not copied. It was shown to Michelagnolo, who, having seen it, was asked by a very dear friend what he thought of it, and he replied: "He has done well, but I know not what this scene will do on the day of Judgment, when all bodies shall recover their members, for there will be nothing left of it"—a warning to those who practise art, that they should make a habit of working by themselves. Passing through Mo-

Points are cords or strings tipped with metal sheaths (aglets) that connected portions of clothing. They were often used lavishly for ornamental effect.

"S. Giovanni" is the Baptistry. The doors are Ghiberti's; the anecdote recounts the origin of their being known as the Gates of Paradise.

dena, he saw many beautiful figures by the hand of Maestro Antonio Begarelli, a sculptor of Modena, made of terracotta and coloured in imitation of marble, which appeared to him to be excellent works; and, since that sculptor did not know how to work marble, Michelagnolo said: "If this clay were to become marble, woe to the ancient statues." Michelagnolo was told that he should show resentment against Nanni di Baccio Bigio, who was seeking every day to compete with him; but he answered: "He who contends with men of no account never gains a victory." A priest, his friend, said to him: "It is a pity that you have not taken a wife, so that you might have had many children and left them all your honourable labours." And Michelagnolo replied: "I have only too much of a wife in this art of mine, who has always kept me in tribulation, and my children shall be the works that I may leave, which, even if they are naught, will live a while. Woe to Lorenzo di Bartoluccio Ghiberti, if he had not made the gates of S. Giovanni, for his children and grandchildren sold or squandered all that he left, but the gates are still standing." Vasari, sent by Julius III to Michelagnolo's house for a design at the first hour of the night, found him working at the Pietà in marble that he broke. Michelagnolo, recognizing him by the knock at the door, left his work and took a lamp with his hand by the handle; Vasari explained what he wanted, whereupon Michelagnolo sent Urbino upstairs for the design, and then they entered into another conversation. Meanwhile Vasari turned his eyes to examine a leg of the Christ at which he was working, seeking to change it; and, in order to prevent Vasari from seeing it, he let the lamp fall from his hand, and they were left in darkness. He called to Urbino to bring a light, and meanwhile came forth from the enclosure where the work was, and said: "I am so old that death often pulls me by the cloak, that I may go with him, and one day this body of mine will fall like the lamp, and the light of my life will be spent."

For all this, he took pleasure in certain kinds of men after his taste, such as Menighella, a commonplace and clownish painter of Valdarno, who was a most diverting person. He would come at times to Michelagnolo, that he might make for him a design of S. Rocco or S. Anthony, to be painted for peasants; and Michelagnolo, who was with difficulty persuaded to work for Kings, would deign to set aside all his other work and make him simple designs suited to his manner and his wishes, as Menighella himself used to say. Among other things, Menighella persuaded him to make a model of a Crucifix, which was very beautiful; of this he made a mould, from which he formed copies in pasteboard and other materials, and these he went about selling throughout the countryside. Michelagnolo would burst out laughing at him, particularly because he used to meet with fine adventures, as with a countryman who commissioned him to paint a S. Francis, and was displeased because Menighella had made the vestment grey, whereas he would have liked it of a finer colour; whereupon Menighella painted over the Saint's shoulders a pluvial of brocade, and so contented him.

He loved, likewise, the stonecutter Topolino, who had a notion of being an able sculptor, but was in truth very feeble. This man spent many years in the mountains of Carrara, sending marble to Michelagnolo; nor would he ever send a boatload without adding to it three or four little figures blocked out with his own hand, at which Michelagnolo would die of laughing. Finally Topolino returned, and, having blocked out a Mercury from a piece of marble, he set himself to finish it; and one day, when there was little left to do, he desired that Michelagnolo should see it, and straitly besought him that he should tell him his opinion. "You are a madman to try to make figures, Topolino," said Michelagnolo. "Do you not see that your Mercury is more than a third of a braccio too short between the knees and the feet, and that you have made him a dwarf and all misshapen?" "Oh, that is nothing! If there is nothing else wrong, I will put it right; leave it to me." Michelagnolo laughed once more at his sim-

Antonio Begarelli (1499–c. 1565), Lombard sculptor noted to this day for his works in terra-cotta.

Today, a simple artist like Menighella would probably be known as a folk artist or a primitive.

The name Topolino means "little mouse."

plicity; and when he was gone, Topolino took a piece of marble, and, having cut the Mercury a quarter of a braccio below the knees, he let it into the new piece of marble and joined it neatly together, making a pair of buskins for the Mercury, the tops of which were above the joins; and so he added the length required. Then he invited Michelagnolo to come, and showed him his work once again; and the master laughed, marvelling that such simpletons, when driven by necessity, form resolutions of which able men are not capable.

While Michelagnolo was having the tomb of Julius II finished, he caused a marble-hewer to execute a terminal figure for placing in the tomb in S. Pietro in Vincola, saying to him, "Cut away this to-day," "Level that," "Polish here"; insomuch that, without the other noticing it, he enabled him to make a figure. Wherefore, when it was finished, the man gazed at it marvelling; and Michelagnolo said: "What do you think of it?" "I think it fine," he answered, "and I am much obliged to you." "Why so?" asked Michelagnolo. "Because by your means I have discovered a talent that I did not know I possessed."

Now, to be brief, I must record that the master's constitution was very sound, for he was lean and well knit together with nerves, and although as a boy he was delicate, and as a man he had two serious illnesses, he could always endure any fatigue and had no infirmity, save that in his old age he suffered from dysuria and from gravel, which in the end developed into the stone; wherefore for many years he was syringed by the hand of Maestro Realdo Colombo, his very dear friend, who treated him with great diligence. He was of middle stature, broad in the shoulders, but well proportioned in all the rest of the body. In his latter years he wore buskins of dogskin on the legs, next to the skin, constantly for whole months together, so that afterwards, when he sought to take them off, on drawing them off the skin often came away with them. Over the stockings he wore boots of cordwain fastened on the inside, as a protection against damp. His face was round, the brow square and spacious, with seven straight lines, and the temples projected considerably beyond the ears; which ears were somewhat on the large side, and stood out from the cheeks. The body was in proportion to the face, or rather on the large side; the nose somewhat flattened, as was said of Torrigiano [elsewhere], who broke it for him with his fist; the eyes rather on the small side, of the colour of horn, spotted with blueish and yellowish gleams; the eyebrows with few hairs, the lips thin, with the lower lip rather thicker and projecting a little, the chin well shaped and in proportion with the rest, the hair black, but mingled with white hairs, like the beard, which was not very long, forked, and not very thick.

Truly his coming was to the world, as I said at the beginning, an exemplar sent by God to the men of our arts, to the end that they might learn from his life the nature of noble character, and from his works what true and excellent craftsmen ought to be. And I, who have to praise God for infinite blessings, as is seldom wont to happen with men of our profession, count it among the greatest blessings that I was born at the time when Michelagnolo was alive, that I was thought worthy to have him as my master, and that he was so much my friend and intimate, as everyone knows, and as the letters written by him to me, now in my possession, bear witness; and out of love for truth, and also from the obligation that I feel to his loving kindness, I have contrived to write many things of him, and all true, which many others have not been able to do. Another blessing he used to point out to me himself: "You should thank God, Giorgio, who has caused you to serve Duke Cosimo, who, in his contentment that you should build and paint and carry into execution his conceptions and designs, has grudged no expense; and you will remember, if you consider it, that the others whose Lives you have written did not have such advantages."

With most honourable obsequies, and with a concourse of all the craftsmen, all his friends, and all the Florentine colony, Michelagnolo was given burial in a sepulchre at S. Apostolo, in the sight of all Rome; his Holiness hav-

ing intended to make him some particular memorial and tomb in S. Pietro at Rome. Leonardo, his nephew, arrived when all was over, although he travelled post. When Duke Cosimo was informed of the event, he confirmed his resolve that since he had not been able to have him and honour him alive, he would have him brought to Florence and not hesitate to honour him with all manner of pomp after death; and the body was sent secretly in a bale, under the title of merchandise, which method was adopted lest there might be a tumult in Rome, and lest perchance the body of Michelagnolo might be detained and prevented from leaving Rome for Florence. But before the body arrived, the news of the death having been heard, the principal painters, sculptors, and architects were assembled together at the summons of the Lieutenant of their Academy, and they were reminded by that Lieutenant, who at that time was the Reverend Don Vincenzio Borghini, that they were obliged by virtue of their statutes to pay due honour to the death of any of their brethren, and that, they having done this so lovingly and with such universal satisfaction in the obsequies of Fra Giovanni Agnolo Montorsoli, who had been the first to die after the creation of the Academy, they should look well to what it might be proper for them to do in honour of Buonarroti, who had been elected by an unanimous vote of the whole body of the Company as the first Academician and the head of them all. To which proposal they all replied, as men most deeply indebted and affected to the genius of so great a man, that at all costs pains should be taken to do him honour in the best and finest ways available to them. This done, in order not to have to assemble so many persons together every day, to their great inconvenience, and to the end that matters might proceed more quietly, four men were elected as heads of the obsequies and the funeral pomp that were to be held; the painters Agnolo Bronzino and Giorgio Vasari, and the sculptors Benvenuto Cellini and Bartolommeo Ammanati, all men of illustrious name and eminent ability in their arts; to the end, I say, that they might consult and determine between themselves and the Lieutenant what was to be done in each particular, and in what way, with authority and power to dispose of the whole body of the Company and Academy. This charge they accepted all the more willingly because all the members, young and old, each in his own profession, offered their services for the execution of such pictures and statues as had to be done for that funeral pomp. They then ordained that the Lieutenant, in pursuance of his office, and the Consuls, in the name of the Company and Academy, should lay the whole matter before the Lord Duke, and beseech him for all the aids and favours that might be necessary, and especially for permission to have those obsequies held in S. Lorenzo, the church of the most illustrious House of Medici; wherein are the greater part of the works by the hand of Michelagnolo that there are to be seen in Florence; and, in addition, that his Excellency should allow Messer Benedetto Varchi to compose and deliver the funeral oration, to the end that the excellent genius of Michelagnolo might be extolled by the rare eloquence of a man so great as was Varchi, who, being in the particular service of his Excellency, would not have undertaken such a charge without a word from him, although they were very certain that, as one most loving by nature and deeply affected to the memory of Michelagnolo, of himself he would never have refused. This done, and the Academicians dismissed, the above-named Lieutenant wrote to the Lord Duke a letter of this precise tenor:

"The Academy and Company of Painters and Sculptors having resolved among themselves, if it should please your most illustrious Excellency, to do honour in some sort to the memory of Michelagnolo Buonarroti, both from the general obligation due from their profession to the extraordinary genius of one who was perhaps the greatest craftsman who has ever lived, and from their particular obligation through their belonging to a common country, and also

Don Vincenzo Borghini, a prelate (and noted collector), who headed the Spedale degli Innocenti. The Florence Academy, the Accademia dei Disegni, was founded by Vasari in 1563.

Agnolo Bronzino (1503–76), celebrated Florentine Mannerist painter, known especially for his elegant and refined portraits.

because of the great advantage that these professions have received from the perfection of his works and inventions, insomuch that they hold themselves obliged to prove their affection to his genius in whatever way they are able, they have laid this their desire before your illustrious Excellency in a letter, and have besought you, as their peculiar refuge, for a certain measure of assistance. I, entreated by them, and being, as I think, obliged because your most illustrious Excellency has been content that I should be again this year in their Company with the title of your Lieutenant, with the added reason that the proposal is a generous one and worthy of virtuous and grateful minds, and, above all, knowing how your most illustrious Excellency is the patron of talent, and as it were a haven and unique protector for ingenious persons in this age, even surpassing in this respect your forefathers, who bestowed extraordinary favours on those excellent in these professions, as, by order of the Magnificent Lorenzo, Giotto, already so long dead, received a statue in the principal church, and Fra Filippo a most beautiful tomb of marble at his expense, while many others obtained the greatest benefits and honours on various occasions; moved, I say, by all these reasons, I have taken it upon myself to recommend to your most illustrious Excellency the petition of this Academy, that they may be able to do honour to the genius of Michelagnolo, the particular nursling and pupil of the school of the Magnificent Lorenzo, which will be an extraordinary pleasure to them, a vast satisfaction to men in general, no small incitement to the professors of these arts, and to all Italy a proof of the lofty mind and overflowing goodness of your most illustrious Excellency, whom may God long preserve in happiness for the benefit of your people and the support of every talent."

To which letter the above-named Lord Duke answered thus:

"Reverend and Well-Beloved Friend,

"The zeal that this Academy has displayed, and continues to display, to honour the memory of Michelagnolo Buonarroti, who has passed from this to a better life, has given us much consolation for the loss of a man so extraordinary; and we wish not only to satisfy them in all that they have demanded in their memorial, but also to have his remains brought to Florence, which, according as we are informed, was his own desire. All this we are writing to the aforesaid Academy, to encourage them to celebrate by every possible means the genius of that great man. May God content you in your desire."

Of the letter, or rather, memorial, of which mention has been made above, addressed by the Academy to the Lord Duke, the tenor was as follows:

"Most Illustrious, etc.

"The Academy and the Men of the Company of Design, created by the grace and favour of your most illustrious Excellency, knowing with what solicitude and affection you caused the body of Michelagnolo Buonarroti to be brought to Florence by means of your representative in Rome, have assembled together and have unanimously determined that they shall celebrate his obsequies in the best manner in their power and knowledge. Wherefore they, knowing that your most illustrious Excellency was revered by him as much as you yourself loved him, beseech you that you should deign in your infinite goodness and liberality to grant to them, first, that they may be allowed to celebrate the said obsequies in the Church of S. Lorenzo, a church built by your ancestors, in which are so many beautiful works wrought by his hand, both in architecture and in sculpture, and near which you are minded to have erected a place that shall be as it were a nest and an abiding school of architecture, sculp-

ture, and painting, for the above-named Academy and Company of Design. Secondly, they pray you that you should consent to grant a commission to Messer Benedetto Varchi that he shall not only compose the funeral oration, but also deliver it with his own mouth, as he has promised most freely that he would do, when besought by us, in the event of your most illustrious Excellency consenting. In the third place, they entreat and pray you that you should deign, in the same goodness and liberality of your heart, to supply them with all that may be necessary for them in celebrating the above-mentioned obsequies, over and above their own resources, which are very small. All these matters, and each singly, have been discussed and determined in the presence and with the consent of the most Magnificent and Reverend Monsignor, Messer Vincenzio Borghini, Prior of the Innocenti and Lieutenant of your most illustrious Excellency in the aforesaid Academy and Company of Design, which, etc."

To which letter of the Academy the Duke made this reply:

"Well-Beloved Academicians,

"We are well content to give full satisfaction to your petitions, so great is the affection that we have always borne to the rare genius of Michelagnolo Buonarroti, and that we still bear to all your profession; do not hesitate, therefore, to carry out all that you have proposed to do in his obsequies, for we will not fail to supply whatever you need. Meanwhile, we have written to Messer Benedetto Varchi in the matter of the oration, and to the Director of the Hospital with regard to anything more that may be necessary in this undertaking. Fare you well."

The letter to Varchi was as follows:

Pisa.

"Messer Benedetto, our Well-Beloved,

"The affection that we bear to the rare genius of Michelagnolo Buonarroti makes us desire that his memory should be honoured and celebrated in every possible way. It will be pleasing to us, therefore, that you for love of us shall undertake the charge of composing the oration that is to be delivered at his obsequies, according to the arrangements made by the deputies of the Academy; and still more pleasing that it should be delivered by your own lips. Fare you well."

Messer Bernardino Grazzini, also, wrote to the above-named deputies that they could not have expected in the Duke any desire in that matter more ardent than that which he had shown, and that they might be assured of every aid and favour from his most illustrious Excellency.

While these matters were being discussed in Florence, Leonardo Buonarroti, Michelagnolo's nephew (who, when informed of his uncle's illness, had made his way to Rome by post, but had not found him alive), having heard from Daniello da Volterra, who had been the very familiar friend of Michelagnolo, and also from others who had been about the person of that saintly old man, that he had requested and prayed that his body should be carried to Florence, that most noble city of his birth, of which he was always a most tender lover; Leonardo, I say, with prompt and therefore good resolution, removed the body cautiously from Rome and sent it off to Florence in a bale, as if it had been a piece of merchandise. And here I must not omit to say that this final resolution of Michelagnolo's proved a thing against the opinion of certain per-

sons, but nevertheless very true, namely, that his absence for so many years from Florence had been caused by no other thing but the nature of the air, for the reason that experience had taught him that the air of Florence, being sharp and subtle, was very injurious to his constitution, while that of Rome, softer and more temperate, had kept him in perfect health up to his ninetieth year, with all the senses as lively and sound as they had ever been, and with such strength, for his age, that up to the last day he had never ceased to work at something.

Since, then, the coming of the bale was so sudden and so unexpected that for the time being it was not possible to do what was done afterwards, the body of Michelagnolo, on arriving in Florence, was placed with the coffin, at the desire of the deputies, on the same day that it arrived in the city (namely, on the 11th of March, which was a Saturday), in the Company of the Assumption, which is under the high-altar of S. Pietro Maggiore, beneath the steps at the back; but it was not touched in any way whatever. The next day, which was Sunday of the second week in Lent, all the painters, sculptors, and architects assembled as quietly as possible round S. Pietro, whither they had brought nothing but a pall of velvet, all bordered and embroidered in gold, which covered the coffin and the whole bier; upon which coffin was an image of Christ Crucified. Then, about the middle hour of the night, all having gathered around the body, all at once the oldest and most eminent craftsmen laid their hands on a great quantity of torches that had been carried there, and the younger men took up the bier with such eagerness, that blessed was he who could approach it and place his shoulders under it, believing as it were that in the time to come they would be able to claim the glory of having borne the remains of the greatest man that there had ever been in their arts. The sight of a certain number of persons assembled about S. Pietro had caused, as always happens in such cases, many others to stop there, and the rather as it had been trumpeted abroad that the body of Michelagnolo had arrived, and was to be carried to S. Croce. And although, as I have said, every precaution had been taken that the matter should not become known, lest the report might spread through the city, and there might flock thither such a multitude that it would not be possible to avoid a certain degree of tumult and confusion, and also because they desired that the little which they wished to do at that time should be done with more quiet than pomp, reserving the rest for a more convenient time with greater leisure; nevertheless, both the one thing and the other took a contrary course, for with regard to the multitude, the news, as has been related, passing from lip to lip, in the twinkling of an eye the church was so filled, that in the end it was with the greatest difficulty that the body was carried from the church to the sacristy, in order to take it out of the bale and then place it in the sepulchre. With regard to the question of honour, although it cannot be denied that to see in funeral pomps a great show of priests, a large quantity of wax tapers, and a great number of mourners dressed in black, is a thing of grand and magnificent appearance, it does not follow that it was not also a great thing to see thus assembled in a small company, without preparation, all those eminent men who are now in such repute, and who will be even more in the future, honouring that body with such loving and affectionate offices. And, in truth, the number of such craftsmen in Florence—and they were all there—has always been very great, for the reason that these arts have always flourished in Florence in such a manner, that I believe that it may be said without prejudice to other cities that their principal and true nest and domicile is Florence, not otherwise than Athens once was of the sciences. In addition to that number of craftsmen, there were so many citizens following them, and so many at the sides of the streets where the procession passed, that there was no place for any more; and, what is an even greater thing, there was nothing heard but praises in every man's mouth of the merits of Michelagnolo, all saying that true ge-

nius has such force that, after all expectation of such honour and profit as can be obtained from a gifted man has failed, nevertheless, by its own nature and peculiar merits, it remains honoured and beloved. For these reasons that demonstration was more vivid in effect and more precious than any pomp of gold and trappings that could have been contrived.

The body having been carried with so beautiful a train into S. Croce, after the friars had finished the ceremonies that were customary for the dead, it was borne—not without very great difficulty, as has been related, by reason of the concourse of people—into the sacristy, where the above-named Lieutenant, who had been present in virtue of his office, thinking to do a thing pleasing to many, and also (as he afterwards confessed) desiring to see in death one whom he had not seen in life, or had seen at such an early age that he had lost all memory of him, then resolved to have the coffin opened. This done, when he and all the rest of us present thought to find the body already marred and putrefied, because Michelagnolo had been dead twenty-five days and twenty-two in the coffin, we found it so perfect in every part, and so free from any noisome odour, that we were ready to believe that it was rather at rest in a sweet and most peaceful sleep; and, besides that the features of the face were exactly as in life (except that there was something of the colour of death), it had no member that was marred or revealed any corruption, and the head and cheeks were not otherwise to the touch than as if he had passed away but a few hours before.

When the tumult of the people had abated, arrangements were made to place the body in a sepulchre in the church, beside the altar of the Cavalcanti, by the door that leads into the cloister of the chapter-house. Meanwhile the news had spread through the city, and such a multitude of young people flocked thither to see the corpse, that there was great difficulty in contriving to close the tomb; and if it had been day, instead of night, we would have been forced to leave it open many hours in order to satisfy the public. The following morning, while the painters and sculptors were commencing to make arrangements for the memorial of honour, many choice spirits, such as have always abounded in Florence, began to attach above the aforesaid sepulchre verses both Latin and in the vulgar tongue, and so it was continued for some time; but those compositions that were printed at that time were but a small part with respect to the many that were written.

* * *

TIZIANO DA CADOR
PITTORE.

THE LIFE OF
TIZIANO DA CADORE

Titian

[1487–1577]

THE VENETIAN PAINTER

TIZIANO WAS BORN at Cadore, a little township situated on the Piave and five miles distant from the pass of the Alps, in the year [1487], from the family of the Vecelli, one of the most noble in that place. At the age of ten, having a fine spirit and a lively intelligence, he was sent to Venice to the house of an uncle, an honoured citizen, who, perceiving the boy to be much inclined to painting, placed him with Gian Bellini, an excellent painter very famous at that time. . . . Under his discipline, attending to design, he soon showed that he was endowed by nature with all the gifts of intellect and judgment that are necessary for the art of painting; and since at that time Gian Bellini and the other painters of that country, from not being able to study ancient works, were much—nay, altogether—given to copying from the life whatever work they did, and that with a dry, crude, and laboured manner, Tiziano also for a time learned that method. But having come to about the year 1507, Giorgione da Castelfranco, not altogether liking that mode of working, began to give to his pictures more softness and greater relief, with a beautiful manner; nevertheless he used to set himself before living and natural objects and counterfeit them as well as he was able with colours, and paint them broadly with tints crude or soft according as the life demanded, without doing any drawing, holding it as certain that to paint with colours only, without the study of drawing on paper, was the true and best method of working, and the true design. For he did not perceive that for him who wishes to distribute his compositions and accommodate his inventions well, it is necessary that he should first put them down on paper in several different ways, in order to see how the whole goes together, for the reason that the idea is not able to see or imagine the inventions perfectly within herself, if she does not reveal and demonstrate her conception to the eyes of the body, that these may assist her to form a good judgment. Besides which, it is necessary to give much study to the nude, if you wish to comprehend it well, which you will never do, nor is it possible, without having recourse to paper; and to keep always before you, while you paint, persons naked or draped, is no small restraint, whereas, when you have formed your hand by drawing on paper, you then come little by little with greater ease to carry your conceptions into execution, designing and painting together. And so, gaining practice in art, you make both manner and judgment perfect, doing away with the labour and effort wherewith those pictures were executed of which we have spoken above, not to mention that by drawing on paper, you come to fill the mind with beautiful conceptions, and learn to counterfeit all the objects of nature by memory, without having to keep them always before you or being obliged to conceal beneath the glamour of colouring the painful fruits of your ignorance of design, in the manner that was followed for many years by the Venetian painters, Giorgione, Palma, Pordenone, and others, who never saw Rome or any other works of absolute perfection.

Tiziano, then, having seen the method and manner of Giorgione, aban-

Giovanni Bellini (c. 1430–1516), Venetian painter, the greatest of his age, and the most celebrated of a notable family of artists.

Giorgione da Castelfranco (c. 1477–1510). Epochal Venetian painter whose style influenced the art of Venice from Titian onward. Few paintings definitely attributable to him survive, and many formerly attributed are now considered to be early Titians.

Palma Vecchio (c. 1480–1528), important Venetian painter. Pordenone (1483/84–1538), Northern Italian painter.

331

doned the manner of Gian Bellini, although he had been accustomed to it for a long time, and attached himself to that of Giorgione; coming in a short time to imitate his works so well, that his pictures at times were mistaken for works by Giorgione, as will be related below. Then, having grown in age, practice, and judgment, Tiziano executed many works in fresco, which cannot be enumerated in order, being dispersed over various places; let it suffice that they were such, that the opinion was formed by many experienced judges that he would become, as he afterwards did, a most excellent painter. At the time when he first began to follow the manner of Giorgione, not being more than eighteen years of age, he made the portrait of a gentleman of the Barberigo family, his friend, which was held to be very beautiful, the likeness of the flesh-colouring being true and natural, and all the hairs so well distinguished from one another, that they might have been counted, as also might have been the stitches in a doublet of silvered satin that he painted in that work. In short, it was held to be so well done, and with such diligence, that if Tiziano had not written his name on a dark ground, it would have been taken for the work of Giorgione.

Meanwhile Giorgione himself had executed the principal façade of the Fondaco de' Tedeschi, and by means of Barberigo there were allotted to Tiziano certain scenes on the same building, above the Merceria. After which work he painted a large picture with figures of the size of life, which is now in the hall of M. Andrea Loredano, who dwells near S. Marcuola. In that picture is painted Our Lady going into Egypt, in the midst of a great forest and certain landscapes that are very well done, because Tiziano had given his attention for many months to such things, and had kept in his house for that purpose some Germans who were excellent painters of landscapes and verdure. In the wood in that picture, likewise, he painted many animals, which he portrayed from the life; and they are truly natural, and almost alive. Next, in the house of M. Giovanni D'Anna, a Flemish gentleman and merchant, his gossip, he made his portrait, which has all the appearance of life, and also an "Ecce Homo" with many figures, which is held by Tiziano himself and by others to be a very beautiful work. The same master painted a picture of Our Lady with other figures the size of life, of men and children, all portrayed from the life and from persons of that house. Then in the year 1507, while the Emperor Maximilian was making war on the Venetians, Tiziano, according to his own account, painted an Angel Raphael with Tobias and a dog in the Church of S. Marziliano, with a distant landscape, where, in a little wood, S. John the Baptist is praying on his knees to Heaven, whence comes a radiance that illumines him; and this work it is thought that he executed before he made a beginning with the façade of the Fondaco de' Tedeschi. Concerning which façade, many gentlemen, not knowing that Giorgione was not working there any more and that Tiziano was doing it, who had uncovered one part, meeting with Giorgione, congratulated him in friendly fashion, saying that he was acquitting himself better in the façade towards the Merceria than he had done in that which is over the Grand Canal. At which circumstance Giorgione felt such disdain, that until Tiziano had completely finished the work and it had become well known that the same had done that part, he would scarcely let himself be seen; and from that time onward he would never allow Tiziano to associate with him or be his friend.

In the year after, 1508, Tiziano published in wood-engraving the Triumph of Faith, with an infinity of figures; our first Parents, the Patriarchs, the Prophets, the Sibyls, the Innocents, the Martyrs, the Apostles, and Jesus Christ borne in Triumph by the four Evangelists and the four Doctors, with the Holy Confessors behind. In that work Tiziano displayed boldness, a beautiful manner, and the power to work with facility of hand; and I remember that Fra Sebastiano del Piombo, conversing of this, said to me that if

Maximilian I (1459–1519), Holy Roman Emperor, crowned in 1493.

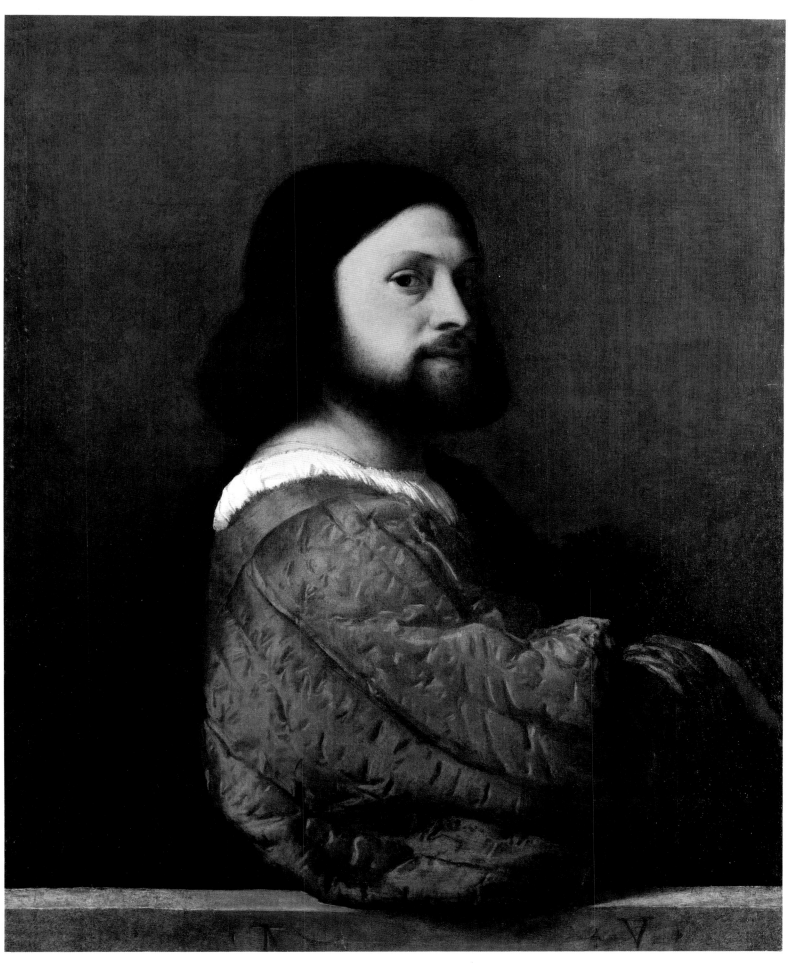

COLORPLATE 97. Titian. *Portrait of a Man* (so-called *Ariosto*). c. 1510. Canvas.
32 × 26¼″ (81.2 × 66.3 cm). The National Gallery, London.

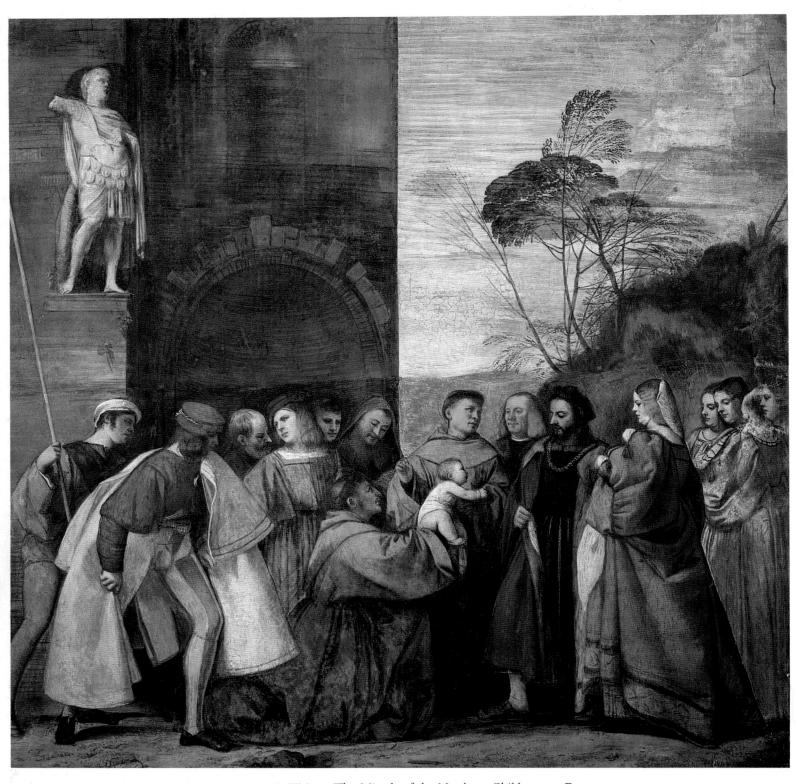

COLORPLATE 98. Titian. *The Miracle of the Newborn Child.* 1511. Fresco.
Basilica di Sant'Antonio, Padua.

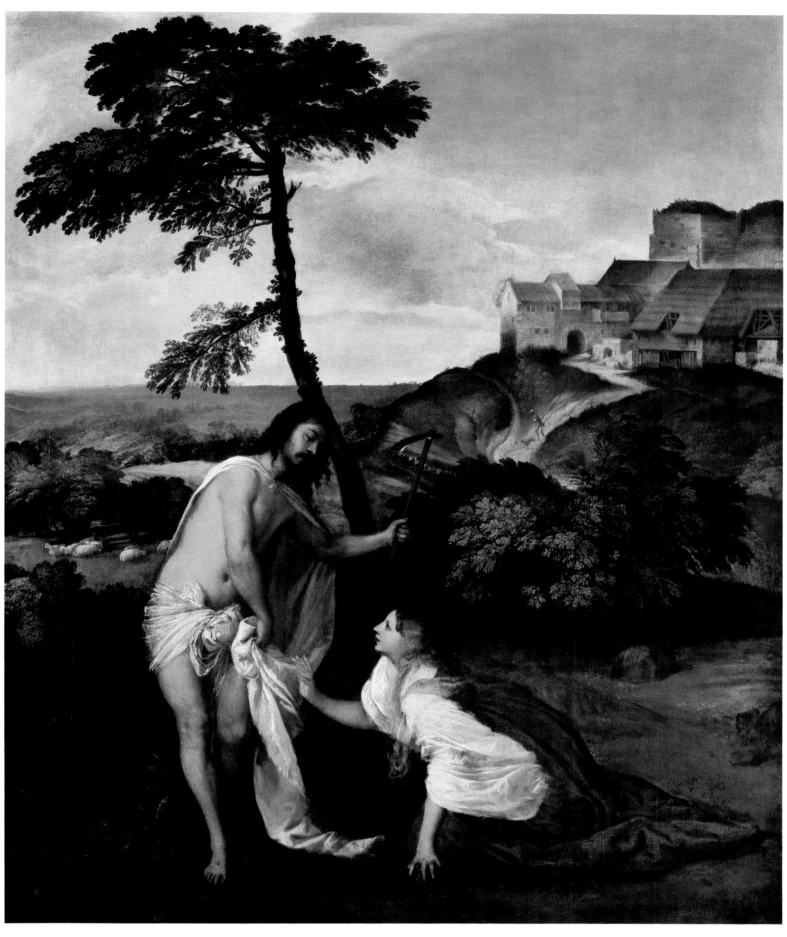

COLORPLATE 99. Titian. *Noli Me Tangere*. c. 1511. Canvas. 42¾ × 35¾″ (108.6 × 90.8 cm).
The National Gallery, London.

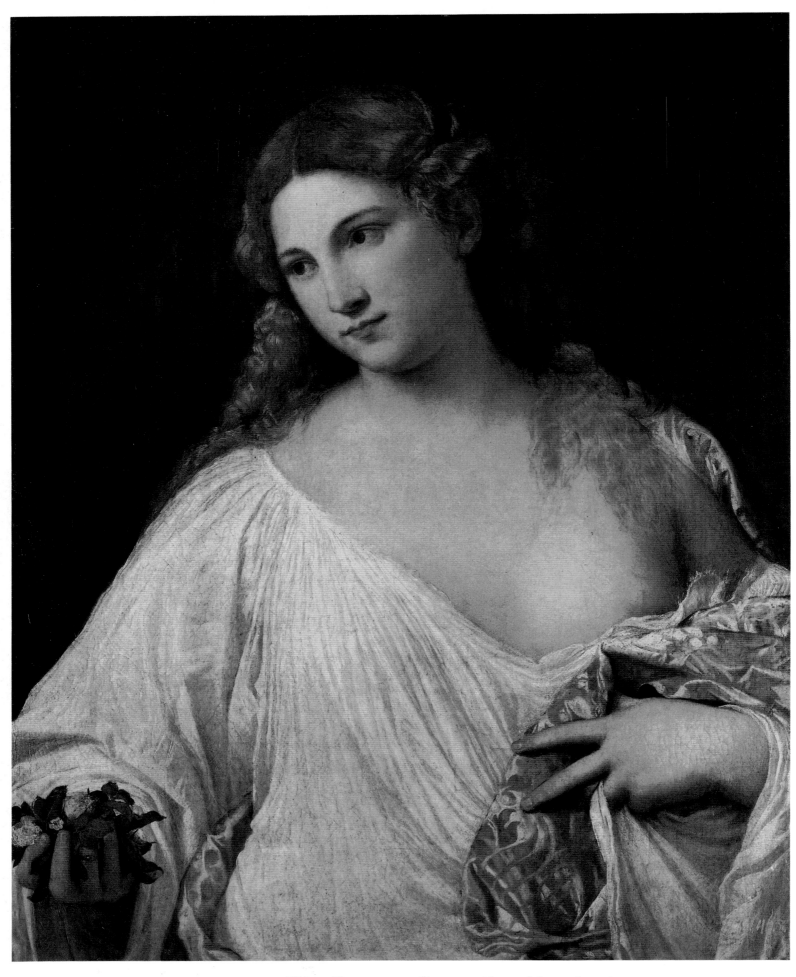

COLORPLATE 100. Titian. *Flora*. c. 1515. Canvas. 31¼ × 25″ (79 × 63 cm).
Uffizi Gallery, Florence.

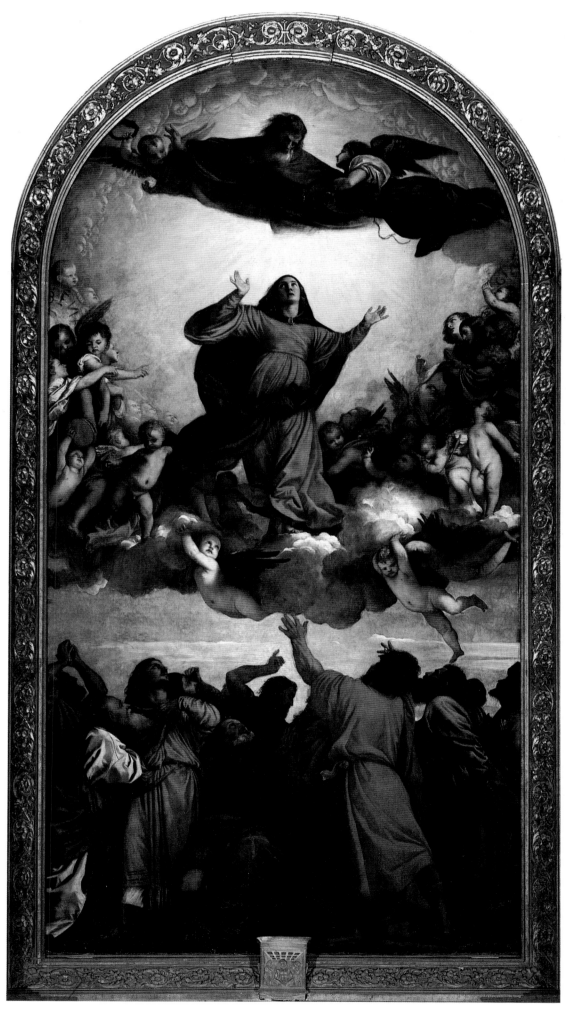

COLORPLATE 101. Titian. *The Assumption*. 1516–18. Oil on Panel. 272½ × 142″ (690 × 360 cm).
Church of Santa Maria Gloriosi dei Frari, Venice.

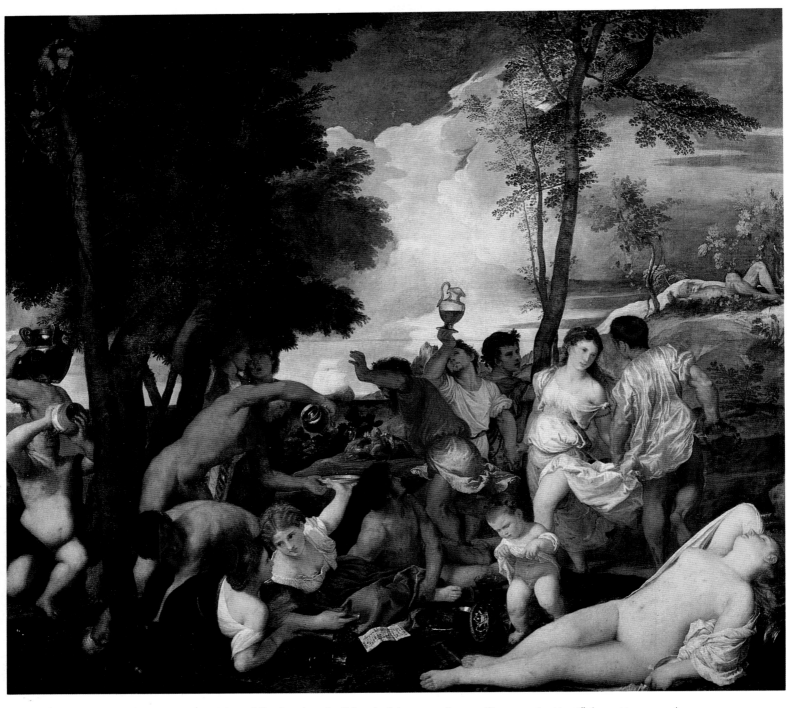

COLORPLATE 102. Titian. *The Bacchanal of the Andrians.* 1518–19. Canvas. 69 × 76″ (175 × 193 cm).
The Prado, Madrid.

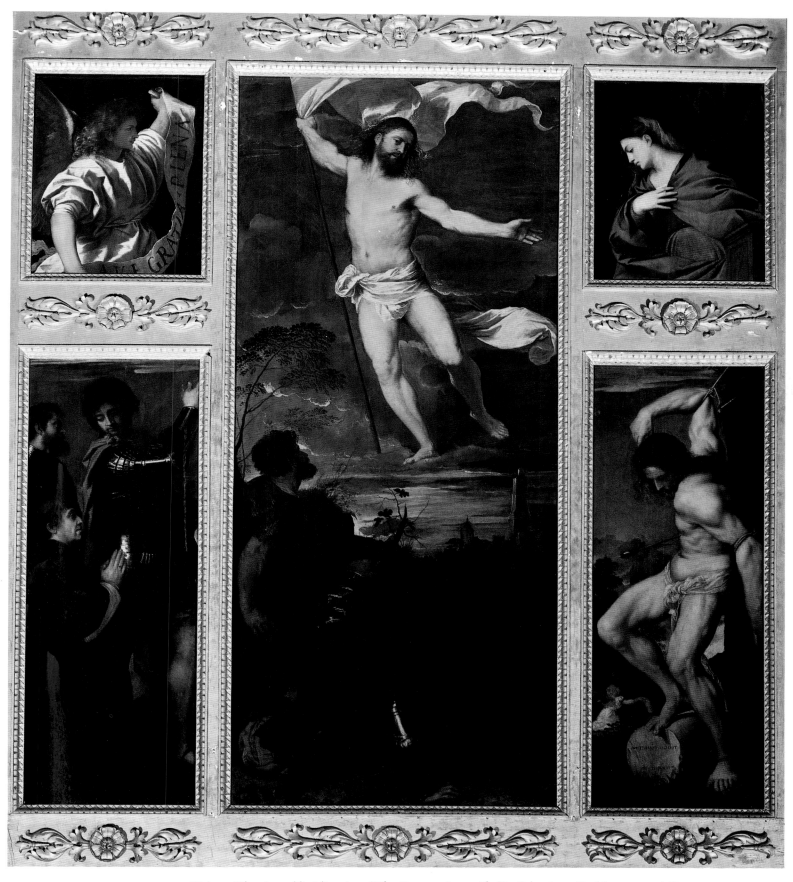

COLORPLATE 103. Titian. *The Averoldi Altarpiece (The Resurrection with St. Sebastian, St. Nazarus and Donors, the Angel Gabriel and the Virgin Annunciate).* 1520–22. Oil on Panel. Approx. overall dimensions 109¾ × 104¼″ (278 × 264 cm). Church of Santi Nazzaro e Celso, Brescia.

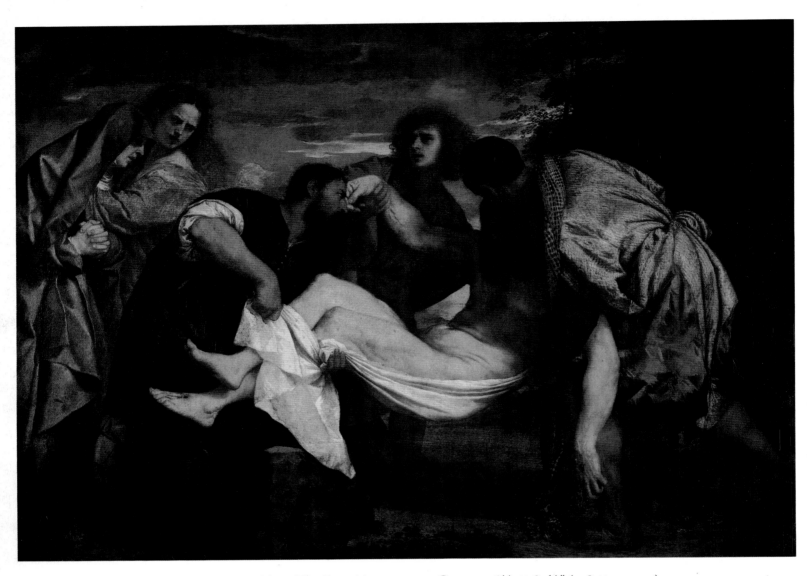

COLORPLATE 104. Titian. *The Deposition*. c. 1525. Canvas. 58¼ × 83½″ (148 × 212 cm).
The Louvre, Paris.

Titian. *Tobias and the Angel.* 1543. Canvas. 76 × 51 ½″ (193 × 130 cm). Church of San Marziale, Venice.

Tiziano had been in Rome at that time, and had seen the works of Michelagnolo, those of Raffaello, and the ancient statues, and had studied design, he would have done things absolutely stupendous, considering the beautiful mastery that he had in colouring, and that he deserved to be celebrated as the finest and greatest imitator of Nature in the matter of colour in our times, and with the foundation of the grand method of design he might have equalled the Urbinate and Buonarroti. Afterwards, having gone to Vicenza, Tiziano painted the Judgment of Solomon in fresco, which was a beautiful work, under the little loggia where justice is administered in public audience. He then returned to Venice, and painted the façade of the Grimani. At Padua, in the Church of S. Antonio, he executed likewise in fresco some stories of the actions of that Saint, and for that of S. Spirito he painted a little altar-piece with a S. Mark seated in the midst of certain Saints, in whose faces are some portraits from life done in oils with the greatest diligence; which picture many

The "Urbinate" is Raphael, who came from Urbino.

COLORPLATE 98

341

have believed to be by the hand of Giorgione. Then, a scene having been left unfinished in the Hall of the Great Council through the death of Giovanni Bellini, wherein Frederick Barbarossa is kneeling at the door of the Church of S. Marco before Pope Alexander IV, who places his foot on Barbarossa's neck, Tiziano finished it, changing many things, and making there many portraits from life of his friends and others; for which he was rewarded by receiving from the Senate an office in the Fondaco de' Tedeschi, called the Senseria, which yields three hundred crowns a year. That office those Signori are accustomed to give to the most excellent painter of their city, on the condition that he shall be obliged from time to time to paint the portrait of their Prince or Doge, at his election, for the price of only eight crowns, which the Prince himself pays to him; which portrait is afterwards kept, in memory of him, in a public place in the Palace of S. Marco.

In the year 1514 Duke Alfonso of Ferrara had caused a little chamber to be decorated, and had commissioned Dosso, the painter of Ferrara, to execute in certain compartments stories of Æneas, Mars, and Venus, and in a grotto Vulcan with two smiths at the forge; and he desired that there should also be there pictures by the hand of Gian Bellini. Bellini painted on another wall a vat of red wine with some Bacchanals around it, and Satyrs, musicians, and other men and women, all drunk with wine, and near them a nude and very beautiful Silenus, riding on his ass, with figures about him that have the hands full of fruits and grapes; which work was in truth executed and coloured with

Frederick Barbarossa ("Red-beard") was Frederick I (1123?–1190), Holy Roman Emperor and king of the Germans. "Pope Alexander IV" (r. 1254–61) must be an error for Alexander III (r. 1159–81). Titian's painting was destroyed in the great fire of 1577.

That is, Alfonso I d'Este, Duke of Ferrara. Dosso Dossi (c. 1490–1542), Ferrarese painter.

Lucantino degli Uberti (after Titian). *The Triumph of Faith* (section). c. 1510–11. Wood engraving. New York Public Library. Astor, Lenox, and Tilden Foundation.

342

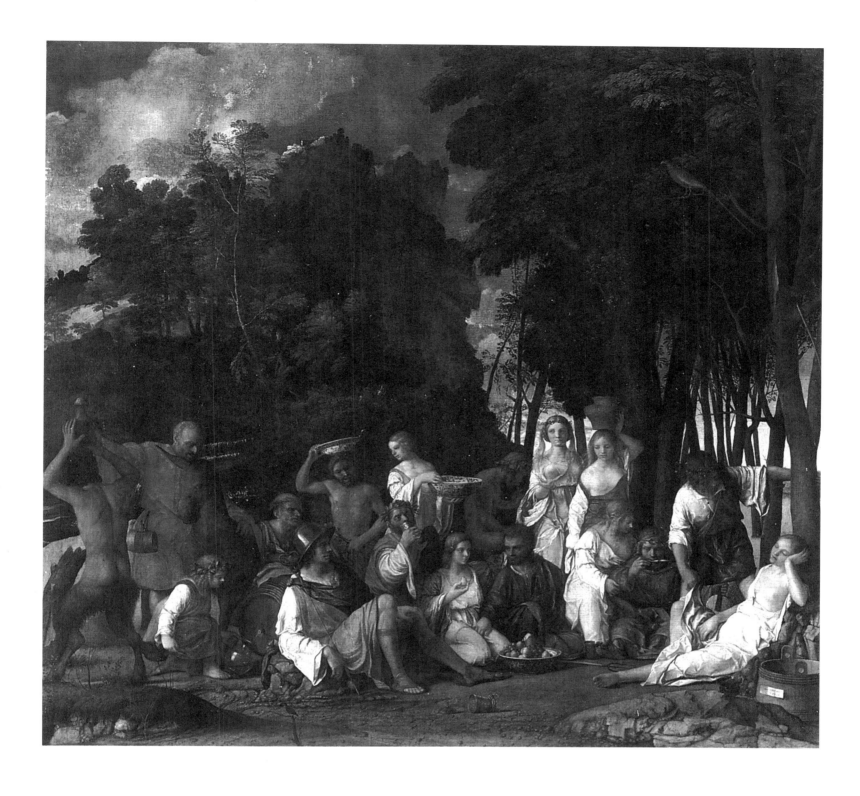

great diligence, insomuch that it is one of the most beautiful pictures that Gian Bellini ever painted, although in the manner of the draperies there is a certain sharpness after the German manner (nothing, indeed, of any account), because he imitated a picture by the [German] Albrecht Dürer, which had been brought in those days to Venice and placed in the Church of S. Bartolommeo, a rare work and full of most beautiful figures painted in oils. On that vat Gian Bellini wrote these words:

Joannes Bellinus Venetus, P. 1514.

That work he was not able to finish completely, because he was old, and Tiziano, as the most excellent of all the others, was sent for to the end that he might finish it; wherefore, being desirous to acquire excellence and to make himself known, he executed with much diligence two scenes that were

Giovanni Bellini (completed by Titian). *The Feast of the Gods.* 1514. Canvas. 67 × 74″ (170 × 188 cm). National Gallery of Art, Washington, Widener Collection.

wanting in that little chamber. In the first is a river of red wine, about which are singers and musicians, both men and women, as it were drunk, and a naked woman who is sleeping, so beautiful that she might be alive, together with other figures; and on this picture Tiziano wrote his name. In the other, which is next to it and seen first on entering, he painted many little boys and Loves in various attitudes, which much pleased that lord, as also did the other picture; but most beautiful of all is one of those boys who is making water into a river and is reflected in the water, while the others are around a pedestal that has the form of an altar, upon which is a statue of Venus with a sea-conch in the right hand, and Grace and Beauty about her, which are very lovely figures and executed with incredible diligence. On the door of a press, likewise, Tiziano painted an image of Christ from the waist upwards, marvellous, nay, stupendous, to whom a base Hebrew is showing the coin of Cæsar; which image, and also other pictures in that little chamber, our best craftsmen declare to be the finest and best executed that Tiziano has ever done, and indeed they are most rare. Wherefore he well deserved to be most liberally recompensed and rewarded by that lord, whom he portrayed excellently well with one arm resting on a great piece of artillery; and he also made a portrait of

Titian. *The Tribute Money*. c. 1516. Canvas. 29½ × 22″ (75 × 56 cm). Gemäldegalerie, Dresden.

Signora Laura, who afterwards became the wife of the Duke, which is a stupendous work. And, in truth, gifts have great potency with those who labour for the love of art, when they are uplifted by the liberality of the Princes. At that time Tiziano formed a friendship with the divine Messer Lodovico Ariosto, and was recognized by him as a most excellent painter and celebrated in his Orlando Furioso:

. . . And Titian, who honors
Cadore no less than Venice and Urbino.

Having then returned to Venice, Tiziano painted on a canvas in oils, for the father-in-law of Giovanni da Castel Bolognese, a naked shepherd and a country-girl who is offering him some pipes, that he may play them, with a most beautiful landscape; which picture is now at Faenza, in the house of the said Giovanni. He then executed for the high-altar in the Church of the Friars Minors, called the Cà Grande, a picture of Our Lady ascending into Heaven, and below her the twelve Apostles, who are gazing upon her as she ascends; but of this work, from its having been painted on cloth, and perhaps not well kept, there is little to be seen. For the Chapel of the Pesari family, in the same church, he painted in an altar-piece the Madonna with the Child in her arms, a S. Peter and a S. George, and about them the patrons of the work, kneeling and portrayed from life; among whom are the Bishop of Paphos and his brother, then newly returned from the victory which that Bishop won against the Turks. For the little Church of S. Niccolò, in the same convent, he painted in an altar-piece S. Nicholas, S. Francis, S. Catharine, and also a nude S. Sebastian, portrayed from life and without any artifice that can be seen to have been used to enhance the beauty of the limbs and trunk, there being nothing there but what he saw in the work of nature, insomuch that it all appears as if stamped from the life, so fleshlike it is and natural; but for all that is held to be beautiful, as is also very lovely the Madonna with the Child in her arms at whom all those figures are gazing. The subject of that picture was drawn on wood by Tiziano himself, and then engraved by others and printed. For the Church of S. Rocco, after the works described above, he painted a picture of Christ with the Cross on His shoulder, and about His neck a cord that is drawn by a Hebrew; and that figure, which many have believed to be by the hand of Giorgione, is now the object of the greatest devotion in Venice, and has received in alms more crowns than Tiziano and Giorgione ever gained in all their lives. Then he was invited to Rome by Bembo, whom he had already portrayed, and who was at that time Secretary to Pope Leo X, to the end that he might see Rome, Raffaello da Urbino, and others; but Tiziano delayed that visit so long from one day to another, that Leo died, and Raffaello in 1520, and after all he never went. For the Church of S. Maria Maggiore he painted a picture with S. John the Baptist in the Desert among some rocks, an Angel that appears as if alive, and a little piece of distant landscape with some trees upon the bank of a river, all full of grace.

He made portraits from life of the Prince Grimani and Loredano, which were held to be admirable; and not long afterwards of King Francis, when he departed from Italy in order to return to France. And in the year when Andrea Gritti was elected Doge, Tiziano painted his portrait, which was a very rare thing, in a picture wherein are Our Lady, S. Mark, and S. Andrew with the countenance of that Doge; which picture, a most marvellous work, is in the Sala del Collegio. He has also painted portraits, in addition to those of the Doges named above (being obliged, as has been related, to do it), of others who have been Doges in their time; Pietro Lando, Francesco Donato, Marcantonio Trevisano, and Veniero. But by the two Doges and brothers Priuli he has been excused recently, because of his great age, from that obligation. Before the sack of Rome there had gone to live in Venice Pietro Aretino, a most famous poet

Lodovico Ariosto (1474–1533), celebrated Italian poet. His masterwork is the epic poem Orlando Furioso ("The Madness of Roland"). His presumed portrait by Titian is reproduced in colorplate 97.

COLORPLATE 101

COLORPLATE 107

COLORPLATE 109

Pietro Aretino (1492–1556), an audacious writer, who called himself the Scourge of Princes. His portrait by Titian is reproduced in colorplate 113.

Titian. *Portrait of Francis I*. 1538. Canvas. 42¾ × 35″ (109 × 89 cm). The Louvre, Paris.

of our times, and he became very much the friend of Tiziano and Sansovino; which brought great honour and advantage to Tiziano, for the reason that the poet made him known wherever his pen reached, and especially to Princes of importance, as will be told in the proper place.

Meanwhile, to return to Tiziano's works, he painted the altar-piece for the altar of S. Piero Martire in the Church of SS. Giovanni e Polo, depicting therein that holy martyr larger than life, in a forest of very great trees, fallen to the ground and assailed by the fury of a soldier, who has wounded him so grievously in the head, that as he lies but half alive there is seen in his face the horror of death, while in another friar who runs forward in flight may be perceived the fear and terror of death. In the air are two nude Angels coming down from a flash of Heaven's lightning, which gives light to the landscape, which is most beautiful, and to the whole work besides, which is the most finished, the most celebrated, the greatest, and the best conceived and executed that Tiziano has as yet ever done in all his life. This work being seen by Gritti, who was always very much the friend of Tiziano, as also of Sansovino, he caused to be allotted to him a great scene of the rout of Chiaradadda, in the Hall of the Great Council. In it he painted a battle with soldiers in a furious combat, while a terrible rain falls from Heaven; which work, wholly taken from life, is held to be the best of all the scenes that are in that Hall, and the msot beautiful. And in the same Palace, at the foot of a staircase, he painted a Madonna in fresco. Having made not long afterwards for a gentleman of the Contarini

Most of these portraits have survived. Colorplate 109 reproduces one of the more splendid examples. The altarpiece depicting Gritti as St. Andrew was destroyed by fire in 1579.

The altarpiece was destroyed when the church burned in 1867. This once-celebrated work is known today only through engraved copies, one of which is reproduced on page 348.

COLORPLATE 109

346

family a picture of a very beautiful Christ, who is seated at table with Cleophas and Luke, it appeared to that gentleman that the work was worthy to be in a public place, as in truth it is. Wherefore having made a present of it, like a true lover of his country and of the commonwealth, to the Signoria, it was kept a long time in the apartments of the Doge; but at the present day it is in a public place, where it may be seen by everyone, in the Salotta d'Oro in front of the Hall of the Council of Ten, over the door. About the same time, also, he painted for the Scuola of S. Maria della Carità Our Lady ascending the steps of the Temple, with heads of every kind portrayed from nature; and for the Scuola of S. Fantino, likewise, a little altar-piece of S. Jerome in Penitence, which was much extolled by the craftsmen, but was consumed by fire two years ago together with the whole church.

It is said that in the year 1530, the Emperor Charles V being in Bologna, Tiziano was invited to that city by Cardinal Ippolito de' Medici, through the agency of Pietro Aretino. There he made a most beautiful portrait of his Majesty in full armour, which so pleased him, that he caused a thousand crowns to be given to Tiziano; but of these he was obliged afterwards to give the half to the sculptor Alfonso Lombardi, who had made a model to be reproduced in marble.

Having returned to Venice, Tiziano found that a number of gentlemen, who had taken Pordenone into their favour, praising much the works exe-

COLORPLATE 80

Titian. *Portrait of Cardinal Pietro Bembo.* c. 1540. Canvas. 37 × 30″ (94 × 76 cm). National Gallery of Art, Washington, Samuel H. Kress Collection.

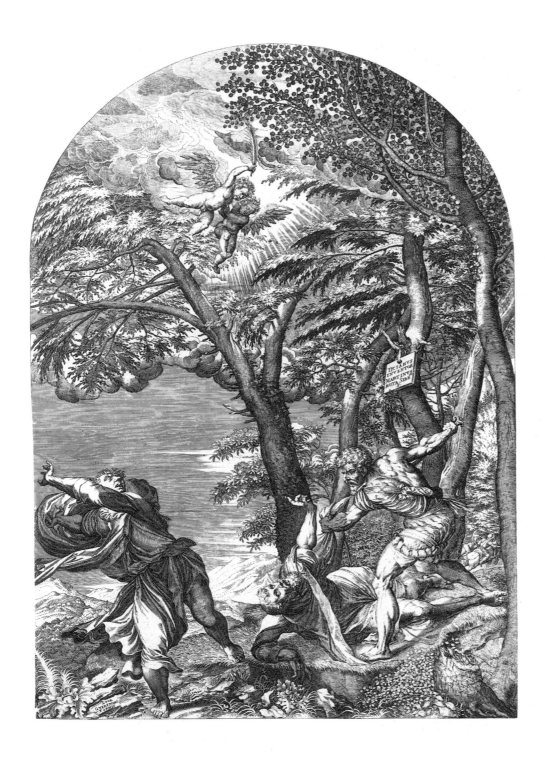

Martin Rota (after Titian). *Death of St. Peter Martyr.* Copperplate engraving. The Metropolitan Museum of Art; Purchase, Joseph Pulitzer Bequest, 1917.

cuted by him on the ceiling of the Sala de' Pregai and elsewhere, had caused a little altar-piece to be allotted to him in the Church of S. Giovanni Elemosinario, to the end that he might paint it in competition with Tiziano, who for the same place had painted a short time before the said S. Giovanni Elemosinario in the habit of a Bishop. But, for all the diligence that Pordenone devoted to that altar-piece, he was not able to equal or even by a great measure to approach the work of Tiziano. Next, Tiziano executed a most beautiful altar-picture of an Annunciation for the Church of S. Maria degli Angeli at Murano, but he who had caused it to be painted not being willing to spend five hundred crowns upon it, which Tiziano was asking, by the advice of Messer Pietro Aretino he sent it as a gift to the above-named Emperor Charles V, who, liking that work vastly, made him a present of two thousand crowns; and where that picture was to have been placed, there was set in its stead one by the hand of Pordenone. Nor had any long time passed when Charles V, returning to Bologna for a conference with Pope Clement, at the time when he came with his army from Hungary, desired to be portrayed again by Tiziano. Before de-

This painting was destroyed in the French Revolution.

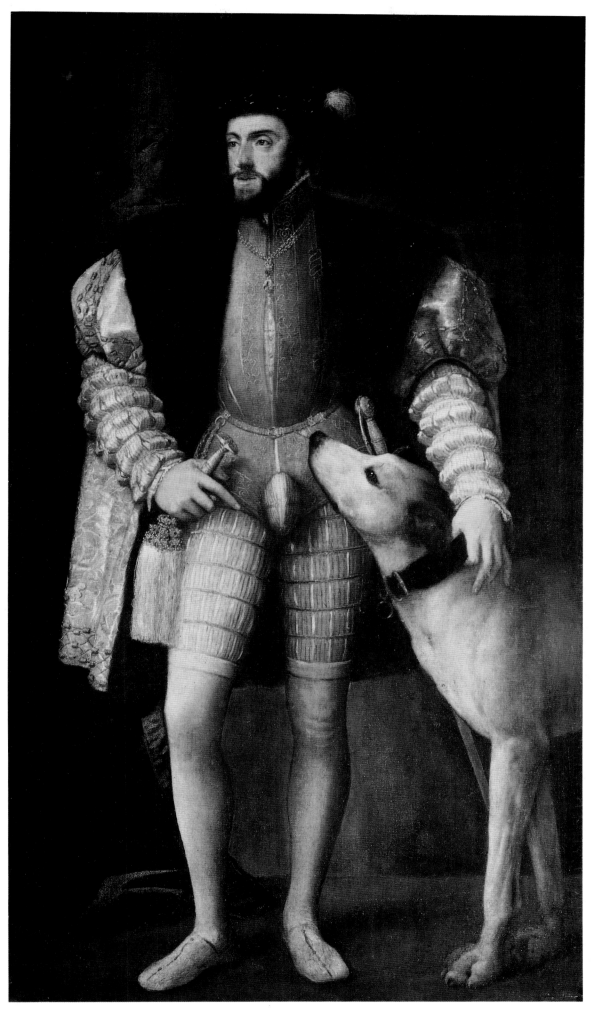

COLORPLATE 105. Titian. *Portrait of Charles V with a Hound*. 1532–33. Canvas.
75¾ × 43¾" (192 × 111 cm). The Prado, Madrid.

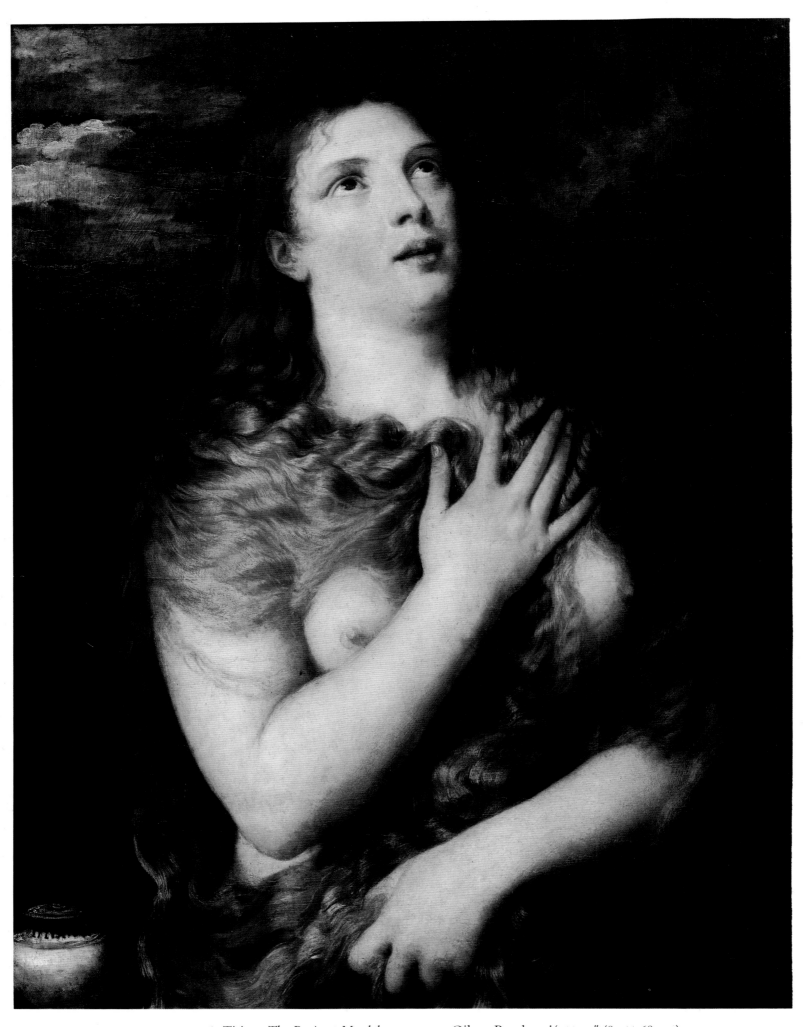

COLORPLATE 106. Titian. *The Penitent Magdalen*. c. 1533. Oil on Panel. 33½ × 27″ (85 × 68 cm).
Pitti Gallery, Florence.

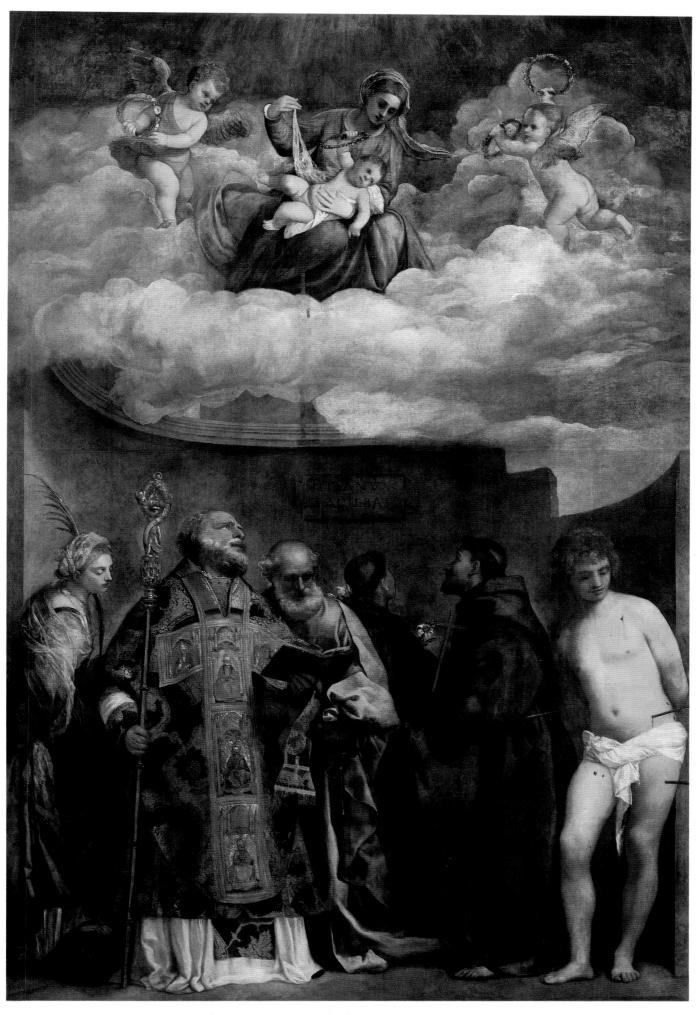

COLORPLATE 107. Titian. *Madonna and Child with Saints Sebastian and Francis.* C. 1535.
Oil on Panel. 133½ × 106¾″ (338 × 270 cm). Pinacoteca Vaticana, Rome.

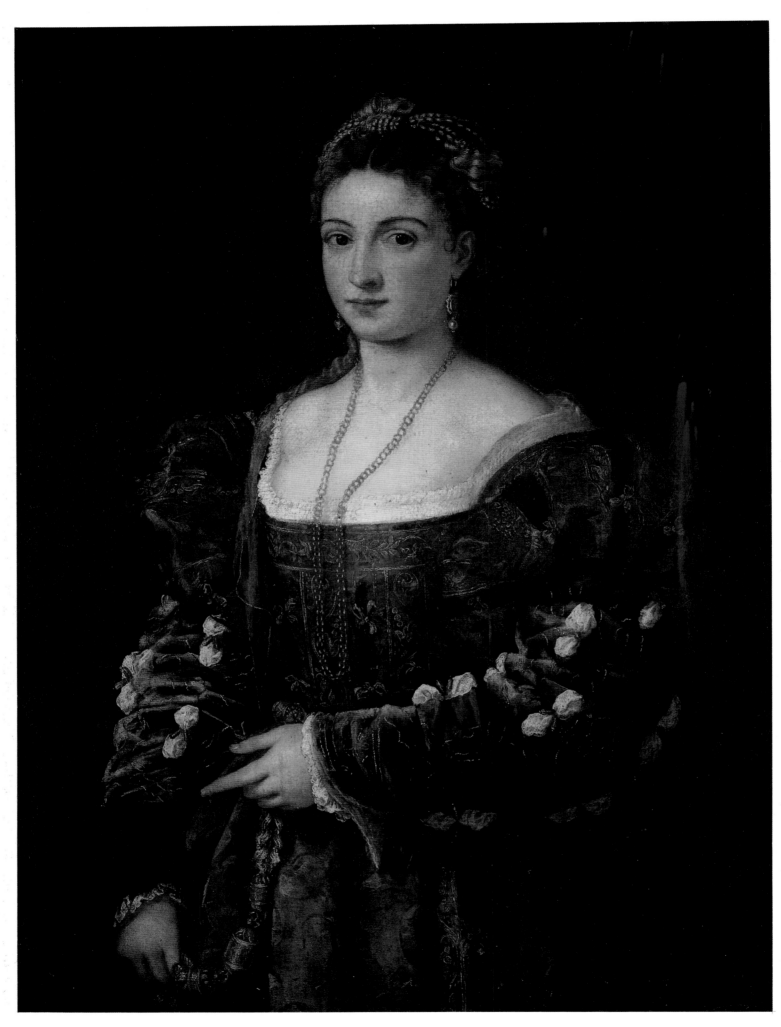

COLORPLATE 108. Titian. *La Bella*. 1535. Canvas. 39½ × 29¾″ (100 × 75 cm).
Pitti Gallery, Florence.

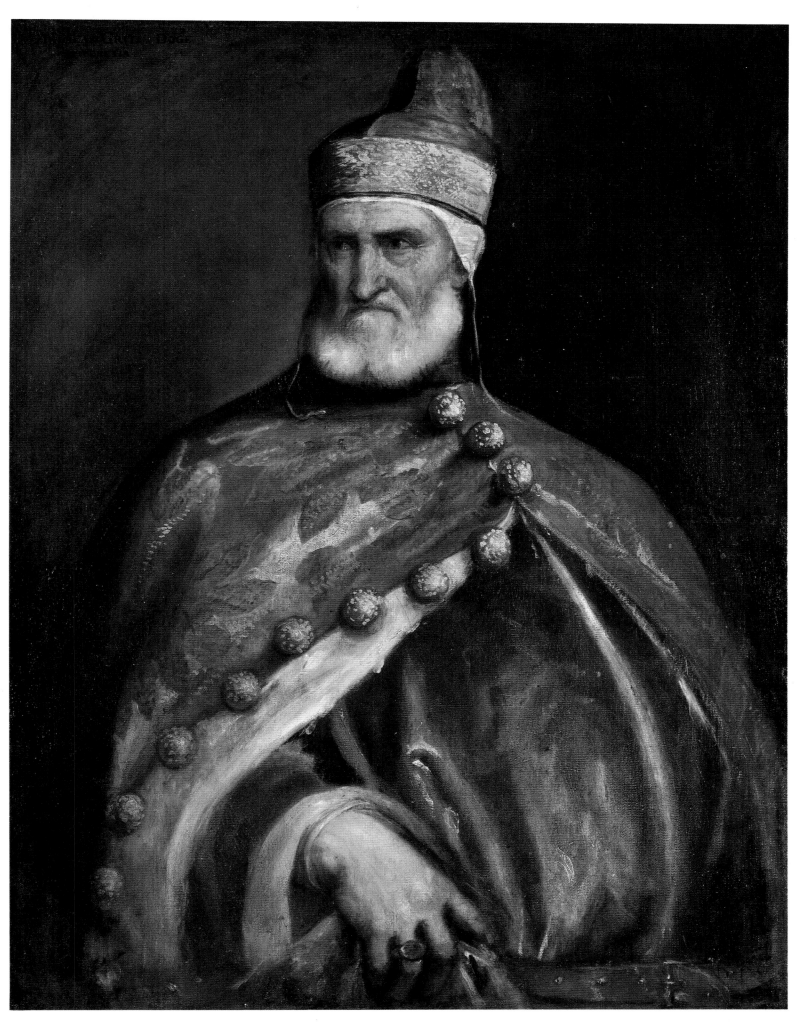

COLORPLATE 109. Titian. *Doge Andrea Gritti*. c. 1535–40. Canvas. 52½ × 40⅘″ (133.6 × 103.2 cm).
National Gallery of Art, Washington, Samuel H. Kress Collection.

COLORPLATE 110. Titian. *The Battle of Spoleto* (or *Cadore*). c. 1537. Black chalk and gray-brown wash, highlighted with white, on blue paper squared with black chalk. 15 × 17¼″ (383 × 446 mm). The Louvre, Paris.

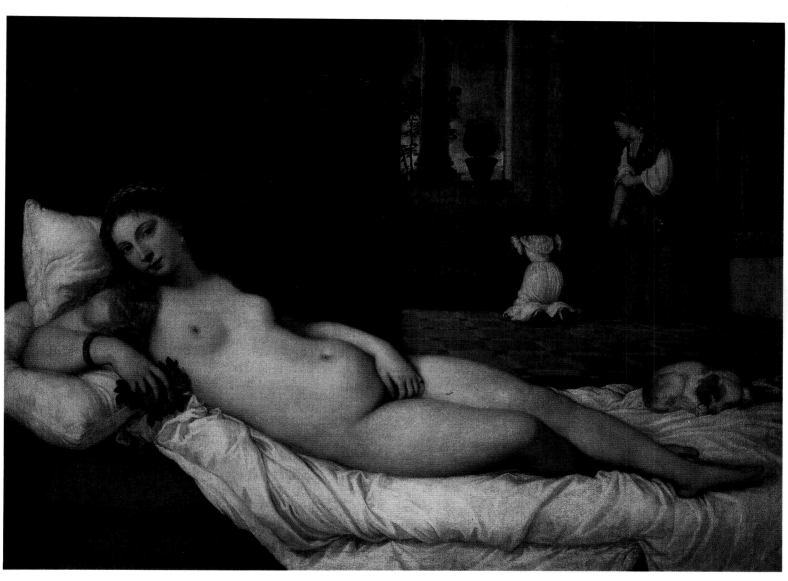

COLORPLATE III. Titian. *The Venus of Urbino*. 1538. Canvas. 47 × 65″ (119 × 165 cm).
Uffizi Gallery, Florence.

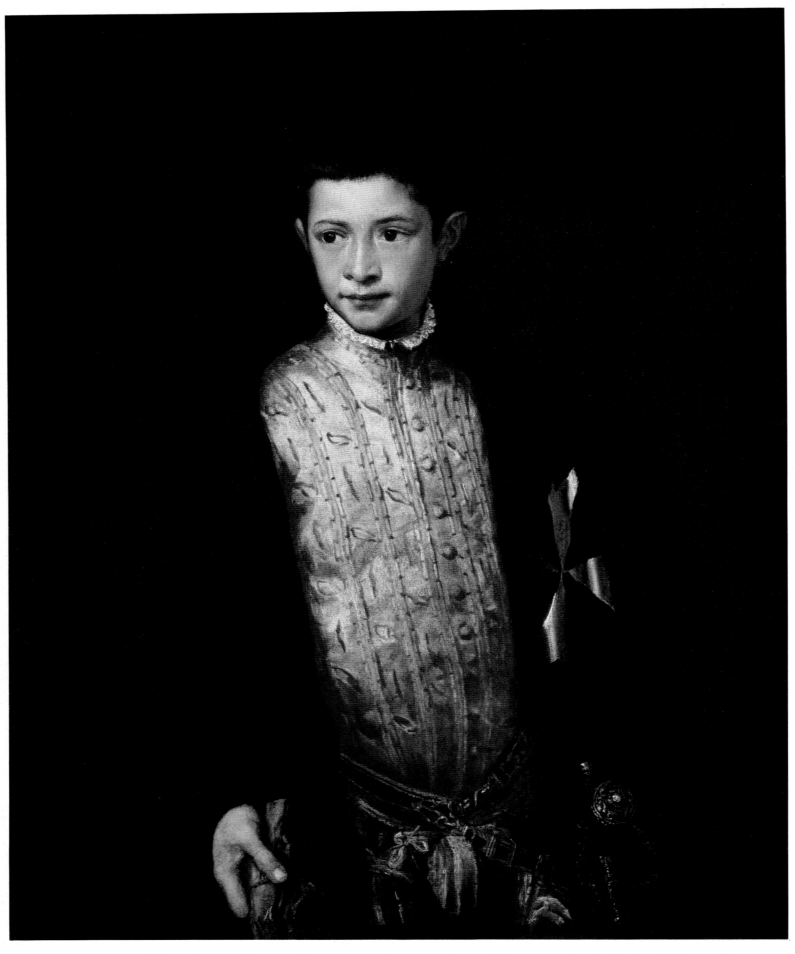

COLORPLATE 112. Titian. *Portrait of Ranuccio Farnese*. 1542. Canvas. 35¼ × 29″ (89.7 × 73.6 cm). National Gallery of Art, Washington, Samuel H. Kress Collection.

parting from Bologna, Tiziano also painted a portrait of the above-named Cardinal Ippolito de' Medici in Hungarian dress, and in a smaller picture the same man in full armour; both which portraits are now in the guardaroba of Duke Cosimo. At that same time he executed a portrait of Alfonso Davalos, Marchese del Vasto, and one of the above-named Pietro Aretino, who then contrived that he should become the friend and servant of Federigo Gonzaga, Duke of Mantua, with whom Tiziano went to his States and there painted a portrait of him, which is a living likeness, and then one of the Cardinal, his brother. These finished, he painted, for the adornment of a room among those of Giulio Romano, twelve figures from the waist upwards of the twelve Cæsars, very beautiful, beneath each of which the said Giulio afterwards painted a story from their lives.

In Cadore, his native place, Tiziano has painted an altar-picture wherein are Our Lady, S. Tiziano the Bishop, and a portrait of himself kneeling. In the year when Pope Paul III went to Bologna, and from there to Ferrara, Tiziano, having gone to the Court, made a portrait of that Pope, which was a very beautiful work, and from it another for Cardinal S. Fiore; and both these portraits, for which he was very well paid by the Pope, are in Rome, one in the guardaroba of Cardinal Farnese, and the other in the possession of the heirs of the

The suite of paintings on the twelve Caesars vanished in the mid-seventeenth century. All, however, were engraved; and one is reproduced on page 358.

Titian. *Portrait of Cardinal Ippolito de' Medici in Hungarian Costume.* 1532–33. Canvas. 54¼ × 41¾" (138 × 106 cm). Pitti Gallery, Florence.

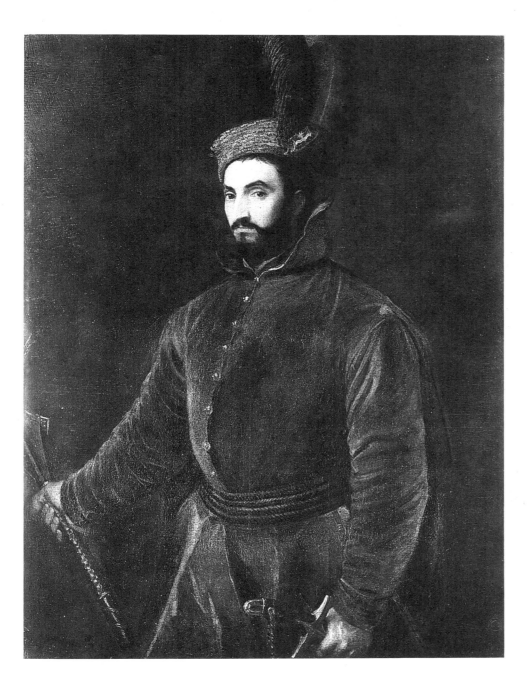

above-named Cardinal S. Fiore, and from them have been taken many copies, which are dispersed throughout Italy. At this same time, also, he made a portrait of Francesco Maria, Duke of Urbino, which was a marvellous work; wherefore M. Pietro Aretino on this account celebrated him in a sonnet that began:

> If radiant Apelles with the hand of Art
> Depicts the face and breast of Alexander. . . .

There are in the guardaroba of the same Duke, by the hand of Tiziano, two most lovely heads of women, and a young recumbent Venus with flowers and certain light draperies about her, very beautiful and well finished; and, in addition, a figure of S. Mary Magdalene with the hair all loose, which is a rare work. There, likewise, are the portraits of Charles V, King Francis as a young man, Duke Guidobaldo II, Pope Sixtus IV, Pope Julius II, Paul III, the old Cardinal of Lorraine, and Suleiman Emperor of the Turks; which portraits, I

COLORPLATE 111

COLORPLATE 106

D. OCT. AVGVSTVS.

II.

Dum rata maestati nitor remanere, tuorque
 Acta Patris, dignum tum gero laude nihil;
Nilque quod emineat supra ac nos euehat istam,
 Quae mihi bellorum laus socianda venit.

Ad famam imperiumque sibi iam Julius armis
 Strauit iter: Trita currere vila via est.
Ista noua, ac maior fuerit mihi gloria, Janum
 Extinctis bellis sub domuisse sera.

Ægidius Sadeler S. C. M. sculp. Titianus inuentor. Marcus Sadeler excudit.

Egidio Sadeler (after Titian). *Octavius Augustus* (from the Twelve Caesars series). Copperplate engraving. Rijksmuseum, Amsterdam.

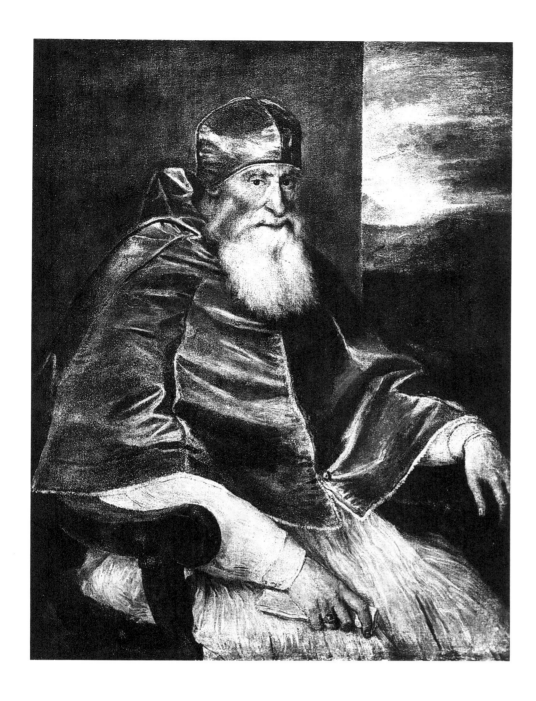

Titian. *Portrait of Pope Paul III.* 1545–46.
Canvas. 42 ½ × 31 ½″ (108 × 80 cm).
Museo e Gallerie Nazionali di
Capodimonte, Naples.

say, are by the hand of Tiziano, and most beautiful. In the same guardaroba,
besides many other things, is a portrait of Hannibal the Carthaginian, cut in
intaglio in an antique cornelian, and also a very beautiful head in marble by the
hand of Donato.

In the year 1541 Tiziano painted for the Friars of S. Spirito, in Venice, the
altar-piece of their high-altar, figuring in it the Descent of the Holy Spirit upon
the Apostles, with a God depicted as of fire, and the Spirit as a Dove; which
altar-piece becoming spoiled in no long time, after having many disputes with
those friars he had to paint it again, and it is that which is over the altar at the
present day. For the Church of S. Nazzaro in Brescia he executed the altar-piece
of the high-altar in five pictures; in the central picture is Jesus Christ returning
to life, with some soldiers around, and at the sides are S. Nazzaro, S. Sebas-
tian, the Angel Gabriel, and the Virgin receiving the Annunciation. In a pic-
ture for the wall at the entrance of the Duomo of Verona, he painted an
Assumption of Our Lady into Heaven, with the Apostles on the ground, which
is held to be the best of the modern works in that city. In the year 1541 he made
the portrait of Don Diego di Mendoza, at that time Ambassador of Charles V
in Venice, a whole-length figure and standing, which was very beautiful; and
from this Tiziano began what has since come into fashion, the making of cer-

Some of these portraits no longer survive.
Charles V, King of Spain and Holy
Roman Emperor (1500–1588). He was
crowned king in 1516 and elected emperor
in 1519.

COLORPLATE 103

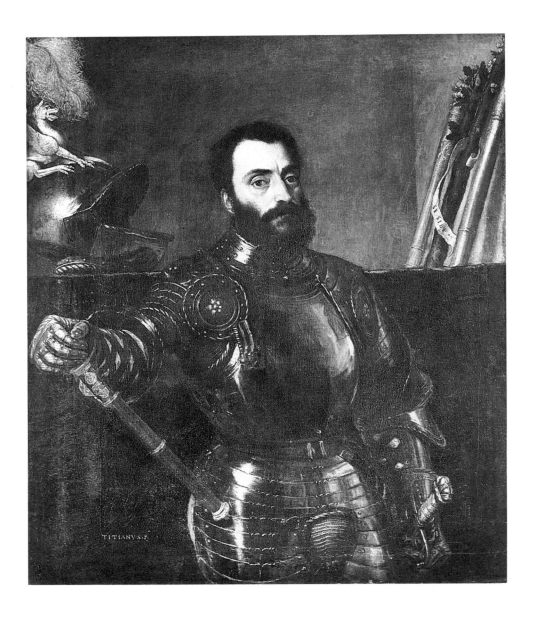

Titian. *Portrait of Francesco Maria della Rovere, Duke of Urbino*. 1536–38. Canvas. 44¾ × 39½″ (114 × 100 cm). Uffizi Gallery, Florence.

tain portraits of full length. In the same manner he painted that of the Cardinal of Trento, then a young man, and for Francesco Marcolini the portrait of Messer Pietro Aretino, but this last was by no means as beautiful as one of that poet, likewise by the hand of Tiziano, which Aretino himself sent as a present to Duke Cosimo de' Medici, to whom he sent also the head of Signor Giovanni de' Medici, the father of the said Lord Duke. That head was copied from a cast taken from the face of that lord when he died at Mantua, which was in the possession of Aretino; and both these portraits are in the guardaroba of the same Lord Duke, among many other most noble pictures.

The same year, Vasari having been thirteen months in Venice to execute, as has been related, a ceiling for Messer Giovanni Cornaro, and some works for the Company of the Calza, Sansovino, who was directing the fabric of S. Spirito, had commissioned him to make designs for three large pictures in oils which were to go into the ceiling, to the end that he might execute them in painting; but, Vasari having afterwards departed, those three pictures were allotted to Tiziano, who executed them most beautifully, from his having contrived with great art to make the figures foreshortened from below upwards. In one is Abraham sacrificing Isaac, in another David severing the neck of Goliath, and in the third Abel slain by his brother Cain. About the same time Tiziano painted a portrait of himself, in order to leave that memory of himself to his children.

The year 1546 having come, he went at the invitation of Cardinal Farnese

to Rome, where he found Vasari, who, having returned from Naples, was executing the Hall of the Cancelleria for the above-named Cardinal; whereupon, Tiziano having been recommended by that lord to Vasari, Giorgio kept him company lovingly in taking him about to see the sights of Rome. And then, after Tiziano had rested for some days, rooms were given to him in the Belvedere, to the end that he might set his hand to painting once more the portrait of Pope Paul, of full length, with one of Farnese and one of Duke Ottavio, which he executed excellently well and much to the satisfaction of those lords. At their persuasion he painted, for presenting to the Pope, a picture of Christ from the waist upwards in the form of an "Ecce Homo," which work, whether it was that the works of Michelagnolo, Raffaello, Polidoro, and others had made him lose some force, or for some other reason, did not appear to the painters, although it was a good picture, to be of the same excellence as many others by his hand, and particularly his portraits. Michelagnolo and Vasari, going one day to visit Tiziano in the Belvedere, saw in a picture that he had executed at that time a nude woman representing Danaë, who had in her lap Jove transformed into a rain of gold; and they praised it much, as one does in the painter's presence. After they had left him, discoursing of Tiziano's method, Buonarroti commended it not a little, saying that his colouring and his manner much pleased him, but that it was a pity that in Venice men did not learn to draw well from the beginning, and that those painters did not pursue a better method in their studies. "For," he said, "if this man had been in any way assisted by art and design, as he is by nature, and above all in counterfeiting the

COLORPLATE 114

In Greek mythology, Danae was the mother of Perseus, slayer of the Medusa.

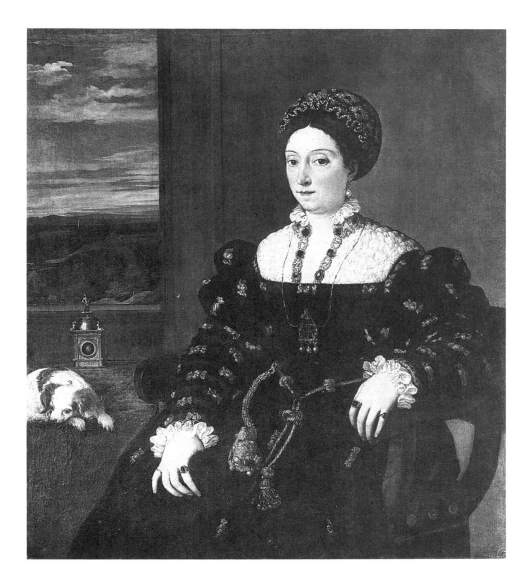

Titian. *Portrait of Eleanora Gonzaga, Duchess of Urbino.* 1538. Canvas. 44¾ × 40½" (114 × 102 cm). Uffizi Gallery, Florence.

life, no one could do more or work better, for he has a fine spirit and a very beautiful and lively manner." And in fact this is true, for the reason that he who has not drawn much nor studied the choicest ancient and modern works, cannot work well from memory by himself or improve the things that he copies from life, giving them the grace and perfection wherein art goes beyond the scope of nature, which generally produces some parts that are not beautiful.

Tiziano, finally departing from Rome, with many gifts received from those lords, and in particular a benefice of good value for his son Pomponio, set himself on the road to return to Venice, after Orazio, his other son, had made a portrait of Messer Battista Ceciliano, an excellent player on the bass-viol, which was a very good work, and he himself had executed some other portraits for Duke Guidobaldo of Urbino. Arriving in Florence, and seeing the rare works of that city, he was amazed by them no less than he had been by those of Rome. And besides that, he visited Duke Cosimo, who was at Poggio a Caiano, offering to paint his portrait; to which his Excellency did not give much heed, perchance in order not to do a wrong to the many noble craftsmen of his city and dominion.

Then, having arrived in Venice, Tiziano finished for the Marchese del Vasto an Allocution (for so they called it) made by that lord to his soldiers; and after that he took the portrait of Charles V, that of the Catholic King, and many others. These works finished, he painted a little altar-piece of the Annunciation for the Church of S. Maria Nuova in Venice; and then, employing the as-

An allocution is a solemn speech or address.

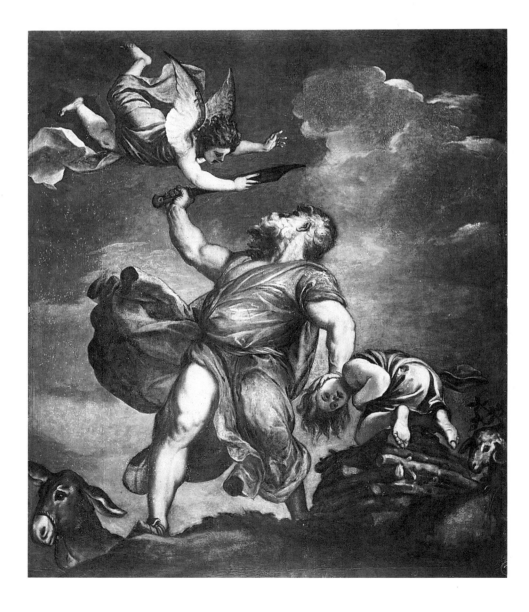

Titian. *The Sacrifice of Isaac.* 1542–44. Canvas. 118½ × 110½" (320 × 280 cm). Sacristy, Church of Santa Maria della Salute, Venice.

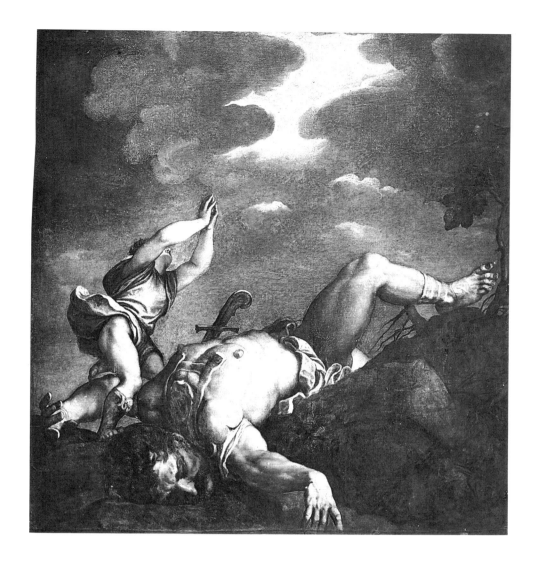

Titian. *David and Goliath*. 1542–44. Canvas. 110½ × 110½" (280 × 280 cm). Sacristy, Church of Santa Maria della Salute, Venice.

sistance of his young men, he executed a Last Supper in the refectory of SS. Giovanni e Polo, and for the high-altar of the Church of S. Salvadore an altarpiece in which is a Christ Transfigured on Mount Tabor, and for another altar in the same church a Madonna receiving the Annunciation from the Angel. But these last works, although there is something of the good to be seen in them, are not much esteemed by him, and have not the perfection that his other pictures have. And since the works of Tiziano are without number, and particularly the portraits, it is almost impossible to make mention of them all; wherefore I shall speak only of the most remarkable, but without order of time, it being of little import to know which was first and which later. Several times, as has been related, he painted the portrait of Charles V, and in the end he was summoned for that purpose to the Court, where he portrayed him as he was in those his later years; and the work of Tiziano so pleased that all-conquering Emperor, that after he had once seen it he would not be portrayed by other painters. Each time that he painted him, he received a thousand crowns of gold as a present, and he was made by his Majesty a Chevalier, with a revenue of two hundred crowns on the Chamber of Naples. In like manner, when he portrayed Philip, King of Spain, the son of Charles, he received from him a fixed allowance of two hundred crowns more; insomuch that, adding those four hundred to the three hundred that he has on the Fondaco de' Tedeschi from the Signori of Venice, he has without exerting himself a fixed income of seven hundred crowns every year. Of the same Charles V and King Philip Tiziano sent portraits to the Lord Duke Cosimo, who has them in his guardaroba. He portrayed Ferdinand, King of the Romans, who afterwards became Emperor, and both his sons, Maximilian, now Emperor, and his brother. He also por-

The Last Supper *was destroyed by fire in 1571.*

COLORPLATE 106

Philip II (1577–1598), king of Spain, who ascended the throne after his father, Charles V, abdicated and retired to the Monastery of San Jeronimo de Yuste in Estramadura. Philip married Mary Tudor (Bloody Mary) in 1554. In 1588 he launched the unsuccessful Armada against the England of Elizabeth I.

Ferdinand I (1503–1564), Holy Roman Emperor from 1556. Maximilian II (1527–1576), emperor from 1564. Some of these portraits have been lost.

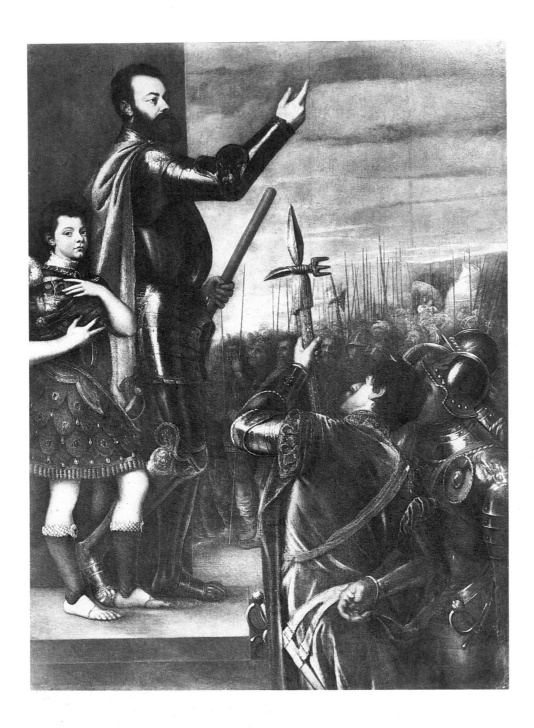

Titian. *The Allocution of Alfonso d'Avalos.*
1540–41. Canvas. 88 × 65″ (223 × 165 cm).
The Prado, Madrid.

trayed Queen Maria, and, for the Emperor Charles V, the Duke of Saxony
when he was a prisoner. But what a waste of time is this? There has been scarce
a single lord of great name, or Prince, or great lady, who has not been por-
trayed by Tiziano, a painter of truly extraordinary excellence in this field of art.
He painted portraits of King Francis I of France, as has been related, Francesco
Sforza, Duke of Milan, the Marquis of Pescara, Antonio da Leva, Massimiano
Stampa, Signor Giovan Battista Castaldo, and other lords without number.

In like manner, besides the works mentioned above, at various times he has
executed many others. In Venice, by order of Charles V, he painted in a
great altar-piece the Triune God enthroned, Our Lady and the Infant Christ,
with the Dove over Him, and the ground all of fire, signifying Love; and the
Father is surrounded by fiery Cherubim. On one side is the same Charles V,
and on the other the Empress, both clothed in linen garments, with the hands
clasped in the attitude of prayer, among many Saints; all which was after the
command of the Emperor, who, at that time at the height of his victories, be-
gan to show that he was minded to retire from the things of this world, as he
afterwards did, in order to die like a true Christian, fearing God and desirous

COLORPLATE 116

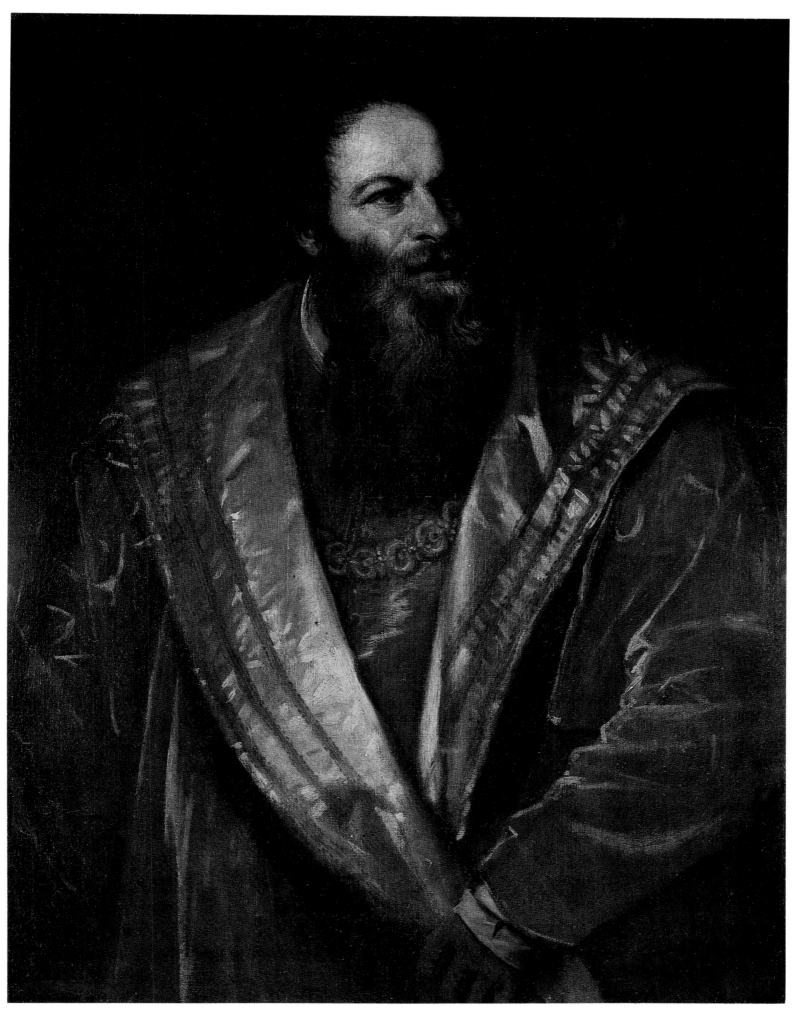

COLORPLATE 113. Titian. *Portrait of Pietro Aretino*. c. 1545. Canvas. 39 × 30¾″ (98 × 78 cm).
Pitti Gallery, Florence.

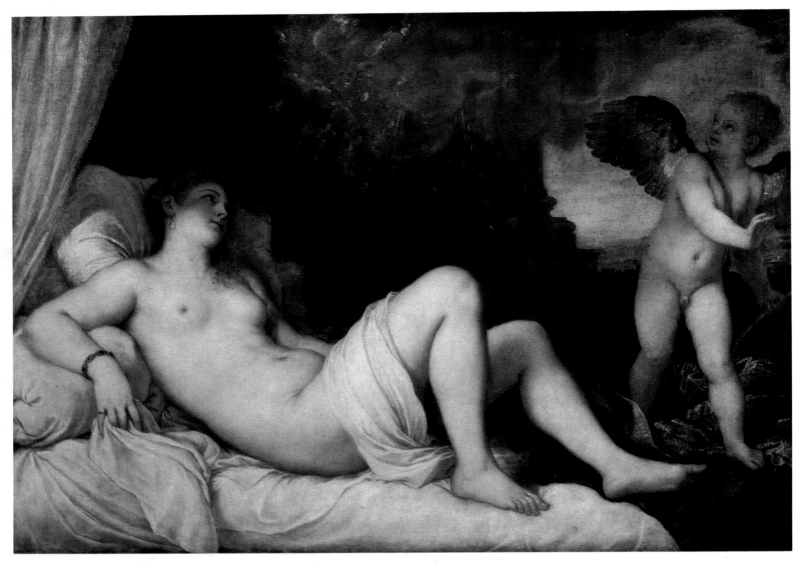

COLORPLATE 114. Titian. *Danae*. 1545–46. Canvas. 47½ × 67¾″ (120 × 172 cm).
Museo e Gallerie Nazionali di Capodimonte, Naples.

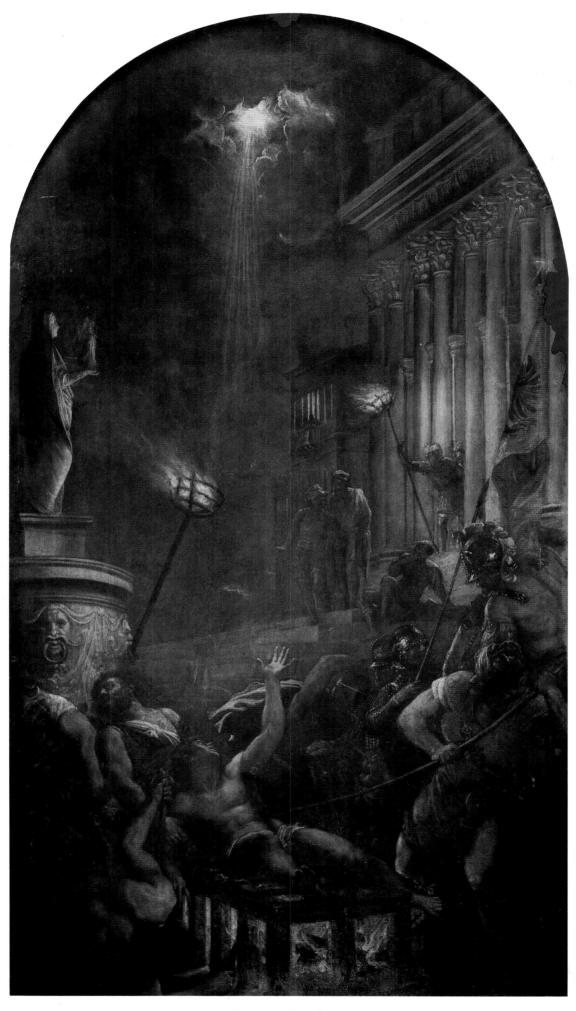

COLORPLATE 115. Titian. *The Martyrdom of St. Lawrence*. 1548–59. Canvas.
197½ × 110½″ (500 × 280 cm). Church of the Gesuiti, Venice.

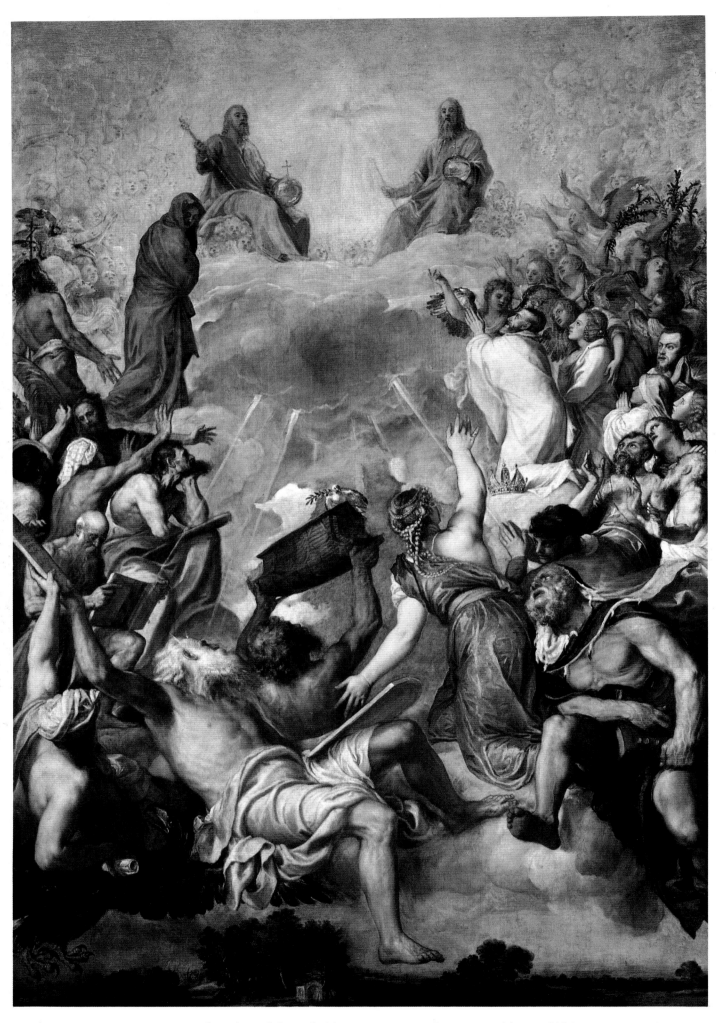

COLORPLATE 116. Titian. *The Glory of the Holy Trinity*. 1551–54. Canvas. 140½ × 94¾″ (346 × 240 cm).
The Prado, Madrid.

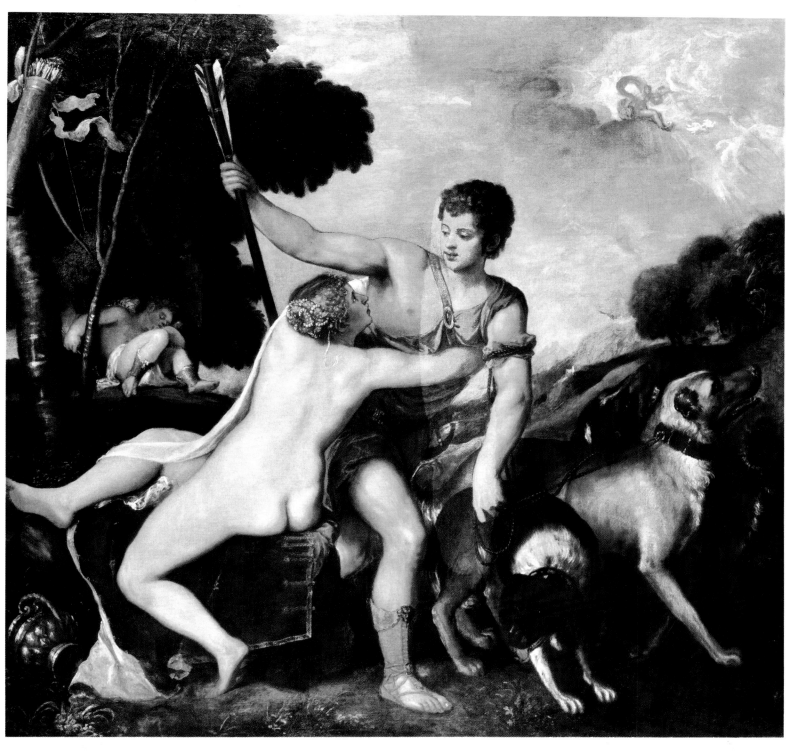

COLORPLATE 117. Titian. *Venus and Adonis*. c. 1554. Canvas. 69¾ × 73¾″ (177.1 × 187.2 cm).
The National Gallery, London.

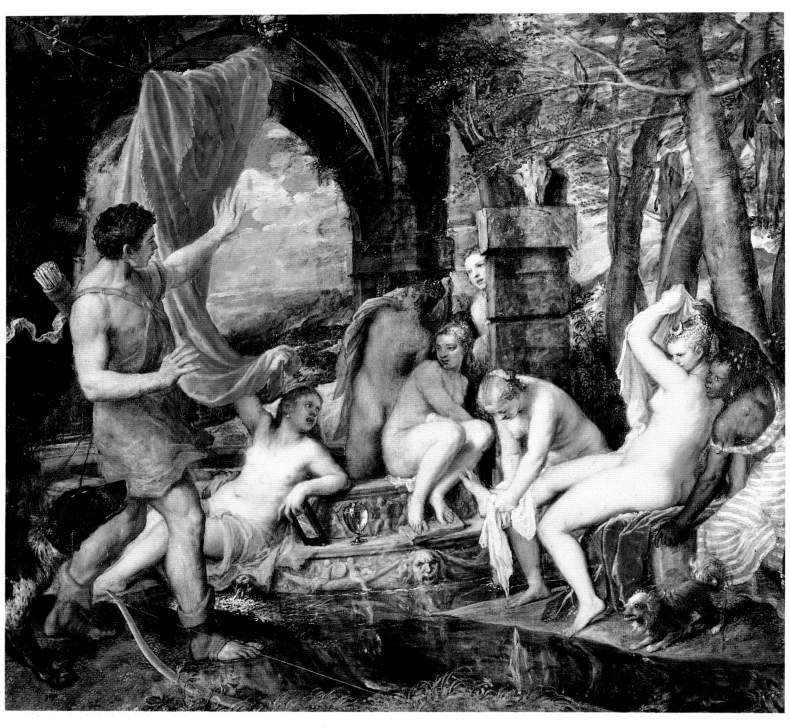

COLORPLATE 118. Titian. *Diana and Actaeon*. 1556–59. Canvas. 43 × 81¾″ (109.3 × 207 cm).
National Gallery of Scotland, Edinburgh.

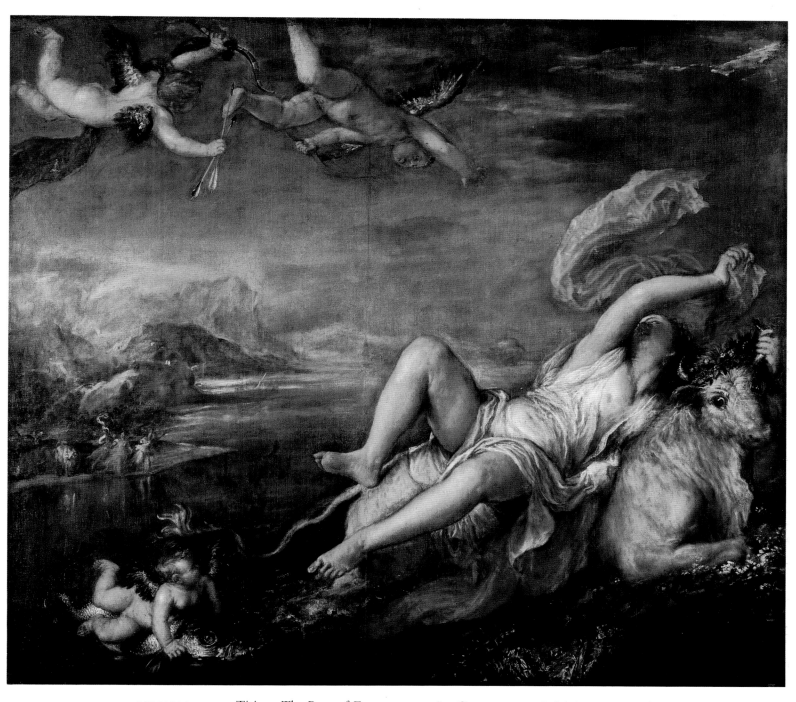

COLORPLATE 119. Titian. *The Rape of Europa*. 1559–62. Canvas. 73 × 81″ (185 × 205 cm).
Isabella Stewart Gardner Museum, Boston.

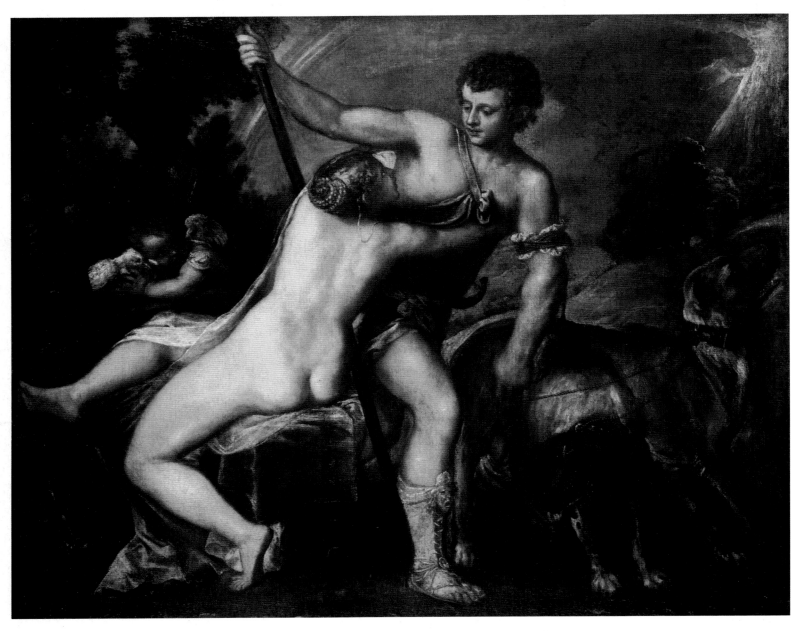

COLORPLATE 120. Titian. *Venus and Adonis*. c. 1560. Canvas. 42 × 53 ½″ (106.8 × 136.0 cm).
National Gallery of Art, Washington, Widener Collection.

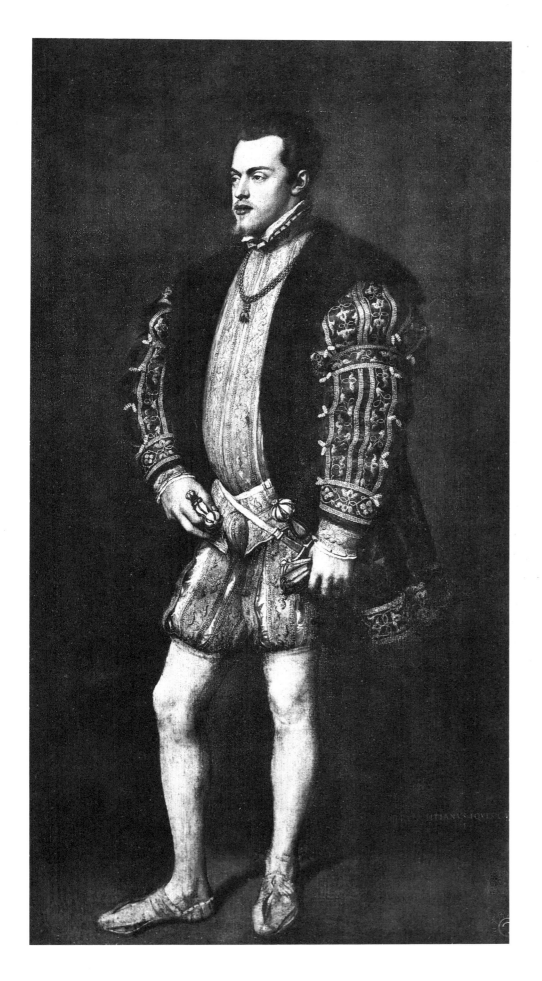

Titian. *Portrait of Philip II*. 1553. Canvas.
73½ × 39½″ (187 × 100 cm). Museo e
Gallerie Nazionali di Capodimonte, Naples.

of his own salvation. Which picture the Emperor said to Tiziano that he wished
to place in the monastery wherein afterwards he finished the course of his life;
and since it is a very rare work, it is expected that it may soon be published in
engravings. The same Tiziano executed for Queen Maria a Prometheus who

*The monastery is that of San Jeronimo de
Yuste, in Estremadura, Spain.*

373

is bound to Mount Caucasus and torn by Jove's Eagle, a Sisyphus in Hell who is toiling under his stone, and Tityus devoured by the Vulture. These her Majesty received, excepting the Prometheus, and with them a Tantalus of the same size (namely, that of life), on canvas and in oils. He executed, also, a Venus and Adonis that are marvellous, she having swooned, and the boy in the act of rising to leave her, with some dogs about him that are very natural. On a panel of the same size he represented Andromeda bound to the rock, and Perseus delivering her from the Sea-Monster, than which picture none could be more lovely; as is also another of Diana, who, bathing in a fount with her Nymphs, transforms Actæon into a stag. He also painted Europa passing over the sea on the back of the Bull. All these pictures are in the possession of the Catholic King, held very dear for the vivacity that Tiziano has given to the figures with his colours, making them natural and as if alive.

It is true, however, that the method of work which he employed in these last pictures is no little different from the method of his youth, for the reason

COLORPLATE 117

There are at least four versions of the Venus and Adonis *in existence.*

COLORPLATE 118
COLORPLATE 119

Titian. *Perseus and Andromeda.* c. 1554–56. Canvas. 69 × 75½″ (175 × 192 cm). The Wallace Collection, London.

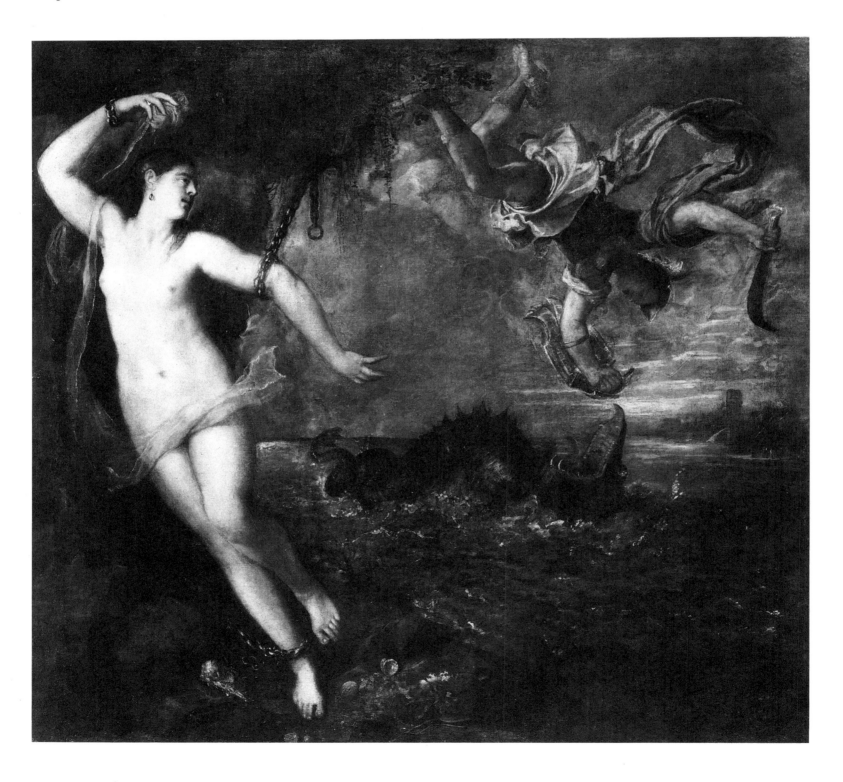

374

that the early works are executed with a certain delicacy and a diligence that are incredible, and they can be seen both from near and from a distance, and these last works are executed with bold strokes and dashed off with a broad and even coarse sweep of the brush, insomuch that from near little can be seen, but from a distance they appear perfect. This method has been the reason that many, wishing to imitate him therein and to play the practised master, have painted clumsy pictures; and this happens because, although many believe that they are done without effort, in truth it is not so, and they deceive themselves, for it is known that they are painted over and over again, and that he returned to them with his colors so many times, that the labour may be perceived. And this method, so used, is judicious, beautiful, and astonishing, because it makes pictures appear alive and painted with great art, but conceals the labour.

Tiziano painted recently in a picture three braccia high and four braccia broad, Jesus Christ as an Infant in the lap of Our Lady and adored by the Magi, with a good number of figures of one braccio each, which is a very lovely work, as is also another picture that he himself copied from that one and gave to the old Cardinal of Ferrara. Another picture, in which he depicted Christ mocked by the Jews, which is most beautiful, was placed in a chapel of the Church of S. Maria delle Grazie, in Milan. For the Queen of Portugal he painted a picture of a Christ scourged by Jews at the Column, a little less than the size of life, which is very beautiful. For the high-altar of S. Domenico, at Ancona, he painted an altar-piece with Christ on the Cross, and at the foot Our Lady, S. John, and S. Dominic, all most beautiful, and executed in his later manner with broad strokes, as has just been described above. And by the same hand, in the Church of the Crocicchieri at Venice, is the picture that is on the altar of S. Lorenzo, wherein is the martyrdom of that Saint, with a building full of figures, and S. Laurence lying half upon the gridiron, in foreshortening, with a great fire beneath him, and about it some who are kindling it. And since he counterfeited an effect of night, there are two servants with torches in their hands, which throw light where the glare of the fire below the gridiron does not reach, which is piled high and very fierce. Besides this, he depicted a lightning-flash, which, darting from Heaven and cleaving the clouds, overcomes the light of the fire and that of the torches, shining over the Saint and the other principal figures, and, in addition to those three lights, the figures that he painted in the distance at the windows of the building have the light of lamps and candles that are near them; and all, in short, is executed with beautiful art, judgment, and genius. In the Church of S. Sebastiano, on the altar of S. Niccolò, there is by the hand of the same Tiziano a little altar-piece of a S. Nicholas who appears as if alive, seated in a chair painted in the likeness of stone, with an Angel that is holding his mitre; which work he executed at the commission of Messer Niccolò Crasso, the advocate. Tiziano afterwards painted, for sending to the Catholic King, a figure of S. Mary Magdalene from the middle of the thighs upwards, all dishevelled; that is, with the hair falling over the shoulders, about the throat, and over the breast, the while that, raising the head with the eyes fixed on Heaven, she reveals remorse in the redness of the eyes, and in her tears repentance for her sins. Wherefore the picture moves mightily all who behold it; and, what is more, although she is very beautiful, it moves not to lust but to compassion. This picture, when it was finished, so pleased . . . Silvio, a Venetian gentleman, that in order to have it, being one who takes supreme delight in painting, he gave Tiziano a hundred crowns: wherefore Tiziano was forced to paint another, which was not less beautiful, for sending to the above-named Catholic King.

There are also to be seen portraits from life by Tiziano of a Venetian citizen called Sinistri, who was much his friend, and of another named M. Paolo da Ponte, for whom he likewise portrayed a daughter that he had at that time, a most beautiful young woman called Signora Giulia da Ponte, a dear friend of

If the Florentine braccia (23 inches) is meant, about 69 inches high by 98 inches wide.

COLORPLATE 115

The "Catholic King" is Charles V.

375

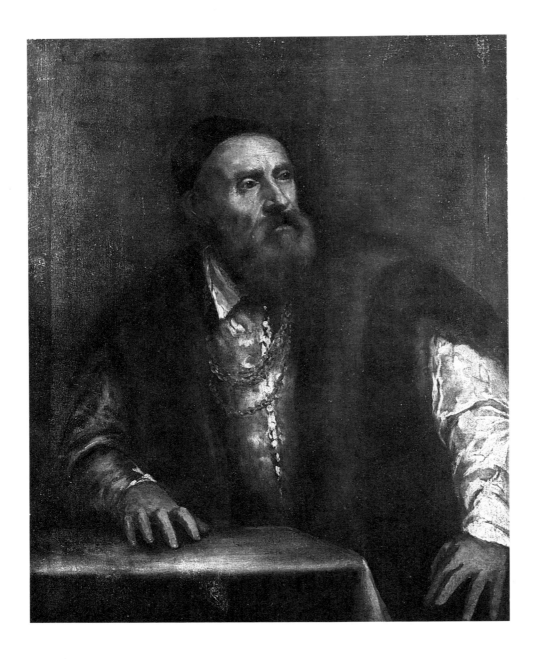

Titian. *Self-Portrait.* c. 1562. Canvas. 37¾ × 29½" (96 × 75 cm). Gemäldegalerie, Staatliche Museen, Berlin.

Tiziano; and in like manner Signora Irene, a very lovely maiden, skilled in letters and music and a student of design, who, dying about seven years ago, was celebrated by the pens of almost all the writers of Italy. He portrayed M. Francesco Filetto, an orator of happy memory, and in the same picture, before him, his son, who seems as if alive; which portrait is in the house of Messer Matteo Giustiniani, a lover of these arts, who has also had a picture painted for himself by the painter Jacopo da Bassano, which is very beautiful, as also are many other works by that Bassano which are dispersed throughout Venice, and held in great price, particularly his little works and animals of every kind. Tiziano portrayed Bembo another time (namely, after he became a Cardinal), Fracastoro, and Cardinal Accolti of Ravenna, which last portrait Duke Cosimo has in his guardaroba; and our Danese, the sculptor, has in his house at Venice a portrait by the hand of Tiziano of a gentleman of the Delfini family. There may be seen portraits by the same hand of M. Niccolò Zono, of Rossa, wife of the Grand Turk, at the age of sixteen, and of Cameria, her daughter, with most beautiful dresses and adornments. In the house of M. Francesco Sonica, an advocate and a gossip of Tiziano, is a portrait by his hand of that M. Francesco, and in a large picture Our Lady flying to Egypt, who is seen to have dismounted from the ass and to have seated herself upon a stone on the road, with S. Joseph beside her, and a little S. John who is offering to the Infant Christ some flowers picked by the hand of an Angel from the branches of a tree that

"Signora Irene" is Irene Spilembergo, who was a pupil of Titian's.

Many of these portraits are now lost, or are no longer attributed to Titian.

is in the middle of a wood full of animals, where in the distance the ass stands grazing. That picture, which is full of grace, the said gentleman has placed at the present day in a palace that he has built for himself at Padua, near S. Giustina. In the house of a gentleman of the Pisani family, near S. Marco, there is by the hand of Tiziano the portrait of a gentlewoman, which is a marvellous thing. And having made for Monsignor Giovanni della Casa, the Florentine, who has been illustrious in our times both for nobility of blood and as a man of letters, a very beautiful portrait of a gentlewoman whom that lord loved while he was in Venice, Tiziano was rewarded by being honored by him with the lovely sonnet that begins—

> *Clearly do I see, O Titian, my beloved,*
> *Who turns and opens her fairest eyes. . . .*

Finally, this excellent painter sent to the above-named Catholic King a Last Supper of Christ with the Apostles, in a picture seven braccia long, which was a work of extraordinary beauty.

In addition to the works described and many others of less merit executed by this man, which are omitted for the sake of brevity, he has in his house, sketched in and begun, the following: the Martyrdom of S. Laurence, similar to that described above, and destined by him for sending to the Catholic King; a great canvas wherein is Christ on the Cross, with the Thieves, and at the foot

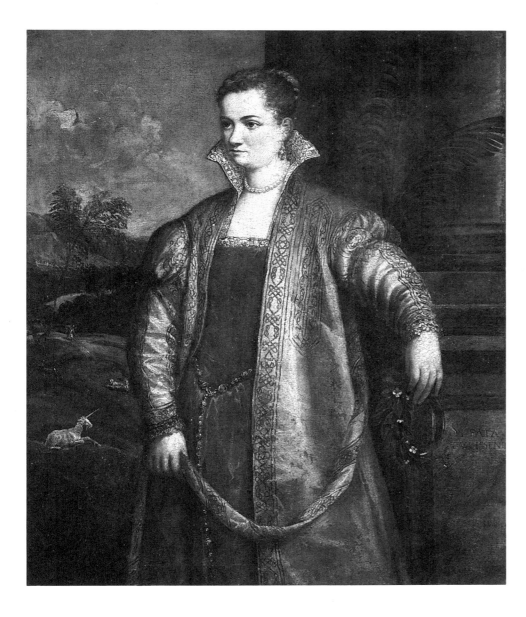

Follower of Titian. *Presumed Portrait of Irene de Spilimbergo*. Updated. Canvas. 48 × 42″ (122 × 106.5 cm). National Gallery of Art, Washington, Widener Collection.

the ministers of the crucifixion, which he is painting for Messer Giovanni d' Anna; and a picture which was begun for the Doge Grimani, father of the Patriarch of Aquileia. And for the Hall of the Great Palace of Brescia he has made a beginning with three large pictures that are to go in the ornamentation of the ceiling, as has been related in speaking of Cristofano and his brother, painters of Brescia. He also began, many years ago, for Alfonso I, Duke of Ferrara, a picture of a nude young woman bowing before Minerva, with another figure at the side, and a sea in the centre of which, in the distance, is Neptune in his car; but through the death of that lord, after whose fancy the work was being executed, it was not finished, and remained with Tiziano. He has also carried well forward, but not finished, a picture wherein is Christ appearing to Mary Magdalene in the Garden in the form of a gardener, with figures the size of life; another, also, of equal size, in which the Madonna and the other Maries being present, the Dead Christ is laid in the Sepulchre; likewise a picture of Our Lady, which is one of the best things that are in that house, and, as has been told, a portrait of himself that was finished by him four years ago, very beautiful and natural, and finally a S. Paul who is reading, a half-length figure, which has all the appearance of the real Saint filled with the Holy Spirit.

COLORPLATE 99

COLORPLATE 104

All these works, I say, he has executed, with many others that I omit in order not to be wearisome, up to his present age of about seventy-six years. Tiziano has been very sound in health, and as fortunate as any man of his kind has ever been; and he has not received from Heaven anything save favours and blessings. In his house at Venice have been all the Princes, men of letters and persons of distinction who have gone to that city or lived there in his time, because, in addition to his excellence in art, he has shown great gentleness, beautiful breeding, and most courteous ways and manners. He has had in Venice some competitors, but not of much worth, so that he has surpassed them easily with the excellence of his art and with his power of attaching himself and making himself dear to the men of quality. He has earned much, for he has been very well paid for his works; but it would have been well for him in these his last years not to work save as a pastime, so as not to diminish with works of less excellence the reputation gained in his best years, when his natural powers were not declining and drawing towards imperfection. When Vasari, the writer of this history, was at Venice in the year 1566, he went to visit Tiziano, as one who was much his friend, and found him at his painting with brushes in his hand, although he was very old; and he had much pleasure in seeing him and discoursing with him. He made known to Vasari Messer Gian Maria Verdezotti, a young Venetian gentleman full of talent, a friend of Tiziano and passing able in drawing and painting, as he showed in some landscapes of great beauty drawn by him. This man has by the hand of Tiziano, whom he loves and cherishes as a father, two figures painted in oils within two niches, an Apollo and a Diana.

Tiziano, then, having adorned with excellent pictures the city of Venice, nay, all Italy and other parts of the world, deserves to be loved and revered by the craftsmen, and in many things to be admired and imitated, as one who has executed and is still executing works worthy of infinite praise, which shall endure as long as the memory of illustrious men may live.

* * *

Titian died in 1577, nine years after the second edition of Vasari's Lives *was published (1568). During the last years of his life he created some of the most extraordinary works of his career, and it seems that he painted until the year before his death.*

CHRONOLOGY

Names in capital letters are artists whose lives appear in this edition.

1252 First florin minted in Florence; soon became standard coin throughout Europe.

1254 Marco Polo born (d. 1324).

1265 Dante Alighieri born (d. 1321).

1267 GIOTTO born.

1272 Cimabue active (to 1302).

1275 Marco Polo at court of Kublai Khan.

1278 Duccio active (to 1318).

c. 1280 GIOTTO apprenticed to Cimabue.

c. 1290 Andrea Pisano born (d. 1348).

Invention of eyeglasses.

Giottesque Master works on frescoes in Church of San Francesco in Assisi (to 1299?).

1294 Accession of Pope Boniface VIII; a patron of the arts, he was last pope to proclaim universal authority ("I am Pope, I am Caesar"). Boniface brought to humiliation by King Philip IV of France and dies in disgrace in 1303.

1295 Marco Polo returns from China.

1296 Florence Cathedral (Santa Maria del Fiore) begun by Arnolfo di Cambio.

1299? Construction begins on the Palazzo della Signoria (Palazzo Vecchio) in Florence.

1300 GIOTTO in Rome: executes fresco in Church of St. John Lateran and, possibly, the *Navicella* for St. Peter's (other sources state 1313).

1304 Pope Benedict XI (elected 1303) exiled to Perugia.

Birth of Petrarch (d. 1374).

1304–6 GIOTTO in Padua, works on Scrovegni Chapel frescoes.

1305 Commencement of Avignon Papacy; seven popes forced to reign in Avignon, beginning with Clement V.

1311–12 GIOTTO in Florence.

1313 GIOTTO in Rome.

Giovanni Boccaccio born (d. 1375).

1317–25 GIOTTO in Florence; probably begins on frescoes in Bardi and Peruzzi chapels.

1323 Thomas Aquinas canonized.

1327 GIOTTO works on designs for Tomb of Bishop Tarlati.

1328–33 GIOTTO in Naples, at court of King Roger of Anjou.

1334 July 18: Foundations for Florence Campanile begun.

1337 Jan. 8: GIOTTO dies.

1338 Founding of the University of Pisa.

1342 Pope Clement VI elected in Avignon.

1345 Bankruptcy of two major Florentine banking houses: Bardi and Peruzzi.

1348 The Black Death decimates Florence and Siena.

1352 Pope Innocent VI elected in Avignon.

1362 Pope Urban V elected in Avignon; goes to Rome briefly, but returns to Avignon.

1364 Founding of Aztec capital of Tenochtitlán.

1369 Charles V of France commences the building of a château called the Bastille.

1370 Pope Gregory XI elected in Avignon; toward the end of his pontificate Gregory visits Rome and dies there in 1378.

1377 Filippo Brunelleschi born (d. 1446).

1378 The beginning of the Great Schism: Urban VI elected pope in Rome, and Clement VII elected pope in Avignon. Lorenzo Ghiberti born (d. 1455).

1382–83 or 1386 Donatello born (d. 1466).

1387 Fra Angelico born (d. 1455).

1389 Pope Boniface IX elected in Rome, while Pope Clement VII remains pope in Avignon.

Birth of Cosimo de' Medici, known as *Pater Patriae* ("Father of his Country").

1397 Paolo Uccello born (d. 1475).

1401 Masaccio born (d. 1428).

1403 Ghiberti begins first set of doors (Gates of Paradise) for Florence Baptistry.

1405 War between Florence and the Visconti forces ended; peace party headed by Giovanni de' Medici, a banker and wool merchant and possibly Italy's wealthiest individual.

1406 Pope Gregory XII elected in Rome.

1408 Cardinals of Avignon and Rome convene to end Great Schism.

1409 Council of Pisa attended by 500 prelates from all over Europe; they elect Alexander V. Three popes now reign simultaneously (Alexander, Gregory XII, and Benedict XIII in Avignon); Gregory abdicates.

1410–20 Piero della Francesca born (d. 1492).

1412 Filippo Brunelleschi's *Rules of Perspective*.

1414 So-called antipope, John XXIII (elected 1410), expelled from Rome.

Council of Constance convened to restore unity of Church.

The Medici become bankers to the papacy.

1417 Pope Martin V (of the Roman Colonna family) elected; dissolves Council of Constance.

1425 Masaccio's frescoes in the Brancacci Chapel.

1431 Joan of Arc condemned as heretic; burned at the stake in Rouen.

1433 Cosimo de' Medici exiled from Florence because of Florence's disasterous war against Lucca.

1434 Cosimo's banishment rescinded, beginning the sixty-year Medici domination of Florence.

During convocations of Council of Basel (1431–49) a rebellion breaks out in Rome; Pope Eugene IV (r. 1431–47) flees to Florence.

1436 Andrea del Verrocchio born (d. 1488).

Completion of Brunelleschi's dome of Florence Cathedral.

1439 Council of Basel deposes Eugene IV, elects Amadeus of Savoy as Felix IV (an antipope), solely because of his wealth.

1440 Platonic Academy founded in Florence.

Florence and Venice defeat troops of Filippo Maria Visconti at Battle of Anghiari.

1444 Biblioteca Medicea Laurenziana (Medici Library in San Lorenzo) founded by Cosimo de' Medici.
Probable birth year of Bramante (d. 1514).

1445 BOTTICELLI born.

1447 Election of Tommaso Parenticelli as Pope Nicholas V. A noted scholar, Humanist, and former librarian for Cosimo de' Medici, Nicholas instituted the idea for a new building for St. Peter's.

1449 Domenico Ghirlandaio born (d. 1494).
Lorenzo de' Medici, known as Lorenzo the Magnificent, born (d. 1492).

1450 Pietro Perugino born (d. 1523).

Vatican Library founded by Nicholas V.

Francesco Sforza becomes duke of Milan.

1451 Christopher Columbus born (d. 1506).

Lodovico Sforza (known as Il Moro) born (d. 1508).

Amerigo Vespucci born (d. 1512).

1452 April 15: LEONARDO born.

Completion of Ghiberti's second set of doors (Gates of Paradise) for the Florence Baptistry.

Girolamo Savonarola born.

1453 Constantinople falls to the Turks; the end of the Byzantine Empire.

Series of conflicts between France and England known as the Hundred Years' War ends.

1453–55 Johannes Gutenberg issues the Mazarin Bible, the first book to be printed entirely from movable type.

1457 Filippino Lippi born (d. 1504).

1458 Aeneas Silvius Piccolomini elected Pope Pius II; a Humanist, intellectual, and literary man, he advocated papal supremacy.

c. 1460 Pitti Palace in Florence begun (designed c. 1440 by Brunelleschi).

c. 1461 LEONARDO commences studies with Verrocchio.

1464 Election of Pope Paul III (a wealthy and cultivated Venetian).

Death of Cosimo de' Medici.

c. 1464 BOTTICELLI enters Fra Filippo Lippi's studio.

1469 Death of Fra Filippo Lippi.

Birth of Niccolò Machiavelli (d. 1527).

Florence ruled by Lorenzo de' Medici (Lorenzo the Magnificent).

1470 BOTTICELLI's Fortitude.

1471 Albrecht Dürer born (d. 1528).

Francesco della Rovere becomes Pope Sixtus IV (the Sistine Chapel, built by his command, is named for him).

1472 First printed edition of Dante's Divine Comedy.

1472–76 LEONARDO accepted into the Florentine painters' guild, the Compagnia di San Luca; continues work with Verrocchio.

1474–76 LEONARDO's Ginevra de' Benci and Madonna of the Carnation.

1475 Mar. 6: MICHELANGELO BUONARROTI born.

1475–77 Giorgione born (d. 1510).

c. 1476 Cesare Borgia born, the illegitimate son of a Spanish-born prelate Rodrigo Lanzol y Borja (Roderigo Borgia), a nephew of Pope Callistus III.

1478 Giuliano de' Medici, duke of Nemours, born, youngest son of Lorenzo the Magnificent.

Lorenzo's younger brother, Giuliano, murdered at Easter Sunday High Mass in the Cathedral. Lorenzo is not killed, and thus the Pazzi Conspiracy (secretly approved by Pope Sixtus IV) aimed at eliminating the Medici domination of Florence, fails.

At request of Ferdinand and Isabella, Pope Sixtus IV establishes the Inquisition in Spain to suppress heresy; the first Inquisitor General is the Dominican monk Tomás de Torquemada.

1480 Lodovico Sforza assumes regency of Milan.

BOTTICELLI's St. Augustine fresco in Church of Ognissanti.

c. 1480 LEONARDO invents prototype of parachute.

1481–82 BOTTICELLI in Rome to work on Sistine Chapel wall frescoes; other artists involved include Ghirlandaio, Perugino, Pinturicchio, and Signorelli.

c. 1482 LEONARDO departs Florence for Milan (leaving behind unfinished Adoration of the Magi); enters service of the Sforzas.

1483 LEONARDO begins equestrian statue of Francesco Sforza; first version of Virgin of the Rocks.

Richard III assumes English throne (presumably having murdered his brother Edward V and the "princes in the Tower").

Martin Luther born (d. 1546).

April 6: RAPHAEL born.

1484 BOTTICELLI's Birth of Venus.

Giovanni Cibo elected Pope Innocent VIII; an indolent and corrupt pontiff.

1485 BOTTICELLI's *Bardi Altarpiece.*

1486 Andrea del Sarto born (d. 1530).

1488 MICHELANGELO studies with Domenico and Davide Ghirlandaio.

c. 1488 TITIAN born.

MICHELANGELO admitted to Lorenzo the Magnificent's art school in Medici Gardens; his nose is broken by fellow-student Pietro Torrigiani.

1490 LEONARDO designs *Il Paradiso,* theatrical spectacle produced for Sforza-Aragon nuptials.

1492 Death of Lorenzo de' Medici; his son Piero succeeds as ruler of Florence.

Jews, Muslims, and other non-Catholics expelled from Spain by order of Inquisition.

Roderigo Borgia elected Pope Alexander VI; he becomes a powerful political force although a scandalous pontiff. His illegitimate daughter, Lucrezia, marries Giovanni Sforza.

Oct. 3: First voyage of Columbus culminates in discovery of New World when his three-ship fleet lands on an island in the Bahamas; he names it San Salvador.

c. 1492 LEONARDO designs a prototype flying machine.

1493 Pope Alexander VI appoints his son Cesare (model for Machiavelli's *Prince*) cardinal.

1494 Francis I, king of France, born (d. 1547).

RAPHAEL's father dies.

Lodovico Sforza (Il Moro) becomes duke of Milan.

Charles VIII of France attacks Florence; the Medici expelled.

Nov. 9: Government of Florence taken over by Dominican friar Girolamo Savonarola.

1495 LEONARDO begins work on *The Last Supper.*
BOTTICELLI's *Calumny of Apelles;* begins illustrating *Divine Comedy.*
Syphilis epidemic originating in Naples spreads throughout Europe.

1496 MICHELANGELO's first sojourn in Rome.

1497 MICHELANGELO's *Bacchus.*

Savonarola excommunicated for attempting to depose Pope Alexander VI.

1498 Savonarola executed as heretic in the Piazza della Signoria in Florence.

MICHELANGELO receives commission for *Pietà* for St. Peter's.

1500 Charles V of Spain born.

Benvenuto Cellini born (d. 1571).

MICHELANGELO's *Bruges Madonna.*

RAPHAEL receives commission for *Altarpiece of the Blessed Nicholas of Tolentino.*

1501 MICHELANGELO returns to Florence; *David* commissioned.

1501–02 Amerigo Vespucci charts Brazilian coast; a few years later this discovery led to proposal that New World be named America in his honor.

1503 Nostradamus born (d. 1566).

Pope Pius III (Francesco Piccolomini, nephew of Pius II) dies twenty-eight days after his election.

Giuliano della Rovere elected as Pope Julius II.

LEONARDO in Florence; begins *Mona Lisa.*

1504 RAPHAEL in Florence; paints *Marriage of the Virgin* (so-called *Sposalizio.*

MICHELANGELO and LEONARDO work on projected frescoes for Council Hall of Palazzo Vecchio: *Battle of Cascina* and *Battle of Anghiari.*

MICHELANGELO's *David* installed in front of Palazzo Vecchio.

1505 MICHELANGELO returns to Rome in March; receives contract for Tomb of Julius II.

1506 Pope Julius II lays cornerstone of new basilica of St. Peter's, designed by Bramante.

Laocoön unearthed in Rome.

LEONARDO leaves Florence for Milan.

1507 TITIAN and Giorgione work on frescoes for Fondaco dei Tedeschi in Venice.

1508 Pope Julius II summons MICHELANGELO to Rome; commissions Sistine Chapel ceiling.

RAPHAEL enters service of Julius II.

1509 Henry VII born.

1510 RAPHAEL begins frescoes in the Vatican Stanze.

May 17: BOTTICELLI buried in cemetery of Church of Ognissanti.

1511 MICHELANGELO's Sistine Chapel ceiling unveiled.

July 20: GIORGIO VASARI born.

RAPHAEL's *Parnassus* in the Stanza della Segnatura.

1512 Pope Julius II leads troops and expels French forces from Italy.

Restoration of Medici rule in Florence.

MICHELANGELO completes Sistine Chapel ceiling.

1513 MICHELANGELO signs second contract for Tomb of Julius II.

Death of Pope Julius.

Giovanni de' Medici, son of Lorenzo the Magnificent, becomes Pope Leo X.

1514 Completion of RAPHAEL's frescoes in Vatican Stanze.

Aug. 1: RAPHAEL's appointed Bramante's successor as architect of St. Peter's.

1515 Francis I crowned king of France.

TITIAN's *Flora.*

1516 Death of Giuliano de' Medici, duke of Nemours.

TITIAN commissioned to paint *Assumption* for the Church of the Frari in Venice; also begins working for ducal court of Ferrara.

MICHELANGELO's *Moses.*

RAPHAEL's *Sistine Madonna.*

1517 MICHELANGELO's wooden model for façade of Church of San Lorenzo.

At invitation of Francis I, LEONARDO leaves Italy to stay at Cloux, near Amboise.

RAPHAEL's *Transfiguration* commissioned.

Oct. 31: Martin Luther posts his 95 Theses on the door of Court Church in Wittenberg.

1518 TITIAN's *Assumption* unveiled.

RAPHAEL's *Pope Leo X with Cardinals*.

RAPHAEL and assistants begin Vatican Loggia frescoes.

1519 Lucrezia Borgia dies.

MICHELANGELO begins work on Medici Chapel in San Lorenzo.

Cosimo I de' Medici born (d. 1574).

Seven of RAPHAEL's tapestries hung in Sistine Chapel.

May 2: Death of LEONARDO at Cloux.

1520 Martin Luther excommunicated.

Hernando Cortez captures Aztec capital of Tenochtitlán, deposes Emperor Moctezuma; Aztec empire falls to Spain.

April 6: RAPHAEL dies, his *Transfiguration* uncompleted.

1521 Death of Pope Leo X.

1522 Adrian of Utrecht elected Pope Adrian VI; the last non-Italian pontiff until the present day.

1523 TITIAN's *Bacchus and Ariadne*.

Giulio de' Medici, illegitimate son of Giuliano de' Medici, becomes Pope Clement VII.

Dec.: MICHELANGELO summoned to Rome to discuss projected Laurentian Library with Pope Clement.

1524 MICHELANGELO begins work on Medici Tombs.

1525 Feb. 25: The Battle of Pavia: under Spanish commanders, French forces of Francis I routed, and Francis is captured and sent to Madrid.

TITIAN married.

First English translation of New Testament printed: William Tyndale's Bible.

Composer Giovanni Pierluigi da Palestrina born (d. 1594).

1527 Pope Clement excommunicates Henry VIII and annuls his divorce from Catherine of Aragon.

Medici expelled from Florence; reestablishment of Florentine republic.

May 7: The Sack of Rome by Charles V's Spanish and German mercenaries.

1529 MICHELANGELO's fortifications of Florence.

1530 TITIAN's *Cardinal Ippolito de' Medici*.

Florence falls to armies of the pope and Holy Roman emperor; republic dissolved, and Alessandro de' Medici appointed duke of Florence.

TITIAN's portrait of Charles V.

Charles V crowned Holy Roman emperor in Bologna.

1531 Reappearance of Halley's Comet.

1532 Machiavelli's *The Prince* published.

1533 MICHELANGELO in Florence: works on Medici Chapel, Laurentian Library, *Victory*, and *Slaves* for the still-uncompleted Tomb of Julius II.

Henry VIII marries Anne Boleyn in defiance of Pope Clement VII and is excommunicated.

Birth of Queen Elizabeth I (d. 1603).

TITIAN's *Charles V*.

1534 The English Reformation begins with the Act of Supremacy, which appoints Henry VIII and all succeeding monarchs as head of the clergy and church.

Alessandro Farnese elected Pope Paul III; his pontificate recognized the Jesuits, established the Universal Inquisition.

Duke Alfonso d'Este dies; he is succeeded by his son Ercole II.

Martin Luther completes translation of Bible into German.

1535 Sir Thomas More tried for treason and executed.

1536 Anne Boleyn executed.

TITIAN's *Duke of Urbino*; receives commission from Frederigo Gonzaga for portraits of the twelve Caesars.

1538 TITIAN's *Venus of Urbino*.

1540 Commencement of renovation of Palazzo Vecchio in Florence, including extensive fresco cycles by VASARI (renovations completed in 1572).

Ignatius of Loyola founds The Society of Jesus (the Jesuits) in Rome.

1541 MICHELANGELO completes remodeling of Campidoglio in Rome.

Oct. 31: MICHELANGELO's *Last Judgment* in Sistine Chapel unveiled.

Dec.: VASARI meets with TITIAN in Venice.

1542 MICHELANGELO begins Pauline Chapel frescoes.

1543 Copernicus' *De Revolutionibus Orbium Celestum* (written 1540) published; it propounds theory that planets revolve about the sun. Opposition from theological as well as scientific quarters.

1545 Council meets for first time to form rigid doctrines to oppose the rising tide of Protestantism.

MICHELANGELO's Medici Chapel opened in Florence; in Rome three of his statues (including *Moses*) placed on upper level of Tomb of Julius II.

TITIAN travels to Rome; sightsees with VASARI, meets with MICHELANGELO.

1546 Pope Paul III appoints MICHELANGELO architect of St. Peter's.

1547 VASARI probably begins writing Life of Michelangelo for first edition of the *Lives*.

Death of Henry VIII.

MICHELANGELO's wooden model for St. Peter's; begins work on the Florence Pietà, intending it for his own tomb.

1548 Giordano Bruno born. The eminent anti-Aristotelian and Neoplatonist philosopher was burned at the stake for heresy in 1600.

TITIAN in Augsburg: *Charles V on Horseback*. On his return to Venice stops at Innsbruck and paints children of Ferdinand I, brother of Charles V.

1550 MICHELANGELO's (and Antonio da Sangallo the Younger's) Palazzo Farnese.

First edition of VASARI's *Lives* published; the only living artist included is MICHELANGELO.

MICHELANGELO's Pauline Chapel frescoes completed.

Giovanni Maria del Monte elected Pope Julius III.

1551 TITIAN's *Philip II*.

1553 TITIAN's *Danae*.

Mary Tudor (Bloody Mary), daughter of Henry VIII and Catherine of Aragon, ascends throne of England. She marries Philip of Spain, son of Charles V, later Philip II. Mary attempts to restore Catholic power and supresses Protestants.

1555 Sept. 25: Religious Peace of Augsburg. All principalities and free cities that acknowledged the Confession of Augsburg received freedom to worship as they pleased.

Marcello Cervini elected Pope Marcellus II but reigns only twenty-two days.

Gian Pietro Caraffa elected Pope Paul IV; a vigorous reformer, Paul's pontificate saw the establishment of the Index of prohibited books.

1556 Death of Aretino.

Charles V retires to Monastery of Yuste; Philip II becomes king of Spain.

1558 MICHELANGELO's definitive design for staircase of Laurentian Library; begins design for dome of St. Peter's.

Death of Mary Tudor. Elizabeth I crowned queen of England. Reenactment of Henry VIII's policies regarding church and monarchy.

Sept. 21: Charles V dies at Yuste; Philip continues pension Charles had granted TITIAN.

1559 Giovanni Medici (no relation to Florentine Medicis) becomes Pope Pius IV.

1560 VASARI begins design of Uffizi.

1561 MICHELANGELO begins design for Porta Pia in Rome and the redesigning of Baths of Diocletian for Church of Santa Maria degli Angeli.

1563 Termination of the Council of Trent.

1564 MICHELANGELO working on so-called *Rondanini Pietà*.

Birth of Shakespeare (d. 1616).

Birth of Galileo (d. 1642).

Feb. 18: Death of MICHELANGELO.

Mar. 10: MICHELANGELO's obsequies in Santa Croce in Florence; his tomb designed by VASARI.

1565 MICHELANGELO's *Victory* installed in Council Chamber of Palazzo Vecchio.

TITIAN sends a *Last Supper* to Philip II.

1566 Antonio Michele Ghislieri becomes Pope Pius V. Later canonized, this pope proclaimed Anathema on Queen Elizabeth I in 1570.

1568 Second, and final, edition of VASARI's *Lives of the Most Eminent Painters, Sculptors, and Architects*; this edition included biographies of VASARI's contemporaries.

1571 Oct. 7: Battle of Lepanto. Allied Mediterranean fleets (chiefly Spanish and Venetian) defeat the galleys of the Turks, thus opening the Mediterranean to European navigation once again. Considered at the time to be greatest naval triumph since the Battle of Actium.

1572 Ugo Buoncampagni becomes Pope Gregory XIII; he is remembered for his reform of the calendar in 1582 (the Gregorian calendar in use today).

1574 TITIAN visited by Henry III of France.

Death of VASARI.

1576 Feb.: TITIAN writes last letter to Philip II requesting payment for paintings he had sent him.

Aug. 27: Death of TITIAN.

INDEX

PHOTOGRAPHIC CREDITS